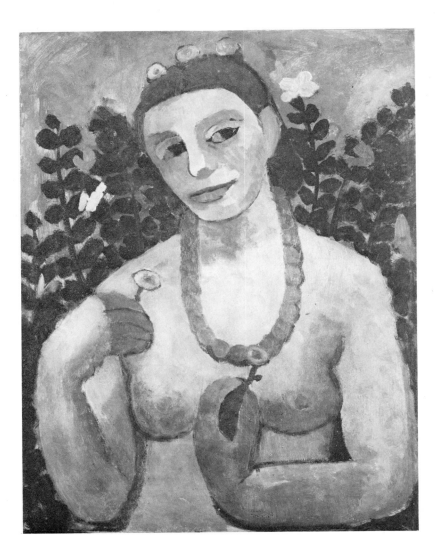

The Letters and Journals of
PAULA MODERSOHN-BECKER

Translated and Annotated by
J. Diane Radycki

Introduction by
ALESSANDRA COMINI

Epilogue by
ADRIENNE RICH
and LILLY ENGLER

The Scarecrow Press, Inc.
Metuchen, N.J., & London
1980

Frontispiece:

Self-Portrait, Half-Nude, with Amber Necklace
cardboard, 62.2×48.2cm (24½×19in)
1906
Ludwig Roselius Collection, Böttcherstrasse, Bremen

Library of Congress Cataloging in Publication Data

Modersohn-Becker, Paula, 1876–1907.
 The letters and journals of Paula Modersohn-Becker.

 Translation of Briefe und Tagebuchblätter.
 Includes index.
 1. Modersohn-Becker, Paula, 1876–1907.
2. Painters—Germany, West—Correspondence.
I. Radycki, J. Diane. II. Title.
ND588.M58A313 1980 759.3 [B] 80-18993
ISBN 0-8108-1344-0

To John McNee

Contents

Acknowledgments

This has been a long and rewarding project. Besides allowing me an intimacy with Paula Modersohn-Becker it has provided me with the experience of making good friends with those who began as my teachers.

I want to acknowledge my debt to the late Dr. Jeanne Wilde of Hunter College. It was she who first encouraged me. My memory of her, and her indomitable energy, sustained me through many tedious nights of scribbling.

My greatest debt is to Johanna Albrecht and Elfriede Plostins. They were there at every point when I needed them, to read and discuss the manuscript. They understood the importance of arguing over words a hundred years old in the task of trying to be true to the life of Paula Becker. Mrs. Plostins's knowledge of *Plattdeutsch*, her memory of life in North Germany, and her personal generosity and patience were invaluable to me.

The poet and critic Robert Fagan made all the right suggestions. With his help this text crossed from translation to English. His close attention to language makes him more than an excellent editor: he is truly a teacher, and my dear friend.

To Sophie and Casimir Radycki, for giving me the opportunity to do this work; to Natalie Goldstein, for all her help; and to those friends who held my hand: thank you; and, finally to the New York Public Library, where I spent some of the happiest days of my life.

Translator's Preface

Some of Paula Modersohn-Becker's writings were first published in 1917 and 1919 in the journal *Die Güldenkammer*. In 1920 an expanded edition, *Die Briefe und Tagebuchblätter von Paula Modersohn-Becker*, was published by Kurt Wolff Verlag in Berlin. The book was very popular in Germany and was reprinted in various abridged editions fourteen times in the next thirteen years. This translation is from the 1920 edition, with the addition of a letter to Westhoff originally published in Rolf Hetsch, ed., *Paula Modersohn-Becker: Ein Buch der Freundschaft*, Berlin, 1932, and of five letters to the Vogelers from Konrad Tegtmeier, *Paula Modersohn-Becker*, Bremen, 1927.

This translation differs from the 1920 edition in organization and editorial material. I have presented Becker's letters and journals chronologically. There are two exceptions in Chapters VII and XV. Here I confess to giving drama priority. S. D. Gallwitz, the editor of the original edition, arranged the letters and journals in alternating sequence. This effectively blocked immediate comparisons between what Becker was saying publicly in letters and what she was admitting privately in her journals. Gallwitz also removed from the text to the introduction Becker's letter to Hoetger, with its implied criticism of her husband. I have not included Gallwitz's introduction or her brief editorial comments, with the exception of several footnotes, which are marked with her initials. Instead I have annotated the

text with headnotes and footnotes about the relevant historical-social-feminist situation and the contemporary artistic milieu.

I chose to translate *Tagebuchblätter* as "journals." There is evidence that Becker made these jottings in a number of places (*Küchenhaushaltebuch*, sketchbooks) and not always in order. I felt that "journals" better reflected this diversity in English than did "diaries." Working with the printed text revealed quite a number of typographical errors. As it was impossible to distinguish which of these might be spelling mistakes, I decided to present in English a correctly spelled text, including proper names (e.g., Jersey, not Harnsey; Colarossi, not Cola Rossi; Namsos, not Namos; Injalbert, not Seyalbert; Girardot, not Girandot). I left in the original whatever Becker wrote in French in order to transmit a sense of the impact of that culture on her. Becker's writing style is simple and straightforward, very like her paintings. It is my hope that this translation captures some of her force and beauty.

J. D. R.

New York City

Introduction: The Monumental Intimacy of Paula Modersohn-Becker

Expressionism, in early twentieth-century art, was primarily a German "intuition." As such, the movement was effective at home just before and just after World War I, but its intense revolutionary style inspired scant enthusiasm in other countries. The English had a word for this emotional art in which form seemed to follow feeling—excessive. And when the style, as represented by two Lehmbruck statues and a canvas apiece by Kirchner and Kandinsky, was introduced to the American public at the now-historic Armory Show of 1913, it was completely overwhelmed, as were the American entries, by the limelight given the Cubist canvases from France. If German Expressionism was too long ignored abroad, the reverse occurred in Germany of the 1930s: every single practitioner of the style as well as its immediate forerunners and followers came under the baleful eye of Adolf Hitler, who hurled his aesthetic wrath into a derisory exhibition of confiscated works assembled by his lieutenants in Munich in 1937. This time the word for such art was—degenerate. In preparation for this spectacle of the "dregs" of German art, some seventy works by Paula Modersohn-Becker were seized from museum collections.

Today, toward the close of the twentieth century, "excessive" and "degenerate" are certainly not adjectives that come to mind when encountering the work of this major early Expressionist artist. Instead one is tempted to repeat the words confided by her painter-husband Otto

Modersohn to his diary: "In her intimacy, she is monumental."

Paula Modersohn-Becker's painterly repertoire of solemn children and bone-weary peasants silhouetted as massive forms against tender country settings comes from a real-life source: Worpswede. A village of farmers, peat cutters, and pottery makers, Worpswede is some twenty miles north of Bremen in the heart of the low-lying North German moors. This thatched-roofed, bucolic retreat, surrounded by pine and birch trees (which to the artist appeared correspondingly male and female in character) and laced with canals, had attracted nature painters since before the turn of the century. The extraordinary and ever-changing light that accompanied its dramatic storms and lingering sunsets made the village unusually picturesque. The artists' colony led by Fritz Mackensen that settled there for year-round living in 1889 saw Worpswede, however, as far more than a scenic locale. To them it was the archetypal community, the *Weltdorf,* or world village. Here the cycles of nature and the pageant of life proceeded with limpid dignity, unaffected by the urban blight of a force-fed Industrial Revolution that was threatening to destroy the soul of a Wilhelmine Germany whose body politic seemed mired in choking materialism. Hence the powerful immediacy of Modersohn-Becker's figural icons as, through drastic simplification and rhythmic patterning, they declaim their elemental oneness with nature. And it is this elemental quality, this totemic colossality of conception, that differentiates and sets Modersohn-Becker's art apart from that of the other Worpswede painters, including Mackensen her teacher and Modersohn her husband. Whereas they felt "small" before the greatness of nature, Modersohn-Becker was inspired to compose ever-larger human antiphonies. Rejecting her colleagues' nostalgic and frequently beautiful celebration of the unspoiled mood of Worpswede, Modersohn-Becker sought "runic script" equivalents for essence. Her quest for a primitivizing style that would convey the "great Biblical simplicity" that she sensed in the village people was constant, single-minded, consuming, and stubborn. It isolated her from the other painters and even from her husband.

Unlike the other members of the Worpswede colony Modersohn-Becker—in spite of her loyalty to the *Weltdorf*—found herself irresistibly drawn to the antipode, the *Weltstadt*. For her the world city was Paris. Time and again she left Worpswede and her husband for long study periods in the French capital. She realized that she needed exposure to the great art of the past and the stimulation presented by contemporary masters (Van Gogh, Gauguin, Cézanne). In the Louvre she began her reductive studies of such sophisticated masters of line as Ingres; her sketchbook notations show that it was not the wrinkles in a velvet glove or the tactile quality of ermine that Mlle. Rivière revealed to Frau Modersohn-Becker, but rather the expressive eloquence of semicurves that built up a great human vertical in front of horizontal bands of nature. Working with what she termed the "naive in line," Modersohn-Becker culled from her Paris studies a selective contour that achieved its trenchant effect through varying pressure and an extraordinarily controlled economy. This willful primitivism was developed with authority in the oil portraits that followed: sober, earnestly compassionate presentations of Worpswede peasants and children, their motionless figures encased in heavy lines, with audaciously flattened backgrounds, illuminated by earthen passages of greens and browns from which bloomed violets, pinks, yellows, and reds.

In her intensity ("personal feeling is the main thing") she violated traditional poetic distance and brought her subjects—whether landscape, still life, or human being—into close, hot focus with the fervor of a Van Gogh. Her single figures in nature seemed to grow before one's eyes, as the ratio of figure to ground increased in favor of a human monumentality directly proportionate to the sensed vastness of nature. Her frankly animalistic mother-and-child portrayals (so offensive to the Nazi Socialists despite their emphasis on child-bearing for the state) did not present what motherhood looks like, but what motherhood *feels* like: horizontal rather than vertical. Not the coiffeured, saccharine, decolleté pyramid of a nursing coquette, but the spent interdependence of two undecorously reclining forms whose heads—whose intellects—are in shadow and whose

bloated bodies press together in unrelieved, unselfconscious nakedness. In a partially nude self-portrait of 1906 she imagined and pondered her own pregnancy in a quizzical, unflinching self-confrontation. In other nude self-portraits she contrasted the white flesh of her breasts with a favorite amber necklace while symbolizing her oneness with nature by holding and entwining small flowers in her hair.

In the year 1907 Paula Modersohn-Becker's personal question about life and death was answered in the negative: nineteen days after she gave birth to her only child she died of a heart attack. She was only thirty-one.

She left some 1,000 drawings and graphic works and over four hundred paintings—a life's cache, the volume of which surprised even her husband when he took inventory of her studio after her death. She also left another treasure-trove, a literary legacy of journal entries and letters that chronicle her lonely, hard-won artistic discoveries and movingly disclose her personal aspirations and disappointments.

The German public had access to Modersohn-Becker's literary legacy ten years after the artist's death, when a collection of her letters and diary (journal) pages was published in 1917. Other editions followed in 1920, 1957, and 1979. This book brings the first full presentation of Modersohn-Becker's writing to an English-reading audience—an event long overdue. An intriguing guide to Paris as seen through the eyes of a foreigner at the turn of the century, the letters and journal commentaries also introduce an engaging and closely-knit German family—the artist's mother and father, who are concerned for her happiness as an artist, her two sisters, whose lives take more conventional routes, and the encouraging Aunt Marie in England. It is also extremely valuable to have another version of the Worpswede colony life and aims than that of Rainer Maria Rilke's. Modersohn-Becker's writings throw a sometimes hyperborean light on the changing relationships between herself, her friend Clara Westhoff the sculptor, who married Rilke, and her husband Otto Modersohn. The subjects she has portrayed in paint take on added color and dimension in her writing.

The conflict—revealed in this book—for Paula Modersohn-Becker between what society expected of her as a married woman (she even went to Berlin to study cooking) and what she craved for herself as an artist will strike many readers as a familiar and still-unsolved problem. The victories and setbacks of these two gravitational pulls are revealed with spell binding directness as the artist puts her thoughts on paper. As with the letters of Van Gogh, tremendous depths are revealed by the author's gift—or affliction—of empathy. Books, people, gestures, "Lutheran" speech, flowers, birds, autumn sunshine, bright snow, nightingale nights are all acutely observed and noted down. All were necessary "harmonies for the principal chord" of her life, her art.

"The desire burns in me to be great in simplicity." Posterity can safely make the judgment that Paula Modersohn-Becker's desire was achieved in her short lifetime. She created what her literary self-expression corroborates: an oeuvre of deeply moving images that are indeed monumental in their intimacy.

Alessandra Comini

Southern Methodist University

Paula Modersohn-Becker: Chronology

1876 Born February 8th in Dresden.

1888 Becker family moves to Bremen.

1892 Goes to England. Attends St. John's Wood School of Art in London.

1893–95 Returns to Bremen. Attends Teachers' Training Seminary for two years. Studies art privately with painter Bernard Wiegandt.

1896–97 In spring and winter attends Zeichen- und Malschule des Vereins der Künstlerinnen in Berlin, where she studies with Jeanna Bauck and Ernst Friedrich Hausmann. Sees drawings by Michelangelo and Botticelli in the Kupferstichkabinett, Neues Museum.

1897 In summer goes to the artists' colony of Worpswede and studies with painter Fritz Mackensen.

1897–98 In fall returns to Berlin to attend Zeichen- und Malschule des Vereins der Künstlerinnen.

1897 At end of November visits Vienna and the

Kunsthistorisches Hofmuseum and Galerie Liechtenstein.

1898 Vacations in Norway in June and July. Reads Jens Peter Jacobsen. Moves to Worpswede in September and studies again with Mackensen. Meets Clara Westhoff. Reads Marie Bashkirtseff.

1899 Visits Switzerland in August. In December has first public exhibition: a group show with Westhoff and Maria Bock in Bremen Kunsthalle.

1900 January to June studies in Paris: attends Académie Colarossi (teachers: Courtois, Collin, Girardot); sketches in Louvre; and attends anatomy lectures at Ecole des Beaux-Arts. Sees Cézannes for the first time at Galerie Vollard. Paris World's Fair opens in April. Sees sculptures by Rodin and, at the Decennial Exhibition, paintings by Cottet and Segantini.

Returns to Worpswede in July. Meets Rainer Maria Rilke in August.

1901 Sent to cooking school in Berlin for January and February in preparation for her marriage. In Berlin meets weekly with Rilke and reads with him plays of Gerhart Hauptmann. Sees Rembrandts and Old German Masters in Altes Museum, and Böcklins in Nationalgalerie.

Rainer Maria Rilke and Clara Westhoff marry April 29th. Becker and Otto Modersohn marry May 25th. The Modersohns settle in Worpswede after their honeymoon, which included a visit to the Hauptmann brothers. Becker's father dies in November.

1902 Estrangement from Rilke and Westhoff. Paints
 Elsbeth in summer.

1903 Visits Paris for six weeks in February and March.
 Again attends Académie Colarossi and sketches
 in Louvre, where she sees Millets, Rembrandts,
 and Tanagra figurines. Reconciliation with
 Rilke and Westhoff, whom she visits frequently
 while in Paris. Together they go to see Hayashi
 Collection of Japanese prints. Sees Rodin's
 sculpture in Paris and Meudon. Visits Luxem-
 bourg Museum (Manets, Renoirs, Zuloagas) and
 modern-art galleries on rue Lafitte.

 Returns to Worpswede.

1905 Again visits Paris for six weeks in February and
 March. Attends Académie Julian. Is impressed
 by "the most most modern painters." Goes to
 Salon des Indépendents (Van Gogh retrospect-
 ive). Sees Gaugins of collector Gustave Fayet.

 Returns to Worpswede. Paints portrait of Clara
 Westhoff.

1906 In January visits Schreiberhau and Berlin with
 Modersohn. In Schreiberhau paints portrait of
 Werner Sombart. In Berlin goes to Kaiser Fried-
 rich Museum and Nationalgalerie. Sees Leibls,
 Trübners, Böcklins, Feuerbachs, and Marées in
 exhibition "Deutsche Jahrhundertausstellung,"
 1775–1875.

 In February is estranged from Modersohn.
 Moves to Paris. Takes anatomy classes at Ecole
 des Beaux-Arts. Sees Manets at Galerie
 Durand-Ruel. Meets sculptor Bernhard Hoetger.
 In April vacations in Brittany with her sister
 Herma. Back in Paris paints life-size nudes and

still lifes. In mid-May Rilke moves to Paris from Meudon and stays until end of June. Paints portrait of Rilke. In June Modersohn comes to Paris for a week. In August paints portraits of Lee Hoetger. In fall Modersohn returns to Paris and in winter they resume living together. In November has her second public exhibition: a group show with Modersohn and other Worpswede painters in Bremen Kunsthalle (organized by Gustav Pauli).

1907 In spring returns to Worpswede with Modersohn. In July visits the Hoetgers in Holthausen. Gives birth to a dauther, Mathilde, November 2nd. Dies November 21st of an embolism.

The Letters and Journals of
Paula Modersohn-Becker

I. London and Bremen, 1892–93

No one in Paula Becker's family had any connection with art. Her mother was from a minor aristocratic military family, the von Bültzingslöwens; her father was a civil engineer with the railroad. Their maverick daughter, born February 8, 1876, in Dresden, was the third of seven children.[1]

In 1888 the family moved from Dresden to the port city of Bremen in north Germany. There in 1892, when she was sixteen years old, Paula Becker took private art lessons from a well-established local painter, Bernard Wiegandt. Originally a scene painter for the theater in Berlin and Hannover, Wiegandt settled in Bremen, where he decorated the Rathaus (with murals of the city) and the Kunsthalle. Earlier that year Becker had enrolled in St. John's Wood Art Schools in London. She had gone to England for an extended visit with her Aunt Marie—her father's sister and the bane of Becker's existence.

Private British art academies were open to amateurs and serious students who wanted to prepare for the schools of the Royal Academy. Although women were denied membership in the Academy itself they were permitted to matriculate in its schools. St. John's Wood and particularly its Principal, Mr. Ward, were very successful at placing candidates in the R.A. Schools. At the time of Becker's attendance Alma Tadema was one of the Royal Academicians giving criticism at "the Wood." Between 1880 and 1895, 250 of the Royal Academy's 394 students were from the Wood, and over 70 percent of R.A. prizes awarded between 1886 and 1895 went to former Wood pupils.[2]

3

The technique taught at St. John's Wood was the tight and highly stippled drawing favored by the Academy. Women out-numbered men students. They worked together in all classes, except those with nude models, which were held separately. "Nude" models for women's classes, as defined in the Royal Academy Report of 1894, meant, "the drapery to be worn by the model . . . consist of ordinary bathing drawers, a cloth of light material nine feet long by three feet wide, which shall be wound round the loins over the drawers, passed between the legs and tucked in over the waistband; and finally a thin leather strap shall be fastened round the loins in order to insure that the cloth keep its place." [3]

To Her Family

Willey, 9 September 1892

Aunt Marie thinks I've written you about my art lessons as though I were a great artist. Unfortunately I must confess this isn't the case yet. I wouldn't even dare send you samples of my brushwork.

London, 21 October 1892

I'll begin with the latest. Aunt Marie and I have just come from the "School of Art," where I start Monday. I'll have lessons every day from 10 to 4. At first I'll only be drawing in pencil—very simple arabesques and the like. If I progress, then I draw in charcoal from Greek models. I saw several enchanting Venuses—such soft shadows. If I make even further progress, then I'll draw and paint from live models. But I don't expect to get that far. I'll be happy if I can make a chalk drawing of one of the Greek casts. There are fifty to seventy ladies and gentlemen in the atelier, most training as artists. I think I'm the youngest and I suppose I won't fit in so well among these talented people. But it'll be

good to see how far I can get, knowing I'm the farthest behind. It spurs my ambition. The lessons begin Monday. I'm so thankful to Uncle Charles for them.

London, 28 October 1892

Naturally, what most occupies my thoughts are my drawing lessons. The Principal is Mr. Ward, a man in his thirties who speaks terribly fast, otherwise he wouldn't have enough time to say all he wants. He gives splendid lessons, but he never gives praise. He has so many students that he can't see each one every day—he's been with me only three times. Assistant-masters take his place on the other days. I wish you could see the "Antique Room." If I had the time, I'd look at the drawings around me and watch them as they approach completion day by day. The ladies all wear baggy smocks and sit at their easels on awfully high stools, even higher than clerks' stools. While that height is certainly celestially artistic, it's too dangerous for this poor mortal. I've chosen a low masculine easel for myself. Today I drew an eye[4] and the area around it, which, I admit, wasn't "antique" but dreadfully ugly instead. At the beginning everything is three times life-size. . . .

November 1892

Dear Mother,

That you find pleasure in all your children, that is my wish for you. I am almost ashamed to say it because all I can give you pleasure with are my letters. And I know you can take no delight in them. My letters have to come from my heart. But often on Fridays when I should write, my heart is closed. I feel angry, I scold myself, but that doesn't unlock my heart or make it any better. Yes, I have to write a letter. All of you have the talent and can do it quickly. I think my talent for letter writing is too little, but it's really not my fault. So when I don't write you any good letters, better compassion for me than scoldings. Remember that I love you all the same. . . .

London, 10 November 1892
I have lots of time today because, just imagine, today there's a real London fog and there was such an Egyptian darkness in the atelier that we couldn't see anything. We couldn't draw the plaster casts in this light since the shadows fall differently. Of course I didn't want to waste my forty-five–minute walk, so I went into the room where the live model was sitting—a man dressed as a monk. A fine, determined face. I stretched a new sheet on my drawing board and sat down at my easel, but I didn't do any more than that. I suddenly got so frightened when I saw myself among all the artists that I crept away with my tail between my legs. Aunt Marie was surprised I had the courage to sit down there at all. . . .

London, 18 November 1892
. . . Now about my drawing lessons. I'm collecting another bunch of drawings to send you. Today I watched my neighbor draw a skull. She handled it as casually as a handkerchief, while just the sight of it gave me goosebumps. Another drew a skeleton. She took out its ribs, looked at them close-up, and put them back in their proper place, all with great composure. Nope, I wouldn't want to go that far.

To Her Aunt Marie

Bremen, 5 May 1893
My dear Aunt Marie,
I'm so happy to be allowed to write in German again. I'm able to express myself in English only very drably and for-mally, which I find terribly tedious. I'm sitting at Aunt Minchen's secretary pleasantly daydreaming about the old days when I was your good girl. I want to be her again. Try to forget all the time I spent with you in England, at least

forget the bad impression you got of me. I'm not like that, really not. You regarded me as extremely egotistical. I've thought about that so often, and I've really looked for this terrible egotism. I can't find it. I've found I'm imperious and used to being in charge. But everyone gives in to me and neither they nor I pay any attention to it. In school it's just a matter of course that my word carries weight. But does that have anything to do with egotism? And if it does, can I help it?

I've almost always been praised by Mama, or we took it for granted that I seldom did anything blameworthy. Then I visited you. I saw that in nearly every way I did not satisfy you, or I frustrated your hopes. Now, I have an enormous amount of pride. Could I bear all this? Could I, a spoiled child, get used to all this? Each time I saw your dissatisfaction I became more unhappy.

The time came when I was afraid of you as I have never been of anyone. I retreated into myself more and more and became a living lump of ice who gave nothing of herself. I felt no burning interest or desire, and these I must have.

You have this impression of me—I'm not like this. I can't imagine I ever was. I am the greatest puzzle to myself. None of us is accustomed to subordination, and I'm not either. I speak to Mama as a friend, but you wanted to be treated differently. At Willey[5] I found the fan arrangement in the "morning room" very pretty. I told you this and you found me presumptuous, so I withheld my comments after that. But I had such a strange feeling when you scolded me. Whenever Mama arranges a vase prettily, I tell her and we are pleased about it together. That's how people become close to each other. I just want to say it's my fate that I'm this way. I was brought up so differently and often I felt I grieved you without intending to.

But precisely because I have my pride I was protected from a lot. I would tell myself, "This is unworthy of you." My pride is the best thing about me. I can't bear humiliation, it makes me tired of life. My pride is my soul, but only its bad side was showing then. Take me back as the

Paula you knew before. The other is only my caricature.
I feel it.

Footnotes: Chapter I

1. "[A] striking characteristic of women artists gen-
 erally: they all, almost without exception, were
 either the daughters of artist fathers, or generally
 later in the nineteenth and twentieth centuries,
 had a close personal connection with a stronger or
 more dominant male artistic personality.... it is
 simply true almost *without exception*... at least
 until quite recently. Many of our more recent
 women artists like Suzanne Valadon, Paula
 Modersohn-Becker, Käthe Kollwitz, or Louise
 Nevelson, have come from nonartistic back-
 grounds." Ann Sutherland Harris and Linda
 Nochlin, *Women Artists: 1550-1950*, New York,
 1976, pp. 501, 502.

2. *The Art Schools of London: 1895*, ed. Tess Mac-
 kenzie, London, 1895, pp. 70-71. I am grateful to
 A. P. Burton, Assistant Keeper of the Library,
 Victoria and Albert Museum, and to K. C. Harri-
 son, City Librarian, Westminster City Libraries,
 London, for providing me with sources and mate-
 rials about St. John's Wood Art Schools. For fur-
 ther information on "the Wood" and its course of
 study see Stuart Macdonald, *The History and Phi-
 losophy of Art Education*, London, 1970, pp.
 34-35; Rex Vicat Cole, *The Art and Life of Byam
 Shaw*, London, 1932, pp. 23-28; and C. R. W.
 Nevinson, *Paint and Prejudice*, London, 1937, pp.
 14-15 ff.

3. Cited in Harris and Nochlin, p. 52.

4. Beginning students drew from plaster casts of separate features of the face of Michelangelo's *David*.

5. The country house of Aunt Marie and Uncle Charles, according to S. D. Gallwitz, ed., *Die Briefe und Tagebuchblätter von Paula Modersohn-Becker*, Berlin, 1920, p. 3. (Hereafter referred to as Gallwitz.)

II. Berlin, 1896–97

After her return to Bremen from England in 1893 Becker was pressured by her parents into attending the municipal teachers' seminary. Completing the two-year course with excellent marks, she remarked after her exams, "It's nice to know that my poor head is able to understand everything that was so hurriedly crammed in, and now in peace can forget all that is uninteresting."

In the spring of 1896, after prevailing upon her parents, Becker enrolled in Zeichen- und Malschule des Vereins der Künstlerinnen in Berlin (Drawing and Painting School of the Association of Women Artists in Berlin). Besides large departments of drawing and painting the school included a graphics department and a program for training drawing masters. This private academy was the same school where Käthe Kollwitz studied in 1885 and taught graphics and life-drawing a little more than a decade later.[1]

In Germany women were not admitted to the government schools that offered fine-arts programs—the usual route to recognition and acceptance by the Royal Academy of Art. Women students were permitted only in the decorative-arts schools. Membership in the Royal Academy was in two categories: regular, for "practicing artists"; and honorary, for "persons who, without being artists, have gained merit in general for art or the Academy, as well as outstanding women artists."[2] Other than private ateliers run by individual artists the school of the Verein der Künstlerinnen was the only place for women to study the fine arts in Berlin.

While women were not allowed to study art alongside men, they were allowed to study under them. All but one of the teachers at the women's school whom Becker mentions were men. The teacher who had the greatest influence on her was Jeanna Bauck. Bauck's significance was not as a stylistic influence but as a strong model of a serious artist. The description "shabby-shaggy," which Becker uses disparagingly of Bauck in these letters, is the term she used for herself two years later when describing her happiness.

While attending school Becker stayed with her Uncle Wulf von Bültzingslöwen and his family in Schlachtensee, then a picturesque colony of villas bordering Grunewald Forest to the southwest of Berlin.

To Her Family

Berlin, 16 April 1896

Today I had my second drawing lesson. Interesting and very funny! I'm drawing an old woman. Had to start over three times the first day, as Herr A is a strict teacher. I began with my hands shaking because I heard him railing at my neighbor:

"Trash! Trash! No?" Whereupon the poor victim had to promptly say "yes" or else Herr A would throw away the charcoal and race off to the next easel. (Thus knowledge of one's limitations is imparted!) At the next victim, "Idiotic! No?" And the contrite "yes" again, which he usually repeated in a sing-song, "Ye-e-s." . . .

I'm afraid that should the same thing happen to me, the "yes" will get stuck in my throat, which he'd interpret as obstinacy, and he'll run away. All good spirits stay with me! I've been fortunate so far—you have to know someone pretty well to be so rude to her face.

At the third easel: "Nüscht! Nüscht! Rien! Nothing! Nothing! Work with devotion, with passion!" Then, using

his whole palm, he rubbed off the fine, careful, charcoal drawing, put down a couple of shadows with his broad thumb, and rubbed on some effective highlights with a piece of bread. At once the drawing had an extremely ingenious, individual, and lively style. It's good he places more value on comprehension than on production, otherwise the matter would become rather superficial.

At the fourth easel: "Lack of talent or lack of diligence, hm? Fails completely. So?" The poor girl was allowed to answer this terrible "So?" very humbly, "Start over." Another was dreadfully abused because she didn't "feel" enough the curves of the ear she was drawing.

The whole thing made a very alarming impression on me, then gradually it became so funny that I could hardly keep from laughing. But of course I forced myself not to. Today he seemed fairly satisfied with my drawing. Well, satisfied is saying too much, for it's much, much too ingenuous for him, and still rather wooden. . . .

Berlin, 23 April 1896
. . . The days fly by! I have no time to feel lonely or bored. Four mornings a week are given to my drawing instruction, which now shapes the content of my thought. Even when I'm not in class, I think about how I would draw this or that face. Out walking, I study physiognomies with great pleasure and quickly try to find the most characteristic trait. Whenever I talk with someone, I diligently observe the shadow the nose casts and the way the deep shadow of the cheek begins powerfully and then blends back into the light. I find this blending most difficult. I still draw each shadow too distinctly. I include too many insignificant things, instead of bringing out more of what's important. Only then will the thing become flesh and blood. My heads are still too wooden and stiff.

Herr A appears to be a splendid teacher. He knows exactly what each student is capable of and demands the exertion of all her powers.

"It's sinful, sinful, if you treat art without devotion."

At present I've drawn two little old women, a sassy one with a feathered hat and a tired, gentle one. I was more successful with the latter. The manner is still so new to me, but I'm beginning to get a sense of it.

Mondays and Tuesdays I draw with Stöving.[3] But not with the same joy, there's no strength behind him. He doesn't criticize very much and really doesn't praise either. You don't know what he finds good or bad. Instead of looking at the work as a whole, he goes into each individual line. And he lacks enthusiasm.

I spend my two free mornings, Friday and Saturday, in the museum.[4] I'm now completely at home with the Germans and Holbein, but Rembrandt remains the greatest. His glorious light effects! He painted with devotion. Do you remember *The Vision of Daniel?* A moving picture. You needn't be at all religious to feel something of Daniel's religious trembling when you look at it. Rembrandt had a knack for shadows, which is why he interests me so much. . . . I must quickly to sleep now, so I'll be quick to absorb the wealth of new things.

Berlin, 18 May 1896

My dear Father,

I've known about my good luck for three days now! I think about it hourly but I still can't believe it. I really am allowed to continue my drawing lessons! I'll exert all my strength and make as much out of myself as possible. I see a splendid year ahead of me, full of creativity and struggle, momentary satisfactions, and striving for perfection.

I'm drawing daily as much as possible. And a great deal is successful in my portraits, but much is strangely exaggerated too.

When I don't have a model I go to the garden to try to sketch in watercolors. Or to the tall acanthus plant. Rough brickwork in reds and blues excites in me a tremendous desire for color.

I must draw you too, but only after your poll has grown

out. Have you scolded your barber yet? Do it please, please.
Or entrust your dear head to a better one, one more skilled.
At our next meeting I'll draw your portrait, but most defi-
nitely not without hair.

 . . . Did you know that we were in Hamburg, this lucky
child too? That we saw Bismarck, our old great Bismarck.
He has grown old, very old. The cheers of the people,
which he was glad to hear for decades, now annoy him. He
acknowledged them with a tired nod. His eye flew over the
crowd without seeing. I offered a rose to him in his carriage,
he took and sniffed it. I was so shaken. For the first time I
saw our great, great chancellor, but fate and age have bro-
ken his power. . . .

 . . . I feel I ought to have you with me so I could hug you
very hard. But if you were here, I probably wouldn't do it
because there is a mean something in me that would not
allow me such luxury. I don't know why it is there or where
it comes from. But it is there now and it will not be shaken
off. With each attempt to rid myself of it, it clung to my
soul only that much more tightly. Along the path of these
twenty years I have also gradually come to recognize its
great strength, this secret something so silent. Rarely now
do I struggle against this stern ruler and when I do it really
hurts.

 I watch M disseminate with hands full her riches out of
love. I feel her caressing, and caressing my innermost self.
But I can not really do that, and yet I do do it. I force
myself. Of course, the spontaneity is missing. I feel awk-
ward, and the others probably do too. . . .

 Berlin, 10 January 1897
Dearests,
 Today my Sunday letter has turned into a Monday letter.
It couldn't be helped. The days have too few hours and the
weeks too few days.

 I can only tell you over and over again how well I am and

how much I thank you. I really dread the way the weeks are
rushing by. I now have a glimmer of an idea in oil painting.
My paintings will surprise you on Papa's birthday, but you
mustn't think about them till then. Of course they're not
very beautiful yet. Still, painting gives me great pleasure.
Although I don't like to work under U half as much as
under Dettmann.[5] U's artistic seriousness is not as great. He
often dupes the public with pretty tricks. The complete
socializer in class—here a "my dear young lady" and there a
"my dear young lady," and while he's talking to you he
finishes painting half your picture. I've told him I'm paint-
ing my third one all by myself. I half-impressed him, half-
annoyed him. By the way, he looks like a caricature of an
artist out of *Fliegende Blätter*.[6] His main strength is
watercolor, which he handles very smartly. I want to break
in my set of watercolors with him soon.

I've made a little progress with A recently. He does take
care that you don't get a swelled head. If he praises one day,
then I'm fairly certain he'll scold the next. I'm getting to
like charcoal more and more.

On Fridays with Körte[7] my red chalk drawing is always
selected for exhibition. I celebrate my greatest triumphs
there and am very unpopular with my competitors—which
both makes me haughty and amuses me tremendously.
Don't be upset, Father, just indulge me. Inwardly I often
am as shaky and nervous as I was in my teens. I can best
overcome this by holding my head high. It's the only way to
keep some of the bothersome "wild" girls at a distance.

In life-drawing my work is coming along quietly. I was
praised yesterday. Hausmann[8] found it very picturesque and
good in light and shadow, though somewhat unclear.

There, I've recited my entire weekly schedule. If I sound
like too many drawing lessons, tell me honestly because I'll
turn my thoughts to another direction for your sake. For
example, I can discuss the woman question. I'm quite famil-
iar with the catchwords. After life-drawing Friday I went to
a lecture, "Goethe and the Emancipation of Women." The
lecturer, Fräulein von Milde,[9] spoke clearly and well, also
very reasonably. Except that modern women have a piti-

fully sarcastic way of speaking about men as if they were
greedy children, which immediately puts me on the male
side. I had all but signed the petition against the new civil
code[10] when Kurt[11] snapped furiously at me. He supports
my original opinion to let the important men handle the
issue and to believe in their judgment. Still, I have to laugh
at myself and the world.

Berlin, 27 January 1897

My Father,
 I've come back from noisy Berlin to our dear, lonely,
snow-covered Schlachtensee.
 My thoughts are with you, you must feel them. I am
concentrating on you and, along with your other five chil-
dren, I'm trying to smooth the wrinkles on your brow. It's a
sad thought that these wrinkles really come about because
of us. Are they balanced by the happy moments we've
brought you? Let's hope there will be so many of those
moments in your new year that no new wrinkles will ac-
company the old. You must think of me at exactly eight
o'clock on the morning of your birthday. At the same time
I'll have my thoughts fixed on you. Watch carefully to see if
you don't feel the brush of a kiss on your right cheek.
 I'm sending some more drawings of heads. I hope the
whole affair isn't boring all of you. It's the same old story
over and over again. The colorful little girl is my first at-
tempt at pastel. It's not overwhelmingly beautiful. The lit-
tle quicksilver was very hard to start, she wouldn't hold still
for a minute. Presently, my entire wealth consists of only
five crayons. The little thing had blue eyes and I, unfortu-
nately, no blue crayon. As I mused on this cruel trick of
fate, I heard two in front of me quarreling about whether
her eyes were blue or brown. For practical reasons I sided
with the brown party. . . . I did the laughing girl very
quickly the second day. That's why it's a little too smeary.
And my three landscapes, which you must not show any-
one! They're too much of a hodge-podge.

On the train[12]
Berlin, 13 February 1897

You Dears,

I'm paying you a visit for a brief moment here on the train in order to give you a short report of my week.

The main event, of course, was the ball at the Frombergs. It was simply ideal! The house was beautifully decorated with flowers. The dark-paneled hall looked enchanting under green pine wreaths, laughing fiery poppies, and garlands of fresh white roses. The music room, done in shades of light yellow, was decorated throughout with mimosa. And the individual tables in the dining room! On one lay fresh white lilacs, on another wallflowers, on others violets, lilies of the valley, precious tea roses.

Lindner and Max Grube presented a prologue for the opening of the house. We three painters had amusing escorts in two painters and two sculptors. The painter Müller-Kurzwelly invited me to dance the Française. But imagine my poor heart when throughout almost the entire dance, with his face beaming, he praised the beautiful eyes and beautiful toilette of the young woman dancing across from us (the wife of Petschnikow, the violinist)! It was too funny.[13]

We were suspended in seventh heaven until three in the morning. Whenever we tried to take our leave we were detained.

I'm finishing this in school during recess. It's buzzing and whirring about me like a beehive. We're planning a class trip and everyone is burning to make an especially beautiful suggestion to the assembled company. I'm trumpeting "Schlachtensee" because I'm at home there.

Recess is over and I have to get back to my little teenage model.

Berlin, 20 February 1897

You Dears,

I'm sitting in an empty classroom in order to write you.

I'm in school—it's before class. I'd like to multiply by six
my days here. I'm discovering I'm just in the middle of
learning.

Colors are becoming beautifully clear to me, their rela-
tionship, their character, and much more that can only be
felt, not spoken. My new teacher, Jeanna Bauck, calls it a
physical comfort. Your child is suspended in this comfort
every day.

Fräulein W, the most talented in the class, and I always
get excited about what each other is doing. When one of us
has a beautiful color on our palette or canvas, then we have
to show it to the other. I feel so at home in class and I'm
glad they like me. How often one of them says, "Becker-
chen, what would we do without you?"

At recess we have the usual school fun, afterward we're
better able to work. They're all special girls, each is to be
respected in some way. . . . This is my life, my heart is set
on it with all its fibers. Even when I'm not here, my
thoughts are. Perhaps that's why I'm somewhat one-sided,
but I believe that if you want to accomplish something, you
must give all of yourself to it.

<div style="text-align:right">Berlin, 5 March 1897</div>

You Dears,

. . . First, the news about school. I've given up my land-
scape lessons and I'm now working on portraits all week.
I'm in the painting class that includes, besides me, the
five most able portraitists. Of course I still want to draw
because I've seen how often the painting of my talented
classmates is deficient because of their drawing. Fräulein
Bauck may realize this too, for she has all of us draw very
simply and vigorously. The quiet determination with which
she carried her point in a new class impressed me.[14] When
it came to the drawings, what a fright, not one of all the
heads was correct! The model held a very difficult pose,
tilting a little left and a little forward. None of us was
successful in expressing these "little" differences. She made
a small sketch for each of us, showing the main thrusts of

the model's stance—just great. She's really very thorough. We don't quite understand her yet. I think she wants to teach us an altogether different way to draw. She wouldn't let us make a single stroke of our own. Everything had to be done her way. Working with your hands tied is terribly tiring. You feel you can't do anything. Of course the results were bad and most of the heads ended up in the fire.

Want to know what kind of person she is? Well, first her appearance. Unfortunately she looks like most artists, rather shabby-shaggy. Her hair, which probably wasn't cared for when she was young, looks like plucked feathers. Her figure is large, heavy, uncorseted, and she wears an ugly blue-checked blouse. But for all that, she has a pair of merry, clear eyes and she is constantly observing. Later she told me she was always drawing horizontal and vertical lines on my face. One might conclude that her genius for drawing is greater than her genius for painting, otherwise she'd think in colors more. But I don't know if that's so. I'll see some of her pictures for the first time in the next few weeks at Schulte's.[15] For now she is a book with seven seals.

Berlin, 12 March 1897 [?]

After a difficult morning's work, I give you a thousand thanks, dear Father, for the beautiful box of pastels. My glance is constantly sliding back over these beautifully colored crayons and I'm burning to try them out.

Sitting for me now is a little Hungarian mousetrap who doesn't understand a word of German, so you can't reprimand him when he comes a half hour late in the morning. But it's fun to draw him.

After class Thursday I was in the Kupferstich for the first time. I'd been in front of the glass door a couple of times before but the tremendous solemnity behind it always scared me away. Yesterday I took heart and stepped in, feeling like an intruder into the Holy of Holies. An assistant came up to me and wordlessly pressed into my hand a slip of paper on which I had to write what I wanted: "Michelangelo, drawings."... He brought me a gigantic

portfolio.[16] I was absolutely greedy about its beautiful
pages. Incidentally, I'd have liked to have donned a cloak
of invisibility as the only female amidst that vast maleness.
But then I forgot the disagreeable world under Michelangelo's
powerful line. Those legs the man draws!

In the evening we had a terrific fellow in life-drawing. At
first, as he stood there, I was shocked by his scrawny hid-
eousness. But when he struck a pose and suddenly stretched
himself so that all the muscles played on his back, I got very
excited. . . . You Dears, that you let me do this! That you
let me live entirely in drawing! It's too wonderful. If only I
can make something of it. But I don't want to think about
that, it only makes me restless.

Recently I had a funny experience. Mother, you took the
female nude with the beautiful black hair back to Bremen
with you. I drew the same model at Fräulein B's too. There
she wore a black dress with a white collar as I did, only hers
was more stylish. She stretched out her prettily shod foot so
coquettishly that I modestly hid my own rather shabby ser-
vants. This time the young lady with the soft, dove eyes
had beautiful chestnut brown hair instead of her black
mane—told some fable about shampooing her hair and
grabbing the wrong liquid. I thought in my quiet way, "Ah
yes, the world, the world!"

 Berlin, 3 April 1897
You Dears,

Here it is Saturday again! This time my week was rich in
adventure. On Sunday I went to N's, to a rehearsal of a play
in which I promised to take part. Now I wish I had back my
free time because I do not like Frau N, do not like the play,
and do not like the lawyer who keeps hugging everybody.

Don't worry about my antipathy at the moment, Father.
I'm striving greatly and heroically against it. I smile at Frau
N, I've already learned my part, and I unfailingly hug the
lawyer. The latter, to be sure, with a secret curse.

I was at the Du Bois-Reymonds[17] Monday. Lucie talked
about her work in Bremen and showed me several stylized

patterns. We had a fine conversation about drawing and painting. They're not modern at all, they strongly defended contour.

We had an amusing model in Hausmann's class, a real Berlin doorkeeper's wife, with all the requisite idioms. She'd never sat as a model before, we snatched her up from the street for want of a better. When we spoke to her, she looked down with horror at her own picturesque, faded clothes and said she'd first have to make herself presentable. When she came back, she had on a really unbearably bright new apron. It was too funny, the effect sitting had on this choleric, panting, little woman. After an hour she called out, "Nah! I always thought doin' nothin'd be the most wonderful thing in the world, but it's a lot, lot worse than workin'." She left us after the first day with these great words: "Sooner scrub three rooms!"

Berlin, 30 April 1897

I awoke in the magnificent sunshine and rejoiced the whole day in this beautiful earth. Everything is laughing and sprouting and blooming, and I have to laugh too. It's gotten hot all at once, summery hot. The nude model very naively asked us if we didn't envy the slight costume. I use my free time to continue sketching happily. It's such a pleasure to sit in this divine air, in front of the slender, delicate birches. And appreciation flows toward me in full measure too. My patrons are mainly railroad signalers. The other day one said repeatedly, "Boy, oh boy, this is art!!!"... It's true, I have to add, he first cautiously inquired whether that which I was painting might be the birch trees.

Models offer themselves in droves. Recently one of three cheerful workers who passed my stand called out, "Freilein, wouldn' ya wanna paint us three ditch diggers?" I took one at his word once, but they don't have a model's endurance and the joke soon begins to tire them.

Meanwhile, it has become evening. The sky is still so bright that I can continue my epistle to you, my Father. I

have a wonderful day's work behind me, interrupted only by my enormous delight in the Kupferstich Botticellis. The originals of his Dante illustrations are here in Berlin.[18] Each picture treats one canto. It's very interesting to me how Dante's strange visions were interpreted by a great fellow Italian. . . . It has grown too dark for me, my Dear. I want to pause a while with you and contemplate the beautiful evening sky, the sun has set magnificently.

<div style="text-align:center;">*Berlin, 7 May 1897*</div>

. . . A real May day, with gorgeous flowers and chirping birds, but an atrocious number of magpies (whose days will soon be numbered when Uncle Wulf returns) and cockchafers, flying around very busily.

I constantly look forward to my lessons with Jeanna Bauck. Now that I'm used to her "rumpledness," I like to look at her. Her features are as interesting as her paintings. I can look at the little piquant curves of her nostrils over and over again. Her mouth stops so nicely all at once, just as if the Lord God might have gone over it with a fine brushstroke. I paint with her, and I love the lush oil colors with all my soul.

Not long ago I visited her in her atelier. I have many more devout thoughts in an atelier than I do in church. Inside I feel quiet and grand and beautiful. Splendid things hung in her atelier, portraits and landscapes. A great, simple interpretation in each picture, and yet not stylized. Fine, fine!

<div style="text-align:center;">*Berlin, 14 May 1897*</div>

. . . You Dears, a pencil again. I fear you'll get to see nothing better of me until you hold me in your arms.

I plan to paint your portraits during my long vacation and I'm already thinking about the backgrounds because this is very important. I love oils. The colors are so lush and strong. It's magnificent to work with them after the timid

pastels. I have Herma[19] in mind as a trial project. Only please drum a good deal of patient sitting into the little soul.

Yesterday I started in oil with Hausmann too. He's having us work very differently from Jeanna Bauck. While the latter takes maximum light as the rule and from there has us work into the shadow, Hausmann proceeds from the shadow. The deeper you start the shadow, the brighter your light must be. Rembrandt achieved such colossal light effects through the depth of his shadows. Living skin in light has something so brilliant, so luminous about it, you can't possibly make it bright enough.

Again I have a fine day behind me. In the morning with Hausmann, my little old man in oil; lunch at G's; and at four o'clock the three of us visited the young sculptor W. He had molded a little faun for each of us and we came to call for them. He's a beautifully simple person—it never occurred to him to pay court to us. And it was just this which pleased me so. Now I'm sitting happily at home with my little faun.

All of you are embraced by

Your happy painting child

Footnotes: Chapter II

1. *Die Fachschulen für bildene Künste und Kunstgewerbe Deutschlands*, Berlin, 1906, p. 5. For this source and for information regarding schooling for women I am indebted to Herr Plany, Leiter der Zentralen Hochschulbibliothek, Hochschule der Künste, Berlin; for copies of archival material concerning Kollwitz, to Prof. Dr. Walter Huder, Leiter des Archivs und der Bibliothek, Akademie der Künste, Berlin; for information about the role of the women's art school at the turn of the century, to

Fritz-Eugen Keller of Freie Universität Berlin and
to Alice Brasse-Forstmann, Chair of the still-
active Verein der Künstlerinnen.

2. *Chronik der Königlichen Akademie der Künste zu
 Berlin vom 1 Oktober 1901 bis 1 Oktober 1902,*
 n.p., n.d., p. 5.

3. Curt Stöving, painter, architect, sculptor, and
 craftsworker, born 1863; taught portrait and
 life-painting at the school of the Verein der
 Künstlerinnen, 1895–96.

4. Altes Museum, Berlin.

5. Ludwig Dettmann, watercolorist and painter,
 born 1865; Professor at the Berlin Academy of
 Arts, 1895. His collected works were exhibited
 at the Grosse Berliner Kunstausstellung, 1893.

6. *Fliegende Blätter,* a German wit and humor
 weekly, published from 1845 to 1944.

7. Martin Körte, portrait painter, born 1857; Pro-
 fessor of Anatomy and Proportion at the Berlin
 Academy of Arts.

8. Ernst Friedrich Hausmann (1856–1914) painted
 religious and genre pictures, church interiors,
 and portraits. His father and sister were both
 painters, and his brother a sculptor.

9. Natalie von Milde, author, born 1850, wrote on
 "the woman question," the rights between hus-
 band and wife, women authors and the women's
 movement, and the future of the family. The
 lecture Becker attended was the basis of von
 Milde's book *Goethe und Schiller und die Frauen-
 frage,* 1905.

10. The new civil code drafted by the imperial government was essentially no different from the 1850 state law barring women from political organizations and meetings. Women could discuss politics only privately or at meetings called by individuals, such as Fräulein von Milde's lecture. During the 1890s feminists worked to change the new civil code before it was officially adopted; and in 1897, following the international women's congress in Berlin, there was a great petition drive to end restrictions on women's political activity. Amy Hackett, "The German Women's Movement and Suffrage, 1890–1914: A Study of National Feminism," in *Modern European Social History*, ed. Robert J. Bezucha, Lexington, Mass., 1972, pp. 355, 366–67.

11. Becker's older brother (1873–1948), who was in Berlin studying medicine.

12. Becker had to commute to school by railway from Schlachtensee, fifteen kilometers southwest of Berlin.

13. At age seventeen Amanda Lindner made a stage sensation in Berlin as Joan of Arc in Schiller's *Die Jungfrau von Orleans;* later she starred in both classical dramas and social comedies.

 Max Grube, actor, director, playwright, theater historian; in 1897 principal director of the Berlin Royal Playhouse.

 Dr. Konrad Alexander Müller-Kurzwelly (Kurzwelly translates as "short wave") first studied natural sciences, archaeology, mathematics, and the history of modern painting before he turned to painting landscape—with some academic success.

 Alexander Petschnikow, Russian violinist and composer, won a gold medal from the Moscow

Conservatory and made numerous successful
tours of Europe and the United States.

14. Jeanna Bauck, landscape, seascape, and portrait
painter, born in Stockholm, 1840. Her compel-
ling personality received as much attention as
her work. See Louise Hagen, "Lady Artists in
Germany," *The International Studio,* v. 4, 1898,
pp. 91–99.

15. Edward Schulte, private art gallery, Berlin.

16. Portfolios were shown on request in the study
room of the Kupferstichkabinett, Neues
Museum.

17. A noted German family of scientists.

18. Botticelli's illustrations of Dante's *Divine Com-
edy* (1485–95), silver-point drawings on large
sheets of white vellum. Eighty-four of these
drawings were in the Kupferstichkabinett, Neues
Museum.

19. Becker's younger sister (1885–1963) and one of
her earliest models.

III. Bremen and Worpswede, 1897

Her first year of art school over, Paula Becker returned home to Bremen. Through the auspices of a friend[1] of her mother Becker went for the summer to study under Fritz Mackensen at the nearby art colony of Worpswede.

Worpswede, a moorland village near the Hamme River, is sixteen kilometers northeast of Bremen. The art colony had come to national attention when Mackensen, one of its original founders, won a gold medal for his painting Sermon on the Moor *in the 1895 Munich Glaspalast exhibition.*

Worpswede was one of several such rural communities founded by German artists near the end of the nineteenth century. The practice continued into the twentieth century with Die Brücke artists at Moritzburg, near Dresden, and Der Blaue Reiter at Murnau, south of Munich. But Worpswede was the only settlement to become the permanent residence of a group of artists. Fritz Mackensen (1866–1953), with his friend from his student days at the Düsseldorf Academy, Otto Modersohn (1865–1943), settled there in 1889. Not long afterward they were joined by another friend from Munich, the painter and etcher Hans am Ende (1864–1918), and in 1892 by Fritz Overbeck (1866–1909), also from the Düsseldorf Academy.

They were attracted, with varying degrees of sentimentalism and true devotion, to the simple, grand landscape: the pine, birch, and willow forests; the heavy skies; the melancholy moors and heaths; the canals and the river, with its traditional black-sail boats. The landscape and its peasants became symbols of over-

27

powering feeling—an idealized ground that rooted the violent flower of expressionism.

Worspwede also attracted the painter, etcher, book illustrator, and designer Heinrich Vogeler (1872–1942). He too studied at the Düsseldorf Academy, but Vogeler was more likely acquainted with Worpswede because his aristocratic family lived in nearby Bremen. He first began visiting the art colony in 1894 and, like Paula Becker, studied informally with Mackensen. Almost a decade younger than the founders of the colony, Vogeler was the chief link between the group and the Jugendstil movement.

In her journals Becker recorded her impressions of these artists and her reactions to the landscape. While absorbing some of their reverence for nature and a strong emphasis on feeling, Becker was never attracted to landscape as a subject: "Painting people is really better than painting landscape."

To Her Aunt Marie

Bremen, 14 July 1897

My dear Aunt Marie,

. . . I find M's character evident in her dear eyes and sweet mouth. She has a very sensitive nature. I reveled in being with her, but it was almost too good for me. It was too great a privilege, never being annoyed or irritated. I must privately have some friction with my environment, otherwise I become unfit for the world, like some kind of mollusk, always drawing in its horns. (Or do they have feelers?) All the same, I've made up my mind to use my horns or feelers not to shove, but softly, quietly, to push my way through life.

Painting, painting, painting is always on my mind. It's the accompanying melody to my present life. Often it sounds softly, as though lost in a dream, like a fairy tale—I call it my *Sunken Bell*[2] mood. Often it sounds loudly and

elegantly and grandly. Then I want to stand on top of a high mountain and shout. Because I can't do that here, I'm inwardly and outwardly very quiet. It's as if I did not live, only my soul lived. It's very, very beautiful. You hardly dare move so as not to break the spell. It's like the mountains at evening—always my favorite—when they lie there enormous and solemn and silent. Suddenly I'm reminded of the wonderful hours on my rock by the waterfall. I sat there like a child, thinking only about the blue sky and the white clouds.

Is it egotistical of me to write you all this? I believe you're glad I do, aren't you? You have to accept me as I am, with all my egotism. I can't get rid of it, it's as much a part of me as my long nose. Many times I think that had I been born a cripple perhaps I would be different. Then you relinquish your love of life with your first breath. But there are so many wishes the heart hears and muses on selfishly, forgetting the wishes of others. Do you get better as you grow older? That's my only hope.

JOURNALS

Worpswede, Summer 1897
Worpswede! Worpswede! Worpswede! My *Sunken Bell!* Birches, birches, pines, and old willows. Beautiful brown moors, exquisite brown! Canals with black reflections, asphalt black. The Hamme with its dark sails. It's a wonderland, a land of the gods. I take pity on this beautiful piece of earth whose inhabitants don't know how beautiful it is. You tell them but they don't understand. And yet one doesn't need to have pity, no, I have none. No, Paula Becker, rather pity yourself, because you don't live here. And yet you're living, lucky one, living intensely. That is: you paint. Indeed, if there were no painting?! . . . And why have pity on this land? There are men here, painters, who have sworn their loyalty to it, who are devoted to it with unending, constant love! . . . First, there's Mackensen, the

man with the gold medals from the exhibitions. He paints
character studies of land and people—the more individual
the head, the more interesting. He understands the peasants
thoroughly. He knows their good sides, he knows all sides
of them, including their failings. It seems to me he wouldn't
be able to understand them so well had he himself not been
born in limited circumstances. It sounds hard, cruelly hard
and greatly presumptuous, yet I must say it: being "born in
limited circumstances" is a misfortune that he can't do any-
thing about. A person can never really shake off having
pinched pennies—not even later when that person lives in
easy circumstances—at least not the proud person. This
struggle leaves traces behind. They're almost invisible, but
there are many, many of them. A keen eye discovers a new
one each moment. The whole person has been bound and
tied. A lack of money fetters you fast to the earth, your
wings are clipped. You don't notice it because the scissors
are imperceptibly cutting away day by day. How this
wicked, wicked fate can gradually cut down a person in the
end! The great, the unconstrained, the absolute raging, the
fragment of Prometheus, the titanic power, the moving
principle, they are lost. Isn't this hard?... So it is with
Mackensen. He's a fine man, clear-headed in every respect,
hard as a rock, energetic, tenderly affectionate towards his
mother. Yet the great thing, the indescribable great thing,
has been lost. Not in his life, but in his art. What a shame,
what a shame.

The second in this roundelay is the little Vogeler, a
charmer, a lucky fellow. He's my very favorite. He's not as
matter-of-fact as Mackensen, he lives in a world of his own.
He carries Walther von der Vogelweide and the *Knaben
Wunderhorn*[3] in his pocket and reads from them almost
daily, dreams about them daily. He reads each work so
intensely, the sense of the words so imaginatively, that he
forgets the word itself. Despite all his reading, he knows
none of the poems by heart. In the corner of his atelier
stands his guitar. He plays old amorous tunes on it. He's so
pretty to look at as he dreams the music with his big eyes.
His pictures move me. He has taken the Old German Mas-
ters as his models. He's quite austere, stiffly austere in his

forms. His picture of spring: birches, slender young birches with a girl among them who dreams of spring. She's very stiff, almost ugly. It's moving to see how this young fellow clothes his urgent spring dreams in this measured form. The austere profile of the girl meditatively beholding a little bird—hers is almost a man's meditation. It would be if it weren't so restrained, so dreamlike. That's little Vogeler. Isn't he charming?

Then there's Modersohn. I've seen him only once and unfortunately very briefly, I didn't get a feeling of him. I remember only someone tall in a brown suit with a reddish beard. There was something gentle and sympathetic about his eyes. His landscapes, which I've seen in exhibitions, have a profound mood. The hot, brooding, autumn sun or the mysteriously sweet evening. I'd like to get to know him, this Modersohn.

Now Overbeck. I've tried to look at him sensitively. But I haven't really been able to understand him. His land-scapes are daring in color but, I feel, they don't have Modersohn's sensitivity.

I don't know Hans am Ende at all.

I believe Schröder,[4] who's in Worpswede at the moment, isn't one of the "Worpsweders." He's said to play very "mu-sically."

The Berlin painter Klein[5] was at lunch with us. A good-looking fellow with soft, womanish features and delicate, nervous hands; in a brown velvet suit. I don't know him as an artist. Fräulein von Finck[6] has some kind of relationship with him as they're on a first-name basis. I was prepared for her and so was not very astonished to see her come to the table in pants. She interests me. She appears to be clever. She has seen much and, I believe, sensitively. She studied in Paris. How long? With what success? I don't know, in any case, I would like to see something by her very much.

These are the priests who serve you, Worpswede.

Worpswede, Worpswede, you are always on my mind. The mood filters down to my smallest fingertip. Your pow-erful, grand pines! I call them my men: broad, gnarled,

heavy, large, yet with fine, fine fibers and nerves within. That's how I imagine the ideal artist. And your birches: delicate, slim, young women who please the eye with their languid, dreamy grace, as if life hadn't unfolded for them yet. They're so ingratiating, you have to submit to them, you can't resist. There are also some that are very masculinely bold, with strong, straight trunks. They are my "modern women." And your willows, your old gnarled trunks with silver leaves. You rustle so mysteriously, telling of times past. You are my old men with silver beards. Indeed, I have company enough, my very own company. We understand each other quite well and often nod a kind response to each other.

Life! Life! Life!

To Her Family

Worpswede, July 1897

This morning I was determined to let my brush rest. I tied up a rucksack, packed my lunch and Goethe's poems, and hiked through the moors—past solitary farms surrounded by pines, along unbelievably green Hamme meadows, through red heather, past slender, nodding birches. I lay down where it was most beautiful and watched the clouds. I slept for a while, and I wandered again a ways. Within me sounded a happy song, it was so peaceful in and around me.

When I got home I started to paint outside but the heavens thwarted my plans and sent a violent rain. So we decided to go to Hans am Ende's, whom we had seen only little of till now. He showed us a lot of his sketches and some first-rate etchings. In between some things by Klinger,[7] a beautiful Dürer, and the work of Worpswede friends. He's able to characterize a person fully in just a few words. Everything he said was to my liking. The tender way he spoke to his young wife captivated me completely. I felt that he was with her in his thoughts at every moment. I can still hear him say "Magdalein."

The evening before last we had a charming time with Heinrich Vogeler in his atelier and Sunday we'll be at Mackensen's.

Life is almost too beautiful for

Your child

Worpswede, July 1897

You Dears,

I am happy, happy!

Only a couple of lines to tell you this as it's ten o'clock. I wasn't able to part any earlier from the moon outside. . . . Yesterday and today we were painting in Südwede by a very blue canal. In the evening the three Vogeler brothers[8] took us boating on the Hamme. The lush Hamme meadows were shining in the twilight. From time to time somber black sails and their motionless steersmen glided by.

Then, very gently, the moon came up. I thought of you, and then of nothing at all. I was only feeling.

Today we made an expedition to Schlussdorf, where they hold services under the open sky. There were many fine male heads to be seen but the women were ugly in their parti-colored town dress. Still the whole thing was reminiscent of Mackensen's *Sermon on the Moor.*

All of Worpswede is slumbering by this time. Only a few restless souls across the way are rattling the bowling pins.

The night is wonderfully starry.

I painted my first plein-air portrait today in the clay pit. A little blonde, blue-eyed young thing—so beautiful against the yellow clay, shining and glimmering. My heart leapt. Painting people is really better than painting landscape. Do you notice how dead tired I am after a long, hard day's work? But inwardly so peaceful, so happy.

Mother, the provisions you sent were delicious! "And the empty nests were filled."[9] Now we have enough till the end of our days. . . . My Sunday? In the morning, painting my dear blonde Anni Brotmann in the clay pit. In the

afternoon, getting together with my cousins for a hike—a
rich booty of blackberries and motifs.

An evening stroll through the village. There was dance
music at Welzel's. We looked in: the last big social of a
children's dance class, cute to look at in their white dresses.
The dancing master, a funny old man with the physiog-
nomy of a fox, elegantly and pompously led the round
dance.

We wandered on. A new drumbeat sounded in our ears.
We looked in the door: a peasant wedding. The bride was
nearly dozing off under her garland. He was yawning. On
the other side of the hall, peasant quadrilles; in the back-
ground, the awful brass band; to the right, cows' heads.

At the next waltz I did a turn with the bride's father. He
bellowed happily in my ear, "We're both doin' great." I just
looked up at him and nodded. Afterward they laughed at
me a lot because we had danced together. The bridal couple
were none too bright. They spent last winter in the
poorhouse and they'll be there this winter too. . . . Then we
paid an evening visit to the Brotmanns in the cottage oppo-
site. They're very poor people, but happiness was alive in
all their eyes today. Their eighteen-year-old son, the eldest,
had come home from a sea voyage. A quick, bright, blonde
youth. He was telling his amazed family of strange places
and peoples. All his blonde, blue-eyed sisters and brothers
gathered close around him.

Mother, don't you have some clothes for these people?
The girls are fifteen, twelve, and nine years old, the boy
four, and then there's a baby. I'd like to bring something to
the good woman.

It's night again, beautiful, quiet, solemn. I have another
divine day behind me. In the morning I painted an old man
from the poorhouse, a colleague of old Olheit. He sat like a
stick with the gray sky for background.

Lunch is eaten with great appetite at our women's table.
The pants-wearing ladies (the one has been joined by a
second) show their masculinity through their boyish raven-

ousness. It's a great joke for me to look at these indi-
vidualists both inside and out. They really think they aren't
vain and don't care about appearances. Yet they're as proud
of their pants as one of us is of a new dress. I have to say
along with the old sage, "All is vanity."

I'm sunning myself in the world and your love!

Thanks, sweet Mother, for the clothes! There was such
happiness in the Brotmann house! It did me good to look
into all those beaming eyes, the good woman squeezed my
hand time after time.

I painted the whole day. First Becka Brotmann with her
unbound yellow hair and a background suggesting dahlias.
Then I painted Anni Brotmann in the clay pit while the
sun violently assaulted us. In the afternoon, I painted Rieke
Gefken with red lilies. I believe it's my best work. I want to
show it to Mackensen tomorrow.

Yesterday a short hour with Vogeler again. It's always a
pleasure, like a pretty fairy tale. With his dreamy eyes he's so
attractive to look at. He showed us a notebook with
sketches for etchings from his earliest period to the present.
Many fine, original things. Time flies, flies divinely for

Your child

Footnotes: Chapter III

1. An unnamed woman identified by Fritz Macken-
 sen as a painter from an old aristocratic Bremen
 family. Mackensen *et al.*, *Paula Modersohn-Becker:
 Ein Buch der Freundschaft*, ed. Rolf Hetsch, Berlin,
 1932, p. 40.

2. *The Sunken Bell* (*Die versunkene Glocke*), 1896, by
 Gerhart Hauptmann, a "German fairy-tale drama"

about the conflict between art and life. Heinrich, the bell-founder/artist, is the only one who hears the sunken bell, his creation: "Its voice rang out so loud from its great iron throat, waking the echoes of the topmost peaks, that, as the threatening peal did rise and swell, it shook my soul." *The Sunken Bell*, trans. Charles H. Meltzer, New York, 1927, p. 206.

3. Walther von der Vogelweide, greatest German lyric poet of of the Middle Ages; *Des Knaben Wunderhorn*, a collection of over seven hundred German folk songs.

4. Probably Rudolf Alexander Schröder (1878–1962), who was interested in both music and literature. He was a cofounder of the periodical *Die Insel* (see p. 91).

5. Perhaps Philipp Klein (1871–1907), member of the Berlin and Munich Secessions.

6. Adele von Finck, born 1879, studied in Munich, Brussels, and Paris (with Courtois, under whom Becker would study). She exhibited in major public exhibitions and at Galerie Fritz Gurlitt, Berlin.

7. Max Klinger (1857–1920), German painter, sculptor, and etcher, was immensely popular at the turn of the century. Käthe Kollwitz was influenced by Klinger's dramatic etchings. His fantastic and morbid art was based on a conscientious observation of naturalistic detail.

8. Heinrich, Franz, and Eduard.

9. A line from a popular song, "Aus der Jugendzeit."

IV. Berlin, 1897–98

In the fall of 1897 Becker went back to Berlin for her final year of art school. The previous summer in Worpswede shaped her romance with the countryside. The Worpswede artists had adopted a kind of pastoral snobbishness about cities. Much later Becker was to feel that this attitude was very limiting, but in these and subsequent letters from Berlin she expressed a dismay with city life. What Becker did not share, especially with Mackensen, was a disdain for academic art training. She was excited about her painting classes and the different methods she was learning. The Worpswede artists, the "modern" artists of their day in Germany, came together out of not only a love of nature but also a renunciation of the official art being taught in the government schools. But women could only come by the Academy's rigorous training secondhand from men who had had such instruction or from Royal Academy professors moonlighting at schools of the Verein der Künstlerinnen. For women professional art training was too hard won for Becker to be critical of its results.

And she was facing mounting parental criticism. At one point Becker's father, complaining about the financial burden of sending his son to medical school and raising the children still at home, informed Becker that she would have to give up art school and find a position as a governess. Her characteristic response was one of willing compliance, while making provisions to continue drawing. Giving up art school did not mean giving up art. Fortunately a small inheritance erased the immediate need for her to become self-supporting.

TO HER FAMILY

Berlin, 28 October 1897
The latest news is the opening of our school exhibition
today. Jeanna Bauck described to me her feelings when she
enters an exhibition where some of her own work adorns
the walls:
"You steal restlessly through the exhibition hall, furtively
looking to the right and left with the bad conscience of a
criminal. Finally, the horror! You discover your children of
sorrow and speedily hurry away in order to escape persecu-
tion."
It was exactly the same for me. I was able to look at one
wall with calm, then my glance fell upon Rieke Gefken and
the red lilies[1] and I hurried away. . . . Our entire class went
to the exhibition during recess. Each person was kind and
friendly toward the others for fear of being attacked herself.
I celebrated a reunion with Körte, my old friend from last
year. He said all kinds of nice things to me, really courted
me somewhat, which I enjoyed considering all the envious
people there. But he scolded me about the drawing of my
heads. I had hardly escaped him when Fräulein L got ahold
of me (the young painter in whose atelier I worked last
year). She wants to paint me. She said I had inspired her to
make a color study, lilac running into brown—my good old
velvet blouse—with the crowning point the hair. I smiled,
flattered, feeling exalted in fact, but I resolved not to sit. I
have no time, and even if I did I'd use it differently. Com-
pletely inflated, I returned to our quiet painting class, un-
fortunately, wearing so much of the vanity of the world that
I was not in the right, the real, mood for painting. And we
had such a terrific model! An old woman with a yellow face
and a white linen scarf against a golden background. The
composition was so sublime that I was hardly able to work
the first day because of my throbbing heart.
Hausmann's and Bauck's classes continue further in their
extremes. I'm very happy to be working with both of them.
He has a true artist's feeling, a very fine intuition. When

he speaks you can sense it down to the tips of his fingers. But he's impractical. He can't transpose his feelings into anything real, tangible. He can't compose himself, can't concentrate.

So it is with many who have everything—except a little energy.

Jeanna Bauck, on the other hand, is extremely practical. Her every word is practical and yet delightfully sensitive. She's quite modern, which to the general way of thinking is only supposed to mean exuberant adolescence. She has preserved her youth despite her fifty years. I love her very much. Talking with her evokes a feeling of comfort in me. She's so delightfully guileless that she's disarming. She told us that Dr. Lahmann[2] had prescribed that she paint without any clothes on so that her skin could breathe. She regrets not being able to have us do this in class. In all seriousness. I find her touching. I was delighted by this generosity that is so unsuspicious, and I felt narrow in spirit.

My whole week consists of working and feeling. I work with a passion that excludes all else. I often seem to myself like a hollow "cylinder" in which the "piston" goes up and down at a furious speed.

We were at the theater twice, a comedy both times. The house roared. I buttoned up a button higher inwardly and felt very foreign to the rest of humanity. I found them all so hideous around me that I didn't want to think about it at all. It's what C thinks about—which must make for thorough misery. Here in Berlin I play the ostrich more than ever. Otherwise I couldn't bear it.

Berlin, 1 November 1897

My Mother,

Here I am with you, overjoyed, so overjoyed, because it was such a beautiful day of painting. Not just that I did something special, but all the possibilities of what I could do drove me completely mad inside. The "piston" goes up and down in the "cylinder" with furious speed. We had a magnificent model: a pale blonde girl with wonderfully

shaped, elegant hands, in a light blue-green dress, leaning on a very blue-green table, against a light gray background. Fine! I tremble to my fingertips when I think of it. Fine!

And now to you, my Mother. I am with you so often in my thoughts and I'm beginning to understand you more and more. I'm very aware of you. Whenever my thoughts are with you, it's as if my little restless person were holding on to something firm, unshakable. What's most beautiful, is that this firmness, this unshakableness, has such a generous heart. Thank you, dear Mother, for keeping yourself so for us. Let me embrace you very quietly and for a long while. . . .

Berlin, 7 November 1897
. . . You're unhappy with me? But I'm not aware of doing anything wrong. That I'll have to go through dull times too (and you'll have to receive dull letters) is obvious. Must I then be so roundly scolded by my dear Father because I live in a social whirl, which only exists in my whirling to and from my classes?

Come now, we'll forgive each other generously.

Today on *Buss- und Bettag*[3] our trio once again was in the atelier of the young sculptor Wenck. He finished a Körner monument and was working on a pedestal group for a monument to the Kaiser.[4] I delighted in a very pretty model for a fountain. Wenck was quite funny. All three of us had to take off our hats to see if our hair was right to model. For him none of us was simple enough for the head of a German mother.

And now for my distress. There's conflict in school again. Women! Women! Women!

The director, Fräulein H,[5] is a very fine person. She devotes herself completely to her work. But she wants to be the absolute ruler. There must have been a fight between her and my teacher, Jeanna Bauck. Jeanna will stay at school only until the end of the year, when she'll set up a private atelier.[6] We were told all this yesterday. I hid behind the painting smocks in the corner and wept. The

director is certainly a considerable person, with many vir-
tues. But she has committed a great wrong in regard to
Jeanna Bauck. I feel I'm seeing the impulse of an uncon-
trollable lust for power, as in *Wallenstein.* [7] Jeanna had too
great a hold over her class, and over Fräulein H's creatures.
So the director set up a parallel class, which she taught
herself. For political reasons most of the pupils transferred
to this class. I personally have no doubt that Jeanna is
incomparably greater as an artist. They can't be mentioned
in the same breath. The artistic sensibility that Jeanna
wants to awaken in us is nobler and more difficult. Herein
lies the wrong. The director has to know that Jeanna's
teaching is better than her own. She just could not stand by
and watch Jeanna gain such control over her students.

I don't say any of this in school. One is surrounded there
now by gossips and eavesdroppers. No one says anything,
yet each person knows that the others feel very strongly one
way or the other. It's a sad acquaintance with the world.
That's how it is in this little community. What's it like in a
larger one? Or in the government? Disgraceful! Disgraceful!

Jeanna Bauck behaved beautifully. She didn't allow any
of this to affect her. I felt I wanted to squeeze her hand, she
was so dear. Not at all weak, she remained completely
objective. Spoke as though not a hair on her head had
been injured. Half out of pride, half because she could not
be petty. But we understood each other.

A quick P.S., standing at the post office. Between the
start of this letter and today were three enjoyable lessons
with Hausmann and a fine nude.

Your child

On the train
Berlin, 5 December 1897

Your touring child is returning home from her happy trip.
It really did me a lot of good. This wonderful day is hardly
over and I'm already looking forward to a wonderful tomor-
row. In this instance, Vienna and Jeanna Bauck. I arranged

my affairs before departing so that now I'll go back to school tomorrow in fine fettle.

Vienna! Vienna! It has captured me completely with its historic visage. Each baroque house has something to tell. I relived the time of the Congress of Vienna, when so much took place on this very piece of earth. I always feel quite moved in such a place because history, communing with great people of the past, holds something magical, something fascinating, for me.

The instinctive grasping of a personality strongly draws me to history. It's this same comprehension that makes me vibrate in quick, delicate waves of feeling while I paint, or overpowers me when I look at a great picture.

I wish there were a history of the world written by Hermann Grimm.[8] He would have focused on the great personalities who shape events and have given them their true value. Such an interpretation suits my ideal much more than the assumption that the situation makes the person. That may be so for the average person, but not for the giants.

I saw magnificent pictures in Vienna.[9] I can't forget Moretto's *Divina Justina,* Titian's wonderful colors in his noble portraits, and Rubens with all his splendor.

The Old Germans have captured me completely. Dürer, for all his power and masculinity, is so moving, so delicate. And Lucas Cranach with his little, half-childlike, half-coquettish Eves, and God the Father seriously threatening the children of Paradise with His finger. Holbein lit a very special light for me. He was an instructive illustration of Bauck's text: the great effect of noble simplicity.

In the Galerie Liechtenstein I was bewitched by a little head of Leonardo's and by splendid Van Dycks. I reveled. I was seized by a powerful reverence for humanity that uplifted me. In the life of the big city this reverence often sinks to a low. But I struggle against its sinking because it doesn't make others happy and it makes me unhappy.

Now to our big event, the wedding. It was a joy to look at L in her white wedding dress. Her peaceful brown eyes had a soft, womanly expression and a gentle peace lay 'round

her mouth. She's of a singularly tranquil character. She walked toward him in her bridal array without any nervousness at all. In church she maintained the same peaceful, friendly face, reflecting her soul's tranquility.

This peace must work like a heavenly balm on her restless husband.

Here's Berlin!

Berlin, 17 December 1897

My dear Father,

You're getting a late answer to your letter. After reading it I sat down immediately and wrote you eight pages. Aunt P intended to mail it, but unfortunately she lost it.

First let me embrace you and give you a kiss. The thought that you carried your cares around with you for so long, while I was enjoying myself in Vienna, is unspeakably sad to me. I really sense a mood of depression in your letters, which I blame on your old rheumatism. You know you shouldn't worry about me, Father. I intend to make my way in the world, I'm not afraid. Why else are we young, why do we have all our energy? You granted me this wonderful training that has made me a different person. I see now what you sacrificed and it makes me very sad. This one year will nourish me for a long time. It has sown so many seeds in my heart and soul that will gradually begin to grow. So it won't be that hard for me to stop for a year and work as a governess. During that time a lot of things will become clearer to me and I will lay aside a little so that I can continue studying. Please inquire if you hear of a lucrative position somewhere. It has to bring me a thousand marks, [10] otherwise I'll regret my precious time. I can probably get something of this kind only with difficulty here in Germany, but England, Austria, Russia are all the same to me. As long as it puts money in my pocket. Anything abroad is out of the question since I don't want to obligate myself for longer than a year.

My Father, don't be depressed about me. Sometimes a kind of half-dream carries over from painting into my other

life—such a lasting, blessed state of mind. It should help me through a year of working. I'll come through it all right. In my free time I'll draw so that my hand won't grow stiff, and I'll develop my mind further. If only I could take this pressing burden off your shoulders! We young ones, we always have our heads full of plans and hopes. Life can't hurt us very much yet, at least not this way. Let us stand next to one another, shoulder to shoulder, and in love give our hands to one another and hold each other tightly. Even if we don't have any money, we have something else that simply can't be bought. We children have the hearts of two wonderfully dear parents who belong to us completely. This is our best fortune. For myself I have absolutely no desire for mammon. I'd just become superficial. If only you might have a little relief.

Father, promise me one thing. You won't sit at your desk brooding or staring at the picture of your father. Because black sorrows will come flying and cover up the windows of your soul with dark wings. Don't let them. Grant your poor soul some autumn sunshine, you need it. At such gloomy moments, fetch in Mama or Milly[11] and rejoice in their love. For each of you an earnest, loving kiss.

JOURNALS

How this girl fascinates me!

She creates a strong, beautiful world from within. A world like that of a young man who goes into life with great plans. Yet she is, and she remains, a young woman.

She hates the smallness in woman. She loves man in his greatness. She loves him with quiet generosity and with a humble heart.

She sees herself as small and others as great. Yet she is greater than all of us.

She is a bud, awaiting her unfolding. She is unaware, yet she awaits it with a pounding heart.

She speaks like a good man, without falsehood, without

ulterior motives. I love this simple greatness. It has a re-
freshing, calming effect, like that of classical antiquity. But
more natural, more pulsating, because it is reality. It is life,
modern life.

Is there anything more beautiful than a noble person?

TO HER FAMILY

Berlin, 30 January 1898

My dear Father,

I kiss you on the forehead and squeeze your hand and
look into your dear eyes. Don't you feel the enormous love
by which we children are attached to you? For the moment,
it's true, loving you is all we are doing, but isn't that a little
'compense for all the worries we cause you?

When we're all well on our way, dear Father, when our
little ships prove seaworthy, then we'll make it up to you.
The inheritance has certainly brought you some relief. I
can't tell you how amusing it is to find myself an heiress. At
the same time, I have to overcome even more temptations.
Yesterday I passed by a secondhand dealer who had all sorts
of beautiful old things for sale. At once, useless desires arose
in me that never had when I was poor. So it is, wealth
brings worries.

As a birthday surprise, I'm sending you the work I've
perpetrated this month. You'll see I endeavor to draw con-
scientiously and honestly.

A principle underlies this work different from the
drawings done in school under Herr A. Those were sup-
posed to have an effect. These lay claim to nothing at all.
I'm just supposed to learn from them and hopefully I am.
I'm trying to follow contours with precision by stating them
through line. Line really goes against my nature as it's not
present in reality. If you look at your hand you will see it's
not circumscribed by a line.

But I well realize that it's necessary for me to learn line
because it compels accurate observation.

Farewell, my Father. You are affectionately, affectionately kissed by

Your child

Berlin, 8 February 1898[12]

Dearest, dear People,

I've heaved many sighs of delight up here in my little room because life is too beautiful to enjoy quietly.

That's how you feel when you are twenty-two years old. It suits me wonderfully, wonderfully.

I embrace you for all the love you've lavished on me and for all the beautiful, dear letters that I've devoured eagerly, one after another. You have to bear in mind that I starved for them until five this afternoon. I get to see nothing of the mail carrier because every morning I slink away very early under the cover of darkness.

In life-drawing this morning everything was going along as usual when, during the morning break, the huge corrugated metal door opened with a clatter and in stepped Paula Ritter and Fröhlich and Meyerlein, in single file with their faces beaming.

One carried a birthday cake with twenty-two burning candles, the second a bouquet of pussy willows and anemones, the third a charming picture of the *Mona Lisa.*

The easels were quickly moved together and a banquet table prepared. My big bouquet of violets was quartered and placed in our various masses of curls, and in this spirit we enjoyed my birthday chocolate.

Later it was twice the fun to paint. Painting is always such a heavenly joy after a lengthy drawing session.

Much love surrounds me here. Hopefully it'll serve me well, for, I must say, I've won the hearts of these splendid girls without any effort on my part.

And I'm allowed to go on working and learning. As long as I don't become presumptuous in the face of so much happiness. I try to wear it with humility. I'm reading the life and letters of Stauffer-Bern.[13] He had a sacred goal in his

art, without any sham or nonsense. (He taught at our school.) What enormous tragedy and what a tangle of relationships broke him in the prime of his manhood!

Many thanks again for this sizable bundle of love from home. You nearly bury me in love. It's too much. My little person and my little heart can't bear all this happiness.

I often wish to cry with Stauffer-Bern, "Lord! What is man that Thou art mindful of him."

Your Paula says "Good night" to you.

<div style="text-align: right;">

Berlin, 19 February 1898[14]
</div>

You Dears,

So the big day is over. The artists' costume ball numbers among my most beautiful memories. I can still feel it in my limbs and my heart leaps when I think of my different, pretty admirers.

Twenty-eight hundred tickets were sold. Unfortunately, only a small part of such a big crowd could take advantage of all the ingenious performances.

I came as Rautendelein[15] and wore Mother's garland of roses in my hair.

Karla A, who in her gray minstrel's dress was pretty enough to fall in love with, was my partner for the first part of the evening. She played her role charmingly and sang a lovely medieval minnesinger tune.

We went through the crowd arm in arm, then we danced in all kinds of figures we made up as we went along.

If a too-amorous glance from a devil, satyr, or dandy came my way, then the impudent fellow got into trouble with my knight, who, as soon as the enemy was done away with, sang something of spring and love to me, while strumming on a mandolin.

A merry Pierrot, sitting on the head of a sphinx, called out, "Paula Becker from Bremen!" When I caught sight of him again, I made him give an account of himself. It was a student from Helene Lange's *Gymnasium*, Anna S from Bremen, who will be taking her exams next year and then go on to study medicine.[16] She has lovely, merry eyes and danced a beautiful Boston.

My train of admirers noticeably increased. A small, black chimney sweep, a dear soul, helped out when there was nothing better. A cheerful jockey and Lucky Hans[17] alternated with him.

A Hungarian band drew near, at its head was a charming violinist with a temperamental smile. Four couples danced to their music. A small brown Hungarian who reported half hopelessly, half bashfully that he was from Frankfurt-on-Oder was also one of my partners.

Then a mad little hobgoblin came jumping up and tried to kiss me. I was able to extricate myself from his arms only with difficulty.

I fell unhappily in love with Hermann the Cherusker.[18] He was a big fine fellow with gigantic arms and legs and a headful of red curls that gushed out splendidly from under his eagle-winged helmet. His legs were covered in furs from the knees down.

He was a beautiful sight.

This Hermann had really wanted to be a centaur with a fake horse body but his mother wouldn't let him. His heart had already chosen an exquisite, pale, little girl who delicately contrasted his excess of strength. I consoled myself with a little green elf who looked quite merry wearing a red toadstool on his head. We danced with a passion. The last dance I danced with my little Hungarian or, better, I dashed around with him. It proved a worthy end to the affair. When the orchestra stopped (they had been sitting hidden demurely beneath green gauze), you noticed, to put it in good Berlinese, your danced-out little legs. It was wonderful, wonderful!

Appreciate my faithfulness—I've written this entire epistle on the counter at the post office just so you would get your Sunday greeting on time.

Your Paula

Berlin, March 1898

It's evening. I'm alone and I've painted myself again. I have a long day behind me and I'm permitting myself to be

bone tired. So don't ask for too much from my soul, which is still preoccupied with color.

vB invited me to the Pepinière ball[19] today, but I'm not going. I was deep into drawing and painting this week which makes me stingy with my energy, not wanting to give it to other things.

My model, a pretty, curly black-haired girl, a little tempest, didn't come, simply let us down. Some handsome painter has undoubtedly enticed her away from us—the world!

Have I written you about the competition I've entered? They asked for a series of six postcards, from 7 to 14 cm. I submitted six girls' heads with stylized, flowery backgrounds. I read in the newspaper that seven hundred entries arrived. They're to be exhibited in the old Reichstag. My public debut! Of course I can't hope for a prize given the multitude of applicants, but from the exhibition one learns how to do it.

Dear Father, I read to both my aunts what you wrote regarding my sharp judgments of people. I'm glad to hear from them that I've improved in the last year, although I myself haven't noticed much improvement. Time passes for me as if I were in a dream. I'm doing a lot of contour drawing. Sometimes I feel in my soul that I may be grasping form a little more firmly, which makes me very happy.

Such a peaceful comfort comes over me when I draw. I try very calmly and thoughtfully to record what I see. Today we had an old woman with a beautifully shaped skull and neck. It's a quiet pleasure for me to follow the barely noticeable curves of the line with my eyes. I wouldn't have understood this before.

I'm supposed to send you my work? I'd really prefer to show it to you during vacation, there's so much to explain. And saying it is so much better than writing. It's strange, I live so intensely by day that in the evening when I write I always feel a reaction. Yet, essentially, this most beautiful

thing of my life is far too fine and sensitive to be written down.

What I write you is only the external. It is the container that holds the fragrance of a much more delicious moment.

Were I able to communicate a little of the peace that fills my soul! My life is so beautiful! The hardest part is enjoying it undeservedly and without you.

There's a very interesting print exhibition at the Gewerbemuseum, splendid etchings and color prints from all over.

A strange Frenchman, Rippl-Rónai,[20] a disciple of Botticelli, exhibited at Gurlitt's.[21]

The "Eleven" are showing at Schulte's—Lestikow with his beautiful, serious moods.[22] I need only reach out and I touch something of beauty.

Spring is storming outside. Good night, the whole house has already gone to sleep.

It's Saturday again and very early in the morning too. I hear the birds warbling in front of my window. From every corner comes a delightful clamor. We've happily counted ten species of birds nesting in the garden. A soft rain is falling and washing away the dust of the last few days from the new green leaves. An earthy smell is streaming into my window, making my heart even more glad.

I've drawn an elegant pair of hands, boney, nervous, woman's hands with slender wrists.

Everything accompanies the principal chord of my life merely as a simple harmony. But we had a fine musical evening at M's, the government adviser. I enjoyed songs by Hans Hermann.[23]

Footnotes: Chapter IV

1. "I believe it's my best work." Painted the previous summer in Worpswede (see p. 35).

2. Dr. Heinrich Lahmann, founder of Weisser Hirsch Sanatorium near Dresden, advocate of natural healing through exercise and vegetarian diet. He opposed corsets and in magazine advertisements promoted his own "reform underwear" "constructed on the principles of hygiene."

3. A Protestant holiday, the day of prayer and repentance.

4. Ernst Wenck (1865–1929). His works include a monument to the German patriot and poet Karl Theodor Körner in Berlin and monuments to Kaiser Wilhelm I in Weissenfels, Greifswald, and Gross-Lichterfelde (Berlin).

5. Margarete Hönerbach, born 1848, was first a painter and etcher and then became a sculptor as the result of problems with her eyes.

6. Bauck successfully ran her own atelier for women until 1905, when she left Berlin to settle in Munich.

7. *Wallenstein*, a dramatic trilogy by Schiller based on the career of Count Albrecht von Wallenstein, general to the Holy Roman Emperor Ferdinand II during the Thirty Years War. Wallenstein was deposed and murdered because of his political ambitions.

8. Hermann Grimm (1828–1901), German art historian; author of one of the best biographies of Michelangelo; Professor of the History of Art at the University of Berlin, 1872. He was the son of Wilhelm Grimm, one of the two Grimm brothers, and son-in-law of Bettina von Arnim.

9. In the K. k. Kunsthistorisches Hofmuseum.

10. During the years covered by Becker's writings, 1000 M = $238. A governess's salary was in addition to room, board, and travel expenses.

11. Becker's older sister.

12. Becker's twenty-second birthday.

13. Karl Stauffer-Bern (1857–1891), Swiss painter, etcher, sculptor, and poet. The proverbial preacher's son, whose notorious affair with the wife of an ex-schoolmate led him to jail, a nervous breakdown, and finally suicide. Stauffer-Bern taught at the school of the Verein der Künstlerinnen in 1885, when Kollwitz was a pupil. He recognized Kollwitz's talent and encouraged her to concentrate on drawing and graphics instead of painting.

14. Written during *Fasching,* or carnival, the late winter days before Lent of festivities, costume balls, and masquerades.

15. Rautendelein, the elfin creature in *The Sunken Bell* (see p. 35, n. 2) who lures Heinrich, the artist, away from his family.

16. Helene Lange (1848–1930), German feminist, founder of Germany's first *Gymnasium* (university preparatory school) for women, Berlin, 1893. At the time of this letter women were virtually barred from German universities, and they were not allowed to practice medicine in Germany. German women interested in higher education usually went to Switzerland to study. Of more than a hundred women studying medicine in Geneva in 1897–98, only six were Swiss. Hackett, p. 362.

17. Lucky Hans (Hans im Glück), a character from Grimm's fairy tales.

18. Hermann (Arminius), prince of the Cherusci, an ancient German tribe. Tacitus described him as the liberator of Germany. The conception of Hermann as a German national hero reached its apex in the late nineteenth century.

19. The military doctors' ball of the Kaiser-Wilhelm-Akademie.

20. József Rippl-Rónai (1861–1927), painter, graphic artist, craftsworker. Rippl-Rónai was Hungarian, although he had been closely associated with the Nabis since 1891.

21. Galerie Fritz Gurlitt, Berlin (Nolde's first solo show, 1906; the Brücke artists, 1911).

22. Walter Lestikow, German impressionist, one of the group of painters, first called the "Eleven" and later the Berlin Secession, who left the *Verein Berliner Künstler* in 1892 in protest against the Academy's treatment of Edvard Munch. Munch had been invited to exhibit as the guest of honor that year, but after his work was hung the Academy created such a furor over it that the exhibition closed the following week. Peter Selz, *German Expressionist Painting,* Berkeley and Los Angeles, 1957, pp. 36–37.

23. Hans Hermann (1870–1931), German composer, author of several well-known songs ("Drei Wanderer," "Alte Landsknechte").

V. Norway, 1898

Becker did not immediately return home at the end of the school year. During June and July she accompanied her Uncle Wulf von Bültzingslöwen on a fishing trip in Norway.

No enthusiast of the sport, as her remarks on fishing show, Becker spent much of this time drawing, painting, writing, and reading. She did not comment about the subjects of her painting, except to mention farm animals and say she felt she could not do justice to the simplicity of the Norwegian landscape.

The Worpswede artists were influenced not only by the Romantic painters Millet, Rousseau, and Böcklin, but by literary sources as well. Becker spent the summer reading the Danish novelist Jens Peter Jacobsen, whose writing had a profound influence on the poet Rainer Maria Rilke. Jacobsen was also a scientist and the translator of Darwin into Danish. In his literary works Jacobsen emphasized the molding factors of heredity and environment on his characters, thus defining literary Naturalism. His rich descriptions of landscape based on minute observation affected Becker's Norwegian writings, and her poetic descriptions of nature reveal the growing self-consciousness of the journals. By the following Worpswede period Becker had begun to write Symbolist poetry and fiction in the journals.

JOURNALS

June 1898

It's 9:30 in the evening and still daylight. After several heavenly days we've stopped at our hotel in Christiania.[1]

Sunday noon in Stettin[2] we boarded the steamship *Melchior*. I took the *Melchior* into my heart. To stand at the bowsprit looking into the moist blue was lovely. A veil stretched sweetly and thickly around all reality and let my spirit pour out, suspending itself over the water, not thinking, just vaguely feeling.

From time to time the veil lifted on the form of a Norwegian woman, about thirty-five, an original. She was returning home to her native shore from a Hungarian journey. Brimming with adventures, she was looking for victims, on whom she spilled herself with unbelievably snakelike speed. She actually had had many interesting experiences. Through her stamp-collecting hobby she began a correspondence with a young Hungarian woman. Pictures were exchanged, finally an invitation to Hungary followed. Unsuspecting but courageous, the little Norwegian set out on her way and fell in with the highest Hungarian magnates, from one prince to another. She became a celebrity in Hungary, was shown around as a cultural leader, and was written up in four newspapers. She's the daughter of a Christiania army chaplain and—typical of the progressive situation of women in Norway—earned her own vacation money as a secretary for a big trading firm.[3]

My second acquaintance was with a young man of the law. His card read KGL. FULLMEKTIG[4] and he stuffed it into my hand when we parted around midnight after a beautiful sunset. Our conversation took place very comically in three languages: Norwegian, German, and English. Despite this astonishing number of tongues, our best jokes remained hidden from one another.

Number three: a married couple from Christiania. She, Swedish-born, was, or acted, the proper lady. He had a clever, unshaven face. Hints of the gourmand about his mouth. His eyes considered the outer world with a rather

superior scorn. He interested me even more after several typical Christiania philistines told me that he was notorious, not popular, very rich, and extravagant. I feel he came from a strict pedantic background, that he burst those chains, had his fun, and now is at the point where he laughs at the world. And the world, in order not to feel a fool, laughs at him.

I find it very amusing to fix the outlines of such characters who rush like meteors past the tiny ship of my life. I feel again that if I have any talent for painting at all, my forte will be portraiture. The most beautiful thing would be to give figurative expression to this instinctive feeling that often hums softly and sweetly inside me. However, I'll leave this to the coming decades.

I didn't sleep very peacefully on my narrow ship's bed. Each time I woke up I poked my head through the porthole. Heavens and sea shone dim red and lilac. The only thing tangible, real, seemed to be the deep black waves that the ship promptly hid beneath me.

In Copenhagen we took a lovely stroll on the boulevard, the seaside promenade on which the elegant world parades in the afternoons. The rest of the city made a rather sleepy impression on me, perhaps because the fast pace of Berlin is still in my blood.

The entrance into Christianiafjord was glorious. On both sides blue mountains emerged in the distance, small black jagged islands lay in the foreground moving faintly closer, and in front of them, white lightly swelling sails. It made my heart rejoice.

After the most beautiful crossing imaginable, we entered the harbor past the good weather-beaten *Fram* (Sverdrup intends to attempt another expedition in the next few days).[5] Here among the big steamers, with their huge wave-striped reflections, rest gay little green and blue fishing boats.

The sixteenth of June, bright as day, in misty rain, around two o'clock in the morning, on a little steamer between Bergen and Namsos.

We climbed aboard. A narrow wooden bridge led us to the little green steamship. A nasty fish smell filled the air. It came from the big fish bins that stood on deck, it came from the cabin room. It clung to everything.

White seagulls flew over my head in wide arcs. Their wings streaked and clouded the bright mirror of my soul.

Melancholy sat on the distant shore and sounded powerful chords from its harp. I heard the soft minor key in the great symphony of life and I was sad.

On shore people stood watching the ship's departure. They looked across with empty eyes. Their attitude betrayed lives without content.

I looked at the sea. Before me it lay smooth and gray, in the distance it pounded against the stone cliffs. They looked at me with their dull blue. A stripe of gold showed where the sun had been.

Mists rose and wound long veils around the cliffs. The world stood in silence and sorrow.

Only the tiny thing on which we were traveling sounded its voice in terrible, warning tones. I heard the pounding of the propeller and the rush of the waves. Otherwise all was profoundly quiet.

Now and then from shore came the lonely cry of the redshank—monotonous, sad, gray.

To Her Family

Lilleon, Norway, 20 June 1898
. . . We've been here in our "manor" for three days. We are completely at home in our little apartment with its brightly painted wood walls, low ceilings, friendly white curtains, and homemade rugs.

It's even better outside. On top of bright green, grassy, rolling hills stand joyful little birches that laughingly stretch their arms heavenward. What's quite wonderful is the clear blue sky, laughing above, with soft, shimmering clouds floating by. Nature speaks only in green and blue

here. I can't really call it speaking, rather singing, flute
playing, rejoicing. Seeing all this, my heart skips in joyful
bounds. Or, even lovelier, it steps softly and gently, barely
audible, and dreams of Böcklin fields.

In the distance lie blue mountains covered with spruces
dressed in a radiant golden brown by the evening sun. This
lovely mood lasts from about nine to eleven. Everything
takes place in a heavenly peace. Unlike our sunset, theirs
doesn't immediately disappear. In the distance the setting
sun shines in the white snow. From time to time, today for
example, it's really, really cold. [6]

Altogether there were two difficult days before we
reached Lilleon. We left Christiania Wednesday noon and
went to Trondheim, arriving at seven in the morning. This
place did not impress itself fondly on my soul. Smoking
chimneys, fog, horrible wooden barracks, German
waiters—these are my memories.

The old Gothic Cathedral shone like a star in all this
darkness. Its big beautiful lines reconciled me to the world.
It's being restored, and most carefully, so that all the old
motifs, most from the earliest beginnings of the Gothic,
will be preserved.

Around nine o'clock in the evening we left for Namsos.
We were picked up by a hideous little green monster of a
trawler, which contaminated the air with its trailing smell.
To Uncle Wulf this smell was a good omen. I cursed it more
than a hundred times. The next afternoon around five we
reached Namsos, a heap of little half-finished wooden
houses. Within two hours last summer the little town
burned down completely. A three hour ride in a cart and
our friendly coaxing of an eighteen-year-old Lilleon hack
finally brought us to our destination. The host and hostess
are both nice people. She's a good housewife and cook who
really likes to gossip, coming in near the end of each meal
to chit-chat.

The local farms are not to be compared with ours.
They're complexes of wooden houses. Whenever the
people feel like it, they build a new one. Wood is close at
hand and most of them have a little brook nearby that

propels a small mill to cut the wood in the spring. Uncle
Wulf and I have five rooms with two entrances and we
inhabit only a quarter of the house. What the people do
with the remaining three-quarters is a mystery to me. Fac-
ing the main house are two barns on mushroom-shaped
wooden posts that keep out the dampness and the rats. A
stable and a small dairy adjoin them. All these farm build-
ings, like most in Norway, are painted a warm red—
beautifully complementing the green and blue of nature.

The "we all have to go here"[7] of the household is very
funny. It made such a strong impression on me that I can't
let it go unmentioned. The number three predominates
throughout the setting, thus bringing one's soul to a pious
mood. Three steps lead the pilgrim to the little white door
which opens to the little room. The walls are charmingly
decorated with green branches of sprouting mountain ash.
Three little windows let in just enough light to make a
magical, picturesque semi-darkness. In the distance beck-
ons a long bench of gigantic height, onto which one can
swing oneself only with great agility. Then again the
number three, questioning and serious: three lids. Choose.

Finally, the really important thing, the river, the Nam-
sen. It has the breadth of the Weser[8] and when it behaves
it's clear. But it has a lot of bad habits and the weather can
play the most hideous tricks. In it are salmon, possibly the
moodiest creatures in the world. My soul cried to St. Peter
for success and yesterday afternoon brought us two salmon.
But I can't help it, in spite of everything I find fishing an
extremely dull sport. A person is supposed to wait for three
or four hours until a fish bites in order to spend ten minutes
tormenting the poor beast to death. I find it in fact a sport
for catching a bad temper. So far everything's gone well. It's
delightful to see with what boyish passion Uncle Wulf gets
excited about fishing. I naturally, and wisely, keep my an-
tipathy to myself. The worst is whenever they want to spoil
me because that's when they press a fishing rod into my
hand. I maneuver cautiously to avoid this.

My Father, thank you very much for your faithful letter.
Milly, aren't you going to send me one of the books? Here

in the glory of nature the soul so needs something of the
world. I can't yet say how long my stay will be. I believe
Herr Salmon determines that.

... We live a highly contemplative life here. One day
draws to a close as quickly as the next. Really it doesn't
end—instead our stay has gone on through three weeks of
daylight. The weather has been very favorable, at least from
the human standpoint, which doesn't always coincide with
that of the salmon.

Three times we've made excursions to a little solitary
forest lake. The result of these expeditions were small red-
spotted trout, several of which, I have to admit with horror,
fell victim to my fishing rod. Now the souls of these fish
haunt me. My window shade, which has a pattern of dots
with circles around them, looks like an eternity of fish eyes
to me.

This morning the farm animals were driven up to the
Alpine dairy. It's a long way, so they had to set out early.
There were two horses with blankets, milk pails, and all
imaginable household effects hanging from them, led by a
picturesquely dirty cowherd. We accompanied them and
came upon the other animals at the edge of the forest. The
sheep, the pretty colored cows, and the lively kids made a
happy turmoil.

Behind them, in slow step, the aged dairy maid and our
farmer's little red-haired daughter.

That I live on salmon and trout and get plenty of wonder-
ful *flöde*,[9] you know. But have you ever eaten the actual
legs of a strong elk? On the whole this sounds better than it
is. The other day we nearly lit upon two of them. We were
walking through the moor, almost up to our ankles in mire
(to which you quickly get accustomed), when the elk broke
out ahead of us. We heard the bushes crackling and the boy
in front of us had just seen them.

What was left was their terrible legacy: the vast swarm of
flies that had surrounded them now fell upon us. The
swarm robbed me of my hearing and sight, and I raced
straight into the bog. My companions, of course, found it

very funny. It was terrible. I'm only surprised Dante didn't
think up a swarm of flies for his *Inferno*.

My life runs along like a quiet brook to which the sun
lends silver splendor. The sun is able to conjure real in-
credibilities here. After two rainy gray days it came out
yesterday with its warmth and gold, magnificent and glori-
ous. I walked around as if in a fairy tale, with a happy,
enchanted heart. The little birches rejoiced and fiddled on
the green hills, the little white fleecy clouds laughed in the
blue sky, and the gentle gray alder trunks seemed even more
gentle.

I went to my rock, very near the water, and sang into the
whirling, bubbling spray. Big slender spruce trunks swam
down the river, dived under, emerged again, and shone at
me. The water with its white tongue licked my rock. I had
to laugh because it still couldn't catch me and I played with
it.

A tiny water-wagtail, with its small black cap and its
small black breast, came and seesawed and cheeped. We
forgot the enmity between humans and animals and for a
little while sat peacefully next to each other and were
happy.

In the evening Uncle W reads aloud and I draw. It's very
homey. The leitmotif of our days, which more and more
urgently permeates everything, is—salmon!

Yesterday the bait broke off, today the line snapped and
two big fish were lost. The river isn't always right—it's
muddy, it's too high, it's too low. Or the weather isn't
right—too warm, too cold, too windy. A salmon sets up
many conditions before it even occurs to the fish to take the
bait. But when one is finally so disposed Uncle W is as
pleased as a boy and has his sport, afterward describing to
me to the last detail where and how the great event took
place.

I draw and paint a lot. First I tried landscape, but the
countryside is so wonderfully simple in color and form that
it would take years of study to reproduce such simplicity
without crudeness. So instead I've painted the little calf
and the chickens, and I draw a lot.

Too bad one can't hike. On two sides there's river, on

the other two, mountains and moor. One can walk for only a quarter of an hour before coming to the end of the world. This confinement is rather terrifying.

But it's by no means as cold as you imagine. Certainly at times you shiver, but soon a cheerful wood-fire roars in the stove. When the sun shines, it burns almost more so than at home. It's the pure clean air that does it.

I think I'll be returning in two weeks. Uncle Wulf will remain to go grouse hunting.

JOURNALS

Under the Alder

I lay under the alder. My soul completely surrendered to its spell. I looked up at its leaves. The sun had colored them a bright yellow and there they stood on their delicate red stems laughing at the heavens.

The sky was a deep blue with one little white cloud. A blue exquisitely complementing the yellow of the leaves. Then the wind came and played with them and turned them over so I could see their shiny surfaces. The wind also came down to me, bringing me armfuls of sweet fragrances.

The alder is its most beautiful in full bloom. Its scent filled the tender breezes and lay on me gently, like a dream, and told my soul a tale of times when I was not and when I would no longer be.

I was in lovely, wondrous spirits. I thought nothing, but my whole being was alive in all my veins.

I lay like this for a long time. Then I came back to myself, to the wind and the sun and the cheerful humming of the insects around me. They too loved the alder with its blossoms and they buzzed around it.

There were honey bees with their industrious buzzing, flying zealously to and fro. And golden brown bumblebees. They hummed above my head, happy in their little warm furs.

There were swarms of flies, which displayed their black proboscises and sharpened and stretched their delicate legs.

Some lively little gnats hummed and fiddled their proud little fiddles in joy.

And dragonflies, rocking themselves in the sun's blossoming warmth, mermaids with slender bodies and iridescent wings.

Among them from time to time a little flake from the willow tree flew to the riverbank. It laughed in its glory and glittered white against the blue of heaven, like a little cloud.

Yes, and so I don't forget, I also heard the great river behind the willows. I didn't hear it as it glided along, splendidly tranquil, but whenever it struck a rock and bubbled, or rippled at the edge among the colored pebbles.

The whole gave such a lovely concert of joy, peace, and bliss that my soul stretched wide its wings and was lifted by the great universal joy of living creatures.

TO HER FAMILY

Lilleon, Norway, 3 July 1898

At last I'm with you again, I mean in writing, as I'm often with you in my thoughts. Perhaps a little too often, because I am looking forward to home.

I've escaped here with my writing materials, underneath the flowering alder. It's a delightful spot. The air is impregnated with the alder's lulling fragrance. And the cheerful little birches are commingling their spicy odor. It's absolutely the loveliest mixture, which I breathe in over and over again with pleasure. My alders are sought out by hundreds of insects, so there's a lovely summer-like humming around me. There are hemlock and spirea and dandelions with their dream-spun heads. Straight ahead are the willows, which are blooming now. From time to time they send me one of their snowflakes through the wind. Behind these willows is the river, the Namsen. It's behaving extremely badly lately, falling rapidly, and nothing has been caught in the last six days.

Unfortunately the first six salmon went the way of all flesh. My hope that you would get a beautiful smoked fish was in vain. Papa, how willingly I'd cede my portion of trout and salmon to you!

This fishlessness is depressing, though Uncle Wulf swallows his sorrow sweetly. But he has nothing to do. At present, out of an overabundance of energy, he's painting the window frames of our castle green.

We've stood on the beach together and skipped stones. I felt as I did when Mother used to take us to the preserve on the sand peninsula in the Elbe—and I played with complete abandon.

Or else we roll back into the water the big spruce trunks that have floated ashore. Very little rafting is done on these rapid rivers. The trunks are simply thrown in upstream and caught farther down. Nothing gets lost thanks to the marvelous honesty of the people. Often the whole river is filled with these big tree trunks. At evening the sun paints them golden yellow and they shine beautifully in the blue water.

The books made me very happy. Isn't this Jacobsen[10] coincidence strange? After his six stories I longed for something more by him. So far I've read *Marie Grubbe* and am completely under the spell of its images. I read it very, very slowly, intoxicating myself with little doses—parts of it here under my alder, other parts on the cliff by the waterfall (another of my favorite places). I sit there, quiet and small, amid the mighty roar and passion of the elements, feeling life pulse within me.

I'm waiting a couple of days before beginning *Niels*. I find I can't read books like these quickly, one after the other. I'm surprised that Vogeler illustrates Jacobsen.[11] I can imagine it excites him to set down the many images that the story awakens in him, but I find that rarely is a poet in less need of illustration than Jacobsen. I also find it a thousand times more artistic, as far as the poet is concerned, to leave the images to the fantasy of the individual reader. Nevertheless, I'm looking forward to them. Of their kind, as artwork independent of the book, they're certainly bewitching.

I'm really looking forward to Worpswede and to all that's

been done there this year. I'm especially looking forward to all of you, to every single one of you. And I'm looking forward to my atelier, for which I already have new plans. I hope this fishless river will drive Uncle Wulf away from here into fish-richer regions. Then I'll sail homeward. Right now I don't have the courage to leave him. I find I'm having to suffer a little for all the beauty I enjoy.

There are neighbors, to be sure, a couple of English anglers a quarter of an hour up the road. But we see nothing of them, which suits me fine.

My Norwegian's so-so. I'm able to make myself understood, but this is a bad place to learn the language. People here speak an atrociously awful dialect and can barely understand pure Christiania Norwegian.

Uncle Wulf just told me he's going to take a trip north to Tromsö through the Lofoten Islands. He wants to take me along, the good man. I don't need to make up my mind just yet. But I'm firmly resolved on my "no," so I'll be returning home soon.

All of you are kissed by

Your Paula

Footnotes: Chapter V

1. Present-day Oslo.

2. Now the port city of Szczecin in Poland.

3. In the second half of the nineteenth century industrialization with its demand for cheap labor pulled women into the work force in Norway. By degrees they found employment in offices, banks, insurance companies, and for the State, in the most modest and poorly paid jobs. By 1910 the percentage of women in paid employment in Norway was 33.2.

Some other aspects of the situation of women in Norway different from that in Germany include political organization and education. At the time of this observation by Becker women in Germany were barred from joining political organizations and meetings (see p. 25, n. 10); in Norway women had founded The Women's Social Democratic Society in 1895 with the aim of securing the vote. The German women's movement was fighting for access to public secondary schools (see p. 52, n. 16), while in Norway women were admitted to all faculties of the universities and to several vocational-training schools. Ellen Bonnevie Seip, *Facts About Women in Norway*, Oslo, 1960, pp. 2, 3–5, 18, 32.

4. Law Clerk in the Royal Ministry.

5. Otto Sverdrup, Norwegian polar explorer, was Captain of the *Fram*, a steamer specially built to withstand the crushing ice floes of the North Pole. In 1896 the *Fram* returned from a well-publicized three-year drift in the Kara Sea. In 1898 Sverdrup began a four-year expedition to the northern islands of the Canadian Arctic Archipelago.

6. They were only two hundred kilometers south of the Arctic Circle.

7. This is not an idiom but a somewhat indirect circumlocution for going to the outhouse.

8. The river on which Bremen is situated.

9. Cream.

10. Jens Peter Jacobsen (1847–1885) wrote *Mogens og andre Noveller* (*Mogens and Other Stories*),

1882, and two novels, *Frau Marie Grubbe*, 1876, and *Niels Lyhne*, 1880.

Marie Grubbe, a seventeenth-century Danish *grande-dame*, was a historical person who, after several marriages and liaisons, found happiness with a groom and ended her life in poverty. She is the first of Jacobsen's women to react against her traditional role, a reaction eloquently expressed by the women in his autobiographical novel *Niels Lyhne*. *Niels Lyhne* deals with typical problems of the time and of Jacobsen himself: marriage vs. free love; Christianity vs. atheism; romantic dreaming vs. disillusioned acceptance of reality. The melancholy hero Niels Lyhne is the romantic dreamer who learns to accept the realities of life.

11. Vogeler illustrated the 1898 German translation of *Frau Marie Grubbe* and several of Jacobsen's short stories (see Heinrich Wiegand Petzet, *Von Worpswede nach Moskau: Heinrich Vogeler: Ein Künstler zwischen den Zeiten*, Cologne, 1977, p. 48).

VI. Worpswede, 1898–99

Frau Mathilde Becker and her three daughters, Milly, Paula, and Herma, arrived in Worpswede in mid-September 1898. They rented Paula a studio in the large farmhouse of Martin Brünjes. Brünjeshof, situated off Ostendorfer Strasse and hidden by foliage, was up the road from Heinrich Vogeler's house, Barkenhof. Paula's bright blue-green room with its white sleeping alcove was furnished only with a table and a pair of red stools with braided-rush seats. Frau Becker provided a bed, and daughter Paula set up her large easel against the wall. She laid her books on the table while her sisters went out and gathered wildflowers. They arranged the fleshy marigolds in a pitcher in front of Paula's mirror—a standing oval mirror with a frame of rococo milk-white and red glass roses. [1]

As in the summer of 1897, Becker again studied under Fritz Mackensen. Although she felt she could "learn a lot from him," their student-teacher relationship, in Mackensen's words, was "not easy." He was condescending of her training at the "ladies' school," with its emphasis on mass, shadow, and dramatic highlights. He insisted on a "devoted copying of nature." According to Ottilie Reylaender-Böhme, a pupil of Mackensen's at the time, Becker often expressed opinions that "were by no means in harmony with those of our teacher." She remembered Mackensen criticizing a large nude study Becker was beginning: he asked "with a penetrating glance if what she was drawing was what she saw in nature. Her peculiar answer was a quick 'yes,' and then a hesitating 'no,' while she gazed into the distance." Clara

Westhoff, another Mackensen pupil and Becker's best friend, characterized Becker's attitude as one of "deliberate obstinacy toward her teacher."[2]

For the most part the Worpswede artists were landscape painters. Mackensen, however, concentrated on figures in landscape. Becker immediately adopted as her subject the people from the poorhouse, the village, and the farms. While "devotedly copying nature," she replaced Mackensen's cold light and emotional distance with a very direct and empathetic depiction of her subjects.

During the fifteen months covered by these writings there are fewer than a dozen letters home. Bremen was so close to Worpswede that visits to and from her family were frequent. Now the journals take precedence. Becker recorded her impressions and worked to phrase these descriptions poetically.

In December 1899 Becker participated in a group show in Bremen, which was scathingly reviewed in the local press. Eleven days after the review appeared she left the provinces.

To Her Family

Worpswede, 18 September 1898

Dearests,

Everything continues to go well with me. Monday I didn't get to say good-bye to my dear Mother. I walked over to Vogeler's from the poorhouse expecting to find you there. Instead I found everything topsy-turvy. The roof was on the lawn next to his house and Vogeler was dreamily descending the ladder from the rafters. As I continued on my way up past the clay pit, I saw your coach below. All my calling and waving couldn't stop it. But I consoled myself knowing it was not a separation for eternity.

Since then, mornings and afternoons, I've been going faithfully to Mother Schröder in the poorhouse. The hours

I spend there are very strange. I sit with this aged little Mother in a big gray hall. Our conversation goes something like this: She, "Ah, are ya comin' back tomorrow?" Me, "Uh-huh, Mother, if it's all right with you?" She, "Oh, it's all the same to me. . . ." A half hour later this profound conversation begins again. The most interesting episodes are in between, when the old woman has a kind of hallucination. She starts telling stories from her youth, but with a different inflection and so dramatic and contradictory that they're fascinating to listen to. I'd like to write them down. Unfortunately I don't understand everything. And one isn't permitted to ask because she gets confused and wakes to her misery again. The scenes she goes through at night with our old Olheit, when the latter falls out of bed and moans, are worthy of being published. And every other moment the poor soul has to go "to the upstairs." . . .

In addition to this sibylline voice, a delightful twittering rings in my ear. It's a little five-year-old blonde whose mother nearly caned her to death. As part of her convalescence she's allowed to take care of the poorhouse geese. This little person has wrapped herself in a web of dreams and fairy tales and holds charming dialogues with her white flock. She slowly crows among them, "Let life be joyful"[3]—and then gives a straying chicken one with the switch. I feel very strange in this place.

JOURNALS

4 October 1898

I went through the dark village. The world around me was black, deep black. It was as if the darkness touched me, kissed me, caressed me. I was in another world and I felt blessed, it was so beautiful there. Then I came back to myself and was happy, for this world is beautiful too—and dark, and gentle, like someone huge and much loved. Little lights shone in the houses and laughed out onto the street and at me. And I laughed back, bright and joyful and thankful. I am alive.

After he had sat still for three hours today my model, old
Jan Köster, said in an ironical tone, "Ah, sittin's no fun.
My ass is all blind."

Old von Bredow from the poorhouse, has he had a life!
He lives in the poorhouse and tends the cow. For years his
brother has wanted to bring him back out into the respect-
able, established world. But the old man has become so fond
of his cow and his dreams that he can no longer leave them.
He leads the cow by a rope, brings it to the yellow-gray
pasture, gives it one with the switch with each step, and
philosophizes. He was a university student. Then a
gravedigger during the cholera epidemic in Hamburg. And
then a sailor for six years, living very crazily and surrender-
ing himself to drink in order to forget. Now he has his
evening peace in the poorhouse.

18 October 1898

Today I drew a ten-year-old girl from the poorhouse. She
has been there with her little sister for the last eight years.
She's lived through four poorhouse directors and now plays
with the present director's little Karl, who loves her very
much. . . . "If I had children she would be able to play with
them too." She can't stand to listen to someone catching a
beating, she runs out into the garden. Nor does she "tattle-
tale," except on Meta Tietjen, who takes her knitting
sticks—"That won' do."—or says they have lice in the
poorhouse. (And they're always so cleanly dressed.) She's
so happy she came to the poorhouse as a small child since
she doesn't know about those things. She has it so good,
she says with her little radiant face. With how little is a
good heart contented.

And how good I have it in comparison. Today a big
window was put into the wall for me.[4] Now it's light in my
little blue-green room. Everything is gradually getting set-
tled. The excitingly new turns into sweet habit and there's
a quiet peace inside me. It is, I believe, the mood in which I
am able to work and learn. Mackensen comes every couple
of days and gives a splendid critique. It's good for me to be
around him. Such passion burns in him for his art.

Whenever he talks about it his voice has such a warm, tremulous sound that I tremble and shake. When he mentions Dürer he does so with a solemnity of tone and appearance, like a devout child reciting from the Bible. His god is Rembrandt. He lies at his feet in complete admiration and ardently follows his footsteps.

Vogeler's going to Dresden one of these days. Too bad he won't be staying. His whole person has a fabulous effect on me. I recently visited his Martha, the schoolteacher's daughter.[5] She's in all of his pictures. He even drew her while she was still going to school and he made little presents for her. When she grew older Mackensen wanted to teach her how to enlarge photographs in crayon[6] to make money. But Vogeler said that wasn't for her: she should draw flowers. Now she's embroidering folding screens and mats for him and living deep within the fairy-tale spirit of his art. She sits all day long in his atelier while he draws her endlessly, or he sits quietly next to her on the sofa in her living room and draws her. She'll be going to the Kunstgewerbeschule in Berlin to learn drawing and embroidery.[7] Then what? He's had his house enlarged. For me their relationship is too tender and too dream-like to have such an everyday ending.

24 October 1898

I spent an evening with the am Endes, which had a warm effect on my spirit, like a mild spring rain and spring sunshine. The tenderness of the love these two people share illuminates their whole house with a rose-red light. Anyone permitted to breathe this atmosphere has to become tender and sensitive too. He has a sensitive artist's soul, with an austere, chaste sense of form. He loves Dürer, Donatello, and Botticelli. They hang in beautiful somber frames on his walls. He picks up vibrations from others. He understands the unspoken and answers without speaking. This dialogue sets one's whole being into a sweet vibration. And there's his wife. She has a heart before which you would like to kneel. She hates spiders. They are vile to her. Yet when she

finds one in her jewel-box of a house, she lovingly takes her enemy and sets it outside the window so that she may go on living happily.

29 October 1898

Mackensen was in Amsterdam at the Rembrandt exhibition. The whole man is inflamed by a sacred passion for "this giant, this Rembrandt." He loves the healthy, the thoroughly Germanic, with his body and soul.

He saw the sea for the first time. They saw a rider in the distance, who stopped, dismounted, and fixed something on his saddle. They asked him, "Where's the sea?" He raised his hand and said, "You're hearing it roar."

In the twilight he saw a man sitting among white birch shavings, carving white wooden shoes. If someone were able to paint this, that person would be greater than all of them.

He's often harsh and egotistical. But before nature he's like a child, tender as a child. It's then that he moves me. He appears to me like an old, proud warrior kneeling before the Almighty.

I've drawn a young mother with her child at her breast sitting in their smoky hut. If only I could paint what I felt about them! A sweet woman, a *caritas*. She was suckling her big one-year-old bambino. Her four-year-old girl with defiant eyes strained and snatched at her mother's breast until she got it. And the woman gives her life and her youth and her strength to the child in complete simplicity, unaware of being heroic.

Mackensen saw a man felling a golden autumn birch. He drew near and the man shouted, "Watch out!" The tree fell and all its gold lay at his feet. It was beautiful.

I've drawn my young mother again. This time outside in the open air. She's lovely in any position and I'd like to do a hundred pictures of her. If only I could! This time her brownish head was against a red brick wall. Later I have to

paint her with the white mud hut as background, the one old Renken built himself. She'll be dark and warm against it. And then with the dark pines as background. Ah!

> I feel as if I were sitting in eternity
> And my soul hardly dared breathe,
> I sit with tightly closed wings
> And spy, wide-eyed, on the universe.
> And a soft mildness comes over me
> And a great strength comes over me,
> As if I wanted to kiss white petals
> And fight great battles beside great warriors.
> I awaken, trembling with wonder...
> So small, you child! Yet so enormous
> The waves that kiss your soul.
> I spy into the dark corner of my chamber,
> Like large, quiet eyes, it looks back,
> Like large, soft hands stroking my brow.
> And a blessing flows through each fiber of my being.
> This is the peace that dwells within me...
> At my side, my lamp burns closely,
> Humming its song of life as if in a dream.
> In the twilight, white flowers are glistening,
> They tremble, shivering, they sense the future.
> With lightly beating wings the bat circles round my
> lair.
> And my soul beholds life's riddle,
> Trembles and is silent and beholds.
> Next to my lair, the lamp hums
> Its life song.

11 November 1898

Evenings I'm drawing a life-size nude. I've begun with little Meta Fijol, with her innocent Cecilia face. When I told her to undress completely, this energetic little person answered, "Nope, I don' do that." I talked her into undressing half way and yesterday, after I gave her a mark, she

mellowed completely. But I blushed inwardly and hated
myself, the tempter. She's a small, knock-kneed little crea-
ture. I'm happy to be contemplating a nude at my leisure
again.

I'm reading the journal of Marie Bashkirtseff.[8] It interests
me very much and I get very excited reading it. She made
such enormous use of her life. I've wasted my first twenty
years. Or has the foundation on which my next twenty are
to be built been quietly laid?

You

She was eleven years old and still dreamed with fervor
the dreams of a child. She was not awakened to what grown-
ups call life. She loved to sit in the garden next to the
flower beds and talk with the wallflowers and the mignon-
ettes. They wafted their sweet fragrances to her, she under-
stood their language and smiled at them. The flowers were
delighted by her brown eyes, over which still lay the blue
veil of dreams. They blossomed and smelled even more
sweetly than before, telling many a charming tale in their
own language. . . . The little maiden had a mischievous
ringlet dangling in front of each ear and in back her hair
rippled like little golden brooks, delicately and softly. The
sun delighted in her curls and rang out sweet melodies from
them.

The child sat in the garden next to the slender white
narcissus and whispered to them. They rocked themselves
on their gray-green stems, fanned the air with their thin
leaves, and spoke in their language. The breezes, impreg-
nated with their fragrance, swirled around, intoxicating
the little maiden. One narcissus with a snow-white face,
the most pious of them, begged her sisters not to smell too
enticing so as not to awaken the maid's senses. So their
scent was soft and sweet. Then the maiden turned to the
big golden brown bumblebees and conversed with them.
She caught the bees with her little fingers and put them
into honey-rich calyxes, which drooped under their heavy

burden. The big bumblebees buzzed their gratitude, talked about their queen, and completely forgot about their stings.

Next to the bed of narcissus ran a yellow path. Along the other side of the path was a rose-lilac glittering of fragrant gillyflowers. Behind these gillyflowers stood tall boards that separated the garden from its neighbor's. The child had never looked over the fence, had never even thought about what might be behind it. But there was something behind it. That something stood on tiptoe trying to peep through the knothole into the garden that smelled so sweetly.

He saw the child among the flowers, and ever since then he often peeped through the fence. He would stand breathless for hours in front of the knothole in the board. It was like a fairy tale to him and he was overcome as if in a dream, as if a sacred tremor went through him, and he did not dare move. Once, when he was no longer able to restrain his curiosity, he whispered fervently through the opening, "You, you." Thereupon the little maiden looked up out of her dream. But as she saw no one, she thought that the flowers were playing hide-and-seek with her. For the boy on the other side of the fence, however, it was as if the heavens had opened and allowed him to look on all their magnificence. His heart nearly stood still with joy. He dared not say another word. Her eyes had burned his soul like two suns—like suns from the south, where people don't have to fight or struggle with the earth for a little bread, where they pass the time dreaming and making poetry like children. The boy could never forget those sun-eyes. He kept them in the purest chamber of his heart and rejoiced in them.

Years passed. The gillyflowers and narcissus no longer stood in the flower garden. There were different bumblebees buzzing over different flowers. And different dreams were dreamt. My soul was sad at the sight of these new gardens. I stole forth from them and went out into the city. I stopped in front of the entrance to the art exhibit, hesitated a moment, and then stepped in. I went through vast halls and my eye wandered casually over the pictures. But my heart was with the old gillyflowers and narcissus and

with the old dreams. Suddenly I was standing in front of my picture. A pair of sun-dreaming eyes looked on me and brought spring into my soul. They belonged to a serious, quiet young woman. In front of each ear hung a mischievous ringlet. On each side she held a slender, white narcissus in her hand. My soul trembled. Under this picture written in fine letters was: *You*. The people passing by, the everyday people, shook their heads and didn't know what to make of *You*. But the brown bumblebee who flew in through the window knew. It was a sad story. The bee's grandmother had often told it to the bee when it was little. . . . And I? I knew it too.

15 November 1898

The journal of Marie Bashkirtseff. Her thoughts run in my blood and make me deeply sad. I say as she does: if only I can become something! It's an ignominious existence. You don't have the right to be proud while you're still nothing. I am weak. I'd like to do everything and I accomplish nothing. In his critique today Mackensen was distracted and dissatisfied. If it hadn't been for the woman from Bergedorf I would have cried afterward. So I slaved on for two long hours, and again this afternoon. The result, less than nothing. I'm placing my hope on my child-nude this evening.

The world around me is gray and the heavens cloudy. The water murmurs, softly dreaming, bringing unrest to my soul. I wander among the birches. They stand here in their chaste nudity. They lift their bare branches up to the heavens and implore fate ardently in prayer. But the heavens are cloudy, so the birches are still, mourning softly, softly, with devoutly folded hands. Living—breathing—feeling—dreaming—living.

I am entwined in the riddle of the universe. I sit down and am silent. The water roars and brings unrest to my soul. Within I am trembling. Sparkling drops hang in the pines. Are they tears?

To Her Family

Worpswede, 25 November 1898

Dearests,

... meanwhile I go on living and drawing, drawing, drawing. I long for the time when I am able to do what I'd like to do now. I really have a gigantic wildcat of a hangover from painting, the biggest of my life so far. Such creatures seem to thrive and grow strong in artistic climates. But the climate is considerate enough to permit other sensitive, special moods to enrich my life: a sunset with pealing bells; a vist to an old woman with one foot in the grave, whose thoughts flare brightly one last time before the great catastrophe. In the beautiful, powerful language of the people she spoke to me, in a breath half giving-out, of birth and marriage and death. Whenever these people have something to say you listen to them transfixed. But most of them speak only in platitudes, only empty words, in order to talk at all. It's terrible and makes them seem so ignorant.

Now is the season of the spinning-room. The old women go from house to house with their spinning wheels. Then the men process the wool into stockings. Even my Garwes knits in his spare time.

I love most going to old Renken " 'hind the firs" (they're pines). He makes brooms, gossips amusingly, and rocks his grandchild on his lap, tirelessly singing "Ooaa, ooaa" to her on two notes. When her young mother said with a mischievous look, "She knows that song by now," he immediately made up something new. Now he sings "Aaoo, aaoo." These people have such heartfelt affection for each other, a rarity here, and they let the larger world be—which for them simply is Worpswede, Worpswede.

My evening nude makes me very happy. Even though the little girl is knock-kneed, she moves with such naive grace. Mackensen had her take about twenty different poses today. I would have liked to have held on to every single one of them.

I'm reading Bismarck's letters. The great man becomes
very human. When he speaks about huntsmanship,
women, and his impressions of nature he shades into Uncle
Wulf for me. Bismarck, *Werther*, Marie Bashkirtseff,
Worpswede, all in one little head. I seem strange to myself
here. I look at the bustle of life as if from the dress-circle
and, given where I'm sitting, I don't think much about how
it affects me. Till now one played a pretty big role on one's
little stage. Now the play is over. One simply is. One ad-
vances and draws back without being bothered by an audi-
ence. Occasionally one's vanity longs for a little boost, a
boost that only the world can give. Even if it's just a kick, at
least one feels important enough to be kicked. It's seldom
and not in the best moments that one longs for nothing
at all.

JOURNALS

29 November 1898
It was a wildcat of a hangover that wrapped its long tail
around my neck and nearly strangled my soul. Marie
Bashkirtseff, I accuse her. I worked terribly hard. The result
was mere industry. The *ingenium,* to use Frau P's word, was
missing.
. Now that the tail end of the hangover is off and my
throat is no longer constricted, I shout "Hurrah!" and sing
all day and draw with pleasure. Life is beautiful again, sin-
gularly beautiful.
This tragic Worpswede act ended with a merry ball at
Dreyer's. I was only an onlooker and it was certainly difficult
to sit still during the watlz. There was so much excitement
—the moonlit path with stormy breezes, the birches against
the blue night sky. The heads of the women shone reddish,
both inside the house, in the lamplight, and at the open
door against the bright evening sky. Really anything against
the sky!!! Finally the six musicians on the raised podium,

the four burning candles in front of them illuminated the
dark fellow beautifully. I studied them especially for myself
and when I came home I made a little sketch of them.[9]
I wish I could etch. It would be perfect for this.

Today I drew the honorable von Bredow again and from
time to time lent half an ear to his torrent of words. It's wild
in his old head, with many weeds among the wheat. He
draws parallels (inwardly) between his life and that of the
greatest men of all times. "Schiller would have lived longer
if he hadn't drunk three hundred thalers worth of cham-
pagne during his great drama, The Bell. Poets and such
people need to. They have to be half mad when they write.

"Yes, and Johannes Gutenberg, he died in the
poorhouse. Doctor Faust lent him a great sum of money,
recalled it, and took possession of his printing press. Then
he went to Paris and sold cheap bibles. It nearly cost him
his life there. Gangs of priests were after him. The waitress
in his hotel, she saved him."

Stories about dreams and years of crises. A strange vi-
sion, which faded like a mist when he awoke, of "somnam-
bulists" who "are only women. No men can't be them." The
constant refrain: "Who wants to love must suffer. You can't
escape your fate."

A unique head sits for me tomorrow, really one to study.
In the afternoon, for dessert, I'll go to the Renkens. I've
grown fond of these people, especially the woman with her
childlike, feminine grace and simple capacity for sacrifice
that is completely unselfconscious. You find this only
among good women of the common people.

If I ever get so far as to be able to paint, I'd like to make
her my first picture.

Her sixty-nine-year-old father still goes out at six o'clock
in the morning to Blockland with his wheelbarrow and sells
brooms. He came home angry the other day. His no-good
son told all his customers that his father was dead. The
brooms were bought from the boy and the old man was
cheated out of his money.

12 December 1898

I drew Anna Böttcher this morning—colossally grand in the color and shape of her head. In the afternoon I fetched old Adelheid Böttcher, "old Olheit," to model. Rivalry reigns among the old women for the model fee. "Big Lisa put on her good cap and thought, now you'll fetch her. She's always tellin' such long-winded tales to me, 'bout boys and girls, and who was there and where it happened. I don' even listen, only say 'Yeah' from time to time and keep my thoughts on somethin' else." That's how the old woman talks to me. There's still a lot of life in her, and passionate conviction, although she's a little childish. Whenever she does something wrong she says to the young woman, "Mother, forgive me, I'm bad." This moves me.

Fräulein Westhoff's model complains about her ear disease, "I've tried everythin' what people told me, everythin' 'cept scrubbin'."

Drawing doesn't satisfy me. I'm breathless. I want to go on and on. I can't wait for the time when I can.

And I long for life. I've just begun to taste it a little. Before I didn't take an interest in it. And here it's not life, here it's a dream.

I'm reading *Zarathustra*. Beside all the intricacy and obscurity, what pearls! His remolding and recreating values! His preaching against false charity and self-sacrifice.

False charity diverts one from great goals. Had they had this concept as a tool, many great souls would not have been cut to little pieces by everyday life. This concept must become innate in the next generation.

15 December 1898

Today old Olheit told me the story of her life. "She worked as a servant on Bessel Street in Bremen, then she got herself married. She had to live somewhere. It went O.K. in the end, only he's dead now."

This morning I drew Frau Meyer from Rusch. She was locked up for four weeks because she and her man treated their illegitimate child so badly. A robust blonde, a masterpiece of nature, a shining neck shaped like the Venus de Milo's.

She's very sensual. Doesn't sensuality, natural sensuality, go hand in hand with this potent, robust energy? For me there's something of great Mother Nature with her full breasts in this sensuality. And sensuality, sensuality down to the fingertips, paired with chastity, is the one, true, right thing for the artist.

16 December 1898

My blonde returned today. This time with her boy at her breast. She must be drawn as a mother, her one true purpose. Exquisite, this shining white breast in its burnt red jacket. The whole composition is so grand in its shape and color.

In the afternoon my old woman. "I says to big Lisa, I wanna keep myself honorable 'n' go to my grave honest, like my husband. So I ask our Good Father every day that He keep me from whorin' 'n' stealin'. You couldn' do anything against what He wants."

I smiled to myself, shaking my head over this innocence. Half-withered, half-blind, almost in her grave, and begging the dear Lord to keep her from becoming a whore.

Out here one becomes familiar with a Lutheran kind of speech. One daily hears coarse folk expressions—they call a thing very plainly by its name. Whenever I walk the old woman up to the door she says, "Now I must go piss." Or "Now I must leak my water." Her little skirt tucked up, I chastely run away.

I feel I'm now developing the true Worpswede spirit. The *Sunken Bell* mood that first dominated me was sweet, very sweet. But it was only a dream, which could not be effectively held on to for long. There was a reaction, and afterward the truth: an intense striving and living for art, wrestling and struggling with all my strength.

It's as if my whole being were sun-drenched, wind-drenched, intoxicated, drunk with moonlight on the bright snow. Snow that lies heavily on each bough and branch. Deep quiet around me. Snow falling from the trees into the silence, a soft crackle, and again peace. This indescribably sweet weave of moonlight and delicate snowy ether encircled me. Nature spoke to me and I listened to it trembling blissfully. Life.

Nature is supposed to become more important to me than people, to speak more loudly from me. I'm supposed to feel small before its greatness. That's what Mackensen wants. It's the alpha and omega of his criticism. Devoted copying of nature—that's what I'm supposed to learn. I let my own little self into the foreground too much.

It began to dawn on me today at Fräulein Westhoff's. She was modeling an old woman closely, intimately. I admired this girl as she stood next to the bust, working up the details. I'd like to have her for a friend. She's big and splendid to look at, as a person and as an artist. We raced down the hill today on a small toboggan. It was fun. My heart laughed and my soul had wings. Life.

Moonglitter and snow. . .
Trembling, sensing, seeking,
The slender trees script
A likeness of their soul
On winter's white sheet.
Piously laying their gracious essence
Down upon the chaste ground. . .
When will the day come
When I in humility
Can cast a shadow
On the pure, chaste ground. . .
A shadow of my soul.

To Her Aunt Marie

Worpswede, 15 January 1899

My dear Aunt Marie,

It's Sunday evening and snug and cozy in my little room. I've put a pair of dry Christmas pine twigs in my stove and now it smells dreamy, sweet, and Christmasy. I've been on the moor all day long, in the storm, with the rushing clouds. One always discovers new beauties in this land. This time I came upon a tangle of birches and timeworn, moss-covered farmhouses with ancient junipers in front of their doors. Here and there stood a pair of gnarled old pines, big and powerful, almost as though from another world. Deep dark brown, rich, marshy soil and shining winter crops. It was wonderful—even the struggle with the elements, which mischievously pulled and plucked at everything and wantonly laughed.

The quiet in my little chamber has such a sweet effect on me. I've taken out your letter. A bit of old Friedrichstrasse comes forth from it. That once one was a child, didn't think about anything, lived, lived quietly, and now suddenly is grown up, is indeed strange. I can hardly tell what I've done with my first twenty years. All of a sudden they're gone. I'll probably have more to tell about the next twenty. At least now I'm living with full consciousness and sipping slowly from the cup of life. My destiny is a blessed one.

JOURNALS

19 January 1899

While bathing today the thought occurred to me that in solitude humankind is reduced to one's self. It was a special feeling, as all my confusion, upbringing, role-playing fell away and a vibrant simplicity arose. I work on myself, remodeling myself, half consciously, half unconsciously. I'm

changing, but for the better? In any case, more purposeful,
more independent. I'm having a good period, experiencing
a fine young energy in myself that makes me rejoice and
exult. I work diligently. I don't tire and my mind's still clear
in the evening so I can take in more. I am proud and yet
more modest than ever, a little vain since there are a few
spectators. For me life is like a nourishing crisp apple into
which new teeth bite with pleasure, aware of and enjoying
their strength. Mackensen says energy is the most beautiful
of all things. In the beginning was energy. I feel and know
this too. Yet energy will not be the lead tone in my art. I
experience in myself a fine weave, a vibration, a wing beat,
a trembling repose, a holding of my breath. When I can
paint, I will paint this.

Outside nature is holding a big beautiful dance. There's
such a tumultuous wind, a whipping rain and hail storm, an
almightiness and primeval mightiness, that it makes one
feel very small. Then one laughs, ready to measure one's
own strength against this ineffable spirit of nature. This
little defiant person, the smallest atom of nature, so absurd
in its attempt.

It's a shame to go to bed at night. My energy wants to
fight on, to be conscious of itself again and again, to be
awake, not asleep. Oh, stay with me forever! My life is like
the flight of a young eagle. I enjoy having wings, I enjoy
flying, I cheer the blue skies. I'm alive.

24 January 1899

Again a beautiful day behind me, again my soul is happy.
I stretch out my arms before me and the joy of life fills me
with awe.

My nude, my Rubens woman, canceled. So I went for a
walk in the dusk, out to the flooded meadows. My soul was
so moved by the power of the twilight hours, overwhelm-
ing, breathtaking. I felt myself so blessed. Isn't it a gift to be
able to experience all this glory? And I yearn for more,
more. I want to strive for it untiringly with all my energy so
that I'll create something one day in which my whole soul

will lie. It won't be anything big, but something charming, virginal, austere, and yet demanding. When? In two years. God, let it happen. I say God, I mean the spirit that imbues nature, of which I am a tiny particle—which is how I feel during a big storm. It's like an intense breathing.

> O Holy Spirit enter me
> And let me be your dwelling
> To my constant joy and delight.
> Sun, delight,
> Heavenly life
> Will you give.

Thereupon I stretched out my arms and was again filled with awe.

I'm reading *Elective Affinities* and am charmed by the elegance of the book. For the first time the man, Goethe, is real to me. I feel he's utterly aesthetic, inside and out. His women's grace, the charm of their conversation, are depicted by a heart that feels deeply. I'm comfortable in this atmosphere. It has the same effect on me as Aunt H and M do. And it's educational. We modern ladies, we abandon elegance and pursue other qualities that we ought to combine with elegance. We must. To dress gracefully and to move gracefully for the sake of grace must become second nature to me. For elegance and not for the sake of an audience—this has been my principle since my teens. Because sometimes the audience is missing, as in my case. Besides, a cult of elegance is far superior to a cult of the audience.

A week in Berlin. Very happy to be back in Worpswede. Breaking myself in with difficulty.

To Her Family

Worpswede, 12 February 1899

Dearests,

I'm back in my country manor and delighted to be here.
I'm surrounded by spring splendor. The heavens are laugh-
ing in exquisite blue and their laughter is reflected even
more exquisitely in the thawing spring. Larks are warbling
and catkins hang from the hazelbushes.

My heart rejoiced at this beauty. Even hiking here was a
joy.[10] As soon as I put Bremen behind me, no longer em-
barrassed by my shabby-shaggyness, I fastened my green
handmade bag on my back, having taken off my jacket and
fur kepi. I was again a whole person and happy about the
species. A lovely spring cheerfulness, a happiness without
rhyme or reason, seized my soul and lives there even now.
In Lilienthal I'd have liked to beat drums or masterfully
pluck harpstrings and sing Schubert's *Allmacht* with a
laudist's voice. But because I have no drums or harp or
voice, I surrendered myself to being played as an instru-
ment, and my strings sounded masterfully and reverberated
a long time.

The magnificence was the blue-green water in the middle
of the green meadows. The vibrance gradually tired me and
I went a little off the main road, laid my bundle under my
head, and had a good nap. From there I kept on dreaming
until I reached my lovely little nest here.

Influenza is everywhere—present, past, and future. In
spite of it my reception was very hearty and mingled with
tears of joy. Now I'm back at work and enjoying it with all
my heart.

A general Thursday bowling night is being instituted.
I'm really not in favor of bowling, especially for women, but
a concrete bond is necessary for all these sensitive souls.
They're spoiled by their solitude. They come out of them-
selves when they bowl, play cheerful roles, and are happy

together—whereas in aesthetic enjoyment they stay inside their fine and oversensitive shells and rub against each other. They're too different and too similar.

This is the only fear I have here for my little self.

I feel I will grow away from here. The number of those with whom I can bear to speak about what lies in my heart and soul is becoming smaller and smaller. Such topics will probably disappear at an age when burning subjectivism is put out and the cold electric light of objectivism is turned on. And people confidently discuss everything with everybody. I am very afraid of this horrid predicament.

JOURNALS

19 February 1899

My best thoughts always come in the morning when I get up. Today: the complication of a character grows with the sensitive understanding of it. In this case, not being understood by people who are not inferior simplifies matters. At least I feel that's how it is for me out here.

Elective Affinities loses my interest as soon as the plot thickens. It's the same in Tasso, where the first act is the most beautiful. Later you're aware of how the artist slaved over the design. The moderns are a step ahead. Their development is so smooth and logical. One doesn't notice the labor pains, which is comforting. For example, Hauptmann's Drayman Henschel. The work is great and plastic and it elevates the audience. Fine!

Helbeck of Bannisdale by Mrs. Humphrey Ward. The book fascinates me as a romance. A not-too-foolish love story, always absorbing in content. At least for me. I don't value the book very highly as a work of art in and of itself. It lacks that Rembrandt flesh and blood. It has the sentimental, flabby effect of an old man—which appears to me

on the whole the failing of English art. It suffers from a false
idealism.[11]

6 March 1899

Little Berta Garwes told me seriously, "Karl Schröder has
a book where he writes down all his misfortunes." Yes, so
do most people. They write their misfortunes into their
memories and diligently memorize them, but their luck,
their good fortunes, they don't notice. For them it's just a
transitional stage to new misery. . . . Poor, poor world. I'm
getting along better.

To Her Father

Worpswede, 9 March 1899

Dear Father,
Today I've come to tempt you. I'll need a new model
Monday and I'd very, very much like to have you on my
little throne. Do you want to abandon Bremen for a week
and throw yourself into my arms? You won't be obliged to
have pancakes all the time, you'll have something sensible.
Besides I wasn't eating pancakes out of a passion for them.

It's wonderful outside here now, just the weather for long
walks.

I ate at Welzel's Sunday in order to see something of the
other women. It was very pleasant and I'll do it more often
lest they think I'm avoiding them. There was a nice conver-
sation over coffee and a beautiful walk through the half-
snow, half-spring landscape. Mostly I'm involved in search-
ing for human contact. Without wanting it, my little ship
has been propelled onto a ridiculously solitary sea (which
was very useful for studying). I've visited the Overbecks and
the Modersohns. Both the Overbecks are people with an
inner quality, but everything lies so much under lock and
key. Unfortunately I'm no great daredevil, at least not in

practice, and I let my arms fall limply when I get no re-
sponse. I don't feel I got very far with them. . . . But
Modersohn pleased me immensely—thoroughly fine and
genial, and of a timbre to which I can play my little violin.
He's already very dear to me from his pictures, a fine
dreamer.

JOURNALS

March 1899

Finished *Thus Spake Zarathustra*, a valuable work. It in-
toxicates me with its Eastern, psalm-like language, with its
tropical profusion of brilliant pictures. Its many obscurities
don't bother me. I look beyond them. Do we ever under-
stand everything in life? Nietzsche with his new values is a
giant. He holds the reins tight and demands the utmost
strength. But isn't that true education? Shouldn't this striv-
ing lie in each love, to propel the love object to its finest
possibilities? It was strange to see clearly expressed what is
still unclear and undeveloped in myself. I experience myself
happily again as a modern person and a child of my time.

I'm reading *Niels Lyhne* for the second time with every
fiber of my being. It intoxicates all my senses. My soul
ambles through a flowering avenue of linden trees at high
noon. The scent is almost too much for me.

It's a peculiar book, with its subtle, psychological de-
velopment. And so simple, so alive. Alive with glowing
colors, with sunshine and nightingale nights. With a fine
whispering music that the ear hears, recognizes, but doesn't
understand.

Never has anyone captured so well for me the mood of a
room in the soul. You feel in advance what kind of thoughts
must arise in that atmosphere, what kind of people grow up
there. I feel him—Jacobsen—in my very nerves, in my
wrists, fingertips, lips. It overpowers me. I read bodily.

Worpswede, 30 March 1899

Carl Vinnen[12] was in Worpswede for two days. He's a
fine, dear person and an artist of heart and soul. He's ex-
hibiting a whole series of pictures in Bremen. Big beautiful
works arising from an intimate love of nature that places
the individual self in the background. Yet from these pic-
tures one feels that human beings are more important than
things. This allows him his great and simple perception.

There was a celebration yesterday in Otto Modersohn's
atelier. It was my nicest evening out with the artists here.
Even the room had something wonderfully cheery about it.
Modersohn birches and canals met your eye everywhere—
splendid. Dim lighting from paper lanterns. Two tables
were laid, one for adults and one for children. At the latter
were Fräulein Westhoff and I, Vogeler, young Mackensen,
and Alfred Heymel (the former owner of our Fido). Vogeler
had just given me some poems by him which I didn't think
too highly of as poems elevating the spirit. What did come
through was a youthful energy that wanted to experience
and manifest itself. Now he's in Munich, salted in with all
our finest, most modern artists. With his cousin Rudolf
Alexander Schröder and Otto Julius Bierbaum, he pub-
lishes a magazine, *Die Insel,* and so on.[13]

Later Vogeler sat down with his guitar and sang "Negro
spirituals." Finally the tables were pushed aside and we
danced. It was Heymel's idea and he devised circle dances,
of which I never had enough. Plus the feminine feeling that
my new green velvet dress looked wonderful and that sev-
eral people took delight in me.[14]

Vinnen visited me this morning and looked at my work
himself. It was an enormous joy for me to be taken seriously
by such an artist. He was satisfied with many things, praised
their picturesqueness, their tones.

I heard a nightingale, a nightingale in Boltes's garden
and one evening a cricket cheeped and a bat whizzed over
my head. Life becomes more and more beautiful.

At night whenever I awake and in the morning when I

get up, I feel as if something dreamlike, something beautiful were upon me. But it's only life standing before me with its beautiful arms outstretched, for me to fly within them. .

To Her Aunt Marie

Worpswede, 20 April 1899

My dear Aunt Marie,

It's a moonlit midnight, a worthy time for me to turn into myself and repent my sins. Your birthday also gives me a moral push so that it's impossible for me to persist in my cherished silence. By virtue of immense self-control I've now learned how to keep silent (which is supposed to be golden, though I'm not experiencing this yet—but the old wisdom is always right).

There's not much new to report about myself. I work a fair amount, think about it a lot. Sometimes I have high hopes and sometimes not. Mackensen's at the opening of the Dresden exhibition, [15] to which the Worpsweders have contributed nicely. The twins[16] were here with me at Easter. It was awfully good fun having house guests. We lay like sardines in my miniature room, everybody snugly together. The rascals were darling to have. I'm now at the age when one is glad to be a child among children again. Till now being a child was the usual and being grown up the extraordinary.

Excuse this letter, I'm badly lacking in imagination and feeling. My only excuse is the late hour. I was bowling until just now, using up my little physical and psychic energies. At last spring is coming. Next to me stands a flowering catkin branch, charmed open not by the sun but by my strongly heated peat—which little pleased my purse or me.

Actually my eyes are three-quarters closed. Morning dawns and mournfully meows our cat Mimi next to her four kittens. I'm fleeing to my enormous eiderdown.

To Her Family

Worpswede, June 1899

My Mother,

I've been planning this letter to you for two days. Now in the late night hours I've at last found the time and the place. First let me give you a kiss for your "gray."[17] It was lying on my Abruzzi blanket when I returned home Saturday around half past ten from a long, beautiful expedition with my sketchbook. I almost planned to surprise you the next morning but the heat held me back. So I spent a pleasant afternoon and evening at the Modersohns.[18] I especially like him. Besides his smile, underneath he's sensitive and serious. She's a little woman of good independent judgment and feeling, with an intuition for people and things. Around ten o'clock Fräulein Westhoff came on her bicycle to fetch me to the dance, the festivities following the Schützenfest.[19] We two girls were with Heinrich Vogeler, Dr. Carl Hauptmann, and a mystic. Waltzing is really something quite beautiful, only not with the mystic.

This afternoon Fräulein Westhoff poled me far up the Hamme. We picked yellow irises, swam, felt blessed in the wet elements, and stuck yellow waterlilies in our hair.

I have a skeleton at my place now. I'm studying it because anatomy is still my weak point.[20] Am etching, and sketching outdoors a lot, and reading.

Milly's letters take me back in spirit to last year. I can hardly imagine that it's only a year since my trip. The time seems much longer and more significant to me. I think this comes from intense living.

Worpswede, June 1899

Dearest,

Why do you tempt me? I really can't. It's really impossible. "Do I want to?" At present I have only one thought, to lose myself in my art, to disappear in it, until I can express

approximately what I feel—perhaps in order to disappear completely. I couldn't get away from here even if I wanted to. Rather, I'm not even able to want to. I couldn't bear it down there despite you and despite the mountains. It's not ingratitude. I was quite passionate at the thought of being with you for so long because we really need to be together. And your dear way of contriving this whole plan. It warms my heart. Yet I didn't waver a moment. I knew I wouldn't be able to. The one thing I want to treat myself to for a vacation is a week in Dresden to enjoy Uncle Arthur and Aunt Gretel and the exhibition. Otherwise I want to live here. Live and develop further as a person and an artist. I'm getting closer to all these fine people and feel I'm learning a lot from them. I want to make of myself the finest that can be. I know it's selfish but it's a selfishness that is great and noble and that gives itself to a tremendous cause. That's how it is with me. Do you understand? I think so. Do you approve? I hope so. In any case, I can not do otherwise. I do not want otherwise. I feel strong and happy and I work, work, work, so as not to be indebted to my most beautiful fate. . . . Farewell. Rest in your beloved mountains. Enjoy your holiday as much as you can. Know that your love makes me feel happy and honored, even if at the moment I can think of neither receiving nor giving love. One is needy.

To Her Aunt Marie

Worpswede, June 1899

My dear Aunt Marie,

Did you receive my second letter? It was on my last half sheet of notepaper, so now I have no choice but this little scrap of paper. My pretty blonde landlady believes my letter made its way into the stove instead of the mailbox. For security I'm sending you this second sheet, over which I want to extend maternal, protecting hands.

I think it would be wonderful to go hiking with you in

the Alps for two weeks and two weeks for such a backwoods person like myself would be really tremendous. But isn't it too short compared with the long trip?

I more and more think you might want to find a better travel companion, someone more cheerful. I don't know that others find me happy and cheery, although I am as I believe few people are. After I've been out in the wide world for three weeks I'll really look forward to my dear Worpswede.

I wandered around in the dark evening meadows for a long time, with the heavens shining above. Now it's night, quiet, with only the isolated barking of dogs. It's quiet within me too and now quietly I go to bed.

In love

Your Paula Becker

Worpswede, 8 July 1899

My dear Aunt Marie,

Your dear note has disclosed golden perspectives to me. That everything about which you write exists, is almost unbelievable to me here. The whole world beyond Worpswede lies veiled in a mist for me. Now suddenly I see turrets and pinnacles and mountains rising.

I'm supposed to choose between Engadine and a *generalbillet*?[21] They're both so splendid that the choice is difficult. It's all the same to you then? I think the *generalbillet* would be better for me personally. I mean better for my character, which in the prevailing atmosphere is perhaps becoming a little too north German in seriousness, heaviness, and helplessness. The general-bounce-around might be a good cure and, after my quiet life here, two weeks of new impressions will feel like eight. Or else do you feel Engadine would be better for Father? I'm still very much hoping for him.

A day in Munich would be a dream. I'd also very much like to spend a day in Nürenberg in order finally to get a thorough sense of Dürer. He's someone you never have enough of in person.

I've resolved to make the trip fourth class. I'm familiar
with it, having traveled this way twice before by chance.
Now I don't see why I shouldn't choose it of my own ac-
cord. The people seem just as decent or elegant or inelegant
as those in third class. Besides, it's interesting to hear their
perpetually varying dialect.

JOURNALS

(*On a summer journey with Aunt M and WD through
Switzerland*)

> Am I not the little girl
> In the spring meadows
> Am I not the little girl
> Luck chose?
> Happy the flowers blossom
> And white clouds draw on
> So thoroughly content
> Only good is meant
> For me, coming 'round the edge
> Luck awaits me in the hedge.

TO HER FAMILY

Worpswede, August 1899

My Mother,

It was a beautiful evening. I painted and then I sat in a
pile of hay with *The Humour of Germany*, [22] really looking
away from the book more often than into it because the
evening was so beautiful. From time to time I burst out
laughing thinking of yesterday's comedy. I want to tell you
about it so you can laugh too.

After a rather uneventful Sunday Clara Westhoff and I

strolled through the village together. We felt that the day shouldn't end this way. We wanted to dance. But where? And how? The next moment we were back on art, on Clara's church angels.

So to church. It was closed. Only the tower was open. For the first time we climbed it and sat on the rafters at the top next to the belfry. Then it came to us: we should ring the bell. We struck it once with the clapper, it rang so temptingly. Then Clara pulled the rope of the big bell and I of the little one, and they chimed, and we were swung by them high up off the ground. They rang and sounded and resounded over the Weyerberg[23] until we were tired.

Just at that moment the loftiest of all teachers climbed up all the steep stairs to demand an explanation in his loftiness. When he discovered two maidens dressed in white, he just wended his way back down the stairs.

We followed him and—the entire churchyard was swarming with people. We had rung the fire bell. Everyone thought there had been a fire. Below in the village the fire wagon had been harnessed. We were making off quickly when we met the pastor, who with a pale, puffed face hissed several times, "Sacrosanctum!" Later we pacified him with a special visit.

Then we went to the newsprinter to make sure we wouldn't be in the paper, and finally home. The good Brünjes couple anxiously awaited me. "Oh, Fräulein, what anxiety I been havin' here. I been at the door probably a hundred times. I thought they locked you up."

And Frau Brünjes: "I always said the big one,[24] she can take it, but our Fräulein, she'll get sick in the clink." The neighbors had assured them that we had probably gone to Bremen. Now the Weyerberg chimes were the talk of the evening. "Did you people hear 'em?" "Yeah." "Know who did it?" "Nope." "Fräulein Westhoff and Fräulein Becker."

In Westerwede[25] Clara Westhoff was greeted with a hullabaloo and Martin Finken would have "given five groschen to have been there." The little hunchbacked maid who's a household fixture and grumblingly peels potatoes all day became sunny and lively at our misdeed.

Worpswede, 10 September 1899

You dear People,

Here I am again in my dear old haunt, working industri-
ously and thinking of past and future times, of all that's to
happen, and of how well-off I'll be. I believe I did well to
look at things out of doors and not just indoors. I mean our
little village and all.

I'm facing the bright and shadowy sides of my present life
a good deal more consciously, inwardly and outwardly. This
is a step forward.

Upon my arrival I found much changed. A casual crowd
and many lady painters have come to our hill while its real
true occupants, Mackensen, Modersohn, and Vogeler,
were traveling. I see nothing of these new people. I'm try-
ing to dig myself deeply into my work again. You must
dedicate your whole person to just one single thing. That's
the only way something can and will be accomplished. I've
made use of the beautiful weather to paint studies out of
doors. I had left paint alone for so long that it became quite
foreign to me. But now it's giving me great pleasure and
we're becoming fast friends. It's a struggle, giving all my
effort, which isn't always easy. A struggle wherein you must
fight and conquer in private. And were there no wrestling,
would it then be so beautiful?

I write this mainly for Mother, who, I believe, thinks my
life is a single, self-centered ecstasy.

There's something unselfish in surrendering to art. Some
give themselves to people, others to an idea. Are the former
to be praised and the latter blamed? People must do what
nature demands of them. . . . Excuse this written defense. It
flows from a kind of self-preservation instinct.

Sunday

Dear Milly,

. . . I'm often quite suddenly flooded by memories of
adolescence. I was awakened by a noise this morning and I
thought I was still in our old wisteria-vined bedroom on
Chaussee.[26] The noise sounded just like the creaking

sounds the door of that triangular room made every time it was opened and closed. I had the feeling Papa was about to appear at our door and wake us. But he didn't. Then I noticed I was lying in my white chamber, already six miles on in life.

I'm still working very hard. Modersohn was here the other day.[27] He said so many pleasant things about my work that I almost no longer believed it was mine. It was lovely. Just Modersohn's opinion alone is worth a lot to me. Afterward I was a little concerned, fearing I might get grand illusions. Well, I'll tell you more when I see you. I'm especially glad for our parents. I already have my share of luck to begin with.

Worpswede, 21 September 1899

Dear Sister,

A word before going to bed. I just ran through the moonlit night. It was so beautiful. Are you enjoying the autumn too on your Weser?

I'm going through a strange period now. Perhaps the most serious of my short life. I see that my goals will part from yours more and more, that you will approve of mine less and less. Nevertheless, I must follow them. I feel that everyone is frightened by me and yet I must go on. I can't go back. I press forward, just as you do, but in my spirit and in my skin and according to my judgment.

The loneliness frightens me a little in moments of weakness. But such moments also help me on and to my goals. You need not show this to our parents. It's an attack of despondency that really best remains untold. Should Ernst Horneffer[28] be coming to Bremen, please let me know ahead of time. I could talk some things over with him. I consider him an ethical person.

Worpswede, 10 November 1899

Dear Mother,

I'd like to write again what I shouted to you in the om-

nibus: Don't worry about me, Dear! I have such a firm will
and wish to make something of myself that won't need to be
shy of the sunlight and that is even supposed to shine a
little. My determination is great and I will amount to some-
thing. Please, please, let me strive for that place I am com-
pelled to go. I can not do otherwise.[29] You can't change
me. It would only make me sad and give my heart and
tongue a harsh ring, which would grieve me. Be patient a
little. Mustn't I also wait? Wait, wait, and struggle? It's the
only thing such a poor little person can do: live according
to one's conscience. We can not do otherwise. And be-
cause we see that our nearest and dearest disapprove of our
actions, there's indeed a great sadness. But we just must
remain ourselves, must, in order to have as much respect for
ourselves as we need to live this life with joy and pride.

These are some heavy minor chords that sound from afar
through the major rejoicing of my life. But may the rejoic-
ing be stronger and the holiday greater, so that an exulting
harmony comes forth. It's worth more than the world's faint
smile, flitting across tired lips and hearts. I'm still young
and feel energy in myself, and I love this youth and this life
too much to want to exchange it for that joyless smile.

Wait a little while. Everything will turn out all right.

JOURNALS

The first exhibition of my pictures at the Bremen
Kunsthalle, in December 1899. Arthur Fitger ran every-
thing into the ground.[30]

Footnotes: Chapter VI

1. Heinrich Vogeler, *Erinnerungen*, Berlin, 1952,
 pp. 95–96.

2. Mackensen, Reylaender-Böhme, and Westhoff in Hetsch, pp. 40, 34, 35, 43.

3. "Freut euch des Lebens," a traditional drinking song.

4. Becker's studio in Brünjeshof (which can still be seen today) had a large skylight cut into the low thatched roof.

5. Martha Schröder, weaver, born 1879 in Worpswede.

6. The "photo-crayon process . . . married photographic truthfulness with the signs of the artist's hand by combining a transparent positive with a crayoned backing." Aaron Scharf, *Art and Photography*, Middlesex, England, 1974, p. 235. In the *fin de siecle* controversy raging over the place of photography in art it is interesting that the Worpswede artists were accepting of the new ideas and technologies. See Scharf, pp. 232–45.

7. Unterrichtsanstalt des Kgl. Kunstgewerbe-Museums was one of only two government art schools in Berlin that admitted women. The other, Königliche Kunstschule, was also a decorative arts school.

8. Marie Bashkirtseff (1859–1884), an extraordinarily gifted Russian who settled on a painting career after injuring her singing voice. She died of consumption at age twenty-four. Some of her works are in the Luxembourg Museum, Paris. At age twelve she began keeping a journal (published posthumously and translated into several languages) for the stated purpose of telling "everything, everything, everything," including her voracious desire for fame.

9. The gouache sketch of the six musicians is repro-
 duced in *Paula Modersohn-Becker: Hand-
 zeichnungen*, Bremen, 1949, plate 2.

10. And it was long. While Worpswede is sixteen
 kilometers due northeast of Bremen, the road
 from the city that winds through the village of
 Lilienthal is about twenty-three kilometers to
 the art colony.

11. Clara Westhoff recalled the first time she visited
 Becker, she found her at her desk, her back to a
 bookcase, surrounded by books. Becker de-
 veloped her love for reading early: "I become so
 tremblingly excited, which really doesn't go with
 me at all. I don't know if this is good or bad. I
 really believe bad because a reaction follows such
 an excited mood. On one's own behalf, one
 sympathetically terms it melancholic. Others,
 however, and not unjustly, call it grouchy."
 During her first half year in Worpswede
 Westhoff missed the stimulation of reading.
 When she was in Becker's studio that first time,
 she immediately became engrossed in one of
 Becker's many books. Becker, who had expected
 to converse with her new guest, first was puzzled
 and then, understanding the situation, began to
 laugh—thus cementing a lifelong friendship.
 Hetsch, p. 42.

12. Carl Vinnen (1863–1922), another acquain-
 tance of Mackensen and Modersohn from the
 Düsseldorf Academy, was "the colorist among
 the Worpsweders." He is perhaps best known as
 the author of *Protest deutscher Künstler*, 1911, "a
 chauvinist attack on the international aspects of
 modern art whose baleful influence was to be
 seen in the corrupt painting of Expressionism."
 Selz, p. 43.

13. Alfred Heymel, writer, publisher, and art connoisseur; Rudolf Alexander Schröder (whom Becker saw in Worpswede the previous summer, see p. 31), artist and poet; Otto Julius Bierbaum, writer, founder of *Pan*, 1895.

 The Munich periodical *Die Insel*, 1899, grew into the publishing house Insel-Verlag, 1903, which published books on modern German art and literature. In 1909 Insel-Verlag published Rilke's "Requiem" for Paula Modersohn-Becker (see Epilogue).

14. Ottilie Reylaender-Böhme recalled that at the end of the party Heymel, with a burning torch in his hand, climbed to the top of the Findorf monument. He challenged those below to scale the granite obelisk and capture his light. Becker was one of the first to the top. From her pinnacle she shouted down, "Rabble up here, more rabble below!" Hetsch, pp. 35–36.

15. The Worpswede artists exhibited together in the Deutsche Kunstausstellung Dresden, which opened on April 20th. Carl Vinnen and Otto Modersohn were awarded gold plaques in this competitive, national art exhibition.

16. The twins are her younger sister and brother, Herma and Henner.

17. "Gray" was the family term for a letter from Mother Mathilde Becker, who always wrote on gray stationery.

18. Otto Modersohn: "I was immediately arrested by her appearance and her lively, sparkling conversation." Although Becker had been in Worpswede the previous year and had visited the Modersohns in early March (see p. 89–90), Otto

Modersohn remembered seeing her for the first time in the summer of 1899 as she lead a nearly blind old woman past his house to her atelier. "Soon afterwards she visited us." Hetsch, p. 19.

19. A national folk festival held in early summer, organized around a shooting match.

20. Becker has gotten far since her first encounter with a skeleton. See p. 6.

21. Engadine is a resort area in eastern Switzerland. *Generalbillet* is an open ticket.

22. The English title of Friedrich Vischer's satirical tragicomedy *Auch Einer*, 1879.

23. The village of Worpswede is built around the "Weyerberg," a hill fifty-seven meters high.

24. Clara Westhoff, who was very tall. One reference describes her as nearly six feet.

25. The moor village two kilometers south of Worpswede, where Clara Westhoff lived.

26. The Becker house in Bremen was located on Schwachhauser Chausee.

27. Otto Modersohn: "I visited her in her atelier and was astonished at her studies which were so very different from the works of the other painters. Everything about them breathed a strong, individual experience, a rare, creative individuality in form and color." Hetsch, p. 19.

28. Ernst Horneffer, a contemporary of Becker, was a philosophical writer who started from Nietzsche, stressing the educational value of antique culture

and demanding a religion of life and redemption through beauty.

29. Becker is quoting Martin Luther.

30. Fitger reviewed the exhibition of work by Becker, Westhoff, and Maria Bock in *Weser-Zeitung*, 20 December 1899.

"The hysterical attack by Arthur Fitger (1840–1909, conventional mural painter turned critic) was primarily intended, however, for Gustav Pauli, the new director who dared to place 'studies' by three unknown young women on hallowed museum walls." Fitger considered their works "'things that the primitive beginner, blushing modestly, might show her teacher or advisor,' but surely unworthy of public display. Further words fit to print fail him, though he talks of nausea and seasickness." Ellen Oppler, "Paula Modersohn-Becker: Some Facts and Legends," *Art Journal*, Summer 1976, p. 364.

VII. Paris, 1900

On the first day of the first year of the new century Paula Becker
arrived in Paris. There she joined her Worpswede friend Clara
Westhoff, who was to study sculpture at the Académie Rodin.
Becker during her six months in Paris attended the Académie
Colarossi, one of the popular "free" ateliers where there were no
entrance exams. In addition to supervised instruction, "free"
ateliers provided open sessions (studio and model with no instruc-
tor) to anyone who paid the small model fee. Becker took draw-
ing and painting classes in the morning and evening; in the
afternoon she attended the open croquis session or went to the
Louvre to sketch. She also studied anatomy at the Ecole des
Beaux-Arts, and continued to do so on a subsequent visit to
Paris.

Paris in 1900 took women seriously as art students. They had
access to the same professional instruction given men. The
Union des Femmes Peintres et Sculpteurs had won for women in
1896 the long-fought-for right of admission to the Ecole des
Beaux-Arts. But gaining admission is not the same as being
encouraged to enroll. "The Paris newspapers severely criticised
the disgraceful conduct of a few hundred art students who hooted
the young girls who went to the school for the first time. This
demonstration, which was based on the most selfish grounds—
namely, the fear of seeing women take their share of the prize-
money, scholarships and other rewards with which the school is
richly endowed, led the government to close the painting and
sculpture studios for a period of one month." [1]

106

Now women were working in the Beaux-Arts studios, attending classes, and receiving instruction that, Becker observed, "girls are offered . . . here as nowhere else." But they were still not permitted to compete for the generous prizes, such as the Prix de Rome. In effect, women could matriculate and graduate, but not with honors. And Beaux-Arts' honors established artists' reputations and ensured their futures.

Also at the insistence of women, ateliers opened their men-only classes, so that by 1900 women and men worked together, though the tradition of women-only classes continued. In Paris Becker was no longer "separate but equal." Her evening class at Colarossi's was the first time she studied from the nude along-side men.

Paris at the turn of the century was Paris of the world's fair. The Exposition Universelle 1900 opened in April, and the city was bustling with preparations months beforehand. The art world focused on the Decennial Exhibition, the fair's international exhibit of art of the last decade. Of the thousands of artists in the Decennial, Becker wrote her parents only about the Breton symbolists—contemporary French equivalents to the Worpsweders in their abandonment of the city and their concentration on a folk subject matter. But to her Worpswede friends Becker also wrote about some of the artists she saw in the galleries. Even then, however, she refrained from naming the painters who affected her work and who were so far from Worpswede ideals. In 1907, when Becker no longer sought support from the Worpswede circle, she reminisced about seeing Cézannes for the first time in 1900 at Vollard's gallery. His work, she wrote, hit her "like a thunderstorm." [2]

TO HER FAMILY

On the train
1 January 1900

You Dearests,

An hour till Paris and my heart's full of expectation! The time hasn't seemed long, even though I had to set my watch back an hour at the Belgian border.

After all of you waved me off, I thought again about each of you, about our glowing Christmas tree, our New Year's song, and New Year's Eve chimes. Then I slept the sleep of the just.

Cologne and the Rhine presented enchanting scenes. Unfortunately I was turned out of the Cathedral by a hard-hearted, red-coated usher just as I was looking around and delighting in the stone lacework. In answer to my question about when the New Year service would end, this red angel with the flaming sword laconically replied, "Five in the morning." . . . So I studied the building from the outside. It's to be admired in every single detail, but its refinement did not speak to my heart. I prefer several of the small early Gothic cathedrals I saw in Switzerland last summer.

From Cologne on, I shared my ladies coupé with a Mademoiselle Claire, at least that's how she was greeted by a young man of negroid features. For six hours the two of them talked some ready nonsense. He was ever at the door, but perceiving my stern German glance, he didn't venture any farther. They were music-hall people returning home from a tour and were reminiscing about their experiences. When, finally, the wellspring of their subject was exhausted, she began to sing in this peculiarly nasal voice while rocking herself back and forth and making dance movements with her hands and feet. She changed her toilette three times, and so on.

In Belgium I thought of Meunier[3] and Maeterlinck and how they both took root here. The whole country seems to be covered with an abundance of little red and white houses, all sheltering workers. . . . Paris nears.

. . . So now I am happily on my Boulevard Raspail. I still am horror-struck by big cities, even now a hideous ant-like feeling stirs inside me.

While I was sitting in the rickety carriage and the fellow drove on and on, I felt as though I were going to be traveling in that rumbly cab my whole life. But we finally stopped. I was received by the darkly dressed, ruddy landlady, who, to judge by a first impression, has her heart in

the right place. Five narrow flights of stairs brought me to my tiny room.[4] It's not much more than a bed long and a bed and a half wide. Everything is flowered and doesn't look overly dirty by the light of my stearin candle.

Good night.

<center>JOURNALS</center>

I am in Paris. I set out on New Year's Eve. I listened to the New Year chimes from our dear old house on Bremen's Weser. Then my family brought me to the train in great procession. I traveled for seventeen hours and now I am in the bustle of this big city. Everyone around me is rushing and hurrying in the foggy, damp air. Much, much dirt, within, deeply within. Sometimes I shudder. I feel that more strength than mine is needed to live here, a brutal strength. But I feel like this only sometimes. Other times it's ecstatically clear and gentle within me. I feel a new world stirring within me.

I'd like to create pious figures with soft, blissful smiles, walking toward the water through green meadows. Everything should be pious and good. I love color. It must yield to me. And I love art. I serve it on my knees and it must become mine.

It glows passionately around me. Each day grants a new red blossom, a glowing, scarlet red. Everyone is carrying one of these blossoms, some quietly in their hearts. Like a poppy first coming to flower, a red tip winks here and there through its green sepals.

Others carry them in their pale, soft hands and walk gently in trailing garments. They look at the earth, waiting for the wind to come and stir the red flowers. Then each blossom will kiss the other, and the glowing two will entwine in flame.

And there are others, tossing glances with impudently raised heads. They brush the blossoms in passing, breaking them as they stroll drunkenly on their way.

Which is life? true life?

To Her Family

Paris, 4 January 1900
I'm sitting by a French fireplace! After dispatching my
letter to you Monday I went to bed rather tired from the
train trip only to be knocked out of my sweet dreams by
Clara Westhoff. We talked till morning. She is overflowing
with excitement.

The next morning, the Louvre; in the afternoon, the
Luxembourg. I begin to understand Titian's *noblesse,* and
there are two wonderful Botticellis here. I saw the moving
Fiesole[5] for the first time. He really speaks to me. And
Holbein's beautiful, serious portraits. Downstairs in the
sculpture, splendid works of the early Renaissance, della
Robbias, Donatellos, and sweet, colorful reliefs of Madonnas.

When you come out of this enormous building, the
Louvre, you cross the Seine—a bewitching sight in yellow
or blue mists. Along the *quai* stand long rows of second-
hand books that you can rummage and search through as
much as you want.

An acrobat performing out in the street. A circle of
spectators who did not take their eyes off him. You watch
and learn wherever you go.

Splendid old two-wheeled carts with even older white
horses in front of them, harnessed closely together. Long,
narrow, two-wheeled beer wagons with three horses in tan-
dem. Colossal omnibuses with three horses in *troika.*

And the buildings! The Cluny Museum on the Boulevard
St. Michel, an old Gothic building. Nearby the ruins of the
Roman *Thermes.* Everywhere you go there is something to
see which you can use. You must always absorb new impres-
sions, always be working internally. When you're too tired
and can't anymore, then you feel a great *dégoût,* for the
world here is much too dirty. Hideous absinthe aromas,
bulbous faces, and vulgar women.

I've never so valued us as I do now. Before I was only
aware of our faults, but now I strongly sense all that we are
and it makes me proud.

Yesterday I heard a lecture on art history at the Sorbonne. The content was middling—I go for the language.

Lessons begin Monday. I need this week to orient and collect myself. *Forte* is continually being hammered on the piano of my nerves. I just have to get used to it.

There are secondhand shops here to rejoicing! Every fourth house is a topsy-turvy mess of interesting old items. I step in with ever renewed astonishment, saying to myself like that little boy, "If I had such a chain, I'd hang an acorn on it, if I had an acorn."

Eating is very expensive, and you get mighty little portions. Even if you pay a franc, you can scarcely eat your fill. Since school is only two minutes away, I'll generally be enjoying the pleasures of my domestic hearth. Everything tastes better to me on my Mount Olympus.

Clara Westhoff and I live next door to each other, so we dine at ease in each other's company. Today I kindled the fireplace for the first time.

Supper and, afterward, evening on the grand Parisian boulevards with both Christmas fair and Parisian night life.

Paris, 11 January 1900

To each of you at the dinner table a Sunday kiss and a very special one to you, my Father, for your two wonderful, long, dear letters.

Milly will laugh, but I must say I feel as if I've been in Paris for months. It has affected me in a thousand ways.

The Louvre is my alpha and omega. You can bathe your soul there to you heart's content, and I do often. It seems to be the only thing in Paris without a catch. Otherwise almost everything here has a catch to it. Sooner or later you get used to it and don't see it anymore, either involuntarily or with an effort. But it's there, and there it stays. But the Louvre hasn't any catch—Hallelujah!

Monday brought me to my academy. Colarossi, with his black hair in bangs, collected the money and instructed the nude to take a pose. Unfortunately everybody models here. They all have a half dozen positions for which they gradually find takers.[6]

Everyone works industriously in class. Critiques are good and to the point. We don't work life-size, but in the Berlin format.[7] I hope to learn a lot, especially as the marvelous instruction in anatomy (given free at the Ecole des Beaux-Arts) will fill the gaps in my deficient anatomical knowledge. Yesterday the knee was explained to us with displays and schematic blackboard drawings. We girls are offered something here as nowhere else.[8]

I spent Sunday with Clara Westhoff at the Uhlemanns in Joinville, near Vincennes. They're a very interesting family, not exactly cheerful, more like a play by Ibsen.

The mother, a widow, is totally deaf and leads a life completely her own. She interrupts quite sophisticated conservations with little naive questions. It's touching. And she reads the answers with her eyes, eyes that life has, a little sadly, dimmed. She's busy in the house the whole loving day. If she tries to sit still, a sadness overcomes her and she has to cry. The focus of the family is the twenty-three-year-old son, Alexander Ular, a talented person. He speaks eight languages fluently, works on a newspaper somewhere, and has attached himself to a forty-year-old woman in Paris. He's the type who scoffs at everything and hasn't a good word to say. Underneath, these scoffers have tender, childlike hearts, of which they're almost ashamed and which they seldom reveal. They risk showing their emotions in their eyes before anywhere else.

We also got to know the twenty-year-old daughter—precocious, intelligent, sober, with a somber view of life. Clara Westhoff with her brown robustness and large frame was very funny.[9] In spirit and in reality, she'd knock over a little table or stool with her every movement.

Joinville lies on the Marne, which rolls its yellow waters through tired, dark meadows banked by austere poplars. We saw it under rainy skies. Under blue skies it must look like a Böcklin. But it rains every second. The atmosphere lends everything a magnificent picturesqueness. No doubt, because of all the moisture.

On the whole Paris makes me feel serious. There's so much sadness here. And what's funny to the Parisians is the

saddest of all. Many times I've longed to walk on the moors.
Still, I'm enjoying my time, taking in a lot, and learning.

Monday I move to a little room that I'll furnish
casually—like Mama's furniture made out of boxes. I won't
have to lose my temper anymore over the waiter who hasn't
made up my room by five in the afternoon. Now I'll fumble
in my own room by myself.

We've made the acquaintance of a couple of young men
who are artists. But they're not the right sort. They don't
have a really serious attitude about art.

The street life offers great fascination—women with pic-
turesque caps; wonderful, strong, gray horses in front of
their weighted carts; great, vagabond, picturesque mobs.

When I can handle French a little better, I'll go see
Sarah Bernard.[10]

This letter is perhaps a little confused. Paris does that.
It's a skin that one does not grow into immediately. It
doesn't just submit, I struggle with it. But I will not let it go
except it bless me.

Your Paula

Paris, 18 January 1900

My dear Father,

Many thanks for your two long letters. Only don't be so
pessimistic about the world and me. It is better by far for
you—for both of us who are so abused—to be allowed the
bit of rose color that does exist. Although in the end it's all
the same.

So my moving upsets you? As for order, it's an improve-
ment. The old hotel furniture and carpets were beyond
hope. Now it's clean in my little place. Empty but cozy.
Financially, it amounts to nearly the same thing.

Right now it's like spring. I'm sitting at an open window,
outside the sun is shining. I'm happy we don't have your
cold weather because our chimney does more flirting than
heating.

About the academy. I'm taking a life-drawing course in

the mornings. Girardot or Collin comes at the beginning of
the week and criticizes the accuracy of our drawings. Cour-
tois comes at the end of the week.[11] His eye is mainly for
the picturesque, values, etc. This two-teacher approach has
proved itself well here, and the Academy Julian has the
same arrangement. I like it too.

In the afternoons there's a *croquis* course, also from the
nude, where the model is drawn in four different positions
in two hours. It's useful for understanding movement. This
course is paid for each afternoon. One is not obliged to
attend and I can go to the Louvre instead. One can learn a
lot from the Old Masters too.

I attend different courses from Clara Westhoff. In general
I lead a different life from hers. Enough for today. Your two
letters have me a little depressed. They sound so utterly
dissatisfied with me. I can see no end to the matter at all. I
must, however, go quietly on my way. Well, when I can do
just that, things will be better. You don't seem to have faith
in me, but I do.

Paris, 22 January 1900

Today I want to tell you about the atelier in particular.
Not about the basic principle, the seriousness, and the
work, but rather about all the trappings connected with it.
Which is to say, there's a lot here to laugh at, a lot to
marvel at.

The rue de la Grande-Chaumière is a little street with
little houses and Colarossi's atelier occupies two of them.
He's king of this street.

Formerly a model, now he's the complete "gentleman."[12]
Very smartly dressed and very gallant toward the ladies, he
tries to maintain the air of a *grand seigneur*. His father is like
him, but to look at him you would think he knocked
around in all sorts of unsavory places. The two appear to
understand each other and get along rather well.

The factotum of the house, who sees to it that the stove
burns badly and that the ateliers remain dirty (the dirt has
gradually become hallowed), this aforesaid very moldly,
dirty, bent, crafty factotum is named Angelo.

Angelo is the good fairy who rules here. He's the first one
to talk to the models, and he's usually sought out by three
or four charming little ladies who hope he'll put in a good
word for them. He jovially puts up with it all.

And now the whole princely court of men and women
students, with its many curious deceits.

A lot of them here look as painters do in books or as you
once imagined they must look. Long hair, brown velvet
suits, strange togas on the street, cravats waving in the
wind—all in all a little odd.

Even the sensible ones and non-artists wear big black or
dark blue capes on the street, capes whose cowls they draw
over their heads in rainy weather. Which looks nice. Sol-
diers and police also wear these cloaks, only somewhat
shorter.

There are funny characters among the women students.
Most of them do unbelievable things with their hair and all
sorts of tricks with their clothes. On the whole their work is
pretty bad. But I've made some nice, talented acquaintances.

My household is running smoothly. A *femme de ménage*
scrubbed for me Sunday for thirty centimes. My girlish and
domestic virtues increase manifoldly. My first piece of fur-
niture (the first was my bed—so really my second) was a
broom. Hand towels, dish towels, and dust rags are already
in effective operation.

I've discovered a *crémerie,* where I eat with all kinds of
ordinary people. In Paris they're rather different from those
at home, more like our important people in a way. Well, I
am the orphan among these worldlings. But they're quite
nice to me. Only sometimes they make rather seemingly
suggestive wordplays out of my French. I don't understand
them, but I won't grow any gray hair over it.

You have to forget about worrying here. There's too much
variety in every direction. Soon you stop being surprised.

In the meantime I've received your dear letter, my
Father. I sincerely thank you for all the detailed news.

I have three teachers, Courtois, Collin, and Girardot,
who take turns among themselves. What you've heard is
true, the professors are unpaid. They teach in order to
become better known and because one learns by teaching.

Moreover, this arrangement is typical of Colarossi's mercantile genius. Daily I am aware of how much I'm learning. There's a lot to be said for academic drawing.

I enjoy the street life enormously. There are among the populace many original figures who don't take any notice of God and the world but dress any way they want. On my way to school I always meet a touching old man who wears a bright lilac quilt and leads a dog of dubious breed.

In anatomy muscles are being explained to us with two live models and one dead body. Extremely interesting. Unfortunately the dead body gives me a headache.

How close together everything is here: laughing faces, *amour, amour,* and the deepest misery. Sometimes it's a little too much for me. Then I take my guitar in hand. It's my David here.

All the boarding house and *chambre garnie* rents are being raised for the Exposition,[13] but not my little atelier. I'm very pleased with it and several times a day I enjoy the piece of sky I see.

The only "drawback" is that in the middle of what's usually considered night, my neighbors are still banging their doors, shaking me roughly out of my sweet dreams, hitting me right on my Achilles' heel.

Six languages are heard in the atelier, it's often unbearable.[14]

Paris, 29 January 1900

My dear, dear Father,
 That your life may be easier for you, at least not so gray, so gray, that you may enjoy what you have and not long for the things you don't have—they're only material things you wish for us children and you ought not to. We are each in our own way happy enough. The little that external circumstances are able to add is of no importance to real happiness. We carry that quietly within ourselves and it warms us whenever our feet get cold in the world. Many are able to warm others. We act according to our natures. Warm your feet too, Dear. You need to. Let yourself be

affectionately sunned in our love, let peace come into your
soul. For what is an aged life without peace?

Be kissed, Dear, and forgive this grandmotherly dis-
course. It comes from a childlike heart.

I saw Notre Dame yesterday. It was an event. Baedeker
hadn't spoken very enthusiastically about it, so I went
somewhat blasé. [15]

Suddenly there it was before me—floating over the yel-
low waters of the Seine. The high humidity of recent years
has darkened the stone. It stood profoundly and solemnly
against the heavens. In spite of its peaks and points it was
colossal.

A service was going on inside. Wonderful color effects
came through the brilliant warm red and green windows. A
little monk in colored robes hopped around preaching
against the Russian Catholics and against us Protestant
heretics. It's unbelievable to me that intelligent, sincere
people hold such beliefs.

I spent an afternoon reading. I'd like to know French
well, as the people are all so witty.

Esprit is here in such monstrous quantities that my poor
peasant's mind and tongue are often at a standstill. There's
also a lot of *esprit* in the art. Their way of painting is
extremely spirited. The most basic, the most subtle, the
ultimate—that they don't have. It's the same thing I in-
stinctively felt in *Cyrano de Bergerac*.

In two weeks there will be a *concours* for a medal in
school. Places will be assigned after this week's work. There
are cash prizes at the Academy Julian—much more sensible
considering the circumstances of art students. [16]

I'd like a book for my birthday, *Wisdom and Destiny*, by
Maeterlinck. [17] The title needn't make you suspicious. This
time it's not anything "mystical," but something quiet and
soothing.

My so-called student housekeeping doesn't go badly. It's
quite orderly and ample. Narcissus and mimosa decorate my
table. Flowers are ridiculously cheap here, and I need them.
All last week I regaled myself with a bundle of eight roses
for fifty centimes. I really have to see a little pure nature

when the complications and the decay make me dizzy. Often a dog or our big long-tailed house cat revive me.

Clara Westhoff and I take pains to lead lives as separate as possible. We feel we need completely different experiences.

Enclosed is a little nude. Sometime it would be quite interesting if you'd like to take the Berlin nude out of the attic for comparison. You'll find that everything is more in the right place, and there's more there.

Really this Paris!!

Spring was here in each shrub, it was in the air and in the hearts of the people. Parisians seem to have a grasp of spring. Whenever I'd come out of school at noon, a general joyousness reigned in the streets. Now that joy has withdrawn and is hidden behind winter jackets and furs.

But I spent the previous sunny Sunday with Clara Westhoff in Joinville. The Marne lay big and wide in its bed and played at the feet of the solemn, old, giant poplars. Overhead, in the trees, there was singing and twittering. Spring arrives here in an intoxicating profusion. It took us captive and we recited and sang all our dear German songs of spring.

Close to the river stretched old enchanted gardens with bilberry ivy gushing up over the gray masonry. Hidden within the greenery were shimmering ivy-covered vases from the time of the Louises. It makes a strange impression, this luxuriant wilderness so close to the big city.

Paris is like its inhabitants. Side by side with incredible depravity is a childlike joy in life and a freedom from restraint, the way nature likes it best, without a lot of questioning about good or bad. We Germans can't be as easygoing as the French, we'd perish in qualms of conscience. People here seem not to be acquainted with them. They begin a new life each day. Naturally this has its good and bad sides.

I have a medal and now I'm a big shot in school. Four professors awarded it to me. The medal certainly has noth-

ing to do with what I've learned, or will learn, in school. That goes much deeper. Inside I am happy. I feel myself growing stronger and I know I'm coming out of the woods into the clearing. When the woods are finally behind me, I'll look around for a moment and say, "That was not easy." Probably new forests lie ahead. But that's just life and why one is strong.

How very thankful I am for this stay in Paris. Really it's only a continuation of Worpswede: constantly working and thinking about art. But new perspectives become visible, complements to and commentaries on the old, and I feel it coming to something. Even spring will be here soon.

Paris, 28 February 1900 [?]

My dear Sister,

Today you get the first family letter and a kiss to each member of the troop at home, naturally.

Now a speedy transition to the order of the day because, once again, time is short. Sunday, Clara Westhoff and I made another excursion into nature. We took a seat on one of the steamboats by the Louvre and traveled up the Seine past the Exposition buildings, [18] which I got to see for the first time. At the end of the line we climbed out of the steamer and continued on alongside the river. The region there has a peculiar charm. In spite of its proximity to the big city, nature is still untouched. They don't have our German devil for orderliness. We climbed up a few hills, past hedges and a beautiful, solemn churchyard gate. We had a merry chat with a married French couple who were hauling a wagon full of cabbage to the city. Then a cozy evening at an open fire—full of naive, natural, gay impressions. Here in Paris you frequently have to seek the naive and the natural with your lamp, the gay offers itself everyday. Actually it's more frivolity than gaiety skipping over all the dismal abysses.

My art, I feel, is coming along. I am satisfied. Afternoons I go strolling in the city, looking at everything fully, trying to absorb everything, or else I work in my atelier. I've seen a lot of pictures, but there's been something entirely too

sweet and second-rate about them. They're keeping the good work for the Salon.[19]

I went back to Notre Dame again. Those wonderful Gothic details, those gargoyled monsters, each with its own face and character. And spring is scurrying across everything. The quiet little church garden is beginning to sprout and old men are sunning themselves on the garden benches. Spring is laughing at the blue sky with its white bundle of clouds (almost as beautiful as in Worpswede, only not as blue). Spring laughs in everyone's heart, though not in every heart here in Paris. Directly behind Notre Dame, with water washing around on all sides, lies the Morgue. There they daily fish out the dead bodies, those no longer able to bear this life or those who were robbed and thrown into the river.[20] Under the bright surface of this smiling Paris lie many sinister, terrible things. Sometimes it nearly breaks my heart.

But there are violets on my table, breathing spring. It must be magical in Paris when everything is green. I'm enjoying it thus far because my purse is still holding out.

I'm not the only female creature in the male life-class[21] in the evening. Four or five girls who draw better than I do are with me. One learns more in this class because better work is done here. And it's interesting to see something of these people. One needn't instantly be on familiar terms with them, which isn't my custom anyway.

There's a great hatred of the English here. Everywhere, like a red cloth to a bull, they shout "Boer, Boer"[22] after us because as far as they're concerned we're English too. I'm not exactly pleased by this mix-up. That nation is becoming disagreeable to me. Whenever it happens, I stress my *allemand* but people really don't want to believe me.

They know little about our German artists. I watched a couple of Frenchwomen look at my Knackfuss *Klinger*.[23] His particular forms struck them as funny. The only phrase they had was "C'est joli." Whereupon I replied enraged, "C'est beau, pas joli." But it was a needless waste of ammunition. Moreover, they don't mean it badly. They say "C'est joli" of their own artists, of Rodin *et al*. They simply have nothing more profound to say.

One just grows older and older, and more and more quiet, and finally, simply, creates something. . . . And so good night to you all.

Paris, 13 April 1900

It's quitting time. I'm sitting in my little room in front of some abundantly fragrant, deep-rose gillyflowers in a green pot.

From afar Paris is rustling. And in between sound the blackbirds' song and the sparrow's twitter. A delicate evening sky with little cream-colored clouds. It's busy in the treetops, which I can see from my window. (I have a broad view from my proud height.) The spring, about which I wrote you four weeks ago, had completely sneaked away. But it's back now, making our city happy.

Yesterday, on Maundy Thursday, we heard the first half of the *Saint Matthew Passion* from the hard steps of a sacristy. There were so many columns between us and the choir that the music sounded as though it were coming from afar, from another world. It was a magnificent, spiritual distance.

The Salon is open. [24] The average is no better than that in the Munich Glaspalast, which occupies only third place among German exhibitions.

But the Exhibition will bring good work. It'll be a celebration. It opens tomorrow and everyone is working feverishly, including the poor little apprentice sculptors from my evening life-class, who are employed on the stucco work. [25]

Being here is doing me a lot of good. Everything is settling a little and I'm beginning to get an idea of the value of things.

There's no Easter vacation. The world here goes steadfastly on and on. Whoever wants to work on Sunday will find a model in the academy. I never work then. It's one of the few Christian practices that has stayed with me.

My letter made you nervous? Dears, of course I am not

like that. But it is one of the characteristic sides of Paris. Paris is an alloy. There's no such thing as pure gold. And just to grasp the mixture as such is fine. To be strong enough to look in the eye the faults of one's friends, the faults of the universe, as well as one's own faults, is truth.

Rodin has set up a school for sculptors, which Clara Westhoff attends.[26] She has only one or two critiques a month from him, otherwise his pupils just come. She's the kind of person who can learn anywhere. In the final analysis, I don't know whether Paris is right for her at the moment. I find her too big and bulky, inwardly and outwardly. But she does have a strong nature. She seizes everything which comes her way, unconsciously twisting and turning it into something she can use. Such people are generally incapable of being unhappy. Whatever happens to her will always be in her favor.

Did my Easter flowers arrive with any fragrance left? I could not resist that profusion of spring. A happy holiday to all of you.

And when do I get a "gray" from my Mother again? You're keeping me short, Dear. Shall I be bad? Which is not all that difficult here, you know.

When I walk along the boulevards in the morning and the sun is shining and it's swarming with people, in my heart I shout, "Such beauty as I have before me, all of you together do not have." It's then that I love life very much.

Paris, 19 April 1900

Spring has sprung! It's so exciting that I think we'll set out on our summer journey Sunday. The nightingales aren't singing yet, but we still should be able to draw new energy from a week among the blooming peach and apple trees.

I'm no skeleton by the way, the roses in my cheeks are still in bloom.

I spent a charming day Sunday with Clara Westhoff. We ended in Velizy, a small village, where in a spring bower, by storm lantern, we wrote postcards to our important men (the Worpsweders, Klinger, and Carl Hauptmann).

Enchantment was the pervading mood. Moonlight on a little village lake, a manor house with small delapidated cottages nearby, and white ducks gleaming in the evening twilight. This peace and rusticity so close to the big city is the great charm of Paris.

We will take our summer journey next week. We prefer to work hard one more week in order to enjoy our vacation so much more. A kiss to my Father for the Saint-Simon letter. By the way, Maeterlinck doesn't speak of his principles at all, but praises him as a noble, happy person.[27] A springtime kiss to all of you.

Paris, 26 April 1900

My dear Brother,

I've swung out of my so-called bed extra early today, always seeing to it that this difficult, energy-consuming event takes place on the right foot. This precaution is supposed to guarantee good humor for the day, something I treasure. I've kept this "right foot" habit from my idyllic days in Dresden's Friedrich-Stadt[28] right up to my *Sturm* period.

Strange how some of those earliest times remain with me! Every bumblebee reminds me of the bees' playground in the mignonette and gillyflower bed behind the corner of the church steeple. It's wonderful the way a child's mind seizes on something and is saturated by it, submitting completely to the impression in its unconscious, and then takes these impressions along into its conscious years. It's still like this for me sometimes. I have periods when being and nothingness blend together, as they used to in our old garden. You did not notice them much. They're veiled, delicate, fleeting things that shun the eye of the sun, but they are the things my life consists of. Compared with this, everything else seems ridiculously small. (I mean all those external events that happen to me, that signify happiness or misfortune to people.) These are the things, the hours, that make up my art, my life, my religion, my soul.

I write you all this on your birthday because I haven't

written you at all for so long and because even when we talk
to each other we don't come to our innermost selves. Some-
times one must speak to another about the flower within. I
long for us to understand each other so that you won't
believe I've changed or become a stranger. I have not.

Only, a sudden development followed this dream, this
sleep-life, that I led. I can understand it frightening you,
but it gives me a feeling of life and happiness and youth and
freedom. Surely something fine will come of it, and you
should take delight in that.

I often think about you here and I'd like to ask you
certain questions to get your advice. Because such a female
is still an ignorant creature. I've been told many things but I
don't always see the point. This is a feminine vice, whether
innate or learned, which will affect our grandchildren. By
then all this will no longer oppress us, we will have quit this
beautiful earth.

Are you reading much? And are you reading a lot of the
moderns? What I wish for you is that you live in your time
with the best, the wisest of your time, with those who strive
and create, not with those who rest on Sunday after their
week's work.[29] You're rooted in the ideas of the preceding
generation. That's all right for those who are of the preced-
ing generation, but not for you. Your nervous system is of
our generation. And if you aren't keeping up, it's a frailty
and weakness you have to overcome.

Remember Niels Lyhne. He didn't, but you can. You
have the stuff for it. But you must send the best of your
person into the struggle. I mean you have to struggle for the
idea, which doesn't mean arguing about our legal system at
the family dinner table. That's wasting energy. But to live
embodying an idea, that's what I want for you, that's what I
want for all our German men. They all too soon lose their
feathers in the battlefield and become philistines.

Be an idealist right into your old age. An idealist who
embodies one idea. Then you'll have lived and the world
will go forward. The great swamp will dry out into luxuriant
garden soil. We are still very much in the swamp.

That's what I had to write you from my soul. Take it in a

brotherly spirit, Dear, and don't be angry. And don't laugh, and don't just shrug your shoulders. It's too well meant for that.

In love,

Your sister

JOURNALS

If only I could paint! For four weeks I knew exactly what I wanted. I saw it and carried it within me like a queen and was blessed. Now gray veils have fallen and obscured my idea. I stand like a beggar, shivering at the door and imploring admittance. It's hard to go patiently step by step when you are young and demanding.

And I am beginning to awaken. I am becoming a woman. The child begins to recognize life, the purpose of a woman, and awaits her fulfillment. It will be beautiful, wonderful. I walk along the boulevards as crowds of people pass by, and something inside me shouts, "The beauty I have ahead of me, none, none, none of you have." Then I cry, "When will it happen? Soon?" And art answers, it wants two more serious, undivided years of work.

Life is serious and rich and beautiful.

I've been sad for days, very sad and serious. I believe my period of doubt and struggle is coming. It comes to each serious, artistic life. I knew it had to come, I expected it. I'm not afraid. I know it will mature me. But it's so serious, so gravely serious, and sad for me. I walk through this big city, and I look into a thousand eyes. Very rarely I do discover a soul. Then I nod to them, greet them, and we each go our separate ways. But we've understood each other. For one moment kindred souls embraced. . . . But then there are others. With them one speaks many, many

words and lets the brook of their babbling flow and hears
the well of their laughter and laughs along. While within
flows the Styx, deeply, slowly, knowing nothing of brooks
and wells. . . . I am sad and around me rest the heavy frag-
rances of spring.

To Her Family

Paris, 4 May 1900
You Dears,
 I've been having a very fine time of it. I'm in good spirits,
and I have two dear "grays" and a dear letter from my
Father. A thousand thanks. I was very sorry that I wrote
you such a long, lachrymose letter. It's just that I'm in a
difficult mood, which will probably continue for several
weeks until I've cleared an obstacle—it has something to do
with painting. Then my adolescent exuberance will return.
Nothing unpleasant has happened in the least. And I feel
well, and thank you for the iron. Whenever I want to
indulge myself, I fetch a bottle of French red wine for sixty
centimes. But, Momma, that story about Brandes doesn't
apply to me.[30] Because despite this giant hangover, out-
wardly I'm having a merry life and laughing a lot. Although
the inner person doesn't have much share in this. Its con-
cern is the dark and difficult hours connected with art,
wrestling with the Angel of the Lord. "I will not let thee go
except thou bless me."
 We know a whole swarm of young German artists with
whom we wander over the countryside every week—
dancing, boating, singing German songs at dusk. Just "be-
ing German" is good to do from time to time in a foreign
country. They are a magnificent breed: reliable, poor,
childlike, and very different from the French. They are
passionate about their concerns. The multitude of their
natural, good sensibilities refreshes and delights my heart.
 Of course we are barbarians compared with the French
and I know they see us as such. But our energy and youth

are behind it. We talk about what goes on in the world, with even a word about politics and history. It's fun and we leave our troubles at home.

Saturday and Sunday we were at the Uhlemanns in Join-ville. The deaf old lady thinks only about how she can make others happy. This time she wanted us to enjoy the revelry of a real, genuine bed and she cooked for us with her own loving hands—all the more enjoyable after seven lean years.

We had a beautiful time rowing on the Marne, with nightingales and flowering trees above us. Spring is in full motion now. But unless a gentle breeze blows, it's stupefy-ing with its thousand fragrances.

Do you know Klinger's etchings, A Love?[31] It's Klinger himself on several pages, together with an attractive wom-an, in the midst of an abundance of flowering chestnuts. The passion in those pages, the fragrance, that's the French spring. When you walk through the Jardin du Luxembourg you find a couple on every bench billing and cooing. Their courting is different from ours. More laughing, less senti-mental, and somewhat detached. Both parties look as if they already have different rendezvous in mind.

I've seen something beautiful in Paris again. Montmartre. The mountain grandly commands the city. You climb up a steep street between little houses. Old women sit at their doors doing their mending, while young people look left and right with curiosity because this is a painters' quarter. Finally you come to a little marketplace with chickens running across the pathway. You are stand-ing in front of the beautiful church, Sacré-Coeur, which looks down solemnly at gay Paris. We entered the church at half past eight, when evening prayer was being said. Here and there a candle, the reddish glow of the perpetual light, and a deep silence. We dined in the refectory among old devotees. One, Valentine, eighty years old, with formid-able expressions and gestures, wanted to convert us. Al-though she became religious only when all else failed. She

asked our *petits noms* and wanted never to forget us and loved us in spite of everything. She took each of our hands between her two large fleshy ones, and then she shuffled away.

I'm beginning to overcome Paris. I'm finding myself again and my inner peace. This past week I've had beautiful, deep, full days. Impressions are becoming more separate. They approach me and I am able to take them all in. The first weeks I was here, one impression followed on top of another. I was frightened by the enormous number of them. Now they're gradually becoming old dear friends who are no longer confusing. I have the beautiful feeling that I am going forward, stretching myself in a different direction, and growing. It's a deep feeling of happiness.

Paris, 15 May 1900

I've been to the Exhibition three times. It's even more beautiful and more instructive than I had imagined, immensely instructive. The French Section is the most beautiful.[32] Cottet, Simon, and Jean Pierre.[33] Together they have an enormous depth of color. They paint Brittany, and how!

Next to them we Germans are rather bourgeois and philistine. A lot of enthusiasm and eagerness but too little study.

I called on Cottet. A fine, red-haired, red-bearded, thoroughly healthy person full of deep feeling. And he knocked on my door once too, but unfortunately I wasn't at home. I found only his signature. I intend to go see him again.

You know, some of the French greats are totally unconventional. They dare to see naively. One can learn an awful lot from them.

It's amazing how I look at the land and the people with such different eyes now.

In my evening life-class, due to spring fever and spring bravado, the French forget where they are and sing their *chansons* to the rest of us. They are champagne. Only they go flat so easily.

The corner of the Jardin du Luxembourg that the students inhabit is splendid now. Couple after couple tarry there in the afternoon. And though they are in large crowds, each couple feels alone and unwatched. They sit under the flowering chestnuts, not saying much, not thinking much, not dreaming much.

I've come out of my evening life-class. These spring moonlit nights are intoxicating. The entire *rapinière* is exulting, Spring! Mandolins and violins, even a cello, and a German singing, "I too was a youth with curly hair."[34] The lovely moon and the white chestnut blossoms from a neighboring garden are shining. Fragrant lilies of the valley stand in front of me. In the middle of all this magnificence I look forward to home. Everything is so bright here that sometimes I become very impatient. At home the tone sounds deeper, fuller, more serious.

Paris, 27 May 1900

Dear Sister,

Your letter was worthy of a punctual Sunday reply and I meant to send one too, but time is daily getting shorter. I'm starting to live long into the night, keeping my soul at peace only with the thought that this will soon end and I'll again be enjoying the seclusion and tranquility of Worpswede.

I lead a rather irregular life. On several evenings A. T. led us along the bygone paths of his Parisian bachelorhood. And we spent a couple of days with our young Germans. They are loyally and truly attached to us and are delightful companions. Very happy to have found two who are steadfast, after all these little Parisian sillies. A party is planned for next week, at Abbeken's and Tormann's. (Abbeken is a sculptor and Tormann a Swiss who paints cows.) Both laughingly assert that they are able to lead faithful married lives only because they beat up on each other from time to time. Which they do in four almost empty rooms, a kitchen, and an alcove. These are the rooms that will be turned into the arena for our celebration. The girls will bring the eatables, the fellows the wine. Candles and paper

lanterns. Mandolin and guitar music. And a large cake that
Tormann's sister will provide. Clara Westhoff and I are to
go there the afternoon beforehand to decorate.

The painter Hansen[35] is a new acquisition. Born the son
of Schleswig peasants, he has long worked in arts and crafts.
In Switzerland he got the clever idea of drawing postcards of
mountains, the Jungfrau, Mönch, and Eiger, as drastic
faces. Do you know them? They were reproduced in *Die
Jugend.*[36] Like a smart peasant, he undertook his own publi-
cation of them and earned ten thousand marks in one week.
Now he carries the banner of true art and has serious aspi-
rations, so he has withdrawn into himself, as do all North-
erners.[37]

The Exposition always offers new splendors. When you
stand atop the Trocadéro in front of you are the Grand
Roue, the Eiffel Tower, the Celestial Globe,[38] and, in the
background, the city with all its towers. You'd like to add
torches and bonfires for the finishing touches. It's an unex-
pected and never-ending profusion. This city has enormous
personality. It offers everything to everyone. You have to
see it sometime, Dear. Not for two weeks, that makes no
sense. In two weeks you can neither grasp nor understand
it. You remain foreign and indifferent to it all, and have
qualms about the corruption of the people. I too was utterly
foreign to the art and seldom related to the French. There's
so much here that doesn't run in our Teutonic blood and
that we fight against. It's interesting to see how my
viewpoint has gradually evolved, though it's far from com-
pleted. What is complete? And when is one complete?
Hopefully never. The same is true of our other opinions
too. Even if many things seem antithetical now, we can
hope that in a year, even in a half, much will change.

Paris, 3 June 1900
So, the celebration! It proceeded from beginning to end
in merriment and high spirits. The afternoon beforehand
was reserved for grand preparations. In the party area Clara
Westhoff and I prepared "almond" and "strawberry" pud-

dings and, with loving hands we arranged the kitchen in-
ventory.

Meanwhile the noble malenesses painted a frieze. In the
parlor, which was completely hung with white paper, the
frieze began with splendid centaurs. In the alcove, where
various mattresses and cushions had been piled up, the
frieze turned into the "Elysian Fields." There were no
chairs, but there was a reception room and a dressing room
with a full-length mirror.

This was the arena of the big *fête.* Everyone got dressed
up and was in good spirits, or rather in highest spirits. We
danced to the accompaniment of mandolins and guitars.
Twelve artificial sconces were made out of strong wire, and
the parlor shined in candlelight. In the alcove, a shadowy
atmosphere of paper lanterns. When in the morning, after
M's percolator rendered its pleasing service, we counted the
five bottles that had been the mainstay of the punch
bowl—it turned out that we had drunk only one and a half.
The rest was all youth and intoxication without wine. It
was good fun. In our fancy dress we returned home through
matinal, dawning Paris. It was quite bright when I reached
my ladies' chamber. Outside, a delirium of flowering acacia,
the morning songs of the birds and the cooing of doves. I
didn't lie down to sleep for long, even though I was free of
inner turmoil and heart's emotion.

At eight o'clock in the morning, the great *lever:* The
Academy. At twelve, our morning-after breakfast in the
party rooms, and happy chit-chat.

I'm writing you the main thing last. The Worpsweders
are coming on the tenth—Modersohn and the Overbecks.
They'll be staying ten to fourteen days and then we'll travel
home together. Hurrah![39]

A kiss to you all.

After a sunny Whitsunday church stroll and after several
discomforts because of the erratic omnibus service, I arrived
home somewhat broken-winged. At such moments this city
is rather formidable. I feel so powerless against it. What it

does not freely give away with overflowing hands is not to be wrested from it.

There are new galleries opened in the Louvre, which was closed for a long time in order to rehang pictures. I walked again through this magnificence in an intoxicated state. I'm very glad to see that this half year has helped me appreciate the Old Masters. This is how I measure my inner progress.

The sculptor Rodin has opened a special exhibition—the great, serious, life's work of a sixty-year-old artist.[40] He has caught life and the spirit of life with enormous power. Rodin is comparable only with Michelangelo, and in some ways I feel closer to him. That there are such people on this earth makes living and struggling worthwhile.

Thursday evening, dancing at Bullier's. Do you know this big dance hall in the Quartier Latin, Father dear? A colorful picture, quite unbelievable to see: students and artists, attractive and merry in their splendid velvet suits and slouch hats, with their little girls. Some dressed in bicycle bloomers,[41] others in silk gowns, and others in summer blouses. They're mostly *couturières* and *blanchisseuses*. Vain, childish gaiety. The gas was extinguished at twelve-thirty and everybody went home. Café life doesn't usually stretch far into the morning. Most every place is closed around two o'clock.

And Monday the Worpsweders are coming! That's my chief colossal joy. Really, my mind is there at all times. I can tell you, sometimes I long for home.

Paris, Friday

You Dears,

Frau Modersohn died very suddenly.[42] The poor man went home with the others. After he had taken care of her through the years with the most moving self-sacrifice, the heavens were so cruel as to take her from him while he was away. He doesn't understand. He saw everything that was happening around him, made the arrangements, and yet he could not grasp the terrible truth. . . . I'm coming home as soon as possible. I'll probably be with you Sunday. This is a

very sad close to my Paris period and my next period in
Worpswede will also be difficult and sad. I've gotten to
know a great deal of Modersohn during the past few days.
 Good-bye.

 Your Paula

 To Otto Modersohn

 Paris, 17 January 1900
 In the most helpless moments I've spent here in Paris I've
always let my thoughts turn to Worpswede. It's a wonderful
remedy. The chaos ceases and a gentle quiet comes over
me. Yes, Paris is wonderful, but you need nerves, nerves,
and more nerves—strong, raw, and receptive. Am I too
slow and clumsy in assimilating separate impressions? I
don't even know this yet. Nevertheless, I'll stay long after
spring because one learns here everywhere one goes.
 The Louvre! Each time I'm there it blesses me richly. I'm
coming closer to understanding Titian, and I'm learning to
love him. A sweet Botticelli Madonna with red roses be-
hind her, against a blue-green sky. And Fiesole with his
moving little Biblical stories, so simply told, sometimes so
wonderful in color. I am at ease in this saintly company.
 You see fabulous things by Millet in the art shops. A man
in a field putting on his jacket in the clear evening air[43]—
to me the most beautiful.
 And the breezes when you cross the Seine! It shimmers
in a confusion of fine gray, yellow, and silver tones. They
even envelop the branches of the trees. By comparison the
beautiful buildings are wonderfully deep.
 I was in Joinville once. The Marne flows there. It was a
cloudy day. The air a yellow gray, the water more yellow
gray. Dreary pastures and tall, bare poplars. It had a pecu-
liar charm.
 Mornings I go to the Academy Colarossi. There I am
corrected by Courtois, who's fine on *valeurs*. Collin, who

gives the critique at the beginning of the week, is more concerned with accuracy. Painters are like sand in the sea here. Among them the most original figures. When in good humor you enjoy it all. Only when you're low you develop a hangover. There's an awful lot of misery, corruption, and degeneracy. I believe we Germans are a better people.

Paris, 28 February 1900 [?]

Now, with spring approaching around and within me, I sometimes think in how much purer form it comes to Worpswede. You sense spring everywhere here. But a thousand violins play in this enormous orchestra and you can't hear individual sounds.

Moreover I'm surrounded by the scent of violets, plus all the artificial scents.

You see little of the latest pictures. They're saving them for the Salon and the Exhibition. I was interested in a couple of colorful figure studies by Bonnat,[44] deep and simple in tone and beautifully held together.

I'd like to see something by Degas other than ballerinas and absinthe bars. Seems he's searching too much for the naive in line and thus becomes affected. But he certainly has the technique and the art.

In several salons *à la* Schulte, where you trip over the trains of elegant Paris, there are many sugary, bad, and superficial works. But I can't help thinking there are treasures buried somewhere here.[45]

Colarossi opened his academy today in the little rue de la Grande-Chaumière—small, rugged, dirty, funny barracks, not lacking in poetry. Next to Julian's, Colarossi's is the best academy. He's a former model, although now he plays the *grand seigneur* and has his clothes made by the leading tailor. He patronizes the arts, the Professors, and the Eleven.[46] Most Mondays he looks like he's paying for his Sundays.

In these sacred halls I draw from the nude—with females in the morning and males in the evening. Mornings among the females there's a lot of wild hair and unpolished boots, a

few clever heads, and little talent. They work like a herd of cattle without any idea about what matters.

In the afternoon I contemplate the world or I work here in my little green atelier.

Evenings, at seven o'clock, with the males, are rather amusing. There are wonderful figures there! Not a single one looks really sensible, like they do at home. These brothers in Apollo exhibit velvet suits, long hair, shirt sleeves, towels for neckties, and other idiosyncrasies. The gala performance: shelling each other with crusts of bread, cock-crowing, caterwauling, and generally affectionate fighting.[47] Many Yankees, many Spanish, English, some French and Germans. The conversations are often strange. The point around which everything rotates is "elle." Whenever anyone sighs at work, they immediately ask, "Est-elle gentille?"

On the whole better work is done here. Not with much comprehension of course, but more accurate than the young ladies'. There's more energy and power. And what's boisterous among men is considered ugly among girls. I believe we have it harder.[48] But in spite of this, life is beautiful, my art is developing, and I am happy.

I'll stay here as long as I can. Then maybe I'll be able to do a little something and come back to Worpswede.

On Sundays Clara Westhoff and I make short trips to the country. It's very fine there. Hilly, with tall withered poplars alongside the water, and soft-toned grass dominated by an overcast sky. In the sun the earth is too bright for me. I like colors deeper, more saturated. I get quite irritated by this brightness.

I was at the Exhibition yesterday and today. These days clearly form an epoch in my life. Every nation is wonderfully represented, but the French Section is the most beautiful. Cottet told me, "Ours are a people of decadence. But some natures live within the decadence, independent of it. And this shapes their completely individual art!"

He's right. We stick too much to the past in Germany.

All our German art is too conventional. Otto Modersohn is one artist who has worked his way through the mountain of convention. Perhaps I don't understand the others, or I don't take the pains to. A person engaged in growth, as I am at the moment, must first think about her own arms and legs. I have some fairly difficult weeks behind me. I worked so hard that the Exhibition yesterday was a release. I again believe in art, in its total greatness, and also that one day my small fire will give a little warmth.

In the academy we paint almost without color. The alpha and omega is *valeurs*, the rest is all a side issue. Now I sense how much I have to learn. I thought that *valeurs* were my strong point, but I've been terribly reprimanded. It takes two weeks to paint a half-life-size nude, putting down light and shadow in the right *valeurs*. Strictly speaking, you can't call it painting. But it does refine the sense of form.

I think more of an independent person who deliberately puts aside convention. I mean one must have possessed and practiced convention with self-discipline and moderation, and then turn away from it. Whenever someone who has never possessed it speaks against convention, I think, "Fox, the grapes hang too high for you." It's a risky business, this so-called living free.

But more about the Exhibition, even if only fragmentary. Everything's still tumbling inside me like in the kaleidoscope we used to look through when we were children.

Cottet exhibited a triptych purchased by the Luxembourg,[49] *Au Pays de la Mer*. In the middle, by the light of a hanging lamp, at evening, women and children with sad, anxious faces. The blue night sea glistens through the window. To the left, part of a boat with sailors on the stormy waves; to the right, the evening shore with women and children waiting. The depth of color! Plus an ornamental greatness coupled with a sensitive, spiritual interpretation.

Another Cottet: a white horse on an evening meadow. A third: three women in black on the shore.[50] Cottet himself is a fine fellow—red-haired, red-bearded, and full of life!

Lucien Simon also impressed me. He has a particularly naive, sound sense of form and a Velasquez tone in his blacks and whites.

There's a little corner in Jean Pierre's painting of men by
the sea[51] which expresses what I'm striving for: a deep,
colorful luminosity in the twilight, a colorful radiance in
the shadows, a radiance without sun, as in autumn and
spring in Worpswede. Blue skies with big white clouds and
no sun.

How happily I look forward to home! What's most beau-
tiful is the depth, the saturation, of color, which I don't see
here. This is a bright, cheerful, graceful land.

I feel close to Northern people, not so much in their
manner of expression as in the spirit from which they
create. Finland exhibits a very original interpretation of
form.[52] But all these Northerners have a lack of construc-
tion that disturbs me a little. "Disturb" isn't the right term,
but I see it now whereas I didn't earlier. This is a Parisian
advancement. Construction is the catchword here.

Segantini is represented by big, serious pictures—a little
crude, but created out of deep feeling.[53] How lucky I am to
be allowed to see all this! Everywhere life is full and beauti-
ful and I feel it lies wonderfully before me. I will slave and
toil gladly if only, at times, my soul can sing an evening
song.

My wicker chair is on strike. It no longer intends to carry
this sinful frame. Very soon I'll be sitting on the floor. But
as for the comforts of life, I can say many a happy word,
although better said in the past tense than in the present.

I have a little blackbird that chirps in front of my win-
dow. And a thunderstorm, after an oppressively hot sun.
Now the fragrance of spring rain again prevails.

We were in Montmartre the other day. The Church
stands solemnly above the big city and exhorts repentance
with its wonderful, tolling bells.

And we have little German painters with whom we sing
German folksongs and go dancing and boating. There's a
Hungarian band with waltzes too!!!! They defy all descrip-
tion. They even play our Worpswede "Dreifuss" and
"Komm Karlineken." We danced twice on the asphalt
pavement at night. People here dance whenever they want
to. They don't wait for a Schützenfest as we do in
Worpswede.

Footnotes: Chapter VII

1. Eugene Muntz, "The Ecole des Beaux-Arts,"
 The Architectural Record, January 1901, p. 14.

2. See p. 311.

3. Constantin Meunier (1832–1905), Belgian
 naturalist painter and sculptor who used
 working-class themes.

4. The "five narrow flights of stairs" to her tiny
 room and the at-home eating arrangement Bec-
 ker shared with Westhoff (mentioned in the
 next letter to her family) while she attended
 Académie Colarossi—whose fee was lower than
 the Académie Julian's—give an idea of the
 budget on which Becker was living. According
 to a curious article in *The Studio,* 1903, by Clive
 Holland, "Lady Art Students' Life in Paris," "If
 she be very independent she will eschew the
 pension . . . in favour of an *appartement au
 deuxieme,* or *au troisieme,* working upwards to-
 wards the sky . . . according to her worldly
 wealth, or lack of it" (p. 226).

5. Fra Angelico da Fiesole.

6. Models were numerous in Paris, and Monday was
 the day all the women, men, and children would
 gather at the Model Market on the Place Pigalle
 or at the various art schools in hopes of obtaining
 an assignment. As they made a regular living by
 posing, many specialized: "there a man with a
 patriarchal beard as his chief point; another, a
 girl, lithe and elegant, from whom an artist
 would be able to evolve a Psyche or a Wood
 Nymph; yet another who sits for Juno and Greek
 goddesses; there a woman and a baby, the

woman with a sad expression—cultivated, of course, as she earns her living by posing as the Virgin Mary, whilst her child has appeared in many pictures as the infant Jesus." Holland, p. 230.

7. The system taught in Berlin and Paris was to fill the page with the full figure. In Worpswede, under Mackensen, Becker had been drawing on a larger scale, filling the page with the head and upper torso.

 An excellent source for Becker's drawings is the exhibition catalogue *Paula Modersohn-Becker: Zeichnungen, Pastelle, Bildentwürfe,* Kunstverein in Hamburg, n.d. [1976].

8. A classmate of Kollwitz described an anatomy lesson at the Berlin women's school in 1885: the teacher brought in a box full of bones, which he passed among the students. The women studied the bones without being instructed as to how they fit together in the skeleton. Beate Bonus Jeep, *Sechzig Jahre Freundschaft mit Käthe Kollwitz,* Boppard, 1949, p. 7.

9. Rilke referred to Westhoff and Becker as the "dark sculptor" and the "fair painter." Rainer Maria Rilke, *Briefe und Tagebücher: 1899–1902,* Leipzig, 1931, pp. 273 ff. (Hereafter referred to as *B. u. T.*)

10. Sarah Bernhardt (née Bernard) was appearing alternately in *La Dame aux Camélias* and *Hamlet* at the Théâtre Sarah Bernhardt.

11. Louis August Girardot, painter and lithographer, born 1858, pupil of Gérôme.

 Raphaël Collin, figure painter, born 1850, pupil of Bouguereau and Cabanel, Professor at the Ecole des Beaux-Arts, 1902.

Probably Gustave Courtois, history and por-
trait painter, born 1852, pupil of Gérôme.

12. Filippo Colarossi was also a sculptor. In the
1880s he exhibited in the Salons in Paris and in
the Royal Academy exhibitions in London.

13. The *Exposition Universelle 1900* opened on April
15th.

14. At the turn of the century being an artist meant
going to Paris—from Germany, England, Po-
land, Russia, Spain, Japan, Scotland, Brazil,
Haiti, Turkey, Egypt, Romania, Finland, Swe-
den, the United States. "At Colarossi's one
morning there were five girls and a half-a-score
of men working at time sketches of a Spaniard in
matador costume; except that 50% of the men
were Americans, there was scarcely another in-
stance of two of the workers being of the same
nationality." Holland, p. 228.

15. Baedeker on Notre Dame, 1900: "The general
effect is hardly commensurate with the renown
of the edifice. This is owing partly to structural
defects, partly to the lowness of its situation, and
partly to the absence of spires. It is, moreover,
now surrounded by lofty buildings which further
dwarf its dimensions. . . ."

16. The *concours* was a competitive exhibition held
several times a year of works by current students
of the atelier. Women and men competed to-
gether for *concours* prizes. Holland, pp. 228–29.

17. "A tract in favor of a qualified optimism, it
points to a salvation, albeit here on earth and
without religion. Pagan in its complete accep-
tance of life, it is mystic in the belief in a power

beyond reason. . . . the chief tenet . . . is that wisdom can conquer destiny or at least protect the soul against its blows." W. D. Halls, *Maurice Maeterlinck: A Study of His Life and Thought*, London, Oxford, New York, 1960, pp. 62, 63.

18. On their boatride Becker and Westhoff saw both the Grand- and Petite-Palais (which housed the art exhibitions of the world's fair) and a number of foreign pavilions. The fairgrounds extended along both sides of the Seine from the Place de la Concorde to beyond the Pont d'Ina, embracing the Champ de Mars, Trocadéro Palace and Park, Esplanade des Invalides, Quai d'Orsay, Quai de la Conference, Cours de la Reine, and a large section of the Champs Elysées. All information on the world's fair taken from the myriad guidebooks in the incomparable New York Public Library.

19. Paris generally hosted a number of Salons every year, but because of the world's fair only one was held in 1900, the Salon of the Société des Artistes Français (opened April 5th).

20. The Morgue—a popular place among artists for anatomy studies—publicly exhibited corpses every day from 9 to 5. Statistics given in a contemporary guidebook to Paris stated that for one year half of the seven hundred bodies in the Morgue had been found in the Seine (250 men; 100 women).

21. That Becker refers to this as "the male life-class" reflects the fact that Colarossi's (and the Ecole des Beaux-Arts) had been integrated only four years earlier. From *The Quartier Latin*, December 1896: "To Mme Demont-Breton, president of the 'Union des Femmes Pientres et Sculpteurs,'

much of the honour is due for the successful ter-
mination of this crusade for women's rights. But
that she and her brave Amazons would eventu-
ally win was a foregone conclusion. Those of us
who were witness to the determined invasion of
Colarossi's by lady students are not surprised
when we hear that brush in hand and palette on
arm, they have now stormed the erstwhile im-
pregnable citadel of the Beaux-Arts" (p. 161).

22. The Boer War, 1899–1902, had reached its turn-
ing point in favor of the English just the day
before this letter, February 27th, with the cap-
ture of a major Boer army at Paardeberg. Popular
sentiment on the side of the South African Re-
public and the Orange Free State was causing a
widespread reaction against British imperialism.

23. Becker's illustrated monograph on Max Klinger
was one of a 122-volume series, *Künstler-
Monographien,* edited by art historian Hermann
Knackfuss. (Rilke's 1903 monograph on
Worpswede was sixty-fourth in this series.)

24. The Salon of the Société des Artistes Français
was smaller in 1900 than in previous years be-
cause artists were reserving their "good work" for
the Decennial Exhibition.

25. On the Grand- and Petite-Palais, which were
built especially for the art exhibitions of the 1900
world's fair.

26. In 1900 Rodin, with his assistants Jules Desbois
and Antoine Boudelle, opened L'Académie
Rodin on Boulevard Montparnasse, around the
corner from Académie Colarossi. Albert Elsen,
Rodin, New York, 1963, p. 211.

27. In *Wisdom and Destiny* Maeterlinck muses on Saint-Simon's story of Fénelon, the pariah character who stood "firm and silent in the midst of the feverish, intermittent glitter of the rest" of the court of Louis XIV. Maurice Maeterlinck, *Wisdom and Destiny*, trans. Alfred Sutro, New York, 1906, p. 278.

28. The quarter of Dresden where Becker had lived.

29. Compare this with Becker's letter to her parents two weeks earlier (13 April 1900), wherein she assured them she never worked on Sunday, it being "one of the few Christian practices that has stayed with me."

30. Perhaps the story Becker refers to is the one Danish literary critic Georg Brandes (1842–1927) told of his "imprudence" in Paris when he nearly killed himself "by taking too strong a sleeping draught." *Recollections of My Childhood and Youth*, London, 1906, p. 244.

31. Klinger's series *A Love* begins with the springtime pursuit of a beautiful woman by an ardent lover who does win her favor. And it ends with her degraded and dying in illegitimate childbirth while he kneels remorsefully at her side. Knackfuss's monograph on Klinger reproduced the third and last images of his ten-print cycle.

32. And the largest. The Decennial Exhibition was grouped according to country. The French Section alone had 1,546 paintings by nearly eight hundred artists, plus drawings, watercolors, pastels, miniatures, graphics, and sculpture.

33. Charles Cottet and Lucien Simon were the leaders of the Brittany painters. Jean Pierre, not a member of the group, also exhibited a painting on seafaring life.

 Cottet (1863–1925), pupil of Puvis de Chavannes.

 Simon (1861–1945), pupil of Tony Robert Fleury.

 Jean Pierre (Laurens) (1875–1932), pupil of Bonnat. Jean Pierre used only his given name professionally to distinguish himself from his well-known father, the history painter Jean-Paul Laurens (who sat on the admissions jury of the Decennial Exhibition).

 Cottet and Simon were awarded gold medals and the young Jean Pierre a silver medal in the Exhibition.

34. Stadinger's song from Lortzing's comic opera *Der Waffenschmied.*

35. Emil Nolde.

36. The Munich periodical begun in 1896 that gave its name to Jugendstil, the German Art Nouveau movement. Becker, under the influence of Vogeler, worked up several designs for the cover of *Jugend,* none of which were published.

37. Nolde: "One noon I met two strange German girls. One, Paula Becker, a painter, was small, questioning, lively; the other, Klara Westhof [sic], a sculptor, was tall and reserved. I never saw either of them again. But not long afterwards the sculptor became the wife of the poet, Rainer Maria Rilke, and the painter the wife of the artist Modersohn. During a few short years she painted some beautiful, intimate, deeply-felt pictures.

And then came her early, difficult death." *Das eigene Leben*, Berlin, 1931, pp. 148–49.

38. The Grande Roue, a gigantic ferris wheel, and the Celestial Globe, an equally gigantic spherical planetarium resting on four stone pillars.

39. According to Modersohn, it was Becker who urged him to come to Paris to see the world's fair. Hetsch, p. 19.

40. Rodin, like Courbet and Manet before him, held his own exhibition as a protest against the Academy. On the same site used by Courbet and Manet, the Place de l'Alma near the fairgrounds, Rodin set up his pavilion. Here on June 1st he presented the first large-scale retrospective of his work: 150 pieces of sculpture (*The Gate of Hell, The Burghers of Calais, Monument to Balzac, Victor Hugo, The Kiss*, etc.), plus a number of studies, drawings, watercolors, books, and designs. Elsen, p. 211.

41. The bicycle craze that hit Europe at the end of the nineteenth century brought with it drastic changes in fashion. In France bloomers became the popular cycling outfit. Women were wearing these modified trousers everywhere—and not without comment. In 1900 Paris hosted the first international cycling championship in connection with the world's fair. Cyclists from all over the world were exposed to women in pants. Lillias Campbell Davidson, *Handbook for Lady Cyclists*, London, 1896.

42. Helene Modersohn, née Schröder, 11 July 1868–14 June 1900 (Modersohn's first wife).

43. *L'Homme à la Veste,* retitled *La Fin de la Journée*
 (*The End of the Day*), c. 1860.

44. Léon Bonnat (1833–1922), genre and portrait
 painter, the most fashionable portraitist of the
 Third Republic and an influence on Toulouse-
 Lautrec, Dufy, and Othon Friesz. Bonnat headed
 the selection committee for the Decennial Ex-
 hibition.

45. One of the treasures she did find was Cézanne.
 "One day she asked me to go for a walk with her
 to the other bank of the Seine, so she could show
 me something special. She took me to the art
 dealer, Vollard. She began right there in his
 shop—we were left alone—to turn around the
 pictures arranged against the wall and with great
 certainty to single out several which were related
 to Paula's method in their simplicity. They were
 pictures by Cézanne, whom we both saw for the
 first time. We did not even know his name.
 Paula had discovered him on her own and for her
 this discovery was an unexpected confirmation of
 her own artistic longings. Later I was surprised to
 find no mention of it in her letters. Perhaps it
 seemed impossible to her to communicate it
 truly—yes, perhaps this experience was so little
 able to be articulated because it could only be
 transformed in her work." Westhoff in Hetsch,
 p. 43.

46. The Professors of the Ecole des Beaux-Arts and
 the eleven original Berlin Secessionist artists
 (see p. 53, n. 22).

47. The routine in German and English art schools
 was to work in deadly silence. Contemporary ac-
 counts of French atelier life by foreign students
 always remark with great surprise on the infor-

mality, incessant chatter, singing, practical
jokes, and boisterous play that daily went on in
class. William Rothenstein, Men and Memories,
v. 1, London, 1931–39, p. 40.

48. Why the situation is more difficult for women
than for men in the arts lies "in our institutions
and our education . . . not in our stars" according
to Linda Nochlin in her ground-breaking essay
"Why Are There No Great Women Artists?"
Not only does education, or habit of mind, find
women "ugly" in the same circumstances where
boys are just being boys, but until the later–
nineteenth-century art institutions did not allow
women to study from the nude model (female or
male) even in all-women classes. Woman in
Sexist Society, ed. Vivian Gornick and Barbara K.
Moran, New York, 1971.

49. In 1818 the Musée du Luxembourg was made a
museum for works by living artists. The State
purchased artworks and kept them in the
Luxembourg until ten years after the death of the
artist, at which time they were either received
into the Louvre—their claim to fame supposedly
established—or, failing this, were consigned to
provincial galleries.

50. Vieux Cheval sur la Lande and Deuil Marin, re-
spectively.

51. Le Cabestan.

52. Finland did not participate in the Decennial Ex-
hibition. Instead, the Finnish Pavilion, designed
by the young Eliel Saarinen, was decorated by
twelve modern Finnish painters. Axel Gallén
(1865–1931) received a gold medal for his
Kalevala frescoes on the dome of the pavilion.

Later he was invited by the Brücke artists to par-
ticipate in their exhibitions.

53. Giovanni Segantini (1858–1899), the leading
 Neo-impressionist painter in Italy. Seven of his
 paintings and nine drawings were exhibited in
 the Italian Section of the Decennial Exhibition.

Clara Westhoff and Paula Becker (in Becker's studio)
c. 1900
Archiv, Worpswede

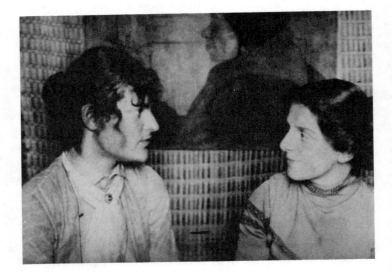

VIII. Worpswede and Bremen, 1900–01

*Becker left Paris without much regret. Within weeks she was
back in Worpswede and in a highly charged emotional situation.
Otto Modersohn began visiting her while she was convalescing
from the strain of the winter. Her doctor ordered bedrest and the
lonely widower came often and read to her. "Little by little our
friendship grew deeper. . . ," [1] and the inevitable resulted.*

*Becker's parents were hesitant. It was only four months since
the death of Modersohn's wife. Their prospective son-in-law was
eleven years older than their daughter, a widower with a two-
year-old child, and he was a painter. Certainly they had not
given up trying to dissuade Becker from painting. Marriage was
one answer to the pressures her parents were applying, but Becker
was not without ambivalence about this precipitous solution—
as the symbolist story she wrote in her journal reveals. To her
parents she made it clear, in double negatives, that "getting mar-
ried shouldn't be a reason for me not becoming something."*

*In Paris Becker had seen something of what she wanted to
achieve in the Nabi-influenced Brittany painters. She wrote Otto
Modersohn about their deep rich colors, their sense of the decora-
tive, and the personal interpretation evident in their works.
These qualities began appearing in her own paintings and isolated
her from other Worpswede artists. However, she was impressed
by the moods conveyed in Modersohn's work, and he was the
only one encouraging and supportive of her experiments.*

*Becker and Modersohn carried on their courtship in writing.
In Worpswede they placed their letters under a designated stone*

on the moor. While Becker was in Bremen, and later when she
was sent by her parents to Berlin, they corresponded by sending
their letters to friends and relations, and even went so far as to
have friends address the envelopes.

One of these friends was the poet Rainer Maria Rilke. Rilke
first visited Worpswede in late December 1898 at the invitation
of Heinrich Vogeler, whom he had met in Florence the previous
spring. At the time of his 1898 visit Becker was in Bremen. Now
in late August 1900, on his return from Russia, Rilke came
again and recorded in his journals his five weeks among the
artists: the regular Sunday parties (which usually lasted until
dawn) in the white music room of Vogeler's manorial Bar-
kenhof; his visits to the "fair painter" and the "dark sculptor,"
Becker and Westhoff; his conversations with Becker on litera-
ture, life and art, God, "death and the beauty of all experience,
dying and wanting to die." [2]

Westhoff and especially Becker were the inspiration for several
of Rilke's poems and images. However, he was not familiar with
Becker's work. "Here a regret comes to me: in Worpswede I
was always at your house in the evening, and then here and there
in the conversation I did see a sketch (a canal with a bridge and
sky still stands clearly before my memory), until words came
from you that I also wanted to see, so that I forbade my glances
the walls. . . . So I saw almost nothing of yours. . . ." [3]

In late September Rilke decided to spend the winter and spring
in the artist colony, and so he rented a "little house." He went to
Berlin in early October to collect his books and other necessities
but he did not return. In a letter to Becker he explained, "Here it
has become clear to me: my studies require me to stay here in the
neighborhood of the big city. . . . As yet I may have no little
house, may not yet dwell. Wandering and waiting is mine." [4]
Whether his sudden change of plans had something to do with her
engagement will always be open to speculation. There is a "sud-
den gap in his diary" [5] at the point when Becker's engagement
became an open secret in Worpswede.

JOURNALS

Worpswede, 2 July 1900
An evening stroll through Schlussdorf. The Ottelsdorf

mill against the dark, glittering heavens, in front of the
moor a waving field of grain. Don Quixote, red-bearded, on
a white horse.

People preparing peat. The mood of evening. Everything
deep. Brown and blue with faint inserts of white and red.
The girl doing the cutting with her bent back and her
well-defined hip bones.

A garden of love. The mood of evening. Bright red
crown imperials. A young couple: he black, she white.

I'm now living at Brünjes's on Ostendorf—beautiful in its
stillness. I'm trying to strip away all the vanity that in-
volved the big city and make out of myself a real human
being, a sensitive soul, and a woman.

Worpswede, 3 July 1900
I spent the entire morning out among the trees around
Boltes's factory. Blue sky and a big bundle of clouds. I was
aware of each shrub. Perhaps someday I'll paint a deserted
factory too.

Today my father wrote telling me to look for a position as
a governess. I lay in the dry clay pit all afternoon reading
Knut Hamsun's *Pan*. [6]

Worpswede, 26 July 1900
While I was painting today thoughts came and went, and
I want to write them down for my loved ones.
I know I will not live very long. But is this sad? Is a
celebration more beautiful because it lasts longer? And my
life is a celebration, a short, intense celebration. My sen-
suous perception is becoming sharper, as if I were supposed
to take in everything, everything, in the few years that are
offered me. At present my sense of smell is amazingly fine.
Almost every breath brings me a new perception of linden,
of ripe grain, of hay and mignonette. I absorb everything.

And if love blooms for me before I go and if I paint three good pictures, then I can leave willingly with flowers in my hands and hair. Now, as in my early childhood, I take great delight in making garlands. Whenever it's warm and I feel listless I'll sit down and twine for myself a yellow garland, a blue one, and one of thyme.

Today I thought of a picture of girls making music under a cloudy sky in shades of gray and green. The girls white, gray, and cloudy red.

A reaper in a blue shirt. He's cutting down all the little flowers in front of my door. It probably won't be much longer for me either. I now know two different pictures with death in them. Will I paint them?

Worpswede, 3 September 1900

Dr. Carl Hauptmann[7] is here for a week. He's a great, strong, struggling soul, someone who does not weigh light. There is in him a great seriousness and a great striving after truth. He gives me much to think about. He read reflective and lyric poetry from his journal. The German hard, the wording difficult and rigid, yet great and deep. Lay aside vanity and be human. Vanity puts up walls between you and nature. You can't get beyond them to nature. Art suffers as a consequence. To sink deeper, to live from the inside out, not from the outside in. The reasons against Paris as far as I'm concerned.

Next, Rainer Maria Rilke, a subtle lyric talent, delicate and sensitive, with small impressive hands. He read us his poems—tender and full of presentiments. Sweet and pale. In the end the two men were not able to understand each other. The struggle of realism with idealism.

To Otto Modersohn

Worpswede, Autumn 1900

To the very Best,

I've thought about us both, I've slept on it, and now it's

clear to me. We're not on the right path, Dear. You see we must first look very deeply into ourselves before we can give each other the ultimate things, or awaken the desire for them. That's not good, Dear. Before we gather the splendid deep rose to ourselves in a beautiful hour, we must first gather the thousand other flowers in the garden of our lives. In order to do this we must, both of us, sink even deeper into one another. Silence a while the iconoclastic lineage of your grandmother and let me be your madonna a little while longer. I mean well by you—you believe me, don't you? Think about gracious Lady Art, Dear. We both want to paint this week. I'll come to you early Saturday. And then we'll be good and gentle. "The gentle whispering," as you said. Good, well-behaved children, "because they must be too," to quote you with a slight variation. Farewell, Dear. Think about the beautiful and feel beautiful. We've joined hands to become finer through our combined strength because we certainly won't be at our zeniths for a long time yet. I not for a l-o-n-g time—nor you, Dear. Thank God, because growth is surely the most beautiful thing on this earth. Isn't that so? We both have a good future ahead of us. . . . You are quietly kissed and your dear head is gently caressed. I am yours, you are mine, of this you may be certain.[8]

Your me

Dear? Sleep well and a lot, and eat nourishingly. Yes? You!!

Wednesday evening
I've done fine work today, that is, considering the circumstances. And I'm immensely happy. Whenever I keep up well and don't suddenly come to a halt, then I think that one day you'll have a wife who will be noticed after all. I so much want this for both of us with all my soul. For the present I'm the only one, I feel, who believes in me. Oh, if you believed in me too, perhaps it would be too much happiness. I might aim too high into the heavens, which of

course is my weakness. I get excited too easily. I was just on the verge again this morning. I must not become artistically excited because that puts an end to art. Seriously. Don't always try to make me laugh at moments when I'm not doing so. Know that these few serious moments are salvation to my soul. A deepening on all sides. Only my laughing side is deep enough.

In the meantime I've thought over the other matter an awful lot and have accumulated so much of the wisdom of life that I hope for both our sakes I sleep it away by Saturday. Otherwise it's too overwhelming. Farewell, my Dear. Don't think about the dull old world at all. Think a lot about art and a little about me.

JOURNALS

I've rented Fräulein R's atelier from Ranke, the tailor. This girl interests me very much. There's so much personality alive in all the little things I've inherited from her. A green, stained birdcage that locks with a spring; no end of broken, colored, dreamy little pots; a portfolio with drawings of children, "The field on which stood a bench," and innumerable versions of her sisters and brothers—with crocheted materials, with a book, with nothing. Some of her characteristic charcoal drawings from last year, stuck on a nail on the floor.

I feel at home among these ruins. I'm making plans and beginning to work. Mornings I'm painting a half-nude, afternoons Herma. And we have moonlight. While the Brünjeses were at a ball yesterday we jumped out the window nude and sang in whispers and danced in a circle. I've been reading The Sunken Bell today. That Gerhart is still something, whatever they may say. He's far from finished, I do believe.

It's sweet having Herma around. She's like a poplar leaf in a breeze. Such sweetness sleeps and dreams in her. And her charm is already awakening. Whenever she recites poems by Goethe and Heine her whole being radiates light and warmth.

I'm reading Ibsen's *Emperor and Galilean.*[9] Again I'm completely caught in the spell of this great man. I hadn't remembered from last year his poetry being so great. Besides his profound thought, there's something noble about him. Mother judges him wrongly, far too much by the length of his hair.

And a letter from the Red King. With an all-embracing love and the passion of life. He makes me religious.

To Her Father

Worpswede, 28 October 1900

My dear Father,

. . . don't worry about an engagement party. Otto and I are both very sensible people. Heinrich Vogeler brought a bottle of red wine to celebrate the occasion with us. It finally dawned on him and he's being very nice about it. Otto mentioned our engagement to him before but he didn't really listen from sheer embarrassment about its being a delicate matter.

At present we're both soundly at our work. Otto has begun three new pictures, one after another. I go to him in his atelier in the evenings and we look at them together. I work a lot outdoors in my wooden shoes and am being thoroughly blown about. One must make use of the few golden days left.

To Her Aunt Marie

Worpswede, October 1900

My dear Aunt Marie,

Yes, I am fortunate, profoundly and easily, and life is blowing sweetly around me. It's all like a dream to me. Really my whole life is like a dream, and now even more so. I feel that such evenings as I spend happen to only very few

in this world. As today when we met in the gathering
darkness at our favorite spot. We stood together among the
trembling pines cracking in the wind. He is a man and a
child. He has a pointed red beard and sensitive, dear hands
and is seventeen centimeters taller than I. He has a great,
deep intensity of feeling. His whole person really consists of
feeling. Art and love are the two pieces he plays on his
violin. He has a serious, almost melancholy nature, but he
takes great pleasure in sunshine and gaiety. I can mean a lot
to him. That is a wonderful blessing. We understand each
other very well in art—one of us will usually say what the
other is feeling. I don't intend to give up my art either. We
want now to strive on together. His great simplicity and
depth will demand piety of me. I'm such a complicated
person, so perpetually trembling—such a calm hand will do
so much good.

I carry happiness in my heart.

Your Paula Becker

JOURNALS

I came to the land of longing. It was sweet and lovely to
behold. The sun shone down from its golden chair onto the
firmament and its silky gold hair twined around everything
it beheld. It wound itself intimately around the big gnarled
pines. And these old companions gladly submitted. They
felt young and joyous under the sun's loving embrace. They
did not stir but stood quietly as though they feared breaking
the gracious spell with any movement. The hair of the sun
made the branches and boughs appear golden and they
rejoiced in their beauty. The sun's hair wound along the
shores of the lake and played with the dried marsh. It cast
its golden strands out onto the lake, far out. I could not see
to the end. And it lay warmly and softly on my breast. My
heart beat slowly and solemnly, joyfully aware of being
alive.

I looked toward the water. My eyes followed the golden strands of the sun, which completely disappeared in the distance and submerged into a gray blue. It was not water, it was not sky. It was a maze of gray veils that absorbed the sun so that its gold could not shine through. It made me sad to look out there. I looked back at the reeds and listened to their soft, intimate conversation.

But I was forced to look into the distance again. And again I saw the gray veils gently stirring. It was as if from behind the veils a pair of large, deep eyes were peering into the bottom of my soul and their gaze would not leave me. My soul was sad. I asked the old pines, "To whom do these deep eyes belong?" But they would not move for fear of breaking the golden spell of the sun. So I asked the reeds but they did not hear me, they just kept on whispering to each other intimately.

I looked back into the distance, into those deep eyes. My soul cried and called out, "Who are you?"

Then the first veil gently rose and let forth three white swans. They swam slowly over the golden surface, slowly and sadly. When they came close to where I stood each cast a white feather toward me. As I took up the first feather, I recognized the deep eyes in the distance. They were eyes of longing, looking at me as though they did not want to let me go. My eyes were drawn to them. I forgot the world around me and I forgot all I loved as I looked into those deep eyes.

I took the second feather and it was as if my eyes were opened. I saw a multitude of people of all ages standing near me. They had a woeful appearance and like me they were looking out into the eyes of longing.

I took the third feather and my ears were opened. I heard murmuring and lamenting all around me. Each sadly spoke of one wish, the one wish of the heart. And the deep eyes of longing were on them, so they could not forget their wishes.

There was a woman who cried for the love of the man she loved. The eyes of longing were on her. She, like me, had forgotten the world and all she had cared for and thought

only about her beloved. There was a youth. He boldly shouted out into the distance, "Honor and glory!" The eyes of longing were on him. He forgot everything else and all that he cared for. Now he carried only the thought of honor and glory.

I looked out into the distance and shuddered. My dearest wish was in my heart and I held it fondly. I thought of nothing else and cried for this, my heart's desire.

Then I heard a voice softly sounding. It grew louder and louder and louder. The gold hair of the sun enswirled me. I was able to look away from the deep eyes of longing and look toward the sun.

It called out, "Go home to your house and create. Think about the people you live with and love them and you will recover."

The hair of the sun sweetly enswirled me. My heart beat slowly and solemnly. A great strength came over me. I went inside and created. I flung my heart's desire out into the lake. It shone there on the bottom.

The gold hair of the sun enswirls me. And peace lives in my soul.

To Her Mother

Worpswede, 3 November 1900

My Mother,

Yes, I should write more, and more often. I feel that way too. It has been fermenting in me. Even without your dear gray letters I would have written you. Although perhaps they are my impetus. Initiative is my weak point at present. It never really was my strongest side. And now I must divide the little I have between Otto Modersohn and myself. He has even mu-u-uch less than I do.

I'm often surprised at how prudent and gentle I am toward him. It's certainly out of love. I believe I'll be a good wife. I've even been afraid I'd lose my pigheadedness entirely in time. (And with my quarter of a century this head

has real antique value—thus I've rationalized I shouldn't allow it to roll completely off my shoulders.) The man has the goodness of a child. If ever he hurts anyone, he does so in such divine innocence that one has to kneel in humility before him. It's exactly this naivete that I so admired in the tender childhood of M. It's really so much more difficult for us who are aware. We shouldn't hurt anyone precisely because we are aware.

I'm painting a lot, making use of every little bit of time I have now. And him? He goes on producing beautiful pictures right out of his sleeve. While I'm still single I want to make good use of my time to learn. Getting married shouldn't be a reason for me not becoming something.

Dr. Carl Hauptmann has published a journal that I have just now gotten ahold of. His dramatic works mean very little to me.[10] But in this book he is genuinely and clearly evident to the reader as a fine person, with his ardent desire to give voice to what is essential, what is deepest, in a person, so that the shallow overtones are silenced. He has the idealism of tender youth, a divine belief in the world. He looks at each being with love. Time has not been able to accomplish its hardening process with him as it has with so many others. A wall of the deepest, purest morality protects and defends him. I want to send the book to you after I've finished reading it so you can get to know him.

Otto saw Klinger at Pauli's.[11] There's really something marvelous about a conquering personality. He's one of these sovereigns, and he's kind too. Whenever I think about that look he gave me in parting three years ago—I was so immature, so very unfinished, and so very unproductive. He looked as if he were gently stroking my hair.

To Otto Modersohn

Bremen, 5 December 1900

Dear,
 I'm here now and won't be getting away again for the time being. What are you doing while the skies are gray?

Shouldn't I be with you and you with me? The world here
turns round and round, making me rather dizzy, so that I
stay standing on my own two legs only with difficulty. If I
hadn't resisted body and soul, I'd be at the theater today for
the second time. They mean so well, but in their love my
poor soul is terribly mistreated. I still have to go to *Cosi Fan
Tutte* tomorrow evening. Then I'll return early Friday and
I'll be very, very glad to. It is cometh of evil when one is
not where one belongs. And I don't belong here in the city.
You are kissed, my man. Friday afternoon I'll come to you
in your atelier. How did your Velasquez manage to paint
such pictures at court? My little person is utterly erased
here. Strange. I have nothing to say, nor do I feel anything.
It's as I told you, I can't endure very much. You are unique
and fine.

Bremen, 23 December 1900

The family is gathered around me again in their Christ-
mas spirit. Right now they're discussing what they want to
give me. I've told them I already have everything I want in
my man. They were trying to tell me what to write in my
letter. Really, they're a little crazy. Kurt is looking forward
to the holiday like a young boy and we are singing lots of
Christmas carols.

And you, Dear? Are you good and well behaved at
home?[12] Go often to see St. Christopher in your Cathedral
and let his golden leaves ripple over you. Think about me
while you're there and I will think about you.

Things have gone well so far and I'm even tolerating the
city. Herma woke me this morning, and I pulled Papa's
heavy fur over my chemise, and together we climbed onto
the flat roof, fed the pigeons, and listened to the big
cathedral bells. Just once I'd like to ring them my-
self. . . . This afternoon at twilight I walked through the
city. The Cathedral, the old chap, stood there so venerably
with its two big towers in the blue air. Beneath them the
gold of the entrance doors shone brilliantly in the twilight
and the arches glittered in a red gold light. I'm really ob-

serving quite a lot. Today my father's wrinkled cheek gave me great pleasure. To be able to paint a person's face accurately is one of the most beautiful things. If only I could!

It's night and everyone's asleep except my parents. My eyes are closing too. But I had to visit with you quickly once more. I happily wear my little fur whenever I go strolling in the city. And you, Dear? Don't think about me sadly or longingly but happily, because we belong to each other. I have the feeling that this separation will only spiritualize and deepen our love.

Bremen, 24 December 1900

You,

It's Christmas Eve, or by this time Christmas morning. It smells of fir trees and burning candles and there are empty green rummers in front of me. My five-armed candlestick on my Christmas table is almost burned down. Its flickering light sprints over a thousand lovely things. Many quaint things for our home. A wonderful old looking glass. Close by crawls my mink—which I let crawl around my neck, Dear. Lying on my table is a little dream of clouds, a bridal petticoat. . . . You? Will we two walk over the hill to the little church one fine day?

I was very much with you today, Dear. My father silently pressed your letter into my hand this afternoon. I went out among the ringing bells through the city as it grew dark. Isn't it funny? I just told M this morning the same thing you wrote me this afternoon. There's so much originality in form and color in a city like this that I haven't exhausted it in the slightest. It seems to me I haven't even begun.

It's a great, deep, heartfelt joy for me to know that I'll see you again before my trip to Berlin. And that you'll be comfortably among my family once more. You dear, they all love you so.

Vogeler looked in for a moment on our Christmas afternoon. He was about to fetch the wedding rings for his Martha and himself. . . . You know the two of us have it so good. All the time I have such a great, quiet feeling of

thanks in my heart. My whole family sends you their greet-
ings. I am with you in all my love and I surround you with
it. Do you feel it?

I'd be happy if you came on the second of January be-
cause I'd like to go off to Berlin soon so I can come back
soon. But if it's not convenient for you, of course I'll wait
until the third.

Will we celebrate next Christmas in our own home? I
don't even want to think about such happiness, Dear. And
you? . . . You are affectionately kissed by me.

Bremen, 25 December 1900

This morning when I finally made my appearance around
ten o'clock in the coffee area downstairs—we three sisters
had again celebrated the ringing of the bells out on the flat
roof—I found your postcards from Münster. With my eyes I
ran along the little street with its gabled houses up to your
dear Cathedral and thought, "There he goes at this very
moment in his big brown cape." My man, you spoil me,
Bismarck's letters and Andersen, what an abundance of
delight! I thank you for everything. I thank you for being in
this world at all, even if far from me, my dear, dear Red
King. Yet for all this, I have impudent plans I have to
quickly tell you. Could you possibly be with us New Year's
Eve? We always are so quiet and close together then. I'd
like this holiday never to be forgotten by my parents and by
you and me. All of us wish from the bottom of our hearts
that our new brother, and my husband, could be with us.

You have to know how you feel, Dear, and what your
parents will say. How are you spending your days? I'm fine.
Everyone here is carried away by the holiday joy. The inner
sunshine each carries inside is building golden bridges of
good will. I'm warmed by this bit of Christianity and accept
it like a fairy tale. You realize this is a special holiday for
women because these tidings of motherhood still live on in
every woman. It's all so holy. It's a mystery that for me is
deep and impenetrable and delicate and all-embracing. I
bow down before this mystery whenever I meet it. I kneel in

humility before it. Birth and death are my religion because I can not understand them. This shouldn't depress you, you should love them, Dear. They are the greatest events on this earth. I love the Bible too. But I love it as a most beautiful book that has given my life much sweetness. Don't worry, I won't say these things when I'm in Münster. Only to you, to you.

M is singing love songs next door. My soul is gently lulled by these notes. Life is easy and gentle for me. It smiles on me out of eyes veiled by dreams. I kiss them and love them.

Kurt said, "You're writing him four pages?" I immediately made a face at him and said, "Yes!"

Yes, Dear, now I must go to bed and I kiss you a thousand times.

> *Bremen, 26 December 1900*

You, how sweetly you've written me! Your letter was like the soft caress of your hands. I held myself out to you and submitted so willingly.

How strange a thing is love. How it lives in us and sleeps in us and takes possession of every fiber of our being. Love envelopes our souls and covers it with kisses.

Life is a wonder. It grips me and often I have to close my eyes, as when you hold me in your arms. It washes over me and illuminates me and evokes such saturated, restrained colors in me that I tremble. I have a wonderful feeling about the world. Let it do what it wants, hobble instead of dance as much as it wants, and screech instead of sing as much as it wants. I'm walking at your side and taking you by the hand. Our hands know each other and love each other and are comfortable together.

> Two who love with all their heart
> Can bear the pains of being apart.
> Two who love with all their being
> Must bow before Heaven's King.
> Two who love with divine flames
> Will find a miracle and come together again.

And a miracle will happen for us! We will see each other again in spite of our good-byes in Vogeler's little library. Soon, my sweetheart, soon. Come whenever you can, Dear. Come on New Year's or on the second, do just as you wish. I'll like whatever you do.

I have this wonderful feeling that our love will be purified and deeply spiritualized during this period of separation. It fills me with grateful devotion to the universe. My Red King! I am the little girl who loves you, who gives herself to you, and whose modesty lies broken before you, having vanished like a dream. In humility, Dear, I give myself as I am and lie in your arms and say, "Here I am."

So be it till the end of our lives. I gently stroke your red beard and kiss you on each cheek. Take up my soul and drink of it. Drink a burning kiss of love.

I am yours always.

Bremen, 28 December 1900

It's midnight and I really should go to bed. But I long for something deep, clear, and total. So I am coming to you for a little while despite the night and the darkness. The time is coming when the city will get to be too much for me again. It constricts me, or squeezes me to death. These half-people and mannikins are gradually cutting me in half and chopping me into little pieces. I don't want to be half, I want to be whole. I'm not myself here. I don't hear my soul speaking or answering. Beauty no longer finds its way to me. In Paris Beethoven's *Fifth Symphony* moved me deeply and ran through the keynote of my life. Today it penetrated only the surface. My nerves neither wanted nor were able to hear it. I hate myself in this halfness and lameness. My little self thinks longingly of the time when I did not hobble and of a future when I will not either.

Will a letter from you beckon me tomorrow morning at coffee? It's always so delightful to feel your letter wrinkling in my pocket all day. And you, my Dear? Are you still on friendly terms with the world? Do you still smoke your pipe in peace? I hope so for you and yours. But now very quickly

to bed. This was just a little epistle, a sigh of an epistle, a tired little epistle. Dear, I have the Bismarck letters now and I'm reading them. They're beautiful! Really too beautiful for one person, we should read them together. Good night, my Red. I am thinking of you tenderly and I kiss you.

To Her Aunt Marie

Bremen, 30 December 1900

My dear Aunt Marie,

... I am well to overflowing with my dear man. Life is quiet and beautiful. My little self sits quite still and scarcely moves while fate strokes me with its tender hand. I have the feeling of living very gently, of enjoying each moment very gently. I find it so amazing when things and sensations seize the person and not the person the things. This is always accompanied by a kind of rape, I'd say (the latter I mean). As is most social intercourse in the city. People will not wait a moment for some little thoughtful spring to come up out of the bottom of their hearts. They hastily stifle everything with coined phrases and coined feelings. We don't want to frequent the city—aside from here at home of course. It doesn't suit me. One gives nothing. One carefully keeps one's little bit to oneself in superficial kinds of conversation. And what one receives is only a dismal, remote impression.

We are a quiet community in Worpswede: Vogeler and his little bride, Otto Modersohn and I, and Clara Westhoff. We call ourselves "the family." We're always together on Sundays and we share a lot with each other. Living my life is wonderful.

Farewell, Dear. I've probably told you nothing substantial. I always forget, feeling that inner experiences are so much more valuable and more important than external ones. As long as they don't interfere with me, they're no concern of mine at all. Anyway... anyway....

To Otto Modersohn

Bremen, 10 January 1901

Now we really are separated, and so quickly and suddenly. I believe that the broom-swinging individual in church was an angel who wanted to sweep away the sad moment of our parting. Now we've said "Good-bye" again. Each of us during these two months of being alone will try to be brave and vigorously create. You, my King, beautiful, beautiful pictures; I, soups, dumplings, and ragouts.

Was your return home as wonderful as mine? I raced from Ritterhude back to our little church, then back again to Ritterhude.[13] Alone, alone in this wide world of yellow and blue that descended further and further upon me, encircled me lovingly, and kissed me. I was very religious at that moment, facing nature praying. Oh, my man, how wonderful it is to have a heart that trembles and lives and stirs in our breast, a part of this great universe. . . .

A migration of wild geese flew over me. I love the whistle of their beating wings over my head. I can understand how people of visionary religions would read the future in them. I've always delighted in and found them very beautiful. In Norway, one quiet evening, I heard close overhead the thunder of a hundred wings. I looked up and trembling violently above me was the sun-golden plumage of many, many starlings. They spoke to me in that quiet hour.

And now you are kissed, my Otto. Have a good time skating, and don't stare into the icy depths too much.

Footnotes: Chapter VIII

1. Modersohn in Hetsch, p. 19.

2. Rilke, *B. u. T.*, pp. 283–87 (9 September 1900).

3. *Letters of Rainer Maria Rilke: 1892–1910,* trans.
 Jane Bannard Greene and M. D. Herter Norton,
 New York, 1969, p. 55 (24 January 1901).
 (Hereafter referred to as *Letters.*)

4. *Letters,* pp. 45, 46 (18 October 1900).

5. ". . . (whether originally there or made by his
 literary executors) points to a shock of some sort
 . . . an emotional upheaval. And the news of
 Paula's engagement would have been a shock to
 him, whenever and however he heard it." E. M.
 Butler, *Rainer Maria Rilke,* New York and Cam-
 bridge, 1941, p. 105. See also Heinrich Wigand
 Petzet, *Das Bildnis des Dichters: Paula
 Modersohn-Becker und Rainer Maria Rilke,*
 Frankfurt am Main, 1957.

6. *Pan,* 1894, by the Norwegian novelist and Nobel
 Prize–winner Hamsun, is the tragic romance of
 Lieutenant Thomas Glahn, a man possessed by
 nature. ". . . the rhythm of his life, and espe-
 cially of his emotional life, which is the proper
 subject of the book, is that of day and night, of
 summer and winter, of spring and autumn, of
 storm and sunshine. His senses in every meaning
 of the word, are wide awake to every stimulus,
 and drink in whatever is offered to him" (a de-
 scription echoed in Becker's next journal entry)
 Illit Grøndahl and Ola Raknes, *Chapters in
 Norwegian Literature,* London, 1923, p. 272.

7. Carl Hauptmann (1858–1921), playwright and
 novelist, lesser-known elder brother of Gerhart
 Hauptmann.

8. Becker is quoting from an anonymous twelfth-
 century love poem.

9. Becker is very much living in the time of the pull
 of traditional Christian obligation and Nietz-
 schean pagan assertion of self. Like Ibsen's Em-
 peror Julian, who initially was attempting to rec-
 oncile the opposites of Christianity and
 paganism, Becker is hoping to combine the tra-
 ditional role of wife with the free life of the ar-
 tist.

10. Becker saw one of his plays at the end of Sep-
 tember, when she went together with other
 Worpsweders to Hamburg. In the carriage on the
 way there Rilke sat facing Becker "and her won-
 derful Paris hat, 'on which tired dark red roses un-
 emphatically rested, as if they had just been laid
 aside by a lonely hand.' And he watched her
 eyes, noticing that they were beginning to unfold
 like double roses. . . ." Butler, p. 102. This image
 inspired his *Fragment*, a fantasy about a dead
 virgin whose lover lays two rosebuds over her
 eyes. The buds open and blossom. Rilke's own
 epitaph is "Rose, oh pure contradiction, delight
 to be no one's sleep under so many lids."

11. Gustav Pauli (1866–1938), art historian and Di-
 rector of the Bremen Kunsthalle, the only place
 where Becker's work was exhibited during her
 lifetime.

12. Otto Modersohn was with his family in Münster
 [S.D.G.].

13. A village more than half way from Worpswede to
 Bremen. Becker "raced" back and forth on ice
 skates over the frozen moor canals.

IX. Berlin, 1901

Becker's cooking was a family joke. In Worpswede her usual fare was said to have been pancakes. Her sister recalled that in Paris in 1906 Becker subsisted on fruit and bread because she was too absorbed in painting to bother about cooking. Now with marriage imminent, the joke was on her. Becker was sent off to cooking school in Berlin for two months. Her parents' choice of Berlin suggests their uneasiness about the engagement. However, Otto Modersohn was gaining a reputation and he had been supporting his family, so they did not resolutely object to a match with the widowed painter. Besides, Becker determination overcame the stumbling blocks they put in her way.

In addition to cooking, while she was in Berlin Becker went to museums and galleries, and she saw Rilke regularly. The previous October he had settled in the Berlin suburb of Schmargendorf. Together they discussed art, poetry, and drama. He read to her; she showed him her journals.

Two major influences on late–nineteenth-century German sensibility were the dramatist Gerhart Hauptmann and the painter Arnold Böcklin. Käthe Kollwitz achieved fame in 1896 with her cycle of prints based on Hauptmann's play The Weavers. With The Weavers Hauptmann initiated modern social drama in Germany, for which he was indebted to the critical work of the Hart brothers. (Becker visited their salon while she was in Berlin.) They had edited a number of short-lived periodicals in the late 1880s that led to the development of Naturalism in German theater.

The Worpswede circle was especially aware of Hauptmann because of the presence among them of his brother Carl. Becker likened Worpswede to Hauptmann's Sunken Bell and she also read his Drayman Henschel, Hannele, and Lonely Lives. Now through Rilke she was introduced to Hauptmann's tragedy Michael Kramer. *This play with its theme of the artist in society so moved Rilke that he dedicated his next volume of poetry,* The Book of Pictures, *to Hauptmann "in affection and gratitude for* Michael Kramer." *Just as* The Sunken Bell *and* Hannele *moved from Naturalist milieu of village and poorhouse into fairy world and dreamscape,* Michael Kramer *transcended detailed and sordid Naturalism through its poetic language. Becker imbibed with Rilke the commitment to art—a sanctity of vocation—that Hauptmann's painter Michael Kramer succinctly enunciated: "Art is religion."*

Another immensely popular figure in Germany with both artists and public was Arnold Böcklin, "a connecting link between the romanticists and expressionists." [1] *Rilke, in his monograph on the men of Worpswede, described the painters' discussions connecting Böcklin with Rembrandt. They felt Böcklin was able to see and express the deepest and most significant traits in nature. So while she was in Berlin Becker took the opportunity to study these two artists so admired by the Worpsweders. She ignored Böcklin's idealized allegorical subject matter, with its fabulous mythological and symbolical creatures, and quarreled with his color balance. She did appreciate Böcklin's brushwork in the details of his landscapes, his sense of mass, and the simplicity of his figures.*

Becker had been interested in Rembrandt when she was an art student in Berlin. His influence is apparent in the compact, very un–Jugendstil-like, humanistic figures in both her paintings and the major graphic work she executed upon her return to Worpswede.

To Otto Modersohn

Berlin, 13 January 1901
I'm in Berlin, feeling very tamed and very confined. I'd

like to blow up the walls and see a bit of heaven. I think
these two months will be very difficult for me. I don't
belong in such a city, especially not here in its elegant
district. I'm out of place. It was different in Paris, in the
Quartier Latin. Here the people around me are sweet and
friendly, but in keeping with their class their lives are lived
in alienation from things. Yet they are delicate, vibrant,
sensitive women—garden flowers; while my flower is of the
open fields. Everything will turn out all right, but my poor
little soul is entering a cage. If I allowed myself the freedom
of Worpswede I would cause a lot of damage in this china
closet.

I still haven't seen anything. Only a lot of faces—many
of which have interested and attracted me. On the whole,
the feeling of having had my wings clipped strongly domi-
nates me. Perhaps things will be better when I've finally
arranged my life in terms of art and cooking. There's a
cooking school nearby that teaches both plain meals and
turkey roasts.

Dear, wasn't our last day on the ice together beautiful?
Was it as wonderful afterward for you as it was for me? I
think of that day with longing. Isn't Worpswede really
lovely? Will everybody be out on the ice again today? I'd be
so happy for you. Skating makes your pulse beat, it brings
life and joy.

I'm going to Rilke's this afternoon to thank him, in your
name too, for the *Stories of God*.[2] Unfortunately I didn't
like all of them. It will be difficult to talk about. Well, we'll
see. He's the kind of person who makes things easy.

When Herma visits you again have her recite "I think of
you"[3] once more. I kiss you affectionately, my Red. I'm
yours with my whole heart and my whole soul and my
whole mind.

Berlin, 15 January 1901

I was in the museum[4] today and heard cherubs singing in
heaven. It was so beautiful that I just have to tell you about
it. Art is the most beautiful thing in the world. Here in
Berlin, with all the feathered hats and the terribly noisy

tramcars, art is a sweet loving mother to me, a shelter from this torment. I sit very quietly amidst all the noise and curl up into myself. Inwardly I smile and my soul is in the Elysian Fields.

Your Rembrandt is a great and mighty person, a king. But I can't always accept him. He's very far from me, beyond me in many of his works, as in *The Consolation of the Widow*. He has a colorfulness to which I was not sympathetic at first glance. But you're right, there's a vibrating in him. The small sketch of the angel in the stable with Joseph and Mary in Bethlehem is wonderful: the light on the wings and parts of the arms of the angel; the angel's hands; Mary in a blue shawl with a striking red; and the cow's head. Everything's so movingly human and so deeply, deeply felt.[5]

Oh, the depth in our hearts! For a long time mine was covered with mists. I knew and sensed little of it. Now it's as if each of my inner experiences lifts these veils so I may glance into this sweet trembling darkness, the darkness that conceals all that makes life worth living.

I feel strongly that everything I previously dreamed of for my own art was not nearly experienced enough inwardly. It must go through the whole person, through every fiber of one's being.

One cherub that sang especially sweetly was a Böcklin photograph at Keller and Reiner's. It was wonderful, Otto. Do you know it? Three girls walking in the evening along the water's edge. The one in front, dark, steps along darkly veiled, and in back is a bewitching blonde with a floating face.[6] We really have to have it, they're so wonderful. I like to think about Böcklin quietly all by myself because all of Berlin is babbling loudly about him. People just have to talk everything to death, even violets and roses.

I finally saw Velasquez today. He strikes me as very immaculately cool and, for me, evokes too moderate an atmosphere. A house with central heating will no longer do. It should be cold in the hallway and warm inside the rooms, and whoever touches the oven should get burnt, and life be everywhere! And no court temperatures, because then I'd

need high heels and silk stockings and *frou-frou* skirts and I'd rather not ruin your future with such expenses.

I very much love the Old German Masters and their lamentations over Christ. Only today I saw one that was a little too well-fed and too contented. I prefer to listen to what hungering, searching souls have to say.

Dear, I still haven't received a letter from you. But today when I beheld all the magnificence and all the splendor, it was as if you had written me or as if I had spoken to you because our souls would have harmonized and chimed together in so many ways.

Sunday at Rilke's was beautiful. Hearing his voice was like a bit of Worpswede for me. I'd been a little cowed before by the noise of the big city. He read the last act of the latest Hauptmann to me. It was very like his *Hannele*. [7]

When M is with you again have her sing "And my soul spread wide its wings."[8] I feel like that at times when I realize how much joy is poured out on this earth.

And cooking! . . . So far I've just been looking at kitchens. I haven't made my final decision yet. There's a drawback to every one of them. But I'll get around to it.

And now I kiss you on your red beard very affectionately, very like a bride, my King.

Berlin, 17 January 1901 [?]

It was wonderful having you appear to me yesterday under Clara Westhoff's colors.[9] I carried you around with me all day and when I was tired of looking, I sat down in a quiet corner next to Verrocchio's charming lady who holds flowers at her breast with her slender hands.[10] There, after having seen many beautiful things, I read you once more and I spoke with you.

I've been to the Böcklins[11] and have never seen him so beautiful. First his picture of spring, *The Three Ages*. The grass and flowers were so impressive. The charming silhouettes of bare trees in the distance, mainly to the right; a little brook so simple and loving; and the very attractive silvery light-blue girl of the lovers, with a delicate veil on

her hat. I'm so happy I'm able to perceive this so much more strongly than before. In his book Böcklin spoke against a dominant blue.[12] The sky in this picture seems too blue. I feel it would have even a more gentle and blissful spring-like effect if it were toned down.

There's a wonderful corner in the left of *Elysian Fields:* lovers drinking out of a gold vessel. Everything's so deep and colorful and big and simple, including the dark lawn on which they sit and the calm water in front of them. . . . But Dr. M is right, the pictures don't keep well. This one and another (*Pietà,* I think) already have a lot of cracks.

I enjoyed details of *Sleeping Nymph and Fauns* very much. I didn't find its big colorful impression satisfying. Perhaps more blue is required to balance the great brown mass of fauns' bodies. At least I think that's why I found it rather unpleasant. But the silver veil over the nymph was something. How it draped across her flesh and lay against her, and how its silver dots sparkled! The ivy and the lichen-covered stones and the urn against which she slept were wonderful too.

Yes, Otto, life is so, so marvelous. I often feel that one should sit very quietly and piously in the midst of it all, and hold one's breath so that the feeling won't escape.

Dear, it has become evening. I'm sitting all alone upstairs here on the quiet floor, thinking all kinds of sweet thoughts. I have to embrace you once more very gently with all my soul. M was just playing a wonderful piano in the dark room next door. Now she's left. I wish you could hear her sometime. It was quite tender, quite delicate, very sad, and full of sorrow. It's then that she gives herself completely, whereas in conversation her shy soul holds her back. Now I too must leave, Dear, leave you and me and go out among people.

Berlin, 18 January 1901

Arnold Böcklin is no more. Dear, the news so preoccupies me. I think about him—a great man. It was a beautiful death. I mean there was so much to him. He was not

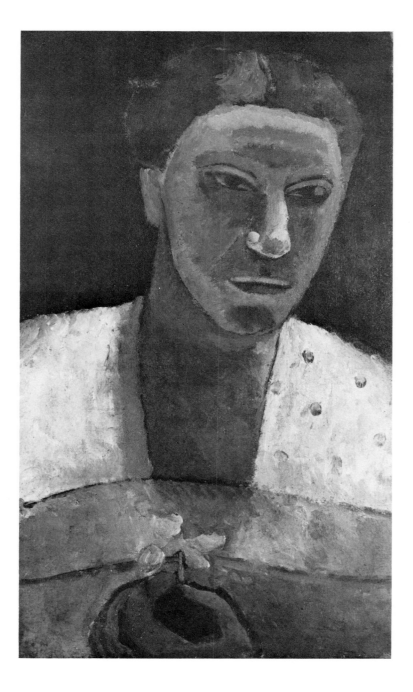

Peasant Woman

charcoal, 48×70cm (19×27½in)
c. 1899/1900
Photograph courtesy of the Allan Frumkin Gallery
Collection of the Art Institute of Chicago

Preceding page:

Half-length Portrait of Lee Hoetger

canvas, 55×33cm (21½×13in)
August 1906
Ludwig Roselius Collection, Böttcherstrasse, Bremen

Blind Woman
in the Woods

etching, 154 × 133mm
(6 × 5¼in)
c. 1901
Collection of Jan and
Natalie Goldstein,
New York

Reclining Female Nude

canvas, 70 × 112cm (27½ × 44in), initialed PM-B
1905
Collection of Mr. & Mrs. Albert Otten, New Jersey

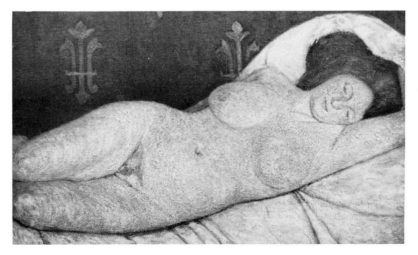

Still Life

cardboard, 37×28cm (14½×11in)
C. 1901[?]
Collection of the Art Institute of Chicago

Woman Sitting by a Birch Tree

wood, 64×56.5cm (25×22¼in), dated 1903
1903
Landesgalerie, Hannover, on loan from
 Frau Ebeling, Hannover

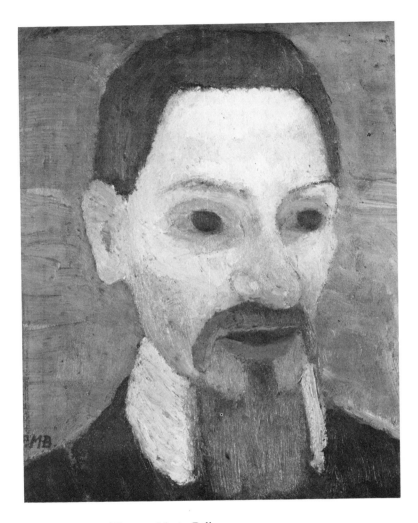

Portrait of Rainer Maria Rilke

cardboard, 32.3×25.4cm (12½×10in), initialed PM-B
June 1906
Ludwig Roselius Collection, Böttcherstrasse, Bremen

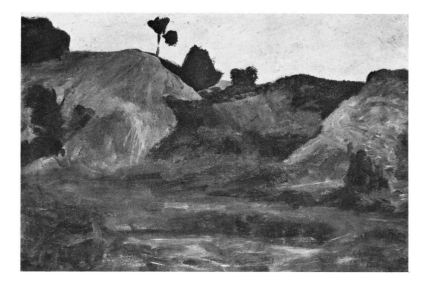

Landscape (*Claypit on the Weyerberg*)
cardboard, 55×74cm (21½×29in), dated 1899
1899
Bayerische Staatsgemäldesammlungen, Munich

Elsbeth

cardboard, 89×71cm
(35×28in)
July 1902
Ludwig Roselius
 Collection,
 Böttcherstrasse,
 Bremen

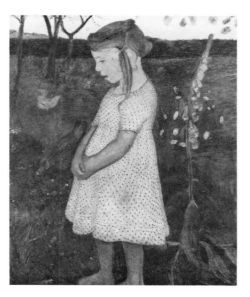

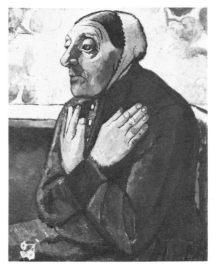

Old Peasant Woman
Praying

*canvas, 75.5×57.5cm
(29¾×22½in)
c. 1906[?]/1907
The Detroit Institute
of Arts; gift of
Robert H. Tannahill*

Portrait of Paula Modersohn-Becker and Clara Westhoff-Rilke
[*or Lee Hoetger and another woman (possibly her sister)*]

*paper, 36.5×46.5cm (14¼×18¼in)
c. 1906/1907
Museum am Ostwall, Dortmund, Gröppel Collection*

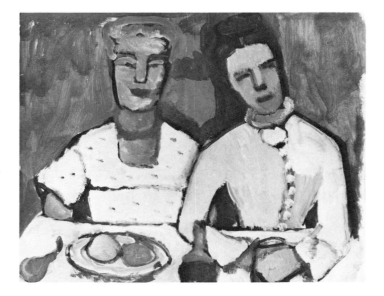

one of those who was gradually hollowed out by the forces
of time. I know little about the family tragedy regarding his
son. I believe it caused him much bitterness. But it's mar-
velous that someone seventy-three years old could still feel
intense bitterness. . . . [13] Dear, having read his book to-
gether before his death is as if we had shook his hand before
his departure.

This death makes me feel very serious, almost religious.
When a tree loses its leaves in autumn one watches it and
blesses the will of nature because energy does not die. A
new green magic arises in the spring. And the spirit, the
spirit of Böcklin, where does it go? Will he reappear to us in
the flowers and trees? Perhaps I'll see him next spring blos-
soming on the Weyerberg. When I think about it my love
and humility increase a thousandfold before each blade of
grass. Even before this I had loved nature so wholeheart-
edly. I believe I'm becoming more religious, perhaps more
so in this irreligious city. You know, Dear, I don't mean
Christian, as there are churches enough here. But I so
seldom see religious eyes.

Next door M is playing Schumann lieder while her
brother G is singing about the walnut tree and the little girl
"who night and day pondered and knew not what." . . . I
have a strange, tender, dreamy sense of life these days. I see
so little of the sky between these big, cold, old new houses,
but I'm aware of it and I carry it inside me. These are days of
gentle whisperings.

This morning your letter accompanied me to my first
cooking lesson. I carried it in my pocket and along with me
it learned to cook salted potatoes, potatoes in their jackets,
mashed potatoes, boullion, sauces, and beef. The two of us
feel luckier than the others. I kiss you, Dear.

My little room is long and narrow. The main furnishing
is a wonderful, soft bed. There's also the desk at which I'm
writing, a wardrobe, and a washstand. Your sketch hangs
above my bed and I awake each morning to its rose clouds. I
gaze at them awhile and linger in Worpswede the first five
minutes of each day. Our picture hangs there too—Clara
Westhoff, you, and me. I look into your eyes each morning.

Do you feel it? Then I turn to my cyclamen, which has me
worried because it doesn't want to bloom. Its little head is
hanging. And then I leap out of bed.

<div align="right">

Berlin, 26 January 1901

</div>

My Dear, again I fetched your letters out of my brown
travel bag, where I keep them, and sat with you in my little
room talking about many, many things. It was beauti-
ful. . . . Here I am in Berlin sitting high up on the fourth
floor, but in spite of this I see little of the sky. In the yard
below me is the constant noise of a beauty beating carpets. I
lead a strange life here, really one all alone within myself. I
try to communicate with my relatives as much as possible
because they are good, kind women. But our communica-
tion goes only so far and then it just stops. And something
remains that sings and hums inside me, lulling me into a
dream in this concrete city. I willingly let it happen because
it's beautiful. So I am dreaming away through our two-
month separation. I hear a lot of music, not at concerts but
in my room, and I feel you near me. I look into your eyes
and feel your soft hands sliding over my hair, my cheeks,
my throat. . . .

I had a remarkable evening at Keller and Reiner's yester-
day. M and I had received tickets as a gift and we went with
little expectation. Through several exhibition rooms, past
some thin, delicate glass and the most wonderful Böcklins,
we came to the back room, which was festively lit with
candles and shaded, dim electric lamps. The cream of Ber-
lin was there. People sat in big comfortable armchairs in-
formally arranged. M and I sneaked off to a quiet corner
from which we could spy without being espied. I sat for a
long time in quiet and simplicity, enjoying the dresses and a
wonderful black velvet hat. Then the electric lights were
turned off and we sat in soft candlelight. The candles were
grouped behind the piano and they shone on a lovely Ver-
rocchio lady holding flowers in her delicate, slender fingers.
We were read aloud a dialogue between Michelangelo and
Vittoria Colonna by the Frenchman Gobineau from his

drama *Renaissance*.[14] The spirit of both these great people
came to me, as it may come to a little girl.

Do you know the love sonnets of Michelangelo?... In
his poetry this hard and immensely strong man was as ten-
der as a babe. He was a vessel that love well nigh knew how
to break open. How it shook him! He surrendered himself
with every fiber of his being and was as gentle as a lamb.
But in spite of this, in each fiber there was more strength
and warmth and humanity than there usually is in one
whole person. And yet he remained silent. When Vittoria
died, this giant ventured to kiss only her brow and her
hands, not her mouth. It fills me with humility and piety to
be allowed to know this about him.

And so I sat at Keller and Reiner's. There was music, a
male and a female voice got involved in one another and
sang of love. I looked around at the blue-draped walls, the
beautiful candlesticks, and some of Rysselberghe's[15] follow-
ers (whom I don't like but willingly suffered at the time)
when suddenly I felt your almost palpable closeness, Dear. I
crept into my quiet corner, where no one saw me and I was
with you. Every evening and every morning I hold a silent
dialogue with you. Evenings, by candlelight, I read one or
another quiet letter. In the mornings I gaze at your sketch
and at your picture. I've also hung up a little print of
Böcklin and I look into those eyes that were permitted to
behold the deepest pain and the deepest joy in the world.
On the other side hangs a yellow garland of immortelles. I
bought the flowers from a little old flower lady on the
Potsdam Bridge and during a quiet hour I braided them into
a garland. After the garland has shone over me and my bed
for a couple of nights I'll send it on to you, Dear.

And cooking? Well, I'm learning. So far I can make
meatloaf, veal fricasse, and carrots—almost. I'm mostly
with future cooks, who can get on my nerves with their
irrelevant training. The head cook told the others I have
beautiful hair. And one cook, from the moment she learned
that my beautiful name is plainly and simply Becker, insists
on calling me "Beckerchen."[16] I take it all grinningly and
good-naturedly.

I see Rilke every Sunday.[17] I visit him in his large room in Schmargendorf and we have a beautiful, quiet time together. He thanks you very much for your letter and sends you his regards through me, even though the addresses on the new envelopes he gave me are his greetings to you, as he said. . . . And Clara Westhoff? Will she be coming soon? Lovely, Dear, that you see each other so often. I feel good about our future when you two understand each other so well. She's such a fine creature. And my greetings to the folks at Barkenhof too.

One more thing, I'd very much like a bright, pretty dress and I have such a wonderful opportunity here. Can you treat me to one? About fifty marks? If you can't, it won't bother me. Farwell for now, Dear. I want to read Hauptmann's *Lonely Lives*[18] to M and Aunt H.

With ardor and my very deep love, I greet you from afar,

Your bride

Berlin, 17 January 1901 [?]

Yesterday, Sunday, I was with M in Friedrichshagen, at the "New Community" founded by Heinrich Hart, you know.[19] It was morning. There were a lot of people there talking about Nietzsche, reading, declaiming the present state of affairs, and reciting the poetry of Herr Hart. Too much vanity, long hair, powder, and too few corsets. Not that I'm exactly for that article of clothing, but one shouldn't be without it. If all those Samsons had but one Delilah to cut off their locks so that they lost their strength, the world would not suffer.

I'm to go to supper at the Gs this evening in a low-necked white silk dress with violets. The Gs are friends from my childhood in Dresden.

So you were in my little room at Brünjes's.[20] Did you wind the clock too? . . . Yes, art! . . . Farewell, my Otto. I embrace you and gaze into your eyes a long time.

Berlin, 31 January 1901

I was just thinking that I no longer wanted white station-
ery, but blue, gray blue, when your big blue letter arrived.
Blue. Even from afar our two minds are one. When one of
us thinks "blue" the other instinctively responds. Isn't that
beautiful?

Clara Westhoff is here. She has told me so much about
you and about how beautiful it is in your atelier, you Dear.
Your letters tell it too. Yet they conceal so much. I'll be
very glad when I finally get to see your work in its beauty.
Such a gentle, wonderful breeze always comes forth from
your letters that I immediately feel how bad things are for
me right now. That is when I'm not myself, or else perhaps
just because I am myself. At least there are so many moor
breezes, and the beauty of the birches, and the all-
encompassing power of nature. Oh, Otto, when we finally
make our pilgrimage to our little moorland cottage and
when we can finally do a thousand other things, it will be
beautiful.

As for Clara Westhoff, we've already seen a lot of each
other—yesterday, a festive hour with Böcklin. The ball less
so. The emancipation of women is very unsightly when
they appear together in gangs.

A quiet evening in Schmargendorf at Rilke's. And now
we are going to the museum. It's still before morning coffee.
I just felt I hadn't been with you for such a long time. I'take
you in my arms with all my love and I very gently stroke
your soft hair.

Your faithful woman

Berlin, 3 February 1901

Dear,

I'm still full of the Annunciation of the angel: "But thou
art the tree," Rilke read aloud.[21] It will come to pass for us,
Dear, and I quietly fold my hands. All I can do is remain
quiet. It's as if my breath comes sparingly and I can utter

only a few words. But they come from my innermost depths
and they must tell you of the things they've seen. These,
then, are my love letters. I don't know whether I've said
what I wanted to say. I am tired too, you know.

Did you receive your garland Sunday? Where is it hang-
ing? I kiss you and bless you. I'll write you a letter tomor-
row, you.

Berlin, 4 February 1901

Am I always writing you about painting and nothing
else? Isn't love in and between these lines, shining and
glowing and quiet and lovely, just as a woman should love
and just as your woman loves you?

Dear, I can not speak my innermost feelings. They are
shy and afraid of the daylight. They come forth in the twi-
light or in the night. You know the world is so strange for
these feelings. With time you'll feel I won't have to speak
them at all, rather that in the hushed silence you will have
blended into me and I into you. I believe it's my virginity
holding me back. And I want to wear it, wear it quietly and
piously, until the hour comes when the last veil is lifted.
And then?— — —

But I don't think about it much in this city—sometimes,
though, as when I'm lying in bed in the evening and your
sketch shines above me, or in the morning when I wake up,
or in a pensive hour—otherwise I don't think about it in
this city because those things that connect my thoughts
with this most holy one are not beautiful and pure. When
spring comes over the Weyerberg and green veils stretch
across the little birches and each young shuddering tree
prepares for fertilization, when the fresh smells of life flow
out of the earth, they will also kiss my brow and blissfully
draw through my whole being. And the impulse will extend
from me to you and it will grow until one day it is fulfilled.
But let me think little about this now and don't allow me to
talk about it. Dear, allow your bride her hibernation.

All that was last night. This morning I'll quickly report
all the beautiful things. Sunday I attended a wonderful

concert with Clara Westhoff, Beethoven's *Eroica* sym-
phony. There's that marvelous funeral march that breaks
through over and over again, solemn and gentle. Then
there's a movement full of the joy of the sun and the uni-
verse. It's so sweet to the sobbing soul. Dear, during the
music the thought strongly came to me that you ought to be
here for my birthday. Will you come? Will you? I don't
want to bother you with one little word more about it.
Naturally, you know best how things are with you and your
work and whether such a trip would inconvenience you. I'd
so like to look at the Böcklins together with you. Any-
way— —

I may buy a little dress for myself? Thank you so much. It
makes me very happy. When I've bought it, I'll tell you all
about it.

 Berlin, 8 February 1901
My birthday, Dear, and your little bride is twenty-five
years old.

You Dear, you mine, you ardent, good you.

Love, love, and more blissful love came pouring out from
the wooden crate and trickled over me. You've strewn so
much beauty and goodness on me—and a sad letter. You
mustn't, Dear, you mustn't worry about a card written in
great fatigue. I'm tired of the city and the cooking and the
people and a thousand other things. I long for freedom, for
air, for people, and I long for you. But I want to be brave
and not complain. Only I feel I probably won't be able to
hold out any longer than February. Is that all right with
you?

Your picture, Dear, was a sweet sound from a different
world, your and my world. All I hear here is a lot of door
banging and carpet beating, and I'm knocking my limbs
sore against the many sharp corners. Oh, when I am once
again with the rosebush and my two people and the floweret
and the birch tree. Here there are just walls, walls, walls,
and swollen Renaissance volutes wherever you look. It's a
comfort to think of you in your simplicity. No, Dear, you

are not complicated—I've been aware of that, and am
aware now, and will always be aware of it. And I thank you
for it. I don't know if I'm complicated. If I am, I probably
have to be. Then I wouldn't call being complicated a fault.
(If only I were with you, I'd quickly be pointing out to you
my strongly developed tongue with that last sentence.)[22]
So, so, so. Plainly I have to be with you soon, true? Mustn't
I? I'm cooking five times a week and learning quickly. Soon
enough I'll be able to cook for the two of us. Besides, you
know you're brooding and ruminating and I'm dying for
lack of air. Clara Westhoff soon will be telling you about me.

Yes, your picture is so beautiful, so very, very beautiful.
That ripple of birches across the evening sky and the har-
mony of the flowers. Yes, Dear, that's how it looks at home.

Write me soon. Write me immediately. We are spending
my birthday today outside in the snow in Grunewald. I
need nature. Then we'll set out for Schlachtensee. The
house where I lived for two winters is empty. You know,
with my aunt and uncle who are in Australia now. This
same uncle is my Norwegian uncle.

Perhaps you feel me with you? I really am always with
you. Or with you in my most beautiful moments. Whenever
I see something beautiful I see it in relation to you.
Whenever I hear music it's as if you were near me, as if I
could feel you. I embrace you affectionately.

Berlin, 12 February 1901

My beloved Man, that was a beautiful letter. Now you
are happy and I am happy. You must promise me never to
be sad again. Or perhaps being sad is only natural. Maybe
it's like taking a breath when you are happy, the soul's
preparation for joy. Only I wouldn't want you to think that
these periods of sadness are caused by me or my letters. No,
they lie within you. They follow a happy mood, as February
does January.

I feel I'm in a philosophical mood today—which in Ger-
man means I'm on thin ice. I'll make for firm ground with
speed so that I don't fall in.

Papa wrote me a touching letter for my birthday. He elaborated upon the matter of my dowry. He wants to give me a thousand marks, which I am supposed to discuss with you. I've told him I need only two hundred marks to do up myself attractively. Hopefully, you'll be satisfied with me then. The rest of the money ought to be kept for the twins' education.

Dear, I have another little something for the house. Another mirror, out of glass, but a small one. It was so charming, I couldn't resist. I bargained for it one night with a most original Jewess. She still has a gray glass tea tray with a carafe and two drinking glasses decorated with tourquoise dots and gold. It's wonderful and has to be ours.

And you, the "little dress" you treated me to for my birthday will be my wedding dress. Just think, I'll have it made here and then I'll be just about finished.

I so often think about our belonging to each other completely this summer. I'll be your loving wife. Now we must think about everything beautiful and prepare everything in and around us, and then the time will not be long. I have samples of very inexpensive flowered wallpaper on which gold frames will look beautiful. Today I wrote a description of a house we might build in ten years. I want always to write down such ideas and you should too. Otherwise one forgets so many of the nice thoughts one has.

Also, I'm thinking of painting Elsbeth[23] with her golden locks. During the hay harvest we will go to a big secluded hayloft and play together like three big children. Oh, I'm always dreaming of so many beautiful things. You too?

I'm sorry you've taken on a pupil. We didn't want to do that just yet. So little money and so much vexation and disillusionment. Can't you put her off?

JOURNALS

Something on building a house. Really, or obviously, I mean a house for Otto Modersohn and myself and our chil-

dren. There should be a regular confusion of stairways, up and down, with rooms on as many levels as possible, forming alcoves and funny corners. The windows in the upper story should go partly down to the floor. Downstairs, a room overlooking the garden, with folding doors to the outside. A few windows with low sills, wide ones you can sit on. Some wide and heavy windows, approximately square, something similar with the doors. The roof, a mansard roof interrupted by a series of windows. If possible, a tower chamber with a flat roof. Lanterns like those on Wilhelmstrasse in Berlin would be beautiful if they could fit in somewhere. A striking, tiny-flowered, brownish or very gray wallpaper.

To Otto Modersohn

Berlin, 16 February 1901
I was with you so much today, Dear, as I am these days and as I am generally. I want to write you a little bit so that you'll have something Sunday. Clara Westhoff will be returning too.[24] She'll tell you all about me and Berlin. Then these final weeks of our separation will fly by more quickly for you. It's beginning to be very difficult for me. At first all the impressions were so new and my spirit was fresh. Now I'm growing weary among all these weary people, who know nothing about this victorious life that smiles upon us. I can tell them about it only as if it were a fairy tale because they've never experienced it. Even then I have to describe it in paler tones and conceal its deep colors because their inability to see its depth would only sadden them. I love this deepness of color as I love my life. I need it to live just as I need air.

Only a little while longer.

Sit down right now, Dear, and on a scrap of paper tell me whether your birthday is the twenty-first or the twenty-second so your little woman will appear on time. And next year? Lying beside you on a big white pillow will be another

head, with a thick reddish brown braid, saying "Good morning" to you.

One more thing. Papa still isn't happy about my dowry, the good man. I'm supposed to buy everything while I'm in Berlin and have the time. I'm to ask you if you think we'll need more linen for the house. Please don't forget to answer as Papa is looking after me with paternal thoroughness.

Oh, were I finished, oh, were I home! I can make quite a lot already. For your sake, for my sake, would I were able to leave. It's only to please my father that I'm still here. Now, somehow, good-bye, you dear man, you.

You write you're painting a nude. Do you have a model? Tell me more.

A kiss from me.

Berlin, 19 February 1901

Dear! Dear! Dear! Today I bought myself chemises and undergarments and nightgowns and all for you. Some of them sweet and Circe-like too. I think you'll like seeing me in them. I carefully chose rather pretty ones, the kind you prefer.[25] Yesterday and today I received a blue letter and I think about the fact that very soon now these rigorous cooking exams will be over. All this and much more contribute to my feeling of jubilant happiness. You're so right, life is marvelous and we two little people are so well off. Although for me it will be completely and totally so only after the end of my Berlin refining process. I can't hold out much longer without painting.

You are so lucky with your art! Hallelujah! And the pictorial idea of a painting centering around a human figure and a human spirit. Yes, it seems like a dream to me too.

You, if you receive a parcel in the mail before the twenty-second, you must not open it. I'm sending it only to the thirty-six-year-old Otto Modersohn.

Dresden, 23 February 1901

My trip from Berlin to Dresden was delightful. Spring

was everywhere, behind each shrub, and I felt it putting
forth new buds. The little brooks were swollen with melting
snow and were rushing swiftly along. The meadows were
covered with big puddles that shouted with joy to the blue
heavens. Spring was everywhere. I thought about
Zwintscher.[26] I was in his area with the vineyards and the
fruit trees and the round towers of the winepress along the
ridge of the hills. In between I read Michelangelo's poems,
which impressed me with their greatness, simplicity, and
humility. What a human being! The starlings are back too.

And next Sunday? Next Sunday at eight o'clock in the
morning I swing myself onto the train and hurry to you,
flinging the world and its glitter behind me. Then I begin
again a beautiful, quiet, serious life in depth, to use Dr.
Hauptmann's phrase. Here and in Berlin I've always wanted
more depth than other people have, which caused con-
tinual friction.

I haven't heard anything from you in a long, long time. I
always assume you're painting something beautiful and, as a
humble woman, I feel that naturally takes precedence. My
relatives send you their heartfelt greetings and we are in-
vited everywhere in the most hospitable manner.

I write fewer "love letters" now than before? I read *Lear*
and was completely under the spell of its greatness. I read
that Cordelia loves and is silent. It seems a similar feeling to
me. Moreover my spirit is exposed to a lot of dust and
convention in this city air.

You're affectionately kissed by

Your girl

February 1901
Dear, I feel like that couple we saw in *The Magic Flute* in
Hamburg. They had to overcome so many ordeals in order
to attain happiness. With my homesickness this Dresden
sojourn is only a new ordeal. I'm offered so much unde-

served love and goodness here. But I'm tired of the world and I long for my quiet little room and for a different work than cooking and traveling. Soon now the matter will really end and I'll be with you again and in my element. Fish belong in water and I in solitude. I've realized it again.

Aside from cooking, perhaps I've profited some inwardly. Yesterday in the Dresden Galerie[27] I unexpectedly chanced upon your picture of the little old woman. It was a great joy suddenly to hear those familiar, lovely tones. And your latest pictures are even more fully developed, especially technically. Perhaps you painted this one over a different ground color? There's some unevenness in color and the hut stands out more solidly against the sky than it does here. But it's still an Otto Modersohn and it makes me happy.

Berlin, 8 March 1901

I'm sitting here next to my packed trunk, detained by a motherly telegram. I'm not supposed to leave yet and just keep cooking, cooking, cooking. But I can't do that any longer. I no longer want to and I no longer will. That's asking more than a human being can do. It would be wasting spring to be hungering for it here behind these high walls. So I'll still leave Saturday. I hope it won't be unpleasant at home. And Sunday I'll come to you. True enough. Despite everything. I have to see all your pictures. I can't bear it that so many eyes have greeted them and not mine. Yes, I'm having to fight my way through a magic fire before I can attain my peace again. But this peace is worth the struggle.

Now Sunday! I kiss you. My soul hungers so for depth, for a more ardent deepening and beauty. It's not here. Such a city makes one shallow, at least it does me. And I don't want to be superficial. I have no wish to be, let alone delight in it.

Be kissed for me. . . .

To Her Mother

Berlin, 8 March 1901

My dear Mother,

That my return will be so unwelcome and upsetting makes me very sad. I'm so very sorry to cause Father anxiety, especially when I know he's more nervous these days than ever. Being in love—how can I write it in words to you? There's no other way for me at all but to come home. I'd so much like our reunion not to be gloomy. It isn't an occasion for gloom and sadness. From the beginning I stipulated two months for my stay in Berlin. I've used my time well, Mother. But now no more. Something inside me that will not be quieted is crying for air. I wrote you about this in a letter before, but you took it for a carnival joke. I'm leading a life here that is not mine. My most inner self is hungering, hungering for depth and peace. The way I approach art here and that which is to be the most important event in my life is made superficial by such circumstances. It distresses me that my soul can't be happy and excited here, as it has to be. Now my soul is demanding freedom of me and I am giving it that. I'm not holding myself back any longer.

It's not just a longing for Otto Modersohn that is driving me, I can't bear this carpet dust and these tall houses any longer. Why should I? I've learned a lot about housekeeping. I know I'm not perfect. But really one can only learn in one's own circumstances.

Dear Mother, I'm writing all this to you because I know that you too recognize this voice in us that is determined. It's our most individual voice. I'm giving in to it. Don't think of me as wicked or heartless. I can not do otherwise. I must. And I'm glad I have this determination in my nature because it's instinct that guides me.

Dear Mother, my letter is very confused. But it disturbs me to make the two of you angry. I'm writing you hoping you'll take my part with Papa in your own lovely, more tender words so that our reunion won't be upsetting. It's so

sad that the two of you are angry with me. But now and
then there are things about me that make you happy, I
mean other than my engagement.

Read this letter with Milly and talk it over with her. Try
to put yourself in my soul a little. I yearn for freedom, I
yearn to burst my chains. It's not bad of me. Nor is it
weakness. It's strength. It's good that I free myself from a
situation that deprives me of air.

Here I stand, I can not do otherwise. Amen.

<div style="text-align: center;">Your Paula</div>

Footnotes: Chapter IX

1. Selz, p. 26.

2. *Stories of God (Geschichten vom lieben Gott)*,
 Insel-Verlag, Leipzig, 1901, thirteen stories writ-
 ten by Rilke in November 1899 and originally
 subtitled "of God and other matters told to
 grownups for children."

 After spending this afternoon together Rilke
 wrote that he read aloud to himself his poem
 dedicated to Becker, "The Singer Sings Before a
 Child of Princes" ("Der Sänger singt vor einem
 Fürstenkind"), "and followed the willing verse
 on and on and thought you still here, hearing
 and remembering. And it really was as though
 you were quite near—there, where my words
 come to an end, at the outermost edge of sound."
 M. D. Herter Norton, *Translations from the
 Poetry of Rainer Maria Rilke*, New York, 1938, p.
 240.

3. Goethe's poem "The Nearness of the Beloved"
 ("Nähe des Geliebten"):

I think of you when the sun's shimmer
Shines from the sea;
I think of you when the moon's glimmer
Reflects in the springs.

I think of you when on the distant road
Dust rises,
In the deep night when on the narrow bridge
The traveler trembles.

I hear you when with a dull roar
Waves rise.
In a quiet wood I often go to listen
When all is silent.

I am with you, however far away you may be,
You are near me!
The sun is setting, soon the stars will shine on
me,
Oh, were you here!

4. Altes Museum.

5. *The Consolation of the Widow*, retitled *The Mennonite Minister Cornelius Claesz. Anslo in Conversation with a Woman*, 1641; *Joseph's Dream in the Stable at Bethlehem*, 1645.

6. The Böcklin "photograph" was a photogravure of his painting *Spring Song* (*Frühlingslieder*), 1876. The München Photographisches Union published 150 photogravures of Böcklin's paintings in four folios.

7. "The latest Hauptmann," *Michael Kramer*, was being performed in Berlin at the time. In the last act Kramer, the hard-working artist without genius, pronounces a funeral oration for his son, the lost artist, the genius, who took his own life. *Hannele*, 1893, is a drama of the fantasies of a dying child.

8. Joseph von Eichendorf's lyric "Moonlit Night" ("Mondnacht"):

It was as if the heavens had
Quietly kissed the earth,
So that she in a glitter of flowers
Now had to dream of him.

The breeze blew across the fields,
The grasses waved gently,
The woods rustled softly,
So starry was the night.

And my soul spread
Wide its wings.
Flew across the still lands,
As if it were flying home.

9. Modersohn's letter came in an envelope addressed by Clara Westhoff. Rilke addressed Becker's envelopes to Modersohn. Even at a distance of three hundred kilometers Becker and Modersohn continued to defer to convention and carry on their correspondence discreetly.

10. Probably a copy of Verrocchio's *Portrait Bust of a Lady* on display at Keller & Reiner's, dealers in fine arts, furniture, and decorative arts. In illustrations accompanying the article, "Die Wohnungsausstellung von Keller & Reiner in Berlin," *Dekorative Kunst*, March 1901, pp. 209–17, there are reproductions of Greek and Renaissance sculpture in Jugendstil interiors. Heinrich Vogeler was one of the artists/designers included in this exhibition.

11. In the Kgl. Nationalgalerie.

12. Possibly they read Böcklin's authoritative dicta on painting in Rudolf Schick's diary,

Tagebuchaufzeichnungen aus den Jahren 1866, 1868, 1869 über Arnold Böcklin, Berlin, 1901.

13. Böcklin died January 16, 1901. Perhaps the tragedy regarding one of his fourteen children (only six of whom survived him) was that involving his namesake Arnold, as told by Dr. H. A. Schmid in the biography appended to the München Photographisches Union publication of Böcklin photogravures. Böcklin was upset by what he assumed was indifference on the son's part to his father's illness. The son, however, had been away on a cruise owing to his own ill health. When he returned after several weeks he did write his father to make amends, and then the son died shortly thereafter.

14. Count Joseph-Arthur de Gobineau's *La Renaissance,* 1877, a series of dramatic dialogues from the lives of Michelangelo, Caesar Borgia, Savonarola, *et al.*

15. Théo van Rysselberghe (1862–1926), Belgian Neo-impressionist painter, participated in the decorative arts revival of Art Nouveau and designed posters, furniture, typography, and jewelry.

16. Becker had a completely different reaction when art students addressed her by this diminutive. See p. 18.

17. During one of these weekly visits Becker showed Rilke her journals. In a letter dated 24 January 1901 (*Letters,* p. 56) he referred to her writings and assured Becker:

> You haven't lost your "first twenty years" [see p. 75], dear and serious friend. You have

lost nothing that you could ever miss. You
didn't let yourself be bewildered by the eyes in
the veils of Schlachtensee that look out of the
space which is not water and not sky. You
went home and created [see p. 158]. Only a
great deal later will you feel how much. In your
heart you will feel it. And someone is going to
feel it in your life. The person who receives
and enlarges it and will lift it into new and
broader harmonies with his ripe, rich, under-
standing hands.

Such was my evening tonight. So it ends as
though in prayer. I thank you for it, today and
always.

Midnight.

18. *Lonely Lives* (*Einsame Menschen*), 1891, a play in
five acts about a man's vacillation between two
women: one, his attractive wife; the other, an
older, unmarried, good-looking philosophy stu-
dent (a rarity in 1890). When the wife's parents
intervene and the student leaves the household,
the husband drowns himself.

19. The home of Heinrich Hart and his brother
Julius in the Berlin suburb of Friedrichshagen was
a center for gatherings of writers belonging to the
Naturalist movement. The "New Community"
("Neuen Gemeinschaft"), made up of "en-
thusiasts, poets, and Socialists," attempted to lay
the basis for a new philosophy of life. Wilhelm
Bölsche (Friedrichshagen), "Heinrich und Julius
Hart," *Die Gesellschaft*, Jahrg. 15, 1899, pp.
38–48.

20. In his journals from 27 January 1901 Otto enu-
merated those qualities that first attracted him to
Paula: her liveliness and cleverness, her rich
chestnut brown hair, her merry laugh, her

"young, fresh appearance" as she walked "piquantly, putting down the toes of her foot first" past his house with one of her poorhouse models, and her naturalness whenever she visited him and his wife Helene.

As for her paintings, he mentioned only his visit to her atelier before the Bremen exhibition. "They did not please me, weren't intimate, too poster-like, which I told her. After the terrible review in Bremen she came with Frau B to my atelier, cheerful, but still mad about Fitger." He then went on describing her charming person. Gallwitz, pp. 247–48.

21. Rilke's poem "Annunciation" ("Verkündigung"), written in Worpswede in 1900, appeared in *The Book of Pictures* (*Das Buch der Bilder*), 1902.

22. Becker is referring to the pronunciation of this sentence in German.

23. Otto Modersohn's daughter, born 1898.

24. Westhoff had been visiting both Becker and Rilke. Rilke, in what seems a veiled reference to his engagement to Westhoff, wrote Becker on 17 February 1901, "Life is serious, but full of good. I am happy too. So much lies ahead of me. You will soon hear how much!" *B. u. T.*, p. 99.

25. With the passing of the Victorian era "underclothes developed a degree of eroticism never previously attempted." " 'Garments not destined for a public career' " began to occupy much attention in fashion magazines: " 'There is something very attractive . . . about the elaborate petticoat and its frou-frouing mysteries' [The Lady's Realm, 1901] . . . 'we must frou-frou till we can't frou-

frou any more.'" Accordingly, fashion magazines
were now advising women to spend large portions
of their trousseau money on these garments as
"'lingerie is by far the most important part of the
trousseau.'" C. Willett and Phillis Cunnington,
The History of Underclothes, London, 1951, pp.
201, 202, 218.

26. Oskar Zwintscher (1870–1916), portrait painter
 and poet, apparently well thought of by the
 Worpswede circle, as Rilke asked him to paint
 Westhoff's portrait "in order that her 'first
 beauty,' before the 'second beauty of
 motherhood,' might be preserved for their chil-
 dren and grandchildren." *Letters,* p. 374.

27. Kgl. Gemäldegalerie.

X. Worpswede and Schreiberhau, 1901–03

Spring in Worpswede—the weaver married the illustrator, the sculptor married the poet, the painter married the painter. The painters' ceremony, performed by Modersohn's brother, took place in the Becker home in Bremen. Herr Becker was terminally ill and could only watch from his bed in an adjoining room. [1] Afterward the young couple went on a honeymoon trip that included a visit to playwright Gerhart Hauptmann and to the Munich art museums.

But the Worpswede idyll did not last. Becker commented on the strains in the Schröder-Vogeler relationship. Finances forced a radical change in the Westhoff-Rilke marriage. And Becker herself observed that "marriage doesn't make one happier I'm probably just as lonely as I was in my childhood." Her sense of loneliness was compounded by a rift in her friendship with Clara Westhoff. Whether as real as Becker felt it or as contingent as Rilke characterized it, the change in Westhoff's attitude affected Becker deeply. "My heart longs for one soul. . . Clara Westhoff."

The emotional upheaval of these years—the death of her father, the disruption of her closest friendship, the disappointment of marriage—made Becker turn to painting with even greater concentration than before. She had never wavered in her desire to be a painter, and now that constancy was her refuge. After a winter of doubts summer in Worpswede in 1902 brought Elsbeth: "In this work my creative power has grown, my expressive power. I know that many other good works will come after this one." (See illustration.)

To Her Aunt Marie

Worpswede, 23 March 1901

My dear Aunt Marie,

I can't describe what I'm experiencing now, which is perhaps one of the other reasons I don't write. We really ought to see each other. Is it possible? Even then it wouldn't be easy to put it into words, but perhaps you would see and feel the happiness in the air here. A great, wonderful happiness. Is it possible?

You Dear, how unexpectedly and richly you have blessed me. The mail carrier thought I had sold a picture. But that wasn't it. What it was was my first wedding present. Isn't it too much, Dear? It seems quite overwhelming to me. I'll have to consult with my Love this evening about how to spend it. Now, you know we do more than just play guitars and practical jokes. We're very sensible people, as far as it's in our bent. Thank you sincerely, dear Aunt Marie.

Oh, it was beautiful coming home. And it's wonderful being here! Here I forget the whole world. My lovely brownish red room and my small blue bed chamber with its snow-white valance are full of a thousand spring catkins. He and Clara Westhoff put them here for me so that hour by hour I would feel that spring is here. And I do.

I'm in and out of our house. We're making plans together to remodel it. In the middle of everything our little girl chirps and laughs and laughs. Then all three of us embrace and chant a happy Indian song.

Our love is having a marvelous effect on his art. Suddenly many of the veils that lay over him fell away and now everything is coming out into the light in so many ways. Inside himself he's always working on new pictures. I wish you could see this magnificence someday, and him in its midst—simple and childlike and boyish in his happiness. I stand here meditating, quite pious and humble before the innocence of this soul. His life is nature. He knows each bird and its habits. With love and care he tells me about birds and butterflies and their lives.

There's so much happiness around us. Soon Heinrich Vogeler will be returning home from his honeymoon with his slender blonde girl. And in a few weeks Clara Westhoff will marry the poet Rainer Maria Rilke, a friend of everyone here.[2]

And on top of everything, it's spring.

Worpswede, 22 April 1901

Dear Aunt Marie,

The nightingales are here. Everything grows more and more beautiful. One can hardly believe that there is such beauty. Outside, the chestnuts in front of my window are visibly splitting open and we two blushing people are planning our wedding. The house is being painted and fixed and we are in high spirits. Pentecost is our wedding day. . . .[3]

To Her Family

Schreiberhau,[4] *June 1901*

You Dearests,

It's June, but which day? Who knows? The waves of another world are engulfing us, and a large part of our life consists of gently tugging each other by the sleeve so that we won't be run over. The sun came out, but it meant us awful harm and we longed for a thunderstorm. In Meissen we didn't seek out the poetic places, instead we looked for the rare shade.

It's become quite clear to us that our honeymoon is one of the ordeals in *The Magic Flute.* I mean that all the arrangements made for most people are just not for us. For example, the iron collar of circular tour tickets wants to close even tighter around our necks in Prague and Munich.

But at the moment we are living in peace and quiet in a saving, divine rain and with good, fine people. The spirit of the great Gert[5] reigns everywhere. He fills and towers over

everyone. He was here with his sons a few days before we arrived. We found the whole house empty—the fellows had gone to Dresden. Our letters and telegrams arrived only yesterday. But we were well received by their circle of friends.

I'm still not settled in myself and I can't yet assess everything. Sometimes I go outside for a quarter of an hour to pick white hemlocks and try to put myself in order and smooth the ruffles. We'll be all right once we're back on our Weyerberg. Bless our hill and all who live on it a thousand times.

Schreiberhau, June 1901

You Dears,

It's Sunday and everyone's going to Warmbrunn, to Dr. Hauptmann's mother. He's very attached to her and visits her every Sunday. Then tomorrow to Agnetendorf, to the great Gert. Simply everything on earth is imperfect, and the drawback to our good Dr. Hauptmann is that he suffers from his brother's fame. Everything's so full of conflict. Intimacy often riddles the greatest people with conflict. One learns a lot here in the wide world. One learns to be very tolerant. The two of us hold long panegyrics on the clean, innocent, simple air of our Weyerberg and all its people.

We'll probably be leaving Tuesday or Wednesday, stay a day in Prague and three in Munich, so we'll be home Sunday or Monday. Then we'll sit next to our dear Father's bedside and tell you everything by turns. We're both fervently looking forward to our work, which we are awaiting with open, longing arms.

The people here are all especially charming and delightful. What makes me very happy is that they feel and understand some of Otto's character. Foremost is our dear Dr. Hauptmann, full of learning and seriousness, striving after the highest good, and full of love for it. He would be perfect in himself if he were not his brother's brother.

His wife is a warm-blooded, clever creature with a sharp eye for his work and full of good advice. She has a quick, natural vigor in any situation. She was raised with her five sisters in a Moravian convent. When they returned to their wonderful but motherless mansion in Kötzschenbroda the three Hauptmann brothers came and married them up, one after the other. The new world she entered neither surprised nor alarmed her. She has gone her own way quietly and surely to this day, which isn't often easy. But she manages it as if it were the most natural thing in the world.

On the whole the scenery leaves us pretty cold here. Schreiberhau is much too much a resort town for our taste. But up at Schneegrube[6] it's beautiful. This vagabond life is not for the two of us.

Our self needs a quiet and sure base, peace, and our kind of landscape in order to collect ourself.

With his brow knitted, Otto is pouring over the timetable for our trip to Prague. Kisses from your two children.

Schreiberhau, June 1901

You Dears,

This is our last day in Schreiberhau, we're leaving tomorrow.[7] Our amiable hosts wouldn't release us any earlier, even though I am anxious to be back with you. I'd like to see my dear Father again and see if he's any better than when we left you. It seems months ago. And I've had enough of the mountains, I sigh for the plains and especially for my quiet hermitage.

I am silent among all these expressive people. What a quiet, pure talisman rests in Otto's heart. There's no delusion, there's quiet, determination, and evenness. The ground is so well prepared and one feels it is good to be here. At the moment he is, I believe, having his skull measured by Dr. P to determine whether he belongs to the glorious caste of long skulls or whether he's condemned throughout his life to live and struggle in the sad consciousness of a round skull.

JOURNALS

Worpswede, 22 October 1901
There have been three young wives in Worpswede for
some time now. And the babies are due around Christmas.[8]
I'm still not ready. I must wait a while so that I will bear
magnificent fruit.

Clara Westhoff has a husband now. I don't seem to fit
into her life any longer. I just have to get used to it. I really
long to have her still be a part of mine because it was
beautiful with her.

TO HER AUNT MARIE

Worpswede, 20 December 1901
Dear Aunt Marie,
 Thank you for your letter and all your kind words. Yes,
Christmas is coming, Christmas without him. Mother
wants to stay quietly at home and think about him and
about all the other Christmases. She's very peaceful. There
was something transfiguring about Father's death. He was
free from care during the last period of his life. He had
retired from business for us a half-year ago. This past half-
year was a gift to us and we lived each day consciously. In
his last days Father had great inner peace as he had not had
for a long time. He wasn't worried about what would hap-
pen after his death. There was quiet within him as he
prepared for eternal rest. The night he passed away from us,
he wore a marvelously peaceful expression that reached the
sublime. Across his mouth and brow lay before us the ex-
pression of a life without regret. I feel we should be silent.

'Thy will be done. We have all grown closer together through his parting. Love each other—that was his wish.

To Clara Westhoff-Rilke

Dear Clara Westhoff,
 . . . Ever since the afternoon I brought money to you in your little room at the hinterm Schloss you've been very withdrawn. And I who have a different lot in life am the one who's been hungry.[9] Isn't love many faceted? Isn't it like the sun shining upon everyone? Must it give all to one person? And take everything from the others?
 Is love even allowed to take? Isn't it much too kind, too great, too all-embracing? Clara Westhoff, live as nature lives. Deer flock together in herds, even the little titmice in front of our window have their communities, not just their families.
 I listen to you a little in sadness. Rilke is too strongly and blazingly evident in your words. Does love demand that the one become like the other? No, a thousand times no. Isn't the union of two strong people so rich and so blessed for the very reason that both rule and both serve in simplicity and peace and joy and quiet moderation?
 I know little about the two of you, but it seems to me that you've laid down so much of your old self, like a cloak spread for your king to step on. For your sake, for the world's, for art's, and for my own, I'd like you to wear your golden cloak again.
 Dear Rainer Maria Rilke, I agitate against you. I feel it necessary to agitate against you—I intend to do so with the thousand languages of love, against you and against the beautiful, colored seals that you press not only on your finely written letters.
 Clara Westhoff, this past year you lived in the place in my heart where my husband and Gerhart Hauptmann live.

I believe I have a faithful heart, a simple German heart. And I also believe no authority in the world gives you the right to trample my heart underfoot. If you do, you are not the better for it.

Is it love demanding this? Think about the *Ninth Symphony*, think about Böcklin. Don't these overflowing emotions argue against your new philosophy? Don't shackle your soul in chains, even if they be golden chains that ring and chime sweetly.

I bless you two. Isn't everything as we six once thought it would be? When you're with us aren't your souls united with a larger community? Can't we prove that six people can love each other? This would be a pitiful world if it were not possible. And isn't ours a beautiful world, a world of the future? I am your old Paula Becker and I'm proud that my love can persevere and remain unchanged.

I thank you very much, dear Friend, for your beautiful book.[10] But please, please, please don't pose us any riddles. My husband and I are simple people, we are bad at solving riddles. Afterward our heads ache, and our hearts.

JOURNALS

24 February 1902

I laid a garland on the grave of her who once was worthy of his love. It was morning. There was snow on the ground, yet a finch was rehearsing its love song.

I was walking along with a smile in my heart as if in a dream. The snow was a carpet under my feet, crisp and brittle from last night's frost. My feet sank into it, softly crunching a little. Close by was the green of the winter rye. Its growing life had conquered the snow. My smile was rather curious. Perhaps I was thinking of where my feet were walking.

I have at times thought about my grave and imagine it

different from the other one's. There must be no mound. It should be a four-cornered oblong bed with white carnations planted round it, encircled by a small smooth gravel path bordered again with carnations. Then a wooden frame, quiet and unpretentious, around my grave to support the weight of roses. At the front of this trellis, a little gate through which people can come to me, and a small, unpretentious, quiet bench at the back where people can sit and face me. It should be in our Worpswede churchyard, in the old part, not in the corner but by the hedge that borders the fields. At the head of my grave, perhaps two small junipers; in the center, a small black wooden plaque with my name—no dates or words.

That's how it should be. . . . There should be a vase where one could place fresh flowers for me, which I'd like very much.

To Her Aunt Marie

Worpswede, 27 February 1902

Dear Aunt Marie,

If I write you very seldom, you must not look for the reason in our relationship but in my nature, which, I feel, is poor in its expression. If I were still engaged, I feel I would write less than most brides-to-be.

At the moment I'm sitting in my little room of old and I can really say that I spend my happiest hours here. I do things or I think about what I will do or about what I've done recently. Or I read. Lately I've been very absorbed in Gottfried Keller,[11] whom I understand more because of Böcklin's very tender, very patient friendship for the poet in his last years. Thoroughly, thoroughly German. Keller's end was largely eclipsed by illness, but breaking through the throes of death again and again is the brilliant golden vision of the poet. During his last days he had marvelous visions and hallucinations, which, because his nature was not in

the least fanciful, seem all the more true and beautiful. I felt very serious and solemn and grateful as I read about his death.

I'm very pleased that you think of me in connection with your painting Fräulein. Otto and I admire her teacher, Kalckreuth, as one of the most sympathetic Germans. Last year in Dresden we saw his portrait of his wife, which numbers among the most heartfelt portraits I know. So true the way a German husband paints his wife. Someone like him contributes many wonderful things to the deepest consciousness of our nation. Most people have lost their little bit of Germanness in these times of *Reise-Zeitung*. They no longer have an ear for its sound. The art leaders in our beloved Dresden refused to purchase this portrait when it was offered to the Galerie for acquisition. They didn't want "such an ugly governess." In Munich, in the Neue Pinakothek, hanging all by itself, is a small picture of a refreshing little garden after a storm where a mother walks with her child. The whole thing expresses in a wonderful way the fresh crispness of color and expression that nature has right after rain.[12] My regards to your Fräulein and I hope she becomes something. It makes no sense for me to send you some of my things. We'll wait a little while. I feel myself still growing and growing, which makes me very happy, almost religious.

Spring arrived today and it's dripping and drizzling from the melting snow. Up in the sky sang the most lovely species of lark, the bell of heaven.

Living in the village now is a young musician from Dresden named Petri,[13] who provides us with heavenly Bach.

JOURNALS

27 February 1902
It's dripping, dripping, dripping, in front of my window. A melting crust of ice is making this watery, quivering

noise. Outside in the apple orchard in front of my window
the snow spreads out in white sheets. I think it will disap-
pear.

Easterweek, March 1902

During my first year of marriage I've cried a lot and
often—as in my childhood, I cry big tears. It happens when
I hear music or when I'm moved by something beautiful.
When I come right down to it, I'm probably just as lonely as
I was in my childhood. Sometimes this loneliness makes me
sad, and sometimes happy. I feel it deepens me. One lives
little for external appearances and recognition. One lives
an internal life. I believe it's out of such feelings that people
used to enter cloisters. My experience is that my heart longs
for one soul whose name is Clara Westhoff. We're no
longer able to find each other. We're going different ways.
Perhaps this solitude will be good for my art, perhaps my
wings will grow in this solemn silence. Blessed, blessed,
blessed.

I welcome the spring outside with ardor. It is to conse-
crate me and my art. At this moment spring strews flowers
in my path. I found yellow coltsfoots in the brickyard. I've
carried them around with me and held them up against the
sky, where their yellow appears so deep and brilliant.

Easter Monday, 31 March 1902

It's my experience that marriage doesn't make one hap-
pier. It takes away the illusion that previously sustained
one's whole reality, that there is a companion for one's
soul.

One feels doubly misunderstood in marriage, since be-
forehand one's whole life was directed at finding a compan-
ion who was understanding. Perhaps it is better to be with-
out this illusion, eye to eye with the great lonely truth?

I write this in my house book, sitting in my kitchen,
cooking a roast veal, Easter Monday 1902.

Evening, the same day

It seems to me Böcklin has learned a lot from Titian. He never or seldom mentions him. Is he close to him spiritually? Böcklin could have painted the hand with flowers in Titian's *Flora.* With what facility those great Renaissance people brought their great pictures onto canvas. I'm looking at a book on Titian.[14] It looks as if such big sumptuous pictures, figures with landscape backgrounds, all finished so mignificently, with everything subordinated to the great concept of the picture, not at all realistic but full of the most beautiful, colorful enticements of modern perception—as if this were the art of the future. Is it a part of my art? Titian was a painter, a rich spirit full of feeling and real creative power. I'd like to see him again. I speak now only from the reproductions. Perhaps the originals would have an entirely different effect on me.

2 April 1902

I believe that what makes me happy is the hope of having my wishes fulfilled. Once I have what I want in hand, it doesn't seem as exciting. Then it seems just a natural stage of development about which one needn't be surprised or excited.

It's like a child wanting to be big and grownup. When the child is grown, being grownup no longer holds any attraction. That's why Paris was such a happy time for me. I had such strong hope. And this hope excites me in spite of everything and everybody. It gives my whole being such a proud strength.

April 1902

Böcklin risked everything in the world! It's beautiful that my life touched upon his in time. One feels one belongs to the epoch that produced him and, therefore, one can understand him better.

Heinrich Vogeler often says how sorry he is to let his pictures out of his hands and out of his house. For me this is

a sign, in the end, of the paucity of his art. A sumptuous, ever-renewing art that thinks only of the future—this is the greatness, the hopefulness that speaks to me from Otto's work.

Probably every young painter has this hope for the future. It provides the energy for the first great flight. Then most of them become torpid. They're not in the future enough, they live artistically too much in what has been.

To be honest, I have nothing in common with Overbeck-type art. I don't feel its inner necessity. Or, better said, it's like the sterile worker bee, whose number is legion and who works with all its might to serve a fruitful queen. [15]

To Her Aunt Marie

Worpswede, 22 April 1902

My dear Aunt Marie,

It's the season for building bowers. Otto and Henry [16] have already put together three very pretty ones: the first under an elder bush, the second under the birches, and the third is a pumpkin bower. We want to make two more. You can imagine what a cozy and comical effect our little doll garden has. In the middle stands a silver glass ball like a brilliant jewel. We're all very happy, Elsbeth not the least of us, about all these pretty spots. I'm planting roses and wildflowers in profusion, wrapping the invalids in cloths and rags, watering those going dry, pulling weeds, dirtying my hands. . . . [17]

The ancient mail carrier is coming along and I want this little epistle to go today. So, a quick kiss in closing.

Journals

2 May 1902

Rilke once wrote that spouses have the obligation to

stand guard over the solitude of each other.[18] But isn't it a superficial solitude that has to be guarded? Doesn't true solitude lie totally open and unguarded? And no one penetrates solitude, although sometimes we wait for someone with whom to wander hand in hand through valley and meadow. But perhaps waiting is only weakness, and it serves to strengthen us when no one comes. Then this wandering alone is good and points out to us many deep and shallow places that we would not notice with someone else.

It seems to me it might be difficult to end life well. The beginning was easy. But now it's more difficult and there are many inner struggles. Anyone can cast a net overboard, but to make a catch!

29 May 1902

I stood in the grass in my bare feet while my husband painted me. First I wore my wedding dress[19] and then a rose, a blue, and finally a white satin dress trimmed in gold. The rose dress was open at the back and sleeveless. I was standing in the sun, and whenever a hint of wind swept over my bare neck, I would smile a little and my eyes, which were closed in the bright sunlight, would open for a moment. . . . The grass around me was sown with white starwort. I picked a handful and looked at them against the bright sky and at the play of their shadow on my arm. I was in a dream though awake, and I looked on my life as though from another life.

3 June 1902

Someday I must paint using very striking colors. Yesterday I laid a bright silver-gray satin ribbon on my lap and bordered it with two black patterned silk ones. On top of them I laid a small, dull, bottle-blue-green velvet bow. I'd like to paint something in those colors.

We're reading a book by Franz Servaes about Segantini.[20] Otto's immensely excited by his technique of putting colors next to each other purely mosaic-like, in order to produce a concrete, luminous effect. He's enthusiastic

about movement in color. I dream about movement in color too. About a subtle shading, a vibrating, a shading of one object by another. But the means I want to use are entirely different. This heavy application of color is too material for me. I'd like to produce it by way of glazes, possibly over a heavily painted undercoat. A glazing different from what Otto has in mind. He's familiar with only a single glaze, which he then covers over with paint. I believe you can lay ten glazes over one another as long as you do it correctly. When I'm more accomplished I'd like to give my pictures a greater vitality. But I'll try to do this in the foundation. Later I'd like to paint on a gold ground.

To Her Mother

Worpswede, 10 June 1902

My dear Mother,

I'll be thinking about both of you tomorrow on your wedding anniversary because Father lives on in all of us. He blesses us with his presence. Accept quietly all this love as the representative for the two of you and be kissed on the hand by

Your child

Worpswede, 27 June 1901

My dear Mother,

. . . Absconding at five in the morning last time you were here! This goes totally against our Worpswede regimen, which consists mainly of a good night's sleep. I'm always glad Otto sleeps in the same deep childlike way I do, especially this summer when we're painting most of the day. Even after supper we two rush across to the poorhouse to paint color studies of the cow, the goat, the old three-legged people, and all the poor children—who in my experience are the only ones here who sing. Of the adults,

only the drunken ones sing. There's so little song in these heavy types.[21]

It's very hot today, as you can probably tell from this letter. This notwithstanding, my master comes and calls me to paint—bathing youths. It's certainly the weather for them today. . . .

<div align="center">6 July 1902</div>

My dear Mother,

It's Sunday morning and I've escaped to my dear atelier. I'm sitting all alone in my dear Brünjes's house. The entire household seems to have gone to church. I had to force open one of the rickety windows in order to let myself in.

My Mother, there's a good reason why this is not my punctual Sunday letter—namely, work. Work, in which at present I am involved heart and soul. There are times when this feeling of devotion and dependence lies dormant. Times when I read a lot, joke around, or just exist. Then all at once this feeling awakens and surges and roars, as if the container would nearly burst. There's no room for anything else.

My Mother. Dawn is within me and I feel the approaching day. I am becoming something. If only I could have shown our Father that my life is not just an aimless shot in the dark. If only I could have accounted to him for the part of himself he planted in me! I feel the time is soon approaching when I won't need to be silent and ashamed, rather I will feel with pride that I am a painter.

I've made a study of Elsbeth. She's standing in Brünjes's orchard with a couple of chickens running around, and next to her stands a big, blossoming foxglove.[22] Of course it's not earth-shaking, but in this work my creative power has grown, my expressive power. I know that many other good works will come after this one. I wasn't sure during the winter. This feeling and knowledge is blessed. My dear Otto stood by, shaking his head, and said I was one devil of a girl. We love each other heartily and talk about each other's art and about our own. Oh, when I'm finally something, it'll take a weight off my heart. Then I'll be able to

look Uncle A bravely in the eye and I won't have to put him off with all kinds of promises. He'll have the satisfaction of knowing that his kind subsidy was a good investment. And I'll be able to face all the other people who treated my being a painter sympathetically and sensitively, like a funny little obstinate spleen that one has to put up with. You think I'm getting cocky.

I often carry the words of Solomon (or David) in my heart. Create in me a clean heart, O God; and renew a right spirit within me. Cast me not away from Thy presence; and take not Thy holy spirit from me. . . .[23] I don't know if this is identical with the feeling I'm talking about. But it's curious that ever since my childhood, whenever there's been the danger of my becoming too proud I've said these words to myself.

And you? We both enjoy your letters. But, Dear, don't stay up until one in the morning so often! You must consider the main purpose of this trip the health of the youngster and yourself. Kiss Herma for me. I hope that someday in her life she will have a feeling similar to mine today. The path, though, is long and you have to have hope in your heart to keep you from becoming weary. My Herma, seek such hope! You innately are really a smart little one. Don't grow up too soon and be premature. A fruit slowly ripened in the wind and the sun—that's how life should be. Stay away from too many books and from the theater. Instead look for activities suitable to your age. Insist on going to Gymnasium. Try not to skip grades. Your health isn't up to it. It's really not necessary in life anyway. One who has a long road ahead does not run. Create quiet, simple surroundings and think about things appropriate to your age.

I kiss you both.

Your Paula

JOURNALS

7 August 1902

The night warmly lays
Down its arms

And where the world ends
It rests its hands . . .
Gnats hum softly
In bright harmony
And all creation trembles
And sings softly about life . . .
It's not great
It's not wide
Tis a short span of time
While eternity continues

Autumn 1902

I took a warm bath today. It felt so good. Little Elsbeth helped me. She tapped my breasts and asked, "What's that?" Yes, child! They are mysteries.

Then I ran outside in the mild autumn wind through the half moonlit dusk. The bath made my blood quick and fervid. There was a note in me that wanted to be sung. Sometimes my voice even chimes. It's when my senses and my soul are drunk.

Today I read that in the first stages of the human embryo, the heart is lodged in the head and only gradually slips down into the breast. I find it a sweet thought that they are born so close together, heart and mind. It confirms my feeling. I usually can't separate one from the other in my-self.

1 October 1902

I feel one need not think about nature while painting, at least not during the conception of the picture. Color sketches should be of something one has felt in nature. But the main thing is my personal feeling. Once I've put that down plainly in form and color, then I bring nature into it so that my picture looks natural, and a lay person will think that I've painted my picture from nature.

I've recently understood what color mood is for me. Ev-erything in the picture changes its local color according to

the same principle, so that all the subdued tones keep a uniform relationship.

To Otto Modersohn

Worpswede, 4 November 1902
My beloved Husband,
 This is the first night of the first big separation in our marriage. It gives me a strange feeling. You in the company of your family are possibly not aware of it. I am reveling in it. Reveling in my solitude.[24] Thinking of you with love.
 Thinking about our love, I wandered home this evening through the dark-damp air and held a dialogue with myself. I have great security in and about our love. As I walked along today a breathless feeling of happiness went through me and I thought that for us the best is yet to come. See, Dear, you needn't be sad or jealous about my thoughts just because I love my solitude. I use it to think about you quietly and peacefully and devoutly.
 My return home to our birches was lovely—seeing everything through the soft veil of your being far away. Each is a part of the other and the other a part of the one. I feel I live within you very much. This separation is dear to me because it spiritualizes this living as one within each other. I love the temporary withdrawal of the body. . . . Dear, love me, even when I am absurd. I still mean it.

Worpswede, 7 November 1902
My beloved Husband,
 . . . Yes, Dear we live in an Elysium. It was like that for me too when I came home from Bremen Tuesday. Much of the charm here lies spellbound and has not been set free. Will you speak the incantation? And will I be allowed to say a little something too? Oh, when I think about all the

happiness and bliss there is ahead of us. I was just outside in Brünjes's orchard. There behind the big scotch pines hung the moon's silver crescent. We've been having beautiful days, even though the air and earth have a wintry appearance. Cold. Here in my little room it's cozy and warm. A couple of baked apples in the stove are spreading their aroma. The cow is lowing and Berta is washing the wedding curtains.

This morning I began little Frau Vogeler with her white child. I was at their house last night. I believe they're both going through a difficult time right now. I feel things may be strained because he can't talk to her about his ultimate concerns.

I bought some very interesting buttons at Christel Schröder's for a mark. I carried them around with me all day, I find them so beautiful. And I'm industriously busy in the garden with Elsbeth, and have already sent a courier to His Highness Gefken requesting him to dung our garden. Elsbeth and I talk about you a lot—she in her compassionate tone, I in a kind of bridal happiness. Nothing else has happened, except that we caught a mouse in the cellar. But I have so much to tell you. I'm imitating you and keeping it under my hat. Oh, how it will be, when we meet and doff our hats.

JOURNALS

1 December 1902

I've read and looked at Mantegna (in a Knackfuss monograph).[25] I feel he does me good. The enormous plasticity he has, there's such a force of being. It's exactly what my work lacks. If in addition to the greatness of form I'm striving for, I could also achieve this quality, that would be something. At the moment simple, less articulated things are before my eyes.

My second major obstacle is my lack of intimacy.

The way Mackensen perceives the people here is not broad enough for me. It's too genre-like. Who can, should write them in runic script.

What I have in mind is something like that in the Louvre: the grave monument with eight supporting figures.[26]

Sometimes Kalckreuth has this strange runic character in his old women. The women with the geese and the old woman with the baby carriage.

Strange, it's as if my voice had totally new sounds and my being a new register. I feel it growing greater within me and broader. God willing, I will become something.

To Her Aunt Marie

Worpswede, 29 January 1903

My dear Aunt Marie,

A couple of days before Christmas Milly told me that you weren't well, that your heart had reacted against the fast pace of life that you demand of yourself. At the same time she told me of Frau D's Italian plans and that you hesitated because of a new boarder at Easter. Dear, put all the boarders out of your mind for a while, pack your bags, and go. Consider it providence that you are rid of your house like this. Fling everything behind you and live only for your health.

I wish I could be with you for just half an hour so I could talk to you about this face to face. I fear so much that you are living at too fast a tempo, and that you are afraid of stopping suddenly and of having nothing to do. Like our Father, who refused every vacation at the time he most needed one. It's my role to preach rest and contemplation to everyone. I only wish they would listen. Then there certainly would be a good deal more happiness in the world. I wish you would listen a little to these words. Why should I

not say them to you? Just because I'm only half your age does not mean I'm always wrong.

As a child I always thought one improved steadily with the years. Now as an adult I think that with age one gets into the habit of making mistakes. What I believe of you is too much work. And it's my firm and sacred conviction, and no joke, that I believe you must gather all your strength to fight against it. By overworking we sin against life and work itself. We rob work of its wonderful, great, calming beauty, which shines on our lives like a mild sun.

We go our way quietly and wait quietly for something to come of us. Otto in his way just as I, for he longs for something greater too. We talk to each other about ourselves, about what we want to do, and we wait for each other.

The studies by Fräulein M interested us. Doesn't she ever work larger? I feel the means has to be different if one wants to express oneself in such a small format. She's not always the same person in her drawings, suggesting one person here, another there. On the whole I prefer what I am striving for, but not everyone need agree. I mean only because you compare us with one another in certain ways.

If you receive few letters from me during the course of the year, please attribute it to a certain taciturnity, which to my knowledge I've had in verbal communication from time immemorial. Sometimes I speak very little and Elsbeth has to inquire quite indefatigably and very subtly in order to get more than a "yes" or "no" from me. Perhaps it comes from having my thoughts knowingly or unknowingly always concentrated on one goal. I myself know no other reason.

Footnotes: Chapter X

1. Gallwitz, p. 161.

2. Westhoff and Rilke married on 29 April 1901. The Vogelers went to Amsterdam, Bruges, and Paris.

3. May 25, 1901.

4. Now Szklarska Poreba in southwestern Poland and still a popular resort.

5. Gerhart Hauptmann [S.D.G.].

6. Schneegrube, one of the giant mountains of the Riesengebirge, the highest range of the Sudetes separating lower Silesia from Bohemia and Moravia.

 Kötzschenbroda, now Radebeul, East Germany; Agnetendorf (Gerhart Hauptmann's home) and Bad Warmbrunn, both in lower Silesia, now Jagniatkow and Cieplice Slaskie Zdroj, Poland.

7. And when they returned to Worpswede the Rilkes left for a trip to the North Sea. For a detailed Rilke chronology see Rainer Maria Rilke, *Briefe: 1897–1914*, Wiesbaden, 1950, pp. 559–64.

8. On the 13th of December Rilke wrote the Modersohns, "Yesterday at noon to our surprise we had a dear little daughter." *B. u. T.*, p. 131. The Vogelers also had a girl, the first of their three daughters.

9. This impassioned letter was answered not by Westhoff but by her husband. See *Letters*, pp. 64–66 (12 February 1902). The "different lot in life," which had Becker lending money and Westhoff borrowing it, was elaborated on by Rilke in his reply. "We had to burn all the wood on our own hearth in order to warm up our house for the first time and make it livable. Do I have to tell you that we had cares, heavy and anxious cares, which might not be carried outside any-

more than the few hours of deep happiness?"
Only a month earlier Rilke's father informed him
that the allowance on which the young couple
had been living would be discontinued as of
mid-year.

10. If it was Rilke's most recently published volume,
 then it would have been *The Book of Pictures*.
 Becker was familiar with many of the poems,
 which were written in Worpswede 1900 and Ber-
 lin 1901.

11. Gottfried Keller (1819–1890), German-Swiss
 realist short-story writer and novelist.

12. Leopold von Kalckreuth (1855–1928), German
 painter of some influence in Weimar and
 Karlsruhe (where he was a professor), Stuttgart
 (director of the academy), and Hamburg (where
 he settled). *Die Frau des Künstlers*, 1888, which
 received an honorable mention in Paris and was
 so ungracefully rejected in Dresden, was pur-
 chased by the Städt. Museum, Leipzig. Mother
 and child in the garden, alternately titled *Der
 Regenbogen* and *Spaziergang*, 1896, was in the
 Neue Staatsgalerie, Munich.

13. Egon Petri, German pianist, born 1881, son of
 Dutch violinist Henri Petri, pupil of Busoni.

14. If from the Knackfuss series, then Hermann
 Knackfuss, *Tizian*, Bielefeld and Leipzig, 1898,
 with 123 illustrations of paintings and drawings.

15. Becker's assuredness and firm opinions are an in-
 teresting contrast to that of family and friends
 regarding her talent. From Otto Modersohn's
 journals, 11 March 1902:

I'm really surprised at Paula's progress;
when she's more accomplished I'm sure she'll
probably do something very fine in art. First of
all, she's very personal; nothing conven-
tional, established. Before I especially valued
her opinion, and now her accomplishments
too. She is understood by no one. Mother,
brothers and sisters, aunts—all are in silent
agreement: Paula will accomplish nothing.
They don't take her seriously. And the same
in Worpswede—her work is never asked
about. Vogeler said, "Art must mean very little
to your wife." He never asks about Paula, he
never goes to her Brünjes atelier. He doesn't
know her, he doesn't appreciate her, assumes
she's very unsuccessful. That's all right. I re-
joice about my Paula, who is really a great
painter. Today she paints almost better than
Vogeler and Mackensen. My opinion is not
out of love, as her family thinks. In all quiet
she strives on and grows and one day everyone
will sit back in astonishment. I'm looking
forward to that. She is thoroughly artistic.
With Paula everything is naive, quiet. Color-
wise she's very talented and perhaps even
more so in her monumental picture sense.
In this Paula is on one very fine way as she
interweaves her personality with nature. In
her intimacy, she is monumental. Her things
are more monumental than several of mine
she's seen. She has fewer, but intimate and
strong. Gallwitz, pp. 248–49.

16. Henry, or Henner (1885–1949), Becker's
 younger brother and Herma's twin. There is a
 portrait of him c. 1900–01 in Günter Busch and
 associates, *Paula Modersohn-Becker zum hun-
 dertsten Geburtstag: Gemälde, Zeichnungen,
 Graphik*, Bremen, 1976, illus. 7.

17. From Otto Modersohn's journals, 9 April 1902:
"In our opinions about art, in our tastes, Paula
and I match superbly. We both love the naive,
the peculiar (our house, the Brünjes atelier, my
atelier). Now she is making little beds
everywhere in the garden, little intimate places,
with benches, a glass globe [a popular garden
decoration]." Gallwitz, p. 249.

18. From Rilke's reply to Becker's letter to Westhoff,
"I hold this to be the highest task of a bond
between two people: that each should stand guard
over the solitude of the other. For if it lies in the
nature of indifference and of the crowd to recog-
nize no solitude, then love and friendship are
there for the purpose of continually providing
the opportunity for solitude." *Letters*, pp. 65–66.

19. Four months earlier Becker painted *Die Schleier-
braut* (*The Veiled Bride*), Busch *et al.*, colorplate
8.

20. *Giovanni Segantini: Sein Leben und sein Werk*,
Vienna, 1902. Becker had seen the work of this
Italian Neo-impressionist in Paris (see p. 137).
Rilke recommended this book to Modersohn in a
letter dated 25 June 1902. *B. u. T.*, p. 194.

21. North Germans.

22. See illustration.

23. Psalm 51:10–11.

24. Becker's singular attitude toward separation was
shared, ostensibly for financial reasons, by Rilke
and Westhoff. They had made the decision "to
dissolve our little household." *Letters*, p. 74. At
the beginning of June Westhoff and their baby,

Ruth, went to Amsterdam, Rilke to Schloss Haseldorf in Schleswig-Holstein for a month's vacation. Then at the end of August Rilke left for Paris to write a monograph on Rodin. Westhoff followed in early October, leaving their daughter with her maternal grandparents.

25. Henry Thode, *Mantegna*, Bielefeld and Leipzig, 1897, 105 black-and-white illustrations.

26. In Becker's sketchbooks there is a drawing of the tomb of Philippe Pot (d. 1493), in Busch *et al.*, illus. 64.

XI. Paris, 1903

After two and a half years of Worpswede "seclusion and tranquility," including a year and a half of marriage, Becker was ready for Paris again. She wanted a distance that would allow her to "examine Worpswede with a critical eye." During her short six-week stay she concentrated on drawing, working in the open croquis sessions at the Académie Colarossi and sketching almost daily in the Louvre.

Rilke and Westhoff were already in Paris when they heard of Becker's plans. Rilke wrote, in his and Westhoff's name, "imploring her to make it up [their year-long quarrel], to forgive them both and to come see them."[1] They did see each other frequently while Becker was in Paris, but it was a while before they re-established intimacy.

For emotional support Becker turned to Modersohn and "bombarded" him with letters in the hope—not always realized—that he would "have to write a lot too." From the onset she expressed the desire that he join her in Paris. Her entreaties, made for the sake of his art, did not move him. Rather he heeded Rilke's advice, "Dear Otto Modersohn, stick to your country! Paris (we say it to each other daily) is a difficult, difficult, anxious city."[2]

Worpswede provincialism and her love for her family tore at her art. Becker presciently recognized what was at stake when she wrote her husband, "I am walking around with the wretched, God-forsaken feeling that if I want to learn something this time, I will have to pay more dearly for it than I did before. I didn't have you and a home then."

223

*The "something" Becker learned this time in Paris determined
the course of her painting: "strive for the greatest simplicity by
means of the most intimate observation." Her Louvre sketch-
books are filled with drawings from Egyptian and Greek an-
tiquities, along with sketches from paintings by Fra Angelico,
Giovanni Bellini, Lucas Cranach, Domenichino, Goya, Ingres,
Rembrandt, and others. Both journals and letters mention the
impression made on her by Rodin and Japanese art. Becker was
attracted to the intimate, "unfinished quality" of French paint-
ing and found fault with a German tendency to overpaint. The
Antique and the Gothic reinforced her concentration on simpli-
fying forms. Rodin and Rembrandt directed her attention to the
character of the surface, something she called the "curl" in
things. "Curl" is also suggestive of Van Gogh, and Selz notes
that her "highly decorative style changed again after her second
trip to Paris. . . . Perhaps it was Van Gogh's influence, perhaps
a development of her own style that bent toward a vibrating,
curled and crimped line. . . ."*[3]

To Otto Modersohn

Paris, 10 February 1903
I'm sitting in the little Grand Hôtel de la Haute Loire,
where I stayed three years ago in the same tiny Room 53.
Only now in number 54 I hear two strange German
painters—back then Clara Westhoff occupied that red-
canopied bed. I'm beginning to enjoy Paris, although I'm
still very shy and a little scared of the people. When I went
to the *crémerie* for supper, one of the well-known Spanish
rascals came right up to me. And as I stepped inside two
Frenchmen passed me and said, "Aha, aha, elle est retour-
née." But in my fur jacket I didn't feel at ease among this
colorful tribe.

Good night, my King Red Beard. In a couple of weeks I
feel I may be writing you to come, because there's cham-
pagne in the air here, quite aside from the art everywhere
you look.

I have the same feeling I had the first time, when I wanted to crawl into a mousehole because everybody looked at me so strangely. I feel, and hear, from the many soft voices around me that I'm not their kind.

I'd very much like to have a letter from you, my dear Red Beard. You know I'm here to examine Worpswede with a critical eye. So far, it still holds its own. . . .

> Your little wife in the big
> city of Paris

Paris, 12 February 1903

My dear Otto,

Just yesterday I mailed you a letter and I immediately began another one today. I want to bombard you so that you'll have to write a lot too. I think about you and Elsbeth an awful lot, always really. I can hardly comprehend that I've left you. And I haven't been able to enjoy myself. Although today everything is already a shade brighter than yesterday. Mainly, the strange characters no longer get on my nerves and so no longer upset me.

In the evening.

The Rilkes were just here and returned my visit. I was at their place last night. They're very friendly to me. But Paris plagues them both with many uneasy anxieties.[4] "There are voices in the night." The same joyless fate rules both these human beings. And this joylessness can be contagious.

My dear Red Beard, I wish it would be quiet around me for a moment, so that I could softly and gently tell you what a fine and big place you have in my heart. I think of your work and your tender brow and your hands. I feel a little like a ship whose sails wait for the wind to seize them. And tomorrow the Louvre is to seize me.

Paris, 14 February 1903

Dear, what are you doing and what are you painting?

Have you stretched your little canvas yet? I'm really looking forward to it.

I've noticed that one of the main things one can learn here in Paris is the impromptu. Today I was on rue Lafitte, a street of art dealers.[5] There one sees a lot of what you call the artistic in art. This not finishing things that the French do so well! It's here that the flexibility of their nature serves them. We Germans always dutifully paint our pictures to pieces and are too slow to make a little extempore color sketch, which often says more than the painting.

Here they make the most lovely things in the smallest format. You should try it too, you have the talent for it. But such things aren't for the public and there are so few artistic art dealers.

Anton von Werner high-polished boots run in our blood.[6]

Although, how strongly those barely finished things by Segantini moved us.

Today I saw works by Cottet and Simon.[7]

Cottet is far better in feeling, while Simon strikes a finer colorful chord. But I don't like the way he applies color as much. He paints faces and objects so flatly that they seem rather violent. The way Cottet applies color should be more mysterious.

There are a couple of still lifes by Décamps[8] in the Louvre, quite small things, but very extraordinary and sensitive, and a couple of small paintings by Millet that excite me very much in technique.

I'm glad I'm gradually succeeding in being able to think amid this noise. It was impossible before.

I'm walking around with the wretched, God-forsaken feeling that if I want to learn something this time, I will have to pay more dearly for it than I did before. I didn't have you and a home then. But I feel it's very good to look at everything from a distance once. You do not come off badly.

Sometimes I want to cry on the street amid all the hubbub. Today I bitterly searched for a room that looks out on a tree, in vain so far.

I really wanted to go to the country tomorrow. But the Rilkes want to see a Japanese exhibition and I'll probably join them. If only they were a little happier! They're singing the blues, and in harmony too.

I'm drawing from the nude in the academy in the afternoon. A different position every half hour. It gives me great pleasure.

I'm still taken for a Fräulein, even though I wear my wedding ring in full force. If I don't wear it I get cold.

Greetings to little Frau Vogeler and see that the mice don't eat my art.

JOURNALS

15 February 1903
I saw an exhibition of old Japanese paintings and sculptures today.[9]

The great inner distinction those works have! I feel our art is much too conventional. We express the stirrings of the soul very imperfectly, which in old Japanese art seems more resolved. The expression of the nocturnal, of the horrible, the lovely, the female, the coquette, all these seem resolved in a more childlike, more pointed way than ours. Stress what's important!! . . . When my gaze glides from pictures to people, I find them much more extraordinary, much more striking, more impressive than they've ever been painted. Such perceptions come only at moments. A leveling life generally obscures them. But it's out of such moments that art arises.

And now I come to another perception that I had yesterday on rue Lafitte: this creating out of impulse—the French do it so well. It's immaterial to them whether what they create ever becomes a picture or whether the public always understands them. The main thing for them is that it's art. They create because it excites them, and often they create on the smallest scale. Degas, Daumier, many small things by Millet. And they have such a delightfully charming way

of applying color—sensitively, lovingly, and with artistic precision. Rodin told Clara Rilke, "Rien à peu près." The feeling is inherent in the whole nation—hit the nail on the head.

At first I felt out of place in Paris and didn't feel it would do me any good. Now I believe it probably will. A cart with a barrel organ, pulled by a shabby, shaggy little donkey, stopped in the street this evening. How its sounds made the people's feet move, that dancing feeling! A little shopgirl was supposed to be bringing in the flowers from the street at the end of the day. She did this bewitched and charmed, hopping in step to the music. And it wasn't just her, every third person here would have done the same. Two others were dancing in the hall. They're a light-hearted people. If we could learn to combine their charm with our virtue, our worth would be dearer.

To Otto Modersohn

Paris, 17 February 1903

I've moved. It was too noisy on the boulevard. I was never able to collect myself in my own place, which, you know, is a necessity for me. Now I've moved and am very happy. It's quiet around me. In front of my window is a tree and behind the tree is a garden and behind the garden is something Catholic, I don't know what.

My hotel has a little garden, a courtyard really, where there are all kinds of dirty and pretty things. Madame promises me the most beautiful buds from the garden.

You've probably noticed that Paris is gradually beginning to agree with me again. Amazing things are rushing in on me from all sides. I feel this is a useful trip.

Sunday I went with the Rilkes to a famous private collection of old Japanese art that is to be auctioned off.[10] The pictures were not paintings in our sense, but paper or silk scrolls. They have a remarkable command of form, color, and spirit. They expressed an enormous range of moods: the nocturnal, the sinister and sensitive, even the modish-

coquettish. And the beautiful leaves with blossoms and birds. One senses how closely these people connect with nature.

I went for a little stroll by myself Sunday evening. On a nearby street was a cart drawn by a donkey with a barrel organ played by an old woman. The entire audience was electrified, like children! A little shopgirl who was supposed to be bringing in the flowerpots, did so rocking and dancing in time to the music. Two other girls were dancing in the hallway. And a couple of boys passed by, their legs twitching. It was charming to watch. This childlike susceptibility is also expressed in their art.

Today, the Louvre. I came closer to Rembrandt, to the Netherlandish painters in general. Finally I've seen some most artistic and striking paintings after Ingres's drawings, and reproductions of wonderful antique portraits, with strange, melted colors.[11] A very exciting picture of Cleopatra.

You see, my Dear, I'm absorbing everything and I'm very capable of enjoying myself. You'll have to question me closely about it all later.

Paris, 18 February 1903

It's strange that the megaphone between us is so endlessly long. And it's really strange that I won't be with you on your birthday.

But in spite of everything I am with you and in you, perhaps more than ever. You are the beloved shade that cools me and the cool water where I bathe my wounded soul. (I feel my soul looks just like my nude.) You are my great, beloved, quiet forest of gentle rustlings and whisperings. And though I'm running in the meadow, I'll soon come back and sit down quietly beside you.

You are my beloved companion and I think of you with a deeply felt love. I kiss your smooth brow and the dear hands from which come your pictures. Your hands and brow are like your pictures for me, and your red beard too. I often

think about your pictures. They have to become more and more extraordinary. There has to be a breath and a foresight in them as there is in nature at moments when our eyes look serenely and clearly into the peculiar essence of things. An expression of yours: one feels something haunting. When you paint a picture, your foremost consideration must be to bring this feeling to expression in all its intensity. You must have all the means for it at your fingertips: technique, color, great form. But while you're thinking about the means, never let the end out of your sight. The aim is to have your compositions begin as pictures.

The French have a charming delicacy and sensitivity of expression. They handle their tools with such a great loving neatness. Amazing, the more I learn to understand Rembrandt, the more I feel that they have understood him.

I'm glad you intend to do some small things. I'm beginning to believe that one can really paint if one can express oneself in small scale. Aren't smaller things the much quicker, more nimble outflow of a happy period? I'm thinking of Millet, Rembrandt, Böcklin.

There are lots of Rembrandts here. Even though they are yellow with varnish, I'm learning a lot from them, about the curl in them,[12] the life.

Here are a few things. I don't know if this is also Potiphar's wife, it's a female nude on a bed. The way it's painted, especially the shape of the cushions with their lace insets, is quite delightful. And the Holy Family by a lovely open window. And two little thinking philosophers sitting in some Gothic building where a little sunlight flits across the tiles. The Good Samaritan appears to have suffered in its colors. It must have been wonderful.[13]

I feel that Paris needs to become an imperial city again and soon. The people are ruining everything. The parquet in the Louvre is going to pieces. And today in the gallery of antique pictures, which is very quiet and secluded, there were ten drunkards of the worst sort and I alone.

But about the antique another time.

Now be kissed, my dear thirty-nine-year-old. Great art is said to begin in the fortieth year. I'll drink my cocoa to this three times on Sunday.

May the new silver glass ball keep for us and for our children's children forever!

I'm sending you a photograph by Cottet. I find it very serious and beautiful. Write me about it.

Paris, 19 February 1903

When I came home this evening from croquis I asked, "Pas de lettre?," and was told, "Rien du tout, Madame." It made me a little sad, but an hour later there was a knock on the door and the garçon called, "Voici, ma petite dame! Voilà tout ce que vous désirez!," and handed me your bulging letter.... With the garçon I have this one small topic of conversation. It's nearly the only thing I say. I hope he isn't expecting any larger issue, because then we won't have any conversation.

Paris more and more is becoming the Paris of three years ago. The same old faces offering violets on the Pont des Arts, the same shriveled people displaying their books on the quai of the Seine.

In the academy they probably find me the same too because they always address me as Mademoiselle. I recently told a Danish woman who talks a lot that I'm married. Now maybe word will be spread around. I was rather incensed that they didn't realize just by looking at me that I'd become your wife since I was last here. And I wear my ring. But they don't pay any attention to that in Paris.

Know what I'm finding out? Your gracious beloved, your art, is enticing you away a little from your Parisian beloved. She'd like a love letter once again. But only happiness and blessings to your dear hands, so that splendor and brilliance and light flourish under them. These are the most beautiful things of all to me.

The monograph is out.[14] Rilke brought me a copy yesterday. I've only leafed through it. There are a lot of good things side by side with a lot of artistic obliquities.

Clara Rilke has a fine commission. She's to model Björnson's daughter in full figure, small. The daughter has nothing of Björnson,[15] nothing Nordic. She's original, capricious, and Parisian in her movements.

Carnival has the city colored with confetti. Three years ago I waded ankle deep in the bright snow, this year all I got to see was a couple of Pierrots from afar.

I have a nice relationship with my landladies, I even went into town with them yesterday, mother and daughter, to see the students' parade. I tell them about you and they listen attentively. They're genuine petty bourgeois Parisians and they amuse me very much.

My hotel is one large portal, the house is tiny by comparison. An enormous rabbit sometimes runs through the courtyard. Everything's funny and comfortable, the people have such naivete in their way of life.

Many good artistic thoughts come to me here. I feel and sense with ever greater vividness that intimacy is the soul of all great art. It's in the Tanagra figurines, [16] in Rembrandt and Millet. That's why I'm happy to be here, where this is really brought home to me.

JOURNALS

20 February 1903
I have to learn to express the gentle vibration in things. The curl in them. I have to find expression for it in drawing too—the way I've drawn nudes here in Paris, only observed with more originality and hence more sensitively. The strange waiting that hovers over opaque things (skin, Otto's brow, fabric, flowers), which I have to strive to achieve in its great simple beauty. Strive for the greatest simplicity by means of the most intimate observation. This is greatness. In the life-size nude of Frau M, the simplicity of the nude drew my attention to the simplicity of the head. I feel it in my blood to want to overwork things.

Getting back to "the curl itself"—I find old marble and sandstone statues that have been exposed to the weather so pleasing because of their rough surface.

The spirit of these people is so nimble and given to word play. Today I asked a dealer near the Temple the price of a

gold braid he was selling. He quoted me the price, to which I said, "Mais si chere, Monsieur, elle est vieille." He smilingly rejoined, "Ah, Mademoiselle, c'est le contraire comme chez nous, qui sont chers, quand nous sommes jeunes."[17] Then I went up to the first floor of the Temple Baedeker talks about. Together there are all the questionable silk skirts that have seen their duty. It's a market of danced-out, colorful, satin shoes and faded artificial flowers, silk dresses and lace skirts. They're bought by the poorest girls to adorn themselves with.

Sometimes in the street I find myself in the same mood I was in three years ago. Everything hurrying and rushing around me, and I feel like a veiled queen.

25 February 1903

I'm seeing a lot and I feel I'm coming closer to beauty. The last few days I've discovered and thought about many forms. Until now I felt very foreign to the antique. I could find it very beautiful in and of itself but I couldn't find any connection between it and modern art. Now I've found it, and that's progress. I sense an inner relationship from the antique to the Gothic, mainly the early antique, and from the Gothic to my sense of form.

A great simplicity of form is something marvelous. I've always striven to bestow the simplicity of nature on the heads I painted or drew. Now I deeply feel I can learn from antique heads. How greatly and simply they are conceived! Brow, eyes, mouth, nose, cheeks, chin—that's all. It sounds so simple and yet it's so very, very much. How simple in its planes is an antique mouth realized. I feel I must look for all the remarkable shapes and overlapping planes when drawing nature. I have a feeling for how things slide into and over each other. I must carefully develop and refine this feeling. I want to draw much more in Worpswede. I want to arrange in groups the poorhouse children or the A or N families. I'm really looking forward to working. I feel my stay here is doing me a lot of good.

To Otto Modersohn

Paris, 26 February 1903

Dear, you've kept me waiting a long time. Your Rafaëlli crayons[18] must be very beautiful if they're able to push me into the background like this. But I'm happy for you that you're creating so much.

Tell me, are you coming? I'd like you to very much. But I don't want to play any part in your decision. Your coming has to depend on how it fits in with your art and your schedule.

There's beauty here to excess. I'd very, very much like you to experience Rodin's art. He's probably the greatest living artist. A French periodical has published his conversations on art (they're more like monologues), which he had with a couple of young girls.[19] They're very simple and can apply to all the fine arts. I look forward to discussing them with you. Dear, I really am so glad you let me come here. I'm grateful to you with all my heart. I feel I'll always want to come back here after certain periods in my life.

Sometimes I spend the evening with the Rilkes. But communication isn't what matters to me at the moment. So many impressions are at work in me. And so much has to be thought through. For the most part I spend my evenings very pleasantly, writing, or reading, or thinking with my gaze on the blinking perpetual light of the Carmelite cloister behind my garden.

The Luxembourg Museum has reopened. There are many beautiful things there: Manet—nude with a Negress, sunlight on a balcony; Renoirs, not as beautiful as ours in Bremen; and Zuloaga—two ladies in black with a gentleman and a pale greyhound, all against the horizon, and a dwarf with a silver ball, like ours, in her arm, quite fantastic in color.[20]

Best of all was seeing Cottet's great triptych again.[21] The right wing with the women and children anxiously waiting in the evening is marvelous in form and color.

And Degas' pastels. Very interesting in their form and very artistic and capricious in their color.

And Worpswede! The other day in the Louvre I saw our Rousseau landscape with the cows. Unconsciously tears came to my eyes for the private happiness of having such a home.

,

Paris, 2 March 1903

My dear Spouse,
You must come. There are many reasons why, but I'll name only one, the great, the greatest: Rodin.

You must experience this man and his whole life's work, which he has gathered around himself in casts. His great art unfolds in full bloom, with its incredible force of will, in complete privacy and secrecy.

I can say little about the work in particular because it should be seen very often and in very different moods in order to absorb it fully.

It's marvelous, the way he works in spite of whether the world approves of his ways or not. It's his unshakable confidence that he's bringing the world beauty.

Many do recognize him, although most of the French put him together in one pot with Boucher and Injalbert[22] and some other lesser lights.

With a card from Rilke recommending me as the "femme d'un peintre très distingué," I went to an afternoon reception in his atelier Saturday.[23] There were all kinds of people there. He didn't even look at my card, he just nodded to me and let me walk quietly among his marble creations. There were many, many marvelous works. Many were unintelligible to me, but I don't dare form an opinion about them so quickly.

Upon leaving, I asked him if it would be possible to see his pavilion in Meudon.[24] He placed Sunday at my disposal and I was allowed to wander in the pavilion undisturbed.

Here there was a study and worship of nature that was really beautiful! He always begins from nature. He makes his drawings, his compositions too, from nature.

The remarkable dreamlike figures that he hurls onto the paper are the most singular expression of his art. He uses the most minimum of means, he draws with pencil and

then shades in with extraordinary, passionate watercolors.
The passion of genius reigns over those pages, disregarding
convention. They remind me of the old Japanese things I
saw, perhaps of antique frescoes too, or the figures on an-
tique vases.

You have to see them! For a painter their colorfulness is
very stimulating. He showed them to me himself and he
was friendly and charming. Yes, the extraordinary in art, he
has it. Besides, there's the pervading feeling that everything
in nature is beauty. He used to make up these compositions
out of his head. But he found they were too conventional.
Now he draws them from a model. When he's energetic,
twenty in an hour and a half.

His pavilion and two other ateliers lie in the middle of
rolling hills covered with stubbly grass. He has an amazing
view of the Seine and its villages, and of Paris with its
domes.

His residence is quite small and cramped. One feels that
life counts for nothing with him. "Le travail c'est mon
bonheur," he said.

I went to Meudon in the morning with Fräulein von M.
We roamed the countryside and I picked yellow coltsfoots,
which I twined into a garland today. The area around Paris
with its delightful views and vistas has a magical charm,
which one has to know if one wants to understand the
people. In contrast to our north country, everything is so
soft and yielding. . . . I kiss you, my dear Red Beard. . . .

Paris, 3 March 1903

This morning I awoke in my mahogany bed like a bride
because last night when I was going to sleep—I had already
put out the light—your letter was handed to me.

Dear, it was a blessing. I read your words very slowly,
each one for itself. I let them softly and sweetly stream
down on me and I sunned myself in them and laughed at
them and delighted in you.

Yes, my King, to you belongs my all. I consecrate myself
to you. Take all into your loving hands. And when spring

comes to our beautiful hill, we will want to join ourselves in love.

Dear, it's the same for me as it is for you. Originally I did not want to write too much about our love so as not to make our separation too difficult. But it's wonderful to have expressed all our love for each other. Now our silence will be much easier. I talk about you so often, whenever I can. It's not easy to do with the Rilkes, they only half listen. They're so preoccupied with themselves. So I tell my *garçon* (who's from Brittany) a lot about you and the beautiful pictures you paint. I wanted to impress him specially the other day, so I showed him your picture in the monograph. But he didn't find you at all handsome. I got mad and told him that you have a red beard and it sets off the rest of your face beautifully. I quietly and affectionately thought about your dear hands and your soul. But I didn't talk to him about these things because I realized I had knocked at the wrong door, and I had a rather contemptuous feeling about him.

And your trip? I in no way want to influence you but I feel that these colorful drawings of Rodin's would be a great experience for you too. Seeing how far one can go without bothering about the public. It's a similar spirit, you know, to what Rembrandt expressed in his day in his etchings.

To Martha Vogeler[25]

Paris, 6 March 1903

Dear Martha Vogeler,

I had sent you a small box of violets Sunday so that before you returned they would sweetly scent your little brown living room. Now I hear that you are staying in the city and the fragrance of the flowers will probably be gone before you reach them. So I want quickly to entrust my greetings to this card. I see a lot of beauty here, even more than I did during my first visit, and I'm seeing it with different eyes. Traveling, I feel, does one good and I'll

probably want to see Paris again every few years, even
though I felt very uncomfortable here at first. But there's so
much beauty and one discovers something new everyday.
Spring is already well on its way here, blackbirds are strik-
ing the Luxembourg, and on the table in front of me are
sweet little yellow coltsfoots, which I wanted to kiss when I
found them outside in Meudon where Rodin lives. Until we
meet.

Your Paula M.

To Otto Modersohn

Paris, 7 March 1903

I'm imagining it's noontime. You are coming out of your
atelier in your brown overcoat. Or is it already so warm that
you're wearing only your gear? Well, in either case, you've
come home and found my letter lying on the chest in our
little dark-yellow vestibule. I know you're happy. Only I
don't know whether you're reading it on the veranda or in
the living room, because I don't know if the veranda is
floating at the moment or not.[26] Then, after you've read it,
B will serve a lovely meal, which I hope tastes good to you.
At least it will taste good to me when I come back home
because I really don't like eating at inns. Sitting with so
many people who mean nothing at all to me. When, by
comparison, I think about our quiet middays, when we'd sit
next to each other on our little wicker bench and you'd not
talk much if you liked the food . . . yes, all that makes me
happy.

But I'm so very intensely happy being here, and I'm using
my time well. At present I'm drawing the paintings and
sculptures in the Louvre almost daily. My sketchbooks will
speak for themselves. I now take an enormous pleasure in
sketching. I hope the stay here helps me. We'll have to wait
patiently and see.

As for the rest, I'm becoming acquainted with all sorts of

crazy situations.[27] But I stay quiet and I think about you, so thoroughly healthy and unspoiled and uneccentric. When I'm alone I secretly kiss my wedding ring, which, strange to say, I've come to rely on in this foreign country. Although I'm quite worried I may lose it because it's so loose.

<div align="right">Paris, 10 March 1903</div>

My dear Red,
Falling asleep at night I sometimes think about little children lovingly. When I read I look up words like *swaddle, suckle,* etc. with great interest. I've noticed, and I feel, how these two years at your side have gently turned me into a woman. As a girl I was inwardly jubilant and full of expectation. Now, as a woman, I'm also full of expectation but it's quieter and more serious. And this expectation has laid aside the uncertainty of girlhood. I feel now that there are two things I am sure of: my art and my family.

My dear Husband, with all these things going on inside me, I feel so strange here. Sometimes it doesn't seem at all believable that I have you and Elsbeth and our little house. But when I do think about it, I feel that it's precisely this wonderful, certain possession that gives me the peace to approach everything with composure and happiness. At the moment I don't feel erotic, probably because of all the intellectual work going on inside me. But if it's possible, I love you perhaps more unreservedly every day, with all your shortcomings. I take such great pride in you.

Last Sunday I made another excursion into the countryside with Fräulein von M. We rowed together on the Marne. The area around the river is so magnificent in form, and rowing is so healthy and invigorating after pounding hard pavement all day. Fräulein von M is a natural, sweet, clever person, and not without talent. She works from the nude at Colarossi's and paints at Blanche's. Will she be able to make something decent out of it? She has done better work than what we saw. But she doesn't consciously begin with a goal. How can one go to Blanche[28] after Kalckreuth? Unfortunately there's something careless and sloppy about

her, as with so many painters. It's so ugly in her room. She's
her nicest out in nature, where she lets everything have an
immediate and jubilant effect on her.

You know, I must come here together with you someday.
I feel that much of what slumbers in you and that you do
instinctively will become conscious to you here. I mean
primarily in form. For example, I'd so much like you to
have a different opinion about the antique. I find early
antique works very close to our own in feeling. I'd like to
show you everything.

Paris, 17 March 1903
I'm turning homeward. Suddenly it thrills me so to be
going to you and Worpswede.

Dearest, by Saturday, possibly Friday, I'll be with you.
Your Father wrote me a charming letter that began in
French, so I will spend a night in Münster and then run
home to you.

Open your arms wide, and see to it that we are alone.
You can quietly say that this would be more fitting on such
an occasion.

I love you as much as you me.

Written on the way
So far I've happily gotten to Wanne.[29] I've shaken the
French dust from my feet and am pleased and surprised that
I can understand everyone here so well. I'm delighted by
their candor and honesty.

And tomorrow, Friday night, the post-chaise with me
inside will stop in front of our little gate and you'll be
waiting for me. You'll come to me out of the darkness.

Dear, this day in Münster that you prescribed will be long
for me in view of my awaited happiness. I'm very feverish
from traveling, and I can't believe that tomorrow I'll be
sitting with you on our little white veranda.

This letter was only supposed to be a postcard, but the
tone has become a shade too warm for the Worpswede mail

carriers. I wanted to temper the style but it wouldn't have it. These words burned through with the pleasure of expectation. Are you burning too? My last day and last night in Paris I thought about Worpswede so very intensely. How does everything look? Has Elsbeth grown? And you? Is anything stirring in our garden yet? Now the answers will soon be mine. I'm all questions.

Footnotes: Chapter XI

1. Description of an unpublished letter dated 29 January 1903 in Butler, p. 107.

2. *Letters*, p. 93.

3. Selz, p. 45.

4. Rilke was in Paris writing his monograph on Rodin; Westhoff was there working on her sculpture. Becker, "at their place last night," was either in Rilke's room or in Westhoff's studio, because husband and wife were maintaining separate living quarters in Paris. Rilke's Paris "anxieties" became the material for his poems *The Book of Poverty and Death* (*Das Buch von der Armut und vom Tode*), the third book of *The Book of Hours* (*Das Stundenbuch*), 1903. Butler, pp. 125–26, 140.

5. Among the galleries located on rue Lafitte were Vollard and Durand-Ruel.

6. Anton von Werner (1843–1915), history painter and illustrator, president of the Academy and leader of the "wild protest" against Munch in the *Verein Berliner Künstler*, 1892. See p. 53, n. 22, and Selz, p. 36.

7. These Breton painters, whom Becker admired during her first visit to Paris, were exhibiting in a group show at Galeries Durand-Ruel, "Exposition de la Société nouvelle de peintres et de sculpteurs," from February 14th to March 7th. My thanks to Charles Durand-Ruel of Durand-Ruel & Cie. for providing me with a detailed list of the gallery's exhibition schedule for the years Becker was in Paris.

8. Alexandre-Gabriel Décamps (1803–1860), a romantic painter of scenes set in the Moslem East. Millet had also attracted Becker's attention in 1900.

9. The Hayashi Collection of Objets d'Art from Japan and China: sculptures, lacquers, bronzes, ceramics, swords, scabards, netsuke, and paintings (including works of the Ukiyo-e School, Hokusai and Utamaro). *La Chronique des Arts et de la Curiosite*, 1903, p. 80.

 Hayashi Tadamasa, as a young Japanese in Paris in 1878, realized the enormous profit to be made from French interest in Japanese color prints. He instructed his wife back in Japan to buy up everything by Hiroshige, Hokusai, Utamaro, *et al.* (which she did—some prints for as little as a penny apiece). He became the principal promoter of Ukiyo-e in Paris and the personal adviser to the first great collectors of things Oriental. Ukiyo-e in particular was an influence on the French Impressionists and Post-Impressionists.

10. The large Hayashi Collection (authenticated by Samuel Bing of Art Nouveau) was sold at the Hôtel Drouot February 16th–21st. *La Chronique*, 1903, p. 80.

11. The encaustic Fayum portraits.

12. "Curl" is a literal translation of Becker's term *Krause*.

13. If these reproductions Becker was sending Modersohn for his birthday were all of Rembrandts in the Louvre, they were *Bathsheba at Her Toilette*, 1654, *The Holy Family*, 1640, *A Philosopher with an Open Book* and *A Philosopher Absorbed in Meditation*, 1633, and *The Good Samaritan*, 1648.

14. Rilke's monograph *Worpswede*, published by Bielefeld and Leipzig, 1903, featured only Fritz Mackensen, Otto Modersohn, Fritz Overbeck, Hans am Ende, and Heinrich Vogeler.

15. Björnstjerne Björnson (1832–1910), Norwegian novelist, playwright, and poet.

16. The Louvre had acquired the first collection of Tanagra figurines known in Europe. Large caches of these ancient terracottas had been discovered in 1873 in tombs in northern Greece.

17. "But so dear, Monsieur; it is old." "Ah, Mademoiselle, it is the opposite of ourselves, who are dear when we are young." The Marché du Temple was a market of secondhand clothes, which were sold not in a temple but in a large hall on rue du Temple.

18. "Paris—The painter J. F. Raffaëlli made some months ago a discovery which has been much discussed in the world of art. By a new process he has succeeded in making *solid oil colours*, which can be used in the form of a pencil, and produce

effects as rich and firm as brushwork." "Studio
Talk," *The Studio*, January 1903, p. 300.

19. Rodin's conversations were published continu-
 ously from December 1902 to May 1903 as "Au-
 guste Rodin pris sur la Vie" by Judith Cladel in
 La Plume, a semimonthly periodical "dedicated
 to the artistic education of the contemporary
 public."

20. The museum had been closed for several weeks
 in order to rehang pictures. In the Luxembourg
 Becker saw Manet's *Olympia* and *The Balcony*;
 Renoir's *Moulin de la Galette* and *At the Piano*
 among others; and Zuloaga's *Portrait of Daniel
 Zuloaga and His Daughters* and *The Dwarf Doña
 Mercedes*.

21. *Au Pays de la Mer.*

22. Alfred Boucher and Antoine Injalbert were very
 successful academic sculptors. Boucher won the
 Grand Prix at the *Exposition Universelle 1900* and
 Injalbert won the same prize at the world's fair in
 1889.

23. Rodin regularly received visitors to his Paris
 studio on Saturdays. Rilke's introduction of Bec-
 ker read, "My dear Master, I venture to intro-
 duce to you one of our friends: Madame
 Modersohn, wife of a very distinguished German
 painter. She has adored your art for a long time
 and you can make her very happy by permitting
 her to admire your work, which is (as you know)
 totally a revelation and a necessity for us. . . ."
 Briefe aus den Jahren 1892 bis 1904, Leipzig,
 1939, p. 305.

24. Rodin's pavilion in Meudon was the same one he erected for his retrospective exhibition in Paris in 1900. He had the structure, built in Louis XIV style, transported to his garden at Meudon. Victor Frisch and Joseph T. Shipley, *Auguste Rodin*, New York, 1939, p. 254.

25. This and the letters to the Vogelers in Chapter XV were originally published in Konrad Tegtmeier, *Paula Modersohn-Becker*, Bremen, n.d., pp. 16–19.

26. In the March thaws.

27. Some of which were of her own making. Rilke went with her to one of the *grands magasins* of Paris, where she selected numerous "dresses and underwear, lace jackets, and other beautiful things which were fashionable at the time." She had the things sent to her on approval. Once at her atelier she tried on everything "in peace and then sent them back." Vogeler tells a similar story. Becker ordered, on approval, some beautiful Gobelin tapestries, which she hung in her atelier. When the time limit was up she sent them back, having "fulfilled a wish." Westhoff in Hetsch, p. 49.

28. Jacques-Emile Blanche, born 1861, a popular French painter of the artistic and intellectual elite of the day. (Picasso, 1935: "Cézanne would not have interested me in the least if he had lived and thought like Jacques-Emile Blanche, even had the apples he painted been ten times as beautiful." Cited in Werner Haftmann, *Painting in the Twentieth Century*, New York, Washington, I, 1965, p. 280.)

29. In Belgium—Becker was south of Münster and her in-laws.

XII. Worpswede, 1903–05

*"Life glides along day by day," and the handful of letters here
gives a puzzling picture of two years of uneventfulness, if not
tranquility. Paris produced a period of hope—and one assumes
that Becker's immersion in painting left her less and less time for
writing. Periods of inactivity did not prompt her to write either,
but to read French. Becker's later life is documented by only
occasional letters or journal entries.*

*In 1903 Martha Vogeler gave birth to her second daughter.
Westhoff received a stipend to study sculpture in Rome for a
year. Rilke accompanied her and then went on to Sweden for six
months. The Vogelers also traveled to Italy. Becker and Moder-
sohn seldom took trips except for visits to their respective in-laws.
Daily life was house and garden, holidays and family, and art.*

*Becker adopted a "precisely regulated" workday. She arose at
seven and attended to domestic chores until nine, when she left
for her atelier. She took the path through the meadow behind the
clay pit, eschewing the more direct and well-traveled main road.
She went back to the house for lunch at one o'clock. Afterward
she napped for "ten minutes," had coffee, and returned to paint
from three to seven. In the evening she and Modersohn looked at
each other's sketches, or Becker played the piano or read ("But
she wouldn't touch newspapers."). Generally she went to sleep
early. On Sunday morning Modersohn would come to her atelier
and she showed him the work she had done during the week.
"She loved to be alone and did not like just anyone in her
atelier." Sunday afternoons and evenings were usually spent
with the other artists at Barkenhof, the Vogelers' home.* [1]

"Many of the things she painted even Otto Modersohn didn't
see. She made them and put them away. After her marriage the
sleeping alcove served as storage space for her pictures. When it
was full then, for lack of space, work was stored behind the
rafters of the old farmhouse. Other paintings which presented
inextricable problems over which she agonized were kept in her
atelier for years. She took them up again and again, or just
looked at them, or altered them by only a stroke."²

Only Becker's startling response to Modersohn's leaving
Worpswede for a few days suggests any turbulence: "I feel so
divinely free!" While she assured him that his role in her life was
one of anchor, not albatross, she immediately left the house to
spend the night in her atelier, sleeping alone among her paintings.

Modersohn related an incident to Rilke that he later incorpo-
rated into his "Requiem" for Becker. One violently stormy day
on the North Sea, despite Modersohn's pleas, she insisted on
walking along a pier nearly submerged by the onrushing waves of
high tide.³

Does the sea-captain still possess the figurehead
at his prow, when the mysterious lightness
of her god-like self lifts her high into the bright sea-wind?
No more can one of us call back the woman
who does not see us any more,
who walks away from us as by a miracle,
on a narrow strip of her own being, without mishap;
unless guilt were indeed his calling and his pleasure.

JOURNALS

April 1903

After my trip to Paris. Home in Worpswede.

I'm becoming close to our people here again and feeling
their great biblical simplicity. Yesterday I spent an hour
with old Frau Schmidt on Hürdenberg. That sensual insight
with which she told me about the death of her five children

and three winter hogs. She showed me a big cherry tree planted by her daughter, who died at the age of eight. "Well, well, like the proverb says, 'When the tree is tall, the planter's dead.'"

I've brought back with me a great craving for the nature of Rodin, Cottet, and Paris. It's probably what was healthy about my trip to Paris. The desire burns in me to be monumental in simplicity.

To Her Aunt Marie

Worpswede, 20 April 1903

My dear Aunt Marie,

There's a winter-like storm around our little house and all feeling of spring is being blown and hailed and snowed away for a while. Every day I circle around our little fruit trees and wonder which of them the night frosts have damaged. I planted our garden full of tulip bulbs in the autumn. They want to open now but they can't. Since Elsbeth doesn't roam through our garden as much during these cold spells, a pair of robin redbreasts have found it abandoned enough to build their nest here. So this cold and tenacious wintriness has its advantages. We can watch the two rust-colored companions hopping close to our window.

What's it like there? I'm thinking of you on your birthday and hope that life's burdens not weigh too heavily on you. I wish your soul peace.

Life glides along day by day, and gives me the feeling it's leading me to something. This hopeful, soaring feeling is the quiet happiness of my days. It's amazing that what are called the usual events play such a little role in my life. I feel I live them, but they don't seem the most important thing to me. What lies in between the daily cycle of days is what makes me happy. That's why I mostly have nothing to write you in my letters. These little, mostly inward things are best described by a more skillful hand than mine. So my trip to Paris is over without my thinking about it. I'm often

surprised at it myself. While I was there, Paris brought me
new understanding. Now I'm busy building on that knowl-
edge. I feel I'm living very intensely in the present. . . .[4]

To Her Family

Worpswede, 2 November 1903

My dear Mother,
 I'm so close to you and still not with you! I don't know
how to steal myself out of my little house without sadly
deserting its three other occupants. Otto needs to see my
face several times a day. Elsbeth makes much too much of a
racket for him, so he's not feeling very sympathetic toward
her. I have to be the oil that calms the waves. "Last not
least" is our new strange houseghost, whom I don't have the
heart to let sail the ocean of our little house alone. So I
must write you my love, which by my nature and disposi-
tion I am bid to put between the lines.
 Dear Mother, may everything around you be happy and
harmonious so that your days and nights and years are not
filled with anxiety. Sometimes I feel I should make you a
little more happy than I do. But I don't know how to begin.
I seem to be the one benefiting most from myself at
present—and Otto.
 We'll come to you one lovely evening next week.
 In tender love

 Your Paula

Worpswede, 30 November 1903

My dear Sister,
 Winter has come. Everything's freezing and in a couple
of days we'll be able to skate. I'm sitting in my dear little
Brünjes cell. It's growing dark. The moon is already bright

in the sky and in front of my window is our beloved hill. Elsbeth and I have just eaten a baked apple together. One can already feel Christmas coming.

Dear, I'd so very, very much like to have you with us for the holidays. Do you think you'd like to be with us? You could just pass through Bremen and quietly have Christmas here with us. We won't talk about the past.[5] We'll be happy just to be together. Only if you feel like it. Money shouldn't keep you from coming. Perhaps you could travel fourth class—it doesn't bother people like us. You decide.

We're especially thankful to be back in our lovely surroundings. Maybe Mother wrote you that we took a trip to Münster. We both made such an effort and we succeeded so little. The old people were so stubbornly opposed, out loud or silently, to everything. Within a couple of days Otto was drained. I called him my "little pastor" because he became so serious and pale. Unfortunately he had had a couple of alarming nervous palpitations this autumn that, since he's the anxious type in general, particularly exhausted him and made him feel nervous about his health. But now he's well again. He flutters through the wind in his brown overcoat and stands in his atelier and paints. Through his little drawing compositions he has dreamed himself back into proper equilibrium. For me these little sheets of paper make up the most beautiful, most simple, most sensitive, and most intense of Otto's works. They're the most direct expression of his feeling. He has looked at them, looked at them again and again, divided them into three different sizes and now we're carefully and lovingly mounting them. Probably seven hundred in all. I find these little things so moving. They're his most beautiful work. Most people haven't seen them yet and those who have, haven't paid attention to them.

Worpswede, 18 January 1904

My dear Sister,

. . . Otto's making beautiful pictures. Autumn and spring and all kinds of fine things. Not to mention his "Ideals,"

which he recently reworked and beautifully copied one evening into a notebook with a green cover and yellow paper (of which he's very proud).

I don't feel much like painting right now. I'm reading a lot, mostly French. I'd like to get to know the language a little better. At the moment I'm reading George Sand's *Lettres d'un Voyageur*, which interests me very much in parts—not the letters themselves as much as the various relationships that resulted in these letters. Relationships she had with the greatest and very different men.[6] I can't judge her as an artist, although she does suffer somewhat from a feminine lack of discipline in style. It seems to me that less would be more.

I've been so foolhardy as to have sat down with my letter in our brown living room. I really must always write at Brünjes's. My thoughts and feelings are closer together there. Here Elsbeth comes in every couple of minutes with all sorts of little requests. I'm afraid that's why there are gaps in my letter.

To Otto Modersohn

Worpswede, 15 April 1904

Dear, when I said *adieu* to you I had almost the same feeling Elsbeth has when she happily puts us in the coach and sees us off to Bremen. She thinks about having a whole day or two to herself with no one forbidding her anything. I feel so divinely free! As I walked over the hill, listening to the larks, I wore a quiet smile within me. The feeling I often had as a girl came over me, "Oh yes, I'll buy this world." It's having you in the background that makes my freedom so beautiful. If I were free and didn't have you, my freedom would be worth nothing to me.

I'm thinking about how I'll spend these next few days at my disposal. To begin with, I ordered something very tempting to eat: cold sweet rice with cold apple slices and raisins.

And it's not raining and our wash is fluttering merrily in the wind.

I went out and dug up some anemones and planted them in our little forest. They should be blooming when you return.

I've also been in your atelier. I said to myself very proudly and softly, "This is the atelier of my husband." The new picture has to be even better. It's a little uncertain in mood. I want to say that, instead of being great, it seems bombastic to me. I'd like to talk to you about it again. The idea pleases me very much though, and you've brought out the head of the old woman splendidly. It makes me think of the old "Empress" on Klinkerberg. Were you thinking of her too?

Dear, do you know where I slept last night? At Brünjes's. It was so delightful. I cooked my eggs on my little oil stove as in the old days. I sat up until ten with my two windows wide open. First a blackbird sang, then a robin, and then they were silent. Throughout the night there were soft sounds, the voice of awakening nature, and every now and then the distant bark of a dog.

I'm as attached to this little room as you are to your bachelor den at Grimm's. Sleeping, waking, the jangling of cows' chains during the night, the cries of the cock and hens in the morning—I enjoy it all.

This morning I went to Gartenberg, where I sat down with my sketchbook and spent a lovely hour. We're having marvelous weather. You'll wonder at how green these two days have made everything. Now farewell, my Dear. What's happening to you and when are you coming back to your little wife?

TO HER AUNT MARIE

Worpswede, 30 April 1904

My dear Aunt Marie,
 . . . I try to imagine myself in your surroundings and ex-

perience you as the spiritual and physical center of certainly
a very large circle. Your birthday turns into a general holi-
day as your young people try to show you their love. Will
you be taking an excursion to the country? Surely every-
thing is blooming and it must really be marvelous in your
fruit-growing regions now.

Spring arrives here somewhat later than it does there, but
it's already quite marvelous. The birches are putting on
their delicate green veils and beneath them on the ground
lie starry white cushions of anemones. And the blooming
willow catkins! Each time is so new and so much joy fills
one's soul, joy one had completely forgotten. Chattering
very close to our bedroom window in the mornings are
starlings, and a redstart has nested under our roof.

Otto was at his parents' in Münster for four days recently.
I played Paula Becker and slept in my old little white bed
under the thatched roof. It was a devil of a lot of fun for me.
At night I listened to the cows with their jangling chains as
in the old days and in the morning the cackling chickens
woke us. I visited the house at lunchtime, when I ordered
us all kinds of baby foods.

Another game here is dancing à la Duncan[7]—Herma,
Frau Vogeler, and I. We have a lot of fun. We do all kinds
of steps. Mother is the most enthusiastic audience. Otto
used to play the flute but he sold it when he was low on
funds. He should rededicate himself to the instrument with
fervor in order to accompany our dances. But he really
growls at it, at the flute that is.

Yesterday I heard the first nightingale. . . .

Worpswede, 13 January 1905

My dear Aunt Marie,

. . . Winter doesn't want to come this year. It's always
spring weather, either heavy spring storms or light spring
rains or mild spring sunshine. I have misgivings about this
untimeliness. I long to skate just once and pump my lungs
full of strong clean air. Otto's contented in any weather—
to that extent he's lucky. Did they write you from Bremen

that I'll probably be going to Paris at the end of January? I'm looking forward to it immensely, in fact it's all I'm living for. Strange, from time to time I get such a tremendous longing for Paris. It's probably a consequence of our life here, which organizes itself mostly around our inner experiences. Sometimes one has the strong desire to have an exterior life—which one can always run away from whenever one likes.

Footnotes: Chapter XII

1. Modersohn in Hetsch, pp. 25, 26.

2. Herma [Becker] Weinberg in Hetsch, pp. 16, 18.

3. Westhoff in Hetsch, p. 48.

4. Otto Modersohn's journal, 15 June 1903:

> My Paula's painting is quite splendid. In the evening our day's studies lean against the flower table in our veranda. Last night Paula really surprised me with a sketch of the poorhouse with Dreebein, a goat, chickens—quite splendid in color, enormously remarkable in conception, and the surface irregular, scratched with the handle of the brush. Strange, how monumental these things are, gigantic when seen as paintings. In fact no one here in Worpswede interests me as much as Paula. She has wit, spirit, imagination, she has a rich sense of color and form. I am full of hope. As I can give her something of the intimate, so can she give me something of the monumental, the free, the concise. Our mutual giving and taking is wonderful. Our relation-

ship is very beautiful, more beautiful than I imagined possible. I am truly lucky. She is a true artist, as are few in the world, she has something quite rare. No one knows her, no one appreciates her. One day this will be different.

5. Following a broken marriage engagement Milly Becker left Bremen and went to work as a governess.

6. *Lettres d'un Voyager*, 1847, records Sand's early years in Paris and her trip to Italy in 1833–34 with the poet Alfred de Musset. Some of the letters are addressed to Franz Liszt and Giacomo Meyerbeer.

7. Isadora Duncan was being applauded in Europe, and caricatured in *Die Jugend* (Nos. 11, 12, and 38, 1903), for her barefoot dancing. The Tanagra figurines inspired her to adopt the Greek chiton as the freest costume for her expressive dances.

XIII. Paris, 1905

Again right after her birthday Becker went to Paris. This time she enrolled in the Académie Julian. "If I were free I'd stay here at the academy at least a year. It'd be good for you too, but you probably don't think so." Becker was resigned to Modersohn's indifference to contemporary art in Paris. In contrast to her 1903 letters, she did not importune her husband to join her. But following the death of his mother Modersohn himself suggested the trip. He came with Milly Becker and the Vogelers, who brought along their eldest daughter. The Worpswede group spent ten days together in Paris and then returned home in early April.

In his diary Modersohn mentioned their seeing the Gauguins of the collector Gustave Fayet. Becker wrote that her attention was being captured by "the most, most modern" artists. During the time she was in Paris Bonnard, Matisse, and Vuillard were showing together in the first exhibition of the "Intimistes." Picasso was having a show of thirty-four of his works, including eight paintings from the Saltimbanques series. The Salon des Indépendants that spring included Bonnard, Delaunay, Denis, Derain, Vlaminck, Dufy, Kollwitz, Matisse, Rousseau, Seurat, Signac, Vuillard, and a Van Gogh retrospective. [1]

To Otto Modersohn

Paris, 16 February 1905

Dear Otto,
 Well, I'm always unhappy at first, and so I am now too.

256

The big city still gets on my nerves and not everything is in order in my quiet haven on rue Cassette. Unfortunately my pretty room with its view onto the garden and tree is occupied. I have an uncomfortable little room and I don't know if I won't move again.

I was at the Luxembourg and was glad to find that for me the great Cottet is still the triptych (which you know). There was a 1904 portrait by Roll—interesting for its treatment of flesh, not as an image. One must admit Meier-Gräfe is right when he scolds the Luxembourg. Its new acquisitions aren't always what they should be.[2]

I greet the three of you affectionately. I wrote this letter so you could see that I haven't thawed yet—even though it's so warm outside that the catkins are blooming.

Paris, 17 February 1905
My mood is still rather low-keyed. I can't get close to things. I'm depressed basically because I don't have a proper home. I look at you as through a fog, as into another life.

I'm awaiting Herma[3] for tea and I've laid the table in the French manner.

Farewell, my dear Red. I'll write better soon.

Your little Paula with the -

Paris, 19 February 1905
My dear Husband,
I'm writing you my birthday letter and am with you in all my wishes for art and life and life and art. I'm sending you a couple of droll Daumiers[4] and a little Japanese sketchbook. I'd prefer sending you greater and more beautiful things but I'll have to wait a couple of years before I can do that, until you or I or both of us have amassed the necessary coins. When we have, I hope you'll like the old Nürnberg edition of *1001 Arabian Nights* that I plan on sending you. If not, it can probably be exchanged.

How are you spending your birthday? I hope the weather is beautiful. If Mother wants to make a punch, there are pineapples in the wine cupboard.

I'm still in my little cage on rue Cassette and I'm not very comfortable. Tomorrow I move: 65 rue Madame, fifth floor. I'll have the great sky above me and Paris below, both agreeable and good. Here I constantly look at a wall, which does not please my Worpswede soul. My new lodging is very close by.

I spent the whole day with Herma in the country. We ate lunch in a bower in the sunshine and enjoyed being alive. The landscape with its ruins of former splendor and the vista from the heights overlooking the big city always inspire me. The farms and haystacks remind me very much of Millet. When we came home we made ourselves a fine tea and had some bread and butter and jam. In front of us stood a bouquet of catkins and yellow coltsfoots, already in bloom here.

I've registered at the Academy Julian for a month to paint the nude from eight to eleven. The museums don't open until ten, so my morning hours won't be wasted and it certainly can't hurt me. My old Academy Colarossi went to the dogs soon after I left. Besides, Julian's has the advantage of not having so many dreadful Englishwomen. I object to their loud voices dominating everything.

Paris, 23 February 1905

I've left my little prison on rue Cassette and am enjoying air and light and space on the fifth floor on rue Madame. Soon I'll be finished acclimatizing myself. I'm experiencing many beautiful things and I know I am in Paris.

I have to tell you something that will amuse you and the family. My *petit chapeau gris* is a failure here. Paris, which can and must tolerate so much, could not tolerate my little hat. Everyone looked at me and laughed, even the cabbies driving by cracked jokes about me. Some time between twelve and one in the afternoon, when the little shop girls

and apprentices are in the streets in droves, I was saluted by
their laughter.

At Durand-Ruel's[5] the porter whispered to a *garçon*,
"C'est une anarchiste." Finally I fled into an omnibus,
where only a limited number of eyes could see me and rode
to Bon Marché, where I bought myself some headgear that
is tolerated. Unfortunately I dislike it.

I was so proud of my *petit chapeau gris* and now the cruel
world has forced me to shelve it.

People are immensely sarcastic here. In the atelier too,
the girls are always throwing each other glances and gig-
gling like children. Actually there's something totally
childlike about these people. They like to quarrel, but right
afterward they're nice to each other. They can gabble so
their mouths are never still, and they have a penchant for
the naive and natural, etc.

There's also something of the good Samaritan about
them. My paint box broke open on the street today, each
color in a different direction. A lady helped me to gather
them together, even though it was snowy and messy out.
Many people here would do that.

It's very funny in the atelier, genuine Frenchwomen are
very amusing. Only I'm still afraid of them because they
laugh so easily. They paint as artists did a hundred years
ago, as if they hadn't seen painting since Courbet. The only
exhibitions they attend are those for the *Prix de Rome*,
probably the same trash but of somewhat better quality.[6]

I've found a canvas here that I feel is my canvas.[7] The
others regard my paintings very suspiciously. When I leave
my easel at recess, they stand six deep in front of my work
and debate it.

A Russian asked me if I really see things the way I paint
them and who taught me.

I lied and said proudly, "Mon mari."

Whereupon a light dawned and she said, enlightened,
"Oh, you paint the way your husband paints."

That you paint the way you see things yourself, that they
would never assume.

In celebration of your birthday yesterday I painted a still life, oranges and lemons—very delicious.

I'm yours with my whole heart. Here in this big city I think about your red beard. But I'm glad I'm a little ways from you, later it will be all the more beautiful.

Paris, 28 February 1905

I'm feeling better. Friday I looked up the Bs, the Norwegian author couple.[8] I found a fine, sympathetic woman to whom one feels immediately close. You know how glad I am when I meet a person I like. Most people are all the same to me.

She's graceful, lovely, womanly, guileless. She's expecting her third child in the spring and is worried that it will be too much for her husband and herself. That's how it happens—too quickly for some, too slowly for others.

Her husband arrived just as I was leaving. He made a robustly healthy, bristly-haired impression on me. He immediately asked if I were a vegetarian too, probably because Rilke's being meatless bothers him.[9]

In celebration of Victor Hugo's birthday *Hernani* was performed at the Théâtre Français Sunday evening. At its premiere *Hernani* signaled a battle in the theater world. Why? People like ourselves can hardly realize why. To us the play seems stilted and pompous. At the end, a black and a white spirit appear next to a bust of the poet. They recite some verses in an exaggerated rhetoric that transported the public. The way people here become enraptured with their own words! Amazing.

I was to Cottet's atelier. It's filled with the most beautiful, most interesting things, which I'd like to show you. They would interest you enormously. Curiously the Old Masters aren't having as strong an effect on me this time as are the most modern painters.

I want to go see Vuillard and Denis. The best impression is gotten in the atelier. Bonnard's in Berlin right now. I saw two things by him that I didn't like very much.

Paris, 6 March 1905

My dear Husband,

... I think tonight is the first evening of spring and I feel
very happy. Out walking today, I just carried my fox muff,
whereas before it really had to keep me warm. I did just as
the poor wretches in the Louvre and the Luxembourg: I
positioned myself legs apart over a hot air vent and let the
warmth blow nicely under my skirts.

Sunday we had a merry foretaste of *mardi gras*. We went
to the grand boulevards, where confetti throwing was al-
ready in solid swing. It's so much fun to see the colorful
snow ripple through the air and, besides, the people are so
funny. Often a whole battle would be unleashed between
two of them. One would bombard with green, the other
with red. At the end a tall fellow shook out his entire bag
over the head of a little girl. When we examined the con-
fetti we found tiny, finely cut newspaper mixed in. Some
resourceful Papa had his family flock engaged in cutting up
the papers and doing the world out of almost four *sous*.
Now he thinks it's a devil of a joke.

Herma and I sat down at a café, a pretty safe place, and
we were able to watch everything undisturbedly. Two
wenches with guitars and enormous tremolos came along
and sang. One was ugly and degenerate, cursing yet good-
natured. The other was a tall, slender Spaniard whose col-
lar hung over her shoulders in a romantically negligent
fashion while she played her guitar.

In the evening Herma and I went to a vaudeville show. It
was not very innocent despite the many children in the
audience. Children are fed cayenne here early on. In the
first piece everyone who came onstage undressed
immediately—the men wore drawers, the women charming
dessous. Then a *concierge* appeared in her night shirt and
night cap. The shirt was the same cut as Mother's. What a
sight it would have been for you! The second piece was a bit
too colorful for me. There were beautifully painted beds on
stage. A man was lying in one, the woman had nearly
nothing on. I was really sorry Herma got acquainted with

this side of life so early. Well, she's a part of it and she'll have to handle it.

Your Worpswede *Holiday* is tacked up on my wall and I'm enjoying it. It hangs beside the three women by Cottet— with whom I wasn't so lucky this time. The first time I went to visit him, a young black man had just gone into his house so I stayed outside. Today I met him twenty paces from his house—he was just leaving. He stared at me and then half greeted me, as one greets a person one can't place yet whom one knows.

I'm back at Julian's this week, painting my nude. I like painting and I enjoy the girls. There's a Pole here who dresses like a man, wears a man's painting smock and has masculine gestures. Fairly many unkempt, coquettish Frenchwomen. Julian has another women's atelier on the other bank of the Seine that costs twice as much. Marquises go there, Bashkirtseff went there.[10]

JOURNALS

Paris
The intensity with which a subject is grasped—still lifes, portraits, or pictures from one's imagination—is the beauty of art.

Life and death shook hands. At *mardi gras* a smiling, blond Frenchman placed a bunch of violets in my hand. I sent them on to Otto's sick mother in Münster. They were placed in her dead hands.

TO OTTO MODERSOHN

Paris, 11 March 1905
My beloved Husband,
I've thought a lot about you today and everyday. Do you feel it? It's so strange that the two of us—who really are

one—are leading such different lives at present. You serious
and depressed by the death of your mother. I in this big
city, in spite of it full of hope. The rich variety, the enor-
mously rich variety of life here, the many different lan-
guages and people are fascinating.

Today at the hour you committed your dear mother to
the earth, I was in Montmartre, at the ever-unfinished
Sacré-Coeur, Paris below me. Again and again I'm deeply
moved by the sea of houses, with its roar, with its various
struggles and pursuits. What strange creatures human be-
ings are. What drives them to their thousand different
deeds? How amazing, the voice within that rules and guides
us, this hunger of our souls that is never satisfied.

What are your thoughts at this time, Dear? Write me. I
see you quiet, with a white brow, sitting in the corner of the
living room where your mother's empty armchair stands.

Dear, I'll be happy when you are finally back in our little
house in your own surroundings. The friendship of Vogeler
and Overbeck will certainly be a help.

Cottet was here, found much good, "but the drawing!"
I'll work awfully hard at my studies when I come home. I
long for you, my dear husband. I'd like to kiss you and hold
you in my arms and comfort you.

Paris, 15 March 1905

I am marvelously happy at the thought that we'll see each
other again in two weeks.

Oh, I have so many beautiful things to show you and so
much beautiful love stored up, which I want to pour into
you and cover you with, to comfort you inside and out.

It is strange that at this time of great sadness in your life,
I am here receiving my major impressions.

Tomorrow is the opening of an exhibition at Georges
Petit: Cottet, Simon, Zuloaga.[11] Frau Simon gave me an
invitation so I could get to see everybody face to face.

I very much hope that you are reinstalled in your atelier,
among your pictures and with your friends. It will be good
for you.

Is spring there around every corner and behind each bush as it is here?

On the boulevards the big pollards are certainly nothing to look at yet, but in the Luxembourg and the *bois* everything is sprouting. We went there for a long stroll Sunday with the two Bulgarians we met at *mardi gras,* a law student and a sculptor. The sculptor attends the Ecole des Beaux-Arts. It's interesting and instructive to see the way people here are under the influence of tradition and school. It's a kind of soldierly discipline. In Germany we approach the matter much too ingeniously. Everyone is always talking about individuality. Here the oldest professors are just about the best because they teach only the A-B-C's.

If I were free I'd stay here at the academy at least a year. It'd be good for you too, but you probably don't think so.

A very old professor at the Academy Julian bestowed praise on me today. But I still feel a little like I'm on stage, in fact as if I were actually a character from an entirely different drama who's now acting in a strange new play. This produces a rather stupid dissonance at times.

Now farewell, my Red, *croquis* is starting. Only ten more days and we'll see each other again. I'll be standing in Gare du Nord with my arms open wide. Have your hair cut again by the "poet" so that you'll be handsome. But have it cut now so that it will have grown out a little by then.

Paris, 18 March 1905

My beloved Husband,

It's a rainy day today. It has been sprinkling lightly ever since morning. Otherwise, we've been having such beautiful weather lately. Often when I sit upstairs on the omnibus my heart smiles over this beautiful city.

I was at Georges Petit's Thursday for the opening of an exhibition for which Madame Simon (whose husband I had missed at home) had given me a ticket. It was a very Parisian sight. Many fine ladies with many long trains and fine gentlemen. The exhibiting artists were there too, so I saw Cottet. Zuloaga was pointed out to me, but his face didn't make much of an impression on me. At the end I came

across a Bremen corner—Heymel and his wife, Sparkuhle, and Wiegand, who, it appears, intend to buy pictures here.[12]

We went to a *variété* with our swarthy Bulgarians the other day. The show was neither good nor bad enough to interest us. Still we enjoyed ourselves very much. We sat around a little table and to make conversation we introduced ourselves. Even though we had met several times before, we didn't know each other's names. All of us really fumble whatever we say in French so that "Madame" and "Monsieur" had sufficed till now. So we introduced ourselves by our first names, which we translated into the most diverse languages in order to explain them. Then our last names, which we wrote out for each other, and finally our addresses. It was terribly funny. Like children introducing themselves. Neither of our cavaliers are burdened with European politeness. Mine, who on the whole has the advantage as far as knowledge and good looks are concerned, spits. We generously overlook such things only now and then making little suggestions. (For example, that before meeting us they not eat anything with garlic in it, and the like.) They listen to us most obediently.

Paris, 24 March 1905

The Salon des Indépendants is open. There's no jury. Pictures hang alphabetically[13] in colorful confusion on burlap-covered walls. You don't exactly know what's missing, but you vaguely sense there's a screw loose somewhere.

Once again it's totally Paris with its caprices, with its ingenuousness—the most stupid conventional works next to eccentric pointillist experiments.

You should have seen the fellows in slouch hats and their little women running around at the opening yesterday. They always amuse me. They look like boys playing soldier. Although one of them here or there will become a general.

Paris is delightful now with its hazy-misty spring sky and its gay new straw hats.

I spent several beautiful mornings in the Bibliothèque

Nationale with Rembrandt etchings. Evening at the Bs'
with Nordic people and Nordic sensibilities. Interesting
too. Within the walls of this city reign an enormous life and
an enormous spirit. It has an almost mystical effect on me.
 You should come on the night of the twenty-eighth to
see Mi-Carême. [14] It would amuse you, the people here are
so natural then.

Footnotes: Chapter XIII

1. The Fayet Collection included paintings (self-
 portraits, The Yellow Christ, pictures from
 Tahiti), watercolors, pastels, drawings,
 sculpture, and ceramics. The Fayet Collection
 was part of the Gauguin retrospective in the
 Salon d'Automne, 1906. Donald E. Gordon,
 Modern Art Exhibitions, 1900–1916, Munich,
 1974, II, p. 172.
 "1905 10–25 Feb. Paris, Galeries Henry
 Graves. Intimistes, 1er Exposition. Bonnard,
 Laprade, Matisse, Vuillard.
 "25 Feb.–6 March. Paris, Galeries Serrurier.
 Trachsel, Gérardin, Picasso.
 "24 March–30 April. Paris, Grandes Serres.
 Artistes Indépendants, 21e Exposition." Gor-
 don, pp. 115, 119, 123.

2. Cottet's Au Pays de la Mer.
 Alfred Philippe Roll (1846–1919), military
 and genre painter, pupil of Gérôme and Bonnat,
 won the Grand Prix at the Exposition Universelle
 1900.
 Julius Meier-Graefe (1867–1935), German
 critic and art historian, champion of Impres-
 sionism. His major work, Entwicklungsgeschichte
 der modernen Kunst (History of Modern Art), pub-

lished in three volumes in 1904 included chapters on Cézanne, Van Gogh, Gauguin, and, of the artists mentioned by Becker in these letters, Daumier, Millet, Courbet, Vuillard, Denis, and Bonnard.

3. Becker's younger sister Herma was in Paris studying French.

4. 1904 saw publication in Paris of a catalogue of Daumier's lithographs by Delteil and Hazard, which was the basis of their ten-volume corpus on his graphics. Becker was first impressed by Daumier's "small scale" things on her previous visit in 1903.

5. At the time of this letter Durand-Ruel in Paris did not have a special exhibition. Instead Durand-Ruel was presenting the work of Boudin, Cézanne, Degas, Manet, Monet, Morisot, Pissaro, Renoir, and Sisley at the Grafton Galleries, London. Durand-Ruel, Charles, Letter to the Author, 25 July 1978.

6. It was not until 1903, seven years after first gaining admission to the Ecole des Beaux-Arts, that women (viz. single French women between the ages of fifteen and thirty) were allowed to compete for the *Prix de Rome*. Winners of the *Prix* were sent to Rome to study for four years at government expense. *La Chronique*, 1903, p. 68.

7. Becker experimented with painting on various materials: canvas, cardboard, masonite, paper, pasteboard, silverfoil, slate, wood, and various combinations thereof, trying to achieve a certain surface quality. She painted "on unprimed ground or paper with a Munich oil tempera. And in order to agitate the surface she often worked

the paint with the handle of her brush. Or she slurred the very pasty coat of paint after it had dried up and then painted over it again, thus gradually reaching her goal by layering one coat over another." Modersohn in Hetsch, p. 27.

8. Johan Bojer and Ellen Lange-Bojer. They had been living in Paris since 1902. He was known for his stories of folk life. Rilke and Westhoff made their acquaintance in Paris in 1903.

9. Rilke was spending six weeks at Dr. Lahmann's sanatorium, Weisser Hirsch near Dresden. Dr. Lahmann, who advised Becker's teacher Jeanna Bauck to paint without her clothes on so that her skin could breathe (see p. 39), was an advocate of natural healing and a vegetarian diet.

10. Marie Bashkirtseff, whose *Journal* Becker read as a student in 1891, was from a Russian family of minor nobility, hence when she attended Académie Julian in 1877 she went to the studio on the right bank.

11. "Exposition de la Société nouvelle de peintres et de sculpteurs, Galerie Georges Petit." *La Chronique*, 1905, p. 88.

 Ignacio Zuloaga (1870–1945), Spanish genre painter, trained in Paris, where he made his reputation. A friend of Degas, Rodin, and the poet Mallarmé, Zuloaga was influenced by the Spanish masters and the French Impressionists.

12. Willy Wiegand, cofounder and director of the Bremen Press, 1911.

13. Bernard, Bonnard, Borissoff-Moussatoff, Camoin, Cross, Delaunay, Denis, Derain, Desval-

lières, de Vlaminck, Diriks, Dufy, Friesz, Girieud, Guerin, Hervé, Kollwitz, Laprade, Le Fauconnier, Lemmen, Manguin, Marquet, Matisse, Metzinger, Munch, Nonell, Puy, Rouault, Rousseau, Roussel, Séguin, Serusier, Seurat, Sickert, Signac, Soffici, Vallotton, Valtat, Van Dongen, Van Gogh, Van Rysselberghe, Vuillard, etc. Gordon, pp. 123–28.

Of 4,269 works exhibited in the Salon, the State purchased twenty-three, including Matisse's *Saint-Tropez* and Signac's *Notation à l'Aquarelle* —*Venezia. La Chronique,* 1905, p. 99.

14. Thursday of the third week in Lent. *Mi-Carême* and Shrove Tuesday were the two days of *mardi gras* celebration in France.

XIV. Worpswede, 1905–06

"Worpswede was still the same far distant place with its slow mail carriage—country, and yet a strange contrast, an intensity beyond that which is rural here in Meudon. Most remarkable was to find Modersohn's wife in a completely original stage of her painting, painting ruthlessly and boldly things which are very Worpswede-like and yet which were never seen or painted before. And in this completely original way strangely in affinity with Van Gogh and his direction."—Rilke [1]

To Her Mother

Worpswede, 11 April 1905

Dear Mother, my homecoming was lovely. Many thanks for the white veranda ceiling with the green Christel trim, and for the luxurious new chair cushion. I'm enjoying the bright little room very, very much. I thank you especially for taking my place so kindly while I was dashing around in the world. You made it possible for me to enlarge the content of my life. I consider my trips to Paris the complement to my rather one-sided existence here. After ten quiet months in Worpswede, I feel that plunging into a strange city with its thousand activities is almost a necessity for me.

Nature has been asleep these two months. The birches

still don't want to bud, the anemones are glimmering furtively in the grass, and today I pinned two violets from our garden on my breast. It's strange that the charm of spring here is due to its sparseness.

Today I went to see all my child models and, strange to say, in all four houses I looked into, a new Hinnerk or Meta had arrived.[2] I looked at all this wriggling new life with undisguised envy.

To Her Aunt Marie

Worpswede, 7 June 1905

My dear Aunt Marie,

I had intended to write you as soon as I heard that you were bedridden. But I've delayed so long that I can only hope you've already recovered and are enjoying the beautiful onset of this summer with a light heart. I feel strongly that health is so important. I'm very glad and thankful that we've been blessed so far.

There are the usual things to report about us. We're all very well. Elsbeth goes to the village school now and she can already write the most impossible words, relate the history of creation, and calculate 2–1. So the foundation of the civilizing process is being laid, which so far makes her happy. In addition she has a white rabbit, which she drags all around by its long ears and for which she must continuously gather food. While I, whenever I'm not painting, sleeping, or eating, am stuffing the gullets of two hungry magpies. Otto meanwhile wanders around with a glass jar full of tree frogs for which he catches bluebottle flies, and another glass jar full of salamanders, water beetles, and fish—he really should be catching earthworms for them, only he's so bad at it. And the roses and carnations in our garden are beginning to bloom. This is always a beautiful time for them and for us.

And painting is a beautiful art that is also difficult.

That's just about the state of things here.

To Her Family

Worpswede, 26 November 1905

My dear Mother,

The few hours of daylight that still shine are now over. I sent away my little nude model and lit my lamp with the intention and resolve to overcome my writing "allergy." Your big long "gray" and your second "gray" have roused my determination to act. . . .

. . . Mornings I'm painting Clara Rilke in a white dress, her head and part of her hand and a red rose.[3] She looks very beautiful and I hope I can capture something of her. Her little girl Ruth plays next to us, a small chubby human being. I'm happy to be seeing Clara Rilke frequently like this. In spite of everything I still like her the best. She lived quite close to Rodin for three or four weeks and is still very much under the influence of his personality and his simple, great maxims. Rilke, as Rodin's secretary, is little by little getting to see the intelligentsia of Europe.[4]

Otto is painting, painting, painting. And we've earned enough so that perhaps after Christmas we can visit you after a small detour to Schreiberhau. That would be very nice. On the whole I've begun this hibernation with all these feelings of longing—perhaps why I dislike writing. I'm secretly planning a little trip to Paris again, for which I've already saved fifty marks. Otto, on the other hand, feels utterly comfortable. He needs activity only as a rest from his art, and he's always satisfied. I get the strong desire from time to time to experience something else. That one is so terribly stuck when one is married, is rather hard. . . .

Worpswede, 6 December 1905

Dear Milly,

We live a very exciting life here and I want to share some of it with you. First, you have to imagine the three of us as regular customers of Welzel's bowling yard every Thursday night. Both Vogeler couples, the Krummachers, the Hartmanns, and your reddish humble servants.[5] I'm very

proud of Otto's strength, his whole "regimen" four times a
day. I by comparison am more prudent.

Ranke, the tailor, had sewn a much lighter seat into
Otto's gray trousers, so I had to exercise my painting skills
on it at the last moment just before we left. I made the
patch very similar to the rest of the pants. This demonstra-
tion of my talent delighted Otto and me.

Last week I spent two evenings at the theater in Bremen.
Eysoldt of Berlin[6] was the guest star in *Elektra* by Hof-
mannsthal and in Wilde's *Salome*. Her performances were
distinguished and individual, very sensitively developed.
The rest of the cast was abominable.

Frau W lent me the Wagner–Wesendonk letters.[7] I feel
as far from them as I did recently from *Tristan und Isolde*.
My soul, or rather my body and my nerves, struggle against
his hypnotic music. In spite of the German subject matter I
consider Wagner un-German. Please excuse my opinion. It
is impulsive and I've become old and wise enough to no
longer admit openly to such things.

In my painting I'm trying in the few daylight hours that
winter brings to approach my continually renewing goal.
Totally disregarding whether or not one has talent, I do
find art very difficult.

Today we received a telegraphed invitation to winter in
Schreiberhau. Perhaps we'll slip over after Christmas. Be-
sides, we're looking forward to a retrospective centennial
exhibition in Berlin with works by Leibl, Marées, Feuer-
bach, etc.

. . . Here it's gray December skies with fog, rain, and
warm winds. Elsbeth is working with pains and joy on a
Christmas gift for you. She believes more firmly than ever
in Father Christmas.

Farewell, loved Sister. Otto is modeling for Clara West-
hoff. . . .

Worpswede, 17 January 1906

My dear Milly,

Now we are sitting at home again, by the lamp in our
brown living room.

We have a lovely trip behind us. We had winter and

snow in the Riesengebirge at Hauptmann's. The landscape, which hadn't much impressed us during the summer, was magnificent! The white mountains were grand and solemn under the cloudy sky that partly covered them. There was an attractive, interesting circle at Hauptmann's: Bürgermeister Reicke and his wife, and Sombart the sociologist.[8] There were always interesting debates among the men during dinner and dessert. All these learned people seem so different from the painters we are used to associating with. Many fine things came forth, especially when Hauptmann and Sombart took the field against each other. Daytime was usually spent tobogganing. It was glorious whizzing down those mountains.

At the end Berlin provided us with a multitude of impressions from pictures. Otto and I saw the Kaiser Friedrich Museum for the first time and we found many art treasures there that were completely unknown to us. There's an exhibition in Berlin of painters of the last century. It hadn't opened yet. We were freely admitted and were able to look at the treasures leaning against the wall: Leibl, Trübner, Böcklin, Feuerbach, Marées. There were wonderful things there.[9]

Now we're home again, where everything goes on in the same old way.

Hans is off traveling again?[10] Use your time well, reading and playing lots of music. Strange how the goods of this world are divided. To me, for example, nothing could be more preferable than to be alone for six weeks from time to time. Well, each bears up in patience.

I am in love and more love

Your Paula

Worpswede, 19 January 1906

My dear Mother,

Frau R is dead. The death of this great woman has moved me very deeply. Slowly, slowly and gradually, to have the

vital energy she had so much of taken away. She was a tree still able to bear fruit. Now this fall!

While rank, ninny-headed, flat-footed beings continue to exist. How can we understand life if we don't see it as the work of each individual in the spirit—we can even say holy spirit. One works with more, another with less ardor. But all, even the smallest, add their share.

The offering and work that Frau R brought was the product of her energy and many struggles. She worked hard on her spirit with consciousness and willpower. There radiated from this woman a strong sense of self-discipline that I treasure very highly. Frau R was the woman in Bremen for whom I had the greatest respect. I imagine I would have told her this one day. Perhaps I could have if she had lived longer. I feel that many of the walls that Worpswede raised between myself and the world are crumbling.

One big wall was always our aspiring to the rustic life, so that when we came in contact with urban life we took exception to superficial differences.

And I wish Frau R might have seen me become something. This way I could have explained myself to her straightforwardly.

Because I will become something. How great or how small I myself can't say, but it will be something complete in itself. Rushing steadily toward one's goal is the most beautiful thing in life. Nothing else equals it.

I am always continually rushing, resting only in order to rush after my goal once more. I ask you to keep this in mind when I sometimes appear poor in affection. I concentrate my energy on one thing. I don't know if one can still call this selfishness. In any case, it is the most noble.

I lay my head in your lap whence I came and I thank you for my life.

Your child

Worpswede, 11 February 1906

My dear Mother,

Your dear gray birthday letter with your maternal love

arrived very punctually. You and my sisters and brothers punctually awaited me with all your letters on my little birthday table. It was so delightful.

... I read a book, *Napoleon, Lover and Husband.*[11] A remarkable man. How he could love, despite his very busy life and his necessary ruthlessness! From an emotional standpoint this larger-than-life human being was often so moving personally, so full of great longing.

Father's picture! I too find the resemblance very striking and we probably share some of it in character too. Only Father was not as inconsiderate as I. I am, I feel, more stubborn. This resemblance was probably why our so-modest Father was never satisfied with me my entire life.

I kiss you affectionately.

Your Paula

Footnotes: Chapter XIV

1. Letter to Karl von der Heydt, 16 January 1906, *Briefe aus den Jahren 1902 bis 1906,* Leipzig, 1930, p. 291.

 Rilke had been away from Worpswede most of 1905. He returned at Christmas and saw the paintings Becker had done that year following her trip to Paris. As Butler noted (p. 108), "Rilke was more competent to judge such matters now than he had been in 1900 or when he excluded her from *Worpswede,* so that his belated praise must have been all the more welcome and encouraging."

2. In 1905 the Vogelers had a third daughter.

3. Illustrations 62–64 in *Paula Modersohn* by Otto Stelzer, Berlin, 1958.

Westhoff recalled how "Paula painted me while my little daughter sat on the floor and played, and after painting one winter afternoon we both sat near the stove in her little atelier. Paula threw one piece of peat on the other through a little squeaking door in the fireplace as one tear after another rolled down while she explained to me how very important it was for her to be out 'in the world' again, to go back to Paris. "'When I think about it, the world'—she said." Hetsch, p. 49.

4. Rilke had become Rodin's secretary in September 1905.

5. Heinrich's brother Franz and his wife, Philine. Karl Krummacher and Richard Hartmann were Worpswede painters.

6. Gertrude Eysoldt was "an extremely clever and subtle player" who, according to *The Oxford Companion to the Theatre*, "was at her best in modern realistic parts . . . in Ibsen, in such parts as Salome and Cleopatra, and in the plays of Maeterlinck." She also starred as Hannele and appeared as Rautendelein in *The Sunken Bell*, by Hauptmann.

7. Mathilde Wesendonk, poet and friend of Richard Wagner. He set five of her poems to music, *Fünf Lieder von Mathilde Wesendonk*, which have been regarded as studies for *Tristan*. Wagner composed the first act of *Tristan* while living at the Wesendonk estate. Their correspondence first appeared in 1904.

8. Werner Sombart (1863–1941), German economics historian. The "interesting debates" that took place could have been about the origins and

development of capitalism. Sombart's research in this field resulted in his major work, *Der moderne Kapitalismus*, 1916–28.

Becker took the opportunity to paint his portrait. Illustration 54 in Stelzer.

9. The Kaiser Friedrich Museum opened in 1904.

"Deutsche Jahrhundertausstellung," an exhibition of German art from 1775 to 1875, was held in the Kgl. Nationalgalerie in Berlin.

Wilhelm Leibl (1844–1900), an "important German realist" and influence on Wilhelm Trübner (1851–1917), one of the painters "who combined an incisive realist perception with the impressionism filtering in from Paris and Berlin." Anselm Feuerbach (1829–80) and Hans von Marées (1837–87), along with Böcklin, worked in Rome. Theirs was a "romanticism of a peculiar kind . . . a romanticism of subject matter based largely on the classical tradition of the academy and . . . fused with realism." Selz, pp. 25, 32, 33.

10. Milly Becker had married Hans Rohland.

11. The English title of Frédéric Masson's *Napoléon et les femmes; l'amour*, 1894. A German translation appeared in 1895.

XV. Paris, 1906–07

"*I couldn't stand it any longer and I'll probably never be able to stand it again either. It was all too confining for me and not what—and always less of what—I needed.*"

"*It*" was marriage and the provincialism of Worpswede; it was the lack of peers; it was not being taken seriously by anyone but a dear man whose art took no risks; it was the cold and long walk to her atelier; it was outgrowing heavy skies and artistic moralism; it was turning thirty; it was frustration and it was ambition.

Rilke met her at Gare du Nord, flowers in his hands and a hundred marks in his pocket. Rilke and Westhoff had long since foregone conventional married life as incompatible with art. Now he was at the train station to applaud Becker's bid for freedom. Within a few days he was off on a lecture tour and did not return to Paris for over a month. When he did, she was the first person he saw: "*She is courageous and young and, it seems to me, well on her way, alone as she is and without any help.*" [1]

Becker hoped to enroll at the Ecole des Beaux-Arts, a course of study that would take years. But besides rigorous entrance exams, the cutoff age was thirty and few Germans had ever been admitted to the Ecole. [2] She did take advantage of those Ecole classes that were free to the public and she sketched from its large collection of plaster casts. Becker again enrolled in a private atelier, where she took a drawing course in the evenings. Mostly, however, she painted in her studio on avenue du Maine.

Besides Rilke, the sculptor Bernhard Hoetger (1874–1949)

*played an important role in Becker's life at this crucial time.
Hoetger was having a modicum of success exhibiting and selling.
Maillol had praised his talent.* [3] *Becker wrote to Hoetger in May
("the most intensely happy period of my life"), "That you
believe in me is the most beautiful thing in the whole world
because I believe in you. . . . You have given me the most won-
derful gift. You have given me myself. Now I have cour-
age. . . . You have done me so much good. I was a little lonely."*

Modersohn, who usually had to be reminded to write, now
was pleading with Becker by mail over and over again to come
home. Whereas three years earlier she could not convince him to
join her in Paris, now she could not convince him that "our lives
can go on without each other." But little by little she succumbed
to the combined pressure of husband, family, and friends (par-
ticularly Hoetger). First Modersohn enlisted friends and ac-
quaintances in a letter-writing campaign urging her to return.
Then he visited her for a week in June. Later he proposed
another visit in the fall. Becker said no, but then relented after a
"preaching to" by Hoetger. She acquiesced with the stipulation
that she and her husband, like Rilke and Westhoff, maintain
separate quarters. So Modersohn came back to Paris, bringing
along the Vogelers, and by November Becker and Modersohn
were living together again. Then came the proposal that they buy
Brünjeshof, where Becker had her studio in Worpswede. By
March she was pregnant, by May they were back in
Worpswede, in November she was dead.

JOURNALS

Paris, 24 February 1906
I have left Otto Modersohn and I am standing between
my old and my new life. What will it be like? And what will
I be like in my new life? Now it is all about to happen.

8 March 1906
Last year I wrote, "The intensity with which a subject is
grasped is the beauty in art." Isn't it also true in love?

To Otto Modersohn

Paris, 22 February 1906

Dear Otto,

Thank you again for your long, dear letter. I can't answer you now and I don't want to because it would be the same answer I gave you in Worpswede. You're only writing things you've already told me. Please, let's not refer to this matter at all for the time being and let's just quietly bide our time. The answer that will reveal itself will be the right one. I thank you for all your love. That I don't give in is not cruelty or hardness on my part. This is very hard for me. I'm doing so only in the firm belief that if I don't test myself now, after half a year I'd be torturing you again. Try to get used to the possibility of the thought that our lives can go on without each other.

Now we won't speak about this again for a long time. It's pointless.

Naturally things aren't very well with me. Because of inner agitations I was fairly depressed when I arrived. I'm not working yet, nor in the right lodgings. Tomorrow I move.

I've seen a beautiful Manet exhibition at Durand-Ruel's. I especially liked the man with the guitar (which we saw illustrated somewhere) and a rabbit still life. There was also a room of Odilon Redon, about whom I can't be enthusiastic. A lot of caprice and grace, but the foundation is somehow too weak. Many flower pieces, mostly pastels. His colors have a great luminosity.[4]

Paris, 9 March 1906

Dear Otto,

Dear, dear letters from you lying in front of me, making me sad. There's always the same cry in them and I still can't give you the answer you want. Dear Otto, let's quietly bide our time and let's both see how I feel then. Only, Dear, try to keep in mind the thought that our ways will part.

I'd like you and my family not to suffer from my decision.

But how am I to do that? The sole remedy is time, which slowly and gradually heals all wounds.

I'm very happy you've sold two pictures. It's heartening during this difficult period.

I wonder if you've been good enough to mail my drawings to me? I'd like to have them for admission to the Ecole des Beaux-Arts, which is still not certain. Good work is said to be done there and it's cheaper. If you haven't sent them yet then please don't bother. It's too late and I'll enroll in one of the private schools instead.[5]

I'm starting to settle in here. The weather this week was magnificent, so warm that I looked for my shadow on the street. It's very beautiful when I come out of my drawing course in the evenings and the big city lies in the bluish dusk with its lamps lit.

Last Sunday Herma and I went to a lovely concert. I don't get together with her often. She has to study a lot, and I realize I must be causing her grief too.

Dear Otto, I squeeze your hand.

Affectionately,

Your Paula

Paris, 19 March 1906

Dear Otto,

I'm drawing regularly. It makes me happy realizing how much I can learn here. The young people are so thorough and meticulous, two qualities that must become much deeper in me. Here my paintings look dark and muddy. I have to achieve a much purer color.[6] I have to learn to model form. I have all sorts of things to learn and then perhaps I'll become something. All my hopes and efforts are concentrated on this goal.

From time to time Paris has me back in its spell as in the old days. It's marvelous in the evenings, the romantic backdrop to a romantic play, and stimulating, though less so to painting than to action.

I go regularly to the excellent anatomy classes at the

Ecole des Beaux-Arts and I'm attending a series of lectures in art history there. I've even made the heroic resolve to draw from their plaster casts in the afternoon. I'm not getting into the life-class so easily, but I can learn modeling from the plasters.[7]

My atelier is wholesome and bright, with a few pieces of pine furniture—a wardrobe and a cot to sleep on similar to mine at Brünjes's. It has one big drawback: I can't see the sky. The windows are opaque.

Paris, 9 April 1906

Dear Otto,

I've just read your letter. It moved me deeply. I was also moved by the words from my own letter that you quoted. How I loved you. Dear Red, if you can, hold your hands over me a while longer without condemning me. I can't come to you now, I can't. And I don't want to meet you in any other place, either.

So many things about you lived in my heart, but then disappeared. I have to wait to see if they'll return or if something else will appear instead. Over and over I ponder what the best thing is to do. I feel insecure myself about having forsaken everything that was certain in and around me. I must stay in the world for a while now, to be tested and to be able to test myself. Will you give me 120 marks a month for the time being? So I can live?

I'll stay in Paris as long as I can stand it. At the moment, I don't want to work independently, but in school. I've rented my atelier at Brünjes's to Fräulein W from May 1st on. I wrote her only that I wouldn't be in Worpswede for the summer.

Thank you for everything you've done for me. You know I'm grateful and you know fundamentally I'm not wicked and heartless. This is just my *Sturm und Drang* period, which I must go through, and I cannot help causing pain to those nearest me. It's hard knowing I bring this pain to your life. Believe me, it's not easy for me, but I have to fight my way through to one exit or the other.

It's beginning to be very beautiful here now. There, too,

probably. I've seen magnificent Courbets. I'm sorry he's coming into fashion. I find him grander than Manet or Monet. He's done an enormous flower piece, splendidly painted, of the most diversely colored hollyhocks with a female figure.[8]

You certainly put a bee in Herma's bonnet about Brittany. The idea of a trip is making her very happy. She's leaving this evening. I'll meet her somewhere during Easter, probably St. Malo. You've contrived it so sweetly.

Stay close to Elsbeth and your art.

Your Paula

Paris, 25 April 1906

Dear Otto,

I want to tell you about our trip to Brittany, which was beautiful beyond expectation. Thank you very much for your wonderful plans. At first I didn't want to go because I considered it unnecessary. But in the end I went so as not to spoil Herma's fun. Now we are both very fresh and refreshed and have returned to Paris tanned. I have beautiful feelings and plans about the art I expect from myself.

This France is really a blessed land. Traveling to St. Malo you pass through fertile fruit regions, apple orchards bordered by deep yellow furze, six foot tall, a kind we don't know at all back home. Big, beautiful, pale yellow primroses were budding everywhere. You enter the suburbs of St. Malo and are rather disappointed, twenty minutes past sheds and billboards, before arriving in a very small, very smelly, boring city of tall buildings. But when by chance you step outside the narrow city walls, there at your feet is the great sea with its rocky cliffs and rocky islands crowned by beautiful old forts, making grand silhouettes. We spent a whole day on the walls and little rocky islands, scrambling up cliffs and laughing when the sea spray hit our faces. Other days we made wonderful excursions. Herma's superb. She made well-thought-out plans, which then I only needed to trim because they began to be too much for us. Have you

any idea how mild the climate is on Jersey and Guernsey?
The area around St. Malo is similar, a southern lushness,
roses in full bloom, gillyflowers, and an abundance of
blooming wallflowers. It's not the austere Brittany of Cot-
tet. That may be farther away, and thus more dear. As is,
St. Malo is ten hours from Paris, the same as the trip from
Bremen to Dresden.

... Before my trip I visited your compatriot, the
sculptor, Hoetger, whose work made such an impression on
me in Bremen. He's working on a wonderful reclining
nude, simply monumental. The small head in Bremen is of
his wife. Both give the impression they've suffered greatly
from their straitened circumstances. He may be in his late
thirties. He was very interested in the Indian photographs.
I'm supposed to go there again this week for tea.[9]

To Bernhard Hoetger

Paris, May 1906

Dear Herr Hoetger,

That you believe in me is the most beautiful thing in the
whole world, because I believe in you. What good is other
people's belief in me if I don't believe in them? You've
given me the most wonderful gift. You've given me myself.
Now I have courage. My courage was always behind lock
and key and didn't know which way to turn. You have
opened the lock. You are a great benefactor. Now I've
begun to believe that I shall become something. And when
I think about this, I weep tears of joy.

I thank you for being on this earth. You have done me so
much good. I was a little lonely.

Your devoted Paula
Modersohn

Your sister-in-law is simply beautiful.

<center>To Her Family</center>

<center>*Paris, May 1906*</center>

Dear Sister,

I am going to become something—I'm living the most intensely happy period of my life. Pray for me. Send me sixty francs for models' fees. Thanks. Never lose faith in me.

<div align="center">Your Paula</div>

<center>*Paris, 8 May 1906*</center>

My dear Mother,

You're not angry with me! I was so afraid you'd be angry. It would have made me sad and hard. And now you are so good to me. Yes, Mother, I couldn't stand it any longer, and I'll probably never be able to stand it again either. It was all too confining for me and not what—and always less of what—I needed.

Now I am beginning a new life. Don't interfere, just let me be. It's so very beautiful. This last week I've been living as if in ecstasy. I feel I've accomplished something good.

Don't be sad about me. If my life should not bring me back to Worpswede, still the eight years I spent there were very beautiful.

I too am touched by Otto. That and the thought of you make this step especially difficult for me.

Let's wait quietly. Time will bring what is right and good. Whatever I do, stay firm in the belief that I'm doing it with the desire to do the right thing. I squeeze Kurt's hand. He's been so good to me. He's a bit of father to me.

You, dear Mother, stay close to me and give your blessing to whatever I do.

<div align="center">I am your child</div>

<center>Journals</center>

<center>*8 May 1906*</center>

Marées and Feuerbach. Marées, the greater. Feuerbach made compromises.

It's said that painting must produce an illusion. It's in this
way that Zuloaga achieves greatness. But the way he
achieves it is prosaic. It must be a mystery.

Great style in form also demands a great style in color.

Zola says in *L'Oeuvre*[10] that Delacroix is in the bones of us
poor realists. We can say that Zola is in our bones.

To Otto Modersohn

Paris, 15 May 1906

Dear Otto,

I haven't written you for a terribly long time because, as
it happens, I've been so hard at work. These last two weeks
have gone very well for me. Night and day I've been in-
tensely thinking about my painting, and I've been fairly
satisfied with everything I've done. I'm flagging somewhat
now, not working as much, and no longer as satisfied. But
on the whole, I still have a deeper and happier attitude
toward my art than I did in Worpswede. Only it demands
great, great exertion.

Sleeping amongst my paintings is delightful. My atelier is
very bright in the moonlight. When I wake during the
night I jump out of bed and look at my work. And in the
morning it's the first thing I see.[11]

Hoetger visited my atelier and he finds I have great tal-
ent. He said such good things to me, and all with such a
simple goodness. It's remarkable! At the exhibition in Bre-
men, his work made the biggest impression on me. And
now we seem to understand each other so well. It's as
though I've known him for a long time. There's no reason
to be jealous. Last year he married a woman he loves above
all. She's the small head in Bremen. He dresses her to his
taste and sees heaven in her. She is utterly devoted to him.
I feel very happy to have met these people.

To the Vogelers

Paris, 15 May 1906

Dear Heinrich Vogeler,

Don't take it amiss when I write you that I am very happy in my work and with my freedom. And continue to feel friendly toward me no matter how my life may change. I do hope it will get better and better and that I will get better and better.

Now a favor today. Don't you have one of those old round Worpswede folding tables? I've spoken to the sculptor Hoetger about them. He would like to have one built for his summer house. Would you be so kind as to make a little sketch of one for me?

What are you doing and when will I see you and Frau Martha again? Whenever I hear a waltz I can't but help think of the two of you—and other times too.

I have worked these last weeks as never before in my entire life. I believe it's happening. And it is beautiful.

This isn't a proper letter. I will write you a long, real letter soon. And I thank Frau Martha very much for hers. If ever she wants to write me again, it would make me very happy.

Yesterday in St.-Cloud the chestnuts were blooming in heavenly profusion. Life here is so full and so beautiful.

My regards to all in your very white house. I am your

Paula Modersohn-B.

Paris, 21 May 1906

Dear Martha Vogeler,

Your little letter made me very happy. I can tell from it that you like me and that's always a good feeling. We will remain "family" regardless, even when I am not with you. I'm not at all sick, despite what Otto Modersohn thinks. I am active and well and take great pleasure in my work. And I feel I am doing the right thing, even though I naturally am

sad about Otto Modersohn and Elsbeth and my family.
Now they are going through the pain that I went through
earlier, only they aren't getting anything out of it, while I
have recently been spending many beautiful hours.[12] You
shall see. With my freedom now I will make something of
myself. I almost believe by the end of the year. Whenever I
think about it I feel very religious. I am living in a big,
well-lighted atelier. Even though I don't have much furni-
ture, it's very comfortable and a bit of home for me. I really
like sleeping among my works and waking among them in
the morning. With faith in God I'm painting life-size nudes
and still lifes. Last week I crawled out of my fortress only at
night. After being wrapped up in one's self all day, at night
this big city seems so strange. Like having a look at a
picture book. It would be wonderful if you and Mining[13]
would come for a week. Can't you leave your new horses by
themselves for a little while? Is Gottlieb back yet? Do
come. Paris is even more beautiful in April because it's
greener, lusher. But you must come soon, while it's still not
too warm.

What you wrote me about my studies, naturally gives me
great pleasure. One loves to hear such things. It would
make me very happy for you to have the three little things
you wrote about. Which little girl with a black hat is it?
Does she have a flower in her hand?[14] If you want to give
me a hundred marks for the three pieces that would be very
fine. Otto Modersohn is good enough to keep sending me
money, but I still need a lot for models' fees. It would be
lovely if I could begin to earn a little myself.

So perhaps I'll see you? Do come, you won't regret it.
Will Mining be good enough to send me the sketch for the
table soon? Let me hear from you again.

With heartfelt greetings to both of you, I am

Your Paula Modersohn

I wrote this letter as soon as I received yours, and then I
left it in my portfolio. The next day Mining's letter arrived.
Dear Heinrich Vogeler, if only you would come with your

little wife and we could talk together, it would be wonder-
ful. Then you could tell me about what you're painting
now. But if your two bays won't permit it, then perhaps
next spring. Then we'll have even more to tell each other.
Be good to Otto Modersohn for me. For the second time,

Your P.B.

Hoetger is doing very strong things, different and more
beautiful than what you saw in Dresden. He thinks the
same as you do about Rodin.[15]

JOURNALS

26 May 1906
When Otto's letters reach me they are like voices from
the earth, while I am like one who has died and is in
Elysium, hearing these earthly cries.

TO OTTO MODERSOHN

Paris, 30 June 1906
Dear Otto,
The package has been here a week and I've been mean-
ing to write you a letter for a long time because I know you
are waiting for one. But something always came up. I have
to thank you for so many things. First for troubling with the
package because making packages is horrible; then for the
letters and the Schützenfest photograph; and finally for the
money.
Unfortunately after your departure I was feeling very
poorly. I'm still not as well as I was before Pentecost,[16] but I

am much better and I've been able to work steadily again for a week. That is the main thing for me right now. The weather is still quite good. Even if there are intervals of hot days, it cools off again. I think I want to stay here until August and then go somewhere in the country. Where remains to be seen. Either Brittany or else just outside the city. Until then I'd like to get on with a few things. At the moment I'm slaving away.

Your still lifes really amuse me. The small one is especially funny with its many oddities. It seems you do very well with Wurm paints.[17] Happily, now that I've tried painting in oils, I discover they have their advantages. I took your things to the Hoetgers, who were very interested in them. They were particularly pleased by the man throwing his cap in the air, the nude reclining on the slope, and the mother with her children sitting under the apple tree. They both have a good impression of you and will surely visit you in Worpswede one day. In the meantime, though, they're staying in Paris since he hasn't gotten any further with his large sculpture because his model was sick. They are both so considerate and charming to me. His wife, who's very quiet at first, opens up in conversation and reveals herself as someone with very fine instincts. It's still a wonder to me that I've found them and that we've become close so quickly.

Herma leaves tomorrow evening, so you'll get to see her soon and she can tell you about all the things we've done together.

I'm pleased Frau Brockhaus bought my still life. Unfortunately I have to pass along the money immediately. I borrowed about a hundred marks from Rilke early on, which I'm happy to be able to give back to him now.

Are you painting a lot? Your big still life arrived somewhat damaged, unfortunately. I'm keeping it here. Herma's bringing the other things along with her.

My best to everybody.

Your Paula M

To Her Family

Paris, 10 July 1906

My dear Sister,

You spoil me. You are so dear. Thank you from the bottom of my heart. If I could only be as good to you. You must believe I was once, and that I will be again. I can only assure you over and over again that I'm trying to do the right thing. Mother complains that I don't write. What should I write? You have to love me for a while, even if appearances are against me.

I remain

Your sister Paula

Journals

20 July 1906

The fleas of Paris. They're so quick and clever. You're happy just to catch a glimpse of one, catching hold of one is impossible from the beginning.

To Heinrich Vogeler

Paris, 31 July 1906

Dear Heinrich Vogeler,

One tries in one's own way to become something. I'm trying here in the big city, but I feel quite as you do that one should really be in the country in the summer, painting people outside. I hope to have many summers to do just that. But as long as it's possible I want to be near Hoetger. In spite of his being a sculptor, he can tell me many fine things about color. Someday when he gets to the country

he also wants to paint, large, perhaps decorative, but powerful things—perhaps something similar to Marées.

My moods vary. Sometimes my painting goes well and that makes me happy. Other times I struggle bitterly. Now I'm beginning to try to work longer on my things. It seems to me this is the only way to get somewhere. Of course it also gives me more time to bungle everything.

I thank you for saying you would like to have me back with the family. I believe and hope that wherever and whenever I meet you and your wife again, we will be happy together. It's sad for Otto Modersohn, I know. I have written him to come here and perhaps paint somewhere in the country after he finishes his pictures for the Gurlitt exhibition.[18] Then we might see what we still have to give to each other. In any case, there will be a decision by fall. Persuade him to let go of the little still life for you. I would enjoy it's being in your home. Perhaps you can say something to him about the other two little pieces that you want to show at Franz's, though it seems to me they are too unfinished. I leave the decision completely up to you. How nice that the art gallery is doing so well.[19] My heartfelt greetings to Franz and Frau Philine. Nice too that you are so hard at work and that you finally have your clay pit. Certainly something wonderful will come of it. How does little Martha look now? More like Mikelies or more like Bettine?[20] Riding certainly is a joy. One day you must send me some photographs on horseback—or on foot. Either way I would very much like to have a photograph. I have such a pretty one of your wife—but you are squinting.

My very best to the two of you. In friendship, I remain

Your Paula Modersohn

I owe you money from last year for a pair of Grünhagen shoes. Perhaps you still have the bill. Please deduct the money from the hundred marks. It's so terribly hot here all of a sudden that I want to go to the country. I hope to go on the hundred marks. Don't think me rude if I ask you to send it to me soon.

12 August 1906

Dear Heinrich Vogeler,

I am delighted about the money. I hope you enjoy the apples. I'm still not in the country,[21] but it might happen yet. At the moment I'm painting Frau Hoetger's portrait. She can look absolutely magnificent, and severe, with a gigantic crown of hair, blond, colossally shaped.[22]

But the Grünhagen shoes?

I wanted only briefly to tell you I received the money. And that I like the two of you very much. And you must keep on liking me too. Quite apart from my relationship to Otto Modersohn. Because basically I am a good guy, though I still make so many stupid mistakes.

One lives this way, another that. All of us as decently as we can.

After all, if people have something in them, they can do what they want, everything will turn out well. I hope and believe it's true of me. And this gives me peace.

My affectionate greetings to you both.

Your Paula Modersohn

To Her Family

Paris, 12 August 1906

Oh, dear Sister, don't torture yourself and me. I'm coming, only I don't know when. Besides, Hans more or less morally obligated me to come by sending me the money for the trip.

The hot spell is over. And even if it were still here, why worry about a little heat? You mustn't be so impatient in your love. Give things time, everything will work itself out.

"To struggle for courage" sounds so dramatic. You do what you can and then you go to bed. And so it happens that one day you have accomplished something.

Guilt or no guilt. One is as good or as bad as one is. Fussing over one's self is of little use. One simply and di-

rectly goes one's way. I consider myself good by nature. If I do something bad now and then, that's natural too.

Perhaps these words sound hard or conceited to you. One person thinks one way, another person another. The main thing is that we think consistently with our whole organism.

When one recognizes that there is something "to" another person (as you do of me), then one must quietly leave that person alone in such a situation as I'm in, and trust that person.

Write me when your guest room is empty, otherwise I'll come when T is there and camp on the sofa.

At the moment I'm painting Frau Hoetger's portrait. In a few days she will no longer be able to sit for me. Perhaps I'll be coming soon.

My regards to you and your dear Hans.

Your sister Paula

Paris, 3 September 1906

My dear Mother,

I've caused you much pain this summer, I've suffered myself. There was no way to spare you.

Mother, I have written Otto not to come. I'll take steps at this time to secure my livelihood for the present. Forgive the misery I bring you. I can not do otherwise.

For the time being, I'm going to the country. I'll try to write you more often. Don't do anything. You can't prevent it any longer.

Your Paula

I love you so much, even though it may not seem that way to you at the moment.

Paris, 16 September 1906

My dear Sister,

Please, no longer use these golden means in order to hear

from me. Thank you so very much for your goodness, but you must now save for Christmas and all kinds of pretty things. Let yourself be given a kiss, and don't send me anything else in return. I have enough for now. My holiday with you at your lovely Amorbach[23] is like a dream now. I am back living my life and my struggle. But when I reflect on the two of you, I'm so happy you kept things on an even keel. I find it intelligent and sensible of you. Stay that way. Everything good is difficult.

I am worried, though, about Hans's fever. Take care of it, both of you, please. And be careful about what he eats. And reread what Nietzsche has to say about cooking. He also eats bread while it is too fresh.[24]

Otto is coming after all. Hoetger preached to me all evening. Afterward I wrote Otto to come. You seem to mistrust the Hoetgers a little. They don't deserve it. They're better than many others and they have been good friends to me. But life has made me a little more cautious, and I haven't made my final judgment about them yet. When does one know others completely? When is one capable of knowing other people completely? The eternal "What is Truth?" confronts us daily in new guises.

Thank you for all your love. And keep on loving me, but without gold. Write me a little note from time to time telling me how you are. That's the most important thing right now.

My love to you and Hans.

Your Paula

You're moving? Should I help? You must tell me honestly if you feel you need me.

To Otto Modersohn

Paris, 16 September 1906

Dear Otto,

I'm writing today with practical questions about your stay

here. Should I rent you an atelier? It's the season now and there's a great rush for places to stay. When do you think you'll be here? I think an atelier will be more suitable for you than a shabby *chambre garnie*. Possibly you might want to send ahead a package by freight: bedding and the like. I also have a few things I need, most of all my beloved eider-down.

Herr and Frau Hoetger will stay here for the winter, and I hope you find a friend in him. He speaks very kindly of you. I wrote that last letter to you on his advice.

This was not supposed to be a letter. I just wanted to know how you want to live here.

Affectionately,

Your Paula M

To Her Family

Paris, 1 November 1906

My dear Mother,

I wish you all the happiness possible in your new year. I myself hope not to cause you any more unhappiness. I send all of you my love. I'm not very happy at the moment because with my moving, Otto's being here, and the past week of celebration with the Vogelers, I have completely stopped working. But I hope to begin again on Monday. I don't enjoy life without work for very long.[25]

Otto and I have talked about Elsbeth. We are by all means in favor of her entering an easier class. With her delicate health and her high-strung disposition, I think they expect too much from her. There's really no harm in keeping her back a year.

My love to the child and my sisters and brothers. I tenderly kiss you.

Your Paula

Paris, 18 November 1906

My dear Sister,

You love me in a truly sisterly way, for which I thank you. I love you too, in my own way, rather poorly, but from my soul. If you don't receive your reward from me, heaven will repay you in another way. It's my opinion that we are rewarded and punished for everything right here on earth.

The review[26] gave me more satisfaction than pleasure. The joy—the overpoweringly beautiful hours—takes place in art without others noticing. The same is true of the sorrow. That's why one mostly lives alone in art. But the review will be good for my show in Bremen and may place a different light on my leaving Worpswede.

Otto and I will move back home in the spring. The man is so touching in his love. We want to try to buy Brünjeshof in order to make our life together more free and open, with all kinds of animals around us. I look at it this way: if the good Lord allows me to create something beautiful once more, I'll be happy and content as long as I have a place where I can work in peace. And I'll be grateful for whatever part of love has come my way. As long as one stays healthy and doesn't die too young.

You're doing so well, Dear! I think about you and the little one very often. Just learn to be patient, and the happy event will soon arrive.[27] Don't let it matter to you whether it's a boy or a girl. Don't you think we're nice too?

Right now Otto is with Hoetger, who's modeling him. I'm to receive a cast. Gradually they have come to understand each other very well. Otto has great hopes for his own art this winter. New ideas are coming to him. This is a great comfort to me.

With your francs I bought myself frivolous baubles, naturally. Something for my head and something for my feet. A pair of beautiful old hairpins and a pair of beautiful shoe buckles.

Farewell, my Dear. Be happy and well and careful.

Paris, 29 January 1907

Dear Milly,

No, I haven't taken the Turkish veil. Besides I love you

very much. You've been the one person for me this year
who has loved me most unselfishly and has believed in me.
One is not really able to give thanks for such a thing,
though Heaven or Fate rewards each good impulse in one
way or another. I find there need be no Heaven or Hell.
These things arrange themselves in a very simple way right
here on earth. May a good piece of Heaven be ours. Your
great little Heaven is moving inside you. Milly, I don't feel
like talking about it at any length. I squeeze both of you by
the hand. May the good that is in both of you be born
anew, for your own and everyone else's joy.

Your Christmas brooch with the pretty little pin! I so
liked seeing its twin on your white tulle *fichu* against your
fair neck. I tenderly thank you.

What you write about Henry worries me. The boy is
phlegmatic. We're able to do little from afar. He's a bashful
soul who has to be handled in his own way. Sometimes
Mother gives him too much, sometimes too little. I had
similar feelings about Mother when I was between sixteen
and eighteen. Too bad the boy didn't talk with me at
Christmas. I love him very much, and I have a strong sense
of how good he is deep down inside.

I send you both my love.

Your Paula

Paris, 21 February 1907

My dear Milly,

Your birthday letter was like the warmth of you when you
used to pat me with your little chubby hands. Thank you,
dear girl. May God bless you. And my thanks for the gold
piece. I haven't bought anything with it yet, but it will be
something beautiful.

And you, and the two of you? You're probably counting
the days one by one until the middle of March. How eager
one is for such a little creature. You wonder what it will be,
whom it will look like, and whose personality it will have.
You'll certainly be a terribly loving mother and Hans a
splendid father. I intend to be a good aunt. More I cannot
do at the moment.

Here in this beautiful city Otto and I lead a quiet life working and reading. Hauptmann and his wife are planning to come next month. There will certainly be more exciting days then. We are thinking of returning home at the beginning of April.

It makes you sad that I don't write about my work? Dear Milly, art is difficult, endlessly difficult. And sometimes I don't like to talk about it. This shouldn't upset you.

Paris, 9 March 1907

My dear Mother,

Maybe in October you will become a grandmother again. I kiss you.

Your Paula

Don't tell anyone except my brothers and Frau R.[28]

Paris, 9 March 1907

My dear Sister,

If all goes well, I will be following your example in October. I hope this happy news will help to ease your difficult days. I kiss you and am very much with you and Hans in my thoughts.

In love,

Your Paula

Footnotes: Chapter XV

1. From a letter to Westhoff (2 April 1906) in *Briefe 1902 bis 1906*, p. 304.

2. Muntz, pp. 16, 15.

3. It was probably Hoetger who introduced Becker
to Maillol. Rilke to Becker, "Have you seen
Maillol again, and what has become of
Hoetger?" *Briefe aus den Jahren 1906 bis 1907*,
Leipzig, 1930, p. 227 (17 March 1907).

4. Galeries Durand-Ruel, 1–17 March 1906, "Tab-
leaux de Manet formant la collection Faure." Be-
sides the *Guitar Player* and the *Rabbit* (1866),
the exhibition at Durand-Ruel included the *Bon
Bock* and the *Absinthe Drinker*.
 28 February–15 March, "Exposition Odilon
Redon." This exhibition included twenty-two
paintings, even more pastels, some drawings,
and several graphics.
 Other artists showing in Paris at this time in-
cluded Cézanne at Vollard (until March 13th)
and Monet at Galerie Bernheim-jeune (until
March 29th). *La Chronique*, 1906, pp. 80, 88.

5. Admissions exams were held twice a year, in
April and October. Foreign students were obliged
to furnish "an introduction from their Ambassa-
dor and a certificate that they are prepared to
take the examinations." John Mead Howells,
"From 'Nouveau' to 'Ancien' at the Ecole des
Beaux-Arts," *The Architectural Record*, January
1901, p. 44.

6. Perhaps she was thinking of the color of Monet
or Matisse, both of whom had exhibitions open-
ing that day.
 19–31 March, Galeries Durand-Ruel, "Exposi-
tion de 17 tableaux de Cl. Monet de la collection
Faure."
 19 March–7 April, Galerie Druet, "Exposition
Henri Matisse." Gordon, p. 152.

7. The Ecole's large collection of copies of antique statues and moldings, including full-size columns of the Parthenon, was arranged in its endless rooms, halls, corridors, and in its famous "Gallery of Casts." See the special Ecole de Beaux-Arts issue of *The Architectural Record,* January 1901.

8. *Jeune Fille Arrangeant des Fleurs,* c. 1865, Toledo Museum of Art, Toledo, Ohio. In 1906 this painting was at Galerie Durand-Ruel.

9. Hoetger was participating in the Salon des Indé-pendants, 20 March–30 April 1906, along with Bonnard, Braque, Cross, Delaunay, Denis, De-rain, de Vlaminck, Dufy, Friesz, Laurencin, Matisse, Metzinger, Munch, Rouault, Rousseau, Signac, Van Rysselberghe, Vuillard, etc. Gordon, pp. 152–57.

 The photographs that interested him were of Indian sculpture. "She collected reproductions of Egyptian portraits (Greff collection), Indian sculp-ture, which an aunt brought back for her, Persian miniatures, which she saw in the Museum Guimet, the early antique, early Italians (Giotto, Uccello), the Old German Masters (Strigel, Cranach), El Greco, and the French moderns: Gauguin, Van Gogh, Cézanne, Denis, Maillol, and others." Modersohn in Hetsch, p. 26.

10. *L'Oeuvre,* one of Zola's Rougon-Macquart novels, is more or less a *roman à clef.* The main character, Claude Lantier, is a composite of Cézanne and Manet (and his paintings an amalgam of works by Cézanne, Manet, Monet, and others). He accepts only Delacroix and Courbet as his masters. "The public . . . insisted on seeing in Claude Lantier an impotent impressionist on the verge of mad-ness." The novel resulted in a break between Zola and Cézanne. John Rewald, *Paul Cézanne: A Biography,* New York, 1968, p. 147.

11. Herma, who occasionally stayed overnight at Becker's studio in Paris, remembered her sister waking in the middle of her sleep, lighting a candle, and standing in front of the painting she had been struggling with that day, checking, appraising, planning, anxious for the new day to begin so that she could go on with her work. Weinberg in Hetsch, p. 18.

12. A number of these hours were spent with Rilke, who in mid-May moved to Paris from Meudon following his abrupt dismissal as Rodin's secretary. Becker's portrait of Rilke is from this period. See illustration.

13. Heinrich Vogeler's nickname.

14. *Head of a Blonde Girl in a Strawhat,* c. 1905? Illustration 30 in Busch.

15. In 1906 Hoetger's style turned from the influence of Rodin to that of Maillol.

16. June 3rd.

17. Wurm paint was a thick oil tempera that did not need to be varnished. Both Becker and Modersohn had been dissatisfied with the shiny surface produced by oil paint. Becker was known to lay a sheet of paper over a fresh layer of paint, press it gently and then pull it off, in order to achieve an even surface. Busch, n.p., cat. no. 375.

18. An exhibition of Worpswede painters presented at Galerie Gurlitt in Berlin at the end of the year. A review of the exhibit in *Kunst und Kunstler* (February 1907, p. 214) does not mention Becker.

19. Heinrich Vogeler's brother Franz and his wife Philine opened an art gallery in Worpswede. In the summer of 1908 the gallery held the first Paula Modersohn-Becker memorial exhibition.

20. The three Vogeler children: Marieluise ("Mieke"), born 1901; Bettina, born 1903; and Martha, born 1905.

21. One visit Becker considered making was to Belgium, to join Rilke and Westhoff on their family holiday. But Rilke discouraged her and sent her a list of suitable places in Brittany instead. Rilke to Becker, 2 August 1906, *Briefe 1906 bis 1907*, pp. 62–63.

22. See illustrations.

23. In western Bavaria.

24. "Because they learned badly and not the best, and everything too early and too fast; because they *ate* badly: from thence hath resulted their ruined stomach;—

 "—for a ruined stomach is their spirit: *it* persuadeth to death! For verily, my brethern, the spirit *is* a stomach!" Thomas Common, trans., *Thus Spake Zarathustra*, New York, 1964, p. 251.

25. A spur to working was probably provided by the Salon d'Automne, 6 October–15 November, which included ten Cézannes and 227 Gauguins.

26. From the *Bremer Nachrichten*, 11 November 1906, by Gustav Pauli:

 ". . . with very special satisfaction we greet on this occasion all too seldom a guest at the Kunsthalle, Paula Modersohn-Becker. Atten-

tive readers of Bremen art news still remember the cruel dismissal given to this highly gifted artist several years ago in one of Bremen's distinguished newspapers. Unfortunately, I fear that her serious and powerful talent will not find many friends among the public at large. She lacks nearly everything to win hearts and attract the casual glance. But upon confronting such a phenomenon it is the duty of the serious critic to point out the quality. It is a pitiable satisfaction for a critic to be assured easy and momentary success as the mouthpiece of the prevailing opinion by tearing down excellent young talent who, naturally, always are readily misunderstood. Whoever ridicules as ugly the *Still Life* and the *Head of a Young Girl* by Paula Modersohn, can safely depend upon an approving nod from many readers. On the other hand, whoever says that there is in this young artist an exceptional power, a highly developed color sense, and a strong feeling for the decorative in painting, will have to be prepared for the opposition. And yet let it be said: we think ourselves fortunate to be able to lay claim to so strong a talent as Paula Modersohn. The artist has been living for some time in Paris, and the influence of the incomparable culture there, especially Cézanne, is evidently not to her disadvantage. . . ."

This was Becker's second public exhibition. She was part of a group show that included Modersohn, Am Ende, and Overbeck in the Bremen Kunsthalle.

27. Milly was five months pregnant.

28. Frau Rohland, i.e., Milly.

When Becker told Rilke the news he replied,
"I do think your life has powers, to replace and to
retrieve and to come to itself at any price. And if
outward circumstances turned out differently
from what we thought in those days, still only
one thing is decisive: that you bear them coura-
geously and have won through to the possibility
of finding within the given conditions all the
freedom *that* in you needs which must not be
destroyed in order to become the utmost that it
can become [*sic*].

"For solitude is really an *inner* affair, and the
best and most helpful step forward is to realize
that and to live accordingly. It is a matter, after
all, of things that do not lie entirely in our
hands, and success, which is something so simple
in the end, is made up of thousands of things, we
never fully know of what." *Letters,* pp. 268–69
(17 March 1907).

Rilke, who had been away from Paris since his
trip to Belgium at the end of July, was at this
time in Capri. Westhoff was in Egypt in early
1907.

XVI. Worpswede and Holthausen, 1907

In the two decades bracketing 1900 modern artists were reacting
against the emotional neutralism of Impressionism. They trans-
formed the vibrating color of the Impressionists from assuming
the properties of light to asserting the emotion of the artist. "We
must work," Becker conceded to Hoetger, "with an assimilated,
digested Impressionism." In Worpswede she went the battle with
Impressionism alone. The Worpsweders, who initially banded
together in opposition to German academicism, had rejected tra-
dition but not convention. Becker's natural allies were never
among the naturalist painters of Worpswede. Her best friends,
Clara Westhoff and Bernhard Hoetger, were sculptors. She was
in awe of Rodin. Through color she modeled form in space
("anything against the sky!") and she simplified it to achieve
more immediate expression.

Unlike the provincial nature worship of the Worpswede ar-
tists, Becker's art was nourished by other art. "I always have to
see what others are painting from time to time."[1] Paris was a
necessity for her. But she had the capacity to transcend her
sources: Cézanne and the structural; Gauguin and the primitive;
Van Gogh and the emotional. She was one of the first German
painters to understand French developments, and she moved on
her own in the direction of a new art. But she had even less time
in the twentieth century than Franz Marc and August Macke
(both killed in World War I) to reach the threshold of
modernism.

Becker's drive to pursue her own vision led her into heady joy

and vulnerable isolation. Except for Rilke and Westhoff, she received no support for her decision to abandon marriage. Even though some money was hers by inheritance, German law gave husbands control over the property of wives, and Becker was forced into financial dependence. Her unexpected pregnancy gave her resumption of married life the veneer of passion. But Becker's remarks in letters to her sister and Westhoff make it doubtful that she ever returned home emotionally and intellectually, only physically.

According to her sister, Becker's pregnancy was difficult and often kept her from painting. [2] *Yet the few self-portraits and nudes done in 1907 are her most forceful and unconventional works. Her color, always rich, becomes keener and her brushstroke more abrupt. Her Worpswede models lose their peasant identity and become vehicles for experiments in painting. In her last self-portrait her formerly matter-of-fact gaze now suggests a sexual knowledge of the world.*

Historically, symbolically, Becker's moment is her independent and prescient achievement. But her art is inseparable from her short and fiercely lived life. It was in an attempt to come to terms with her tragedy that Rilke wrote his long and beautiful Requiem (For a Friend) *in 1908. Convinced that we each have to die our own individual deaths, he could not forgive Becker for dying the woman's death, not the artist's. The struggle of her art and the force of her personality left him haunted:* "Only you, you come back; brush me; walk around. . . . you, who brought about more change than any other woman."

To Her Mother

Worpswede, 8 April 1907

My Mother,

Your last brother is dead. I remember when Uncle Günter died nearly twenty years ago. It must have been very difficult when he closed his eyes, and all the ties and memories you shared pulled twice as hard.

Blood is probably the strongest tie. It bridges the widest abysses. How different you and your brother were from each other, yet you were of the same blood and this made you close. One has to praise the Creator of this common bond.

To Otto Modersohn

Holthausen, ³ *July 1907*

Dear Otto,

... I certainly hope you're still coming, even if we aren't staying here much longer. Dear, I'm glad I made this trip. Nothing ventured, nothing gained. Hoetger really doesn't seem much different than he was in Paris. But his wife says he's very nervous and depressed because he feels he has a sick liver. He may be mostly hypochondriacal. I feel that with your experiences you may be able to talk him out of it a little. He speaks of you with great, kindly feeling. There are a lot of empty whitewashed walls here and we're planning to paint all sorts of things on them. We're very much hoping for your help. I've already told them how well you draw burlesque subjects in the Ostade-Breughel style.

The messenger is hurrying me about this letter. A thousand greetings. Good-bye.

Your P

Come soon. I'm very well.

To Bernhard Hoetger

Worpswede, Summer 1907

I've worked little this summer and I don't know if you'll like any of it. On the whole my subjects are always the same in conception. But the way they look is another matter. I'd like to render the ecstasy, the fullness, the excitement of

color, the power. My Parisian works are too cool and too
lonely and empty. They're the reaction to a restless, super-
ficial period and they strain after a simple, large impression.

I wanted to defeat Impressionism by trying to ignore it.
Which is how I was defeated. We must work with an assimi-
lated, digested Impressionism.

If I'm not mistaken (besides other things in your case),
this was the reason for the tragic fate of the saga.[4]

One can only pray over and over, "Dear God, make me
good so I can go to heaven."

To Her Sister

Worpswede, October 1907

My Sister,

As Anna Dreebein's[5] kin I have to say, as she does when
something vexes and bothers her, "It nearly knocked me off
my rocker." You must have patience, otherwise he or she
will have to hurry. And never again write me a postcard
with the words "diapers" or "blessed event." You know I'm
a soul who doesn't like to let other people know she's busy
with diapers.

Otherwise be kissed affectionately for your maternal lov-
ing care for me. You expressed it last summer and now this
year too. God bless you, dear woman. You know that I
never could and never will be like you. Not because of any
lack of warmth—my warmth will express itself its own way.
We can only wait and hope I will express it well. There are
enough people who condemn me on this account. You, I
believe, never will.

That it's even happier on your Herbstgasse than you had
expected, I've well imagined. I hope Christiane's antip-
athy toward the bottle has disappeared so you can have a
little peace and quiet for yourself. Get on a good scale once
a week so you know exactly how much you've lost. And be
conscientious and diligent about it. You owe it to your
future.

We're having a marvelously mild autumn and are enjoy-
ing it very much. I'm well and forbearing, but you must not
watch me so closely. The other night Anna Dreebein got
up three times because there was a light on in our house.
She was very disappointed in the morning when I floated by.

A true story from hereabouts: somebody went to a farm-
house wanting to speak to the farmer. His wife was stand-
ing at the hearth and said, "He laid down for a little while.
We had kind of a restless night." She, of course, had had a
child that night.

I kiss you affectionately. Remember me, in love

 Your sister Paula

I've seen a quiet, comfortable cradle that we might pick
up for ourselves.

 TO CLARA WESTHOFF-RILKE[6]

 Worpswede, 21 October 1907
Dear Clara Rilke,
 I am and have been thinking hard about Cézanne these
days. He is one of three or four forces in painting who have
affected me like a thunderstorm, a major event. Remember
1900 at Vollard's? At the end of my stay in Paris, some very
striking pictures of youths at Galerie Pellerin. Tell your
husband he should try to go to Pellerin's—a hundred and
fifty Cézannes. I saw only a small part of the exhibit, but it
was magnificent. My craving to know everything in the
Salon d'Automne is so great that I asked him at least several
days ago to send me the catalogue.[7] Please come soon with
the letters,[8] preferably immediately Monday, because I
hope finally soon to be making my claim in another way.
When it's not absolutely necessary for me to be here, I must
be in Paris.

To Her Mother

Worpswede, 22 October 1907
My dear Mother,
No! No! No! This won't do at all. I'm not supposed to become a grandmother yet. This big, enormously splendid creature belongs in your green room and I'd sincerely miss its not being at the window. Since you'll probably be traveling the greater part of the winter, I'll board it at my house for the time being. But when spring urges you homeward again to your dear house, I'll put its black socks on this big splendid creature and have it sent back to you. Thanks for the dear thought.

Otherwise Kurt has probably told you all the news. Unfortunately there's nothing further and you'll have to be patient a while longer. Dreebein really has no more interest in me.

I'd like to go to Paris for a week. There are fifty-six Cézannes on exhibit.

Farewell. I hope the weather continues to be beautiful, although this is almost greedy and immodest to hope or ask for.

Your Paula

On November 2nd Becker gave birth to a baby girl she named Mathilde, after her own mother. On November 21st she died.

Clara Westhoff ends her reminiscences[9] with this description:

"In November I and my little daughter stood at her bedside. She was lying with her little daughter who was just a few days old—with the happiest and quietest smile I had ever seen on her.

"Otto Modersohn told me later what had happened:

"*Paula received permission to get up and was preparing happily to do so. She had a big mirror placed at the foot of the bed. She combed her beautiful hair, braided it, and wound it into a crown atop her head. She pinned on roses someone had given her and then proceeded easily into the other room, ahead of her husband and brother who wanted to support her. The candles were lit, the chandelier, a Baroque angel with a circle of candles around its belly, and many other candles.*

"*She asked if someone would bring her her child, and when she had the baby she said, 'Now it's almost as beautiful as Christmas.' Suddenly she had to put her feet up—and as someone came to help her, her last word was, 'Pity.'*

"*The news of her death reached me belatedly in Berlin. One morning in the slowly growing light of late November I went with a bouquet of autumnal branches down the same avenue of birches where we had so often walked together.*

"*I found the house empty. Otto Modersohn had left. Milly had taken the baby with her. And Paula was no longer there.*

" *'But as to the effect of the death of someone near on those left behind, it has long seemed to me it can be none other than a higher responsibility; doesn't the one who has passed away leave behind a hundred undertakings to be carried on by the survivors, if they were sincerely involved with each other to any extent?'* [10]

"*It is clear that the deep intensity of a noble and seriously searching person radiates an energy which increases abundantly. And Paula's task was not painting alone, as she herself once said, but the process of life, for which we gave up everything in order to share its wealth.*"

Footnotes: Chapter XVI

1. Reylaender-Böhme in Hetsch, p. 36.

2. "Later in her pregnancy she suffered immensely from the upsets and from tiredness, which

paralyzed her creative energy. Although at times there were good weeks and periods of strong artistic excitement and creative displays. The room where she spent her confinement she had hung with her latest pictures in order to continue during her many quiet hours examining, pondering, and checking." Weinberg in Hetsch, p. 18.

3. Hoetger's country house in Westphalia [S.D.G.].

4. Probably the large figure Becker referred to in the last chapter, which Hoetger was having difficulty finishing.

5. Or "Three-legged Anna," a hunchbacked, dwarfed, old Worpswede woman who walked with a cane. She was a favorite model of Becker.

6. Originally published in Hetsch, pp. 49–50.

7. The Salon d'Automne (1–22 October) that year included a Cézanne retrospective and the works of, among others, Bonnard, Brancusi, Braque, Derain, Duchamp-Villon, Dufy, Ensor, Kandinsky, Leger, Marin, Matisse, Modigliani, Münter, Redon, Rouault, Rousseau, and Vlaminck. The Cézanne retrospective was made up of works from the Pellerin Collection, the Cézanne fils Collection, and the Gangnat Collection. Gordon, p. 228.

On October 21st Rilke wrote Becker, "The catalogue is going simultaneously. With it two issues of *Mercure*, containing notes on Cézanne The Salon closes tomorrow. Cézanne was an event which most people had no patience left to see. Hoetger had two heads of Buddha-like *modelés*, which could not have come from his heart. But perhaps I am unjust. I saw only

Cézanne. Farewell and be a little forebear-
ing. . . ." *Briefe 1906–07,* p. 400.

8. According to Westhoff, these are Rilke's letters
 about Cézanne.

9. In Hetsch, pp. 51–52.

10. "This passage is from a letter by Rainer Maria
 Rilke to Elisabeth Baroness Schenk zu
 Schweinsberg from 23 September 1908. . . ."
 Ibid.

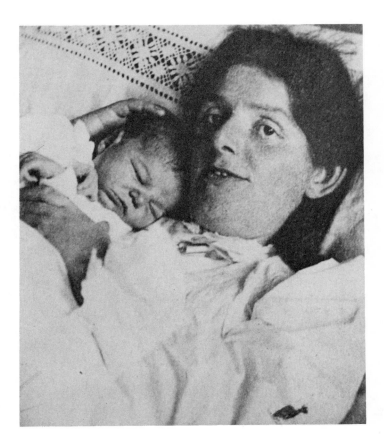

Epilogue

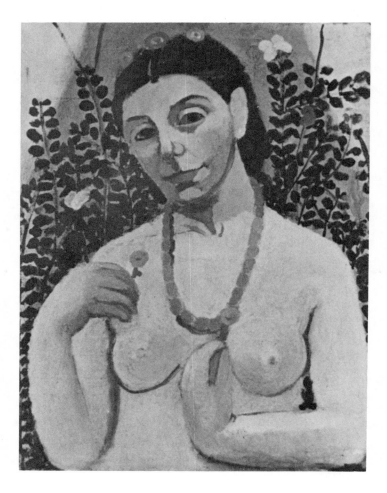

Self-Portrait, Half-Nude, with Amber Necklace
canvas, 60 × 50cm (23½ × 19¾in)
1906
Kunstmuseum, Basel

Rainer Maria Rilke:

Requiem (For a Friend)

I've had my dead, and I have let them go,
have been surprised to see them so content,
so soon at home in being dead, so just,
so different from our expectations. Only you,
you come back; brush me; walk around; you want
to touch something that could resound of you
and betray your presence. Oh, don't take from me
what I'm slowly finding out. I know. You are mistaken
if one single thing here still can move you
to longing and return. We change it:
it doesn't exist, we create its reflection
from our own being, in recognizing it.

I thought you further ahead. I am confused
that *you*, of all of them, have made
the mistake of coming back, you,
who brought about more change than any other woman.
Yes, it stunned us that you died; or rather that
your forceful death interrupted us darkly,
tearing asunder the Until-then from the Since-then:
that concerns us; to put that in its place will be
the long labor we must give to everything.

But that you yourself were stunned, and even now
feel terror, where terror has no meaning—
that you lose one moment of your eternity
and enter here, friend, here
where everything's unfinished—that, scattered,
scattered and divided, for the first time, in the Universe,
you failed to understand the opening of Infinity
as you understood each thing here:
that out of the order of the spheres
that already had received you
the wordless pull of some inquietude
draws you down to measured time—
this thought often disturbs my sleep
like a thief breaking in.

I could say perhaps you just deign to be here,
come out of generosity, of over-fullness,
because you're so secure, so in-yourself
that you can walk, child-like, unafraid
of dangerous places. But no: you beg.
This cuts me to the bone and rasps there like a saw.
If, as a ghost, you came accusing me,
reproaching me when I retreat at night
into my lungs, into my bowels, into
the last and poorest chambers of my heart,
such a reproach would be less cruel to bear
than this entreaty. What are you begging for?

Tell me: shall I travel? Have you somewhere
left behind a thing which is torturing itself
wanting to follow you? Shall I go to a land
you never saw, though it belonged to you
like the other half of your senses?
I want to follow
its rivers, go ashore, and study the old customs,
talk with the women in their doorways,
watch when they call their children.
I want to memorize the turning of the soil,
the old labor of fields and meadows.

I'll ask to see their king, I'll bribe their priests
to lay me before their highest altar,
then to withdraw, locking the sanctuary door.
And finally, full of knowledge,
I want to simply watch the animals
till the essence of their movement glides into my bones;
I want to exist briefly
where their eyes hold me and slowly let me go,
quietly, without judgment.
I want to ask the gardeners
the names of many flowers, so in the shards
of those beautiful names I can bring back
the traces of hundreds of scents.
And I want to buy fruit, fruit that englobes
the land rising up into the heavens.

For that you understood: the fruits in their ripeness.
You set them in bowls before you,
balanced out their heaviness with color.
And, just like fruit, you saw the women, too,
and saw the children so, pressed from within
to find the contours of their being.
And last of all you saw yourself like fruit,
peeled yourself out of your clothes, carried yourself
to the mirror, entered into it.
Only your looking stayed outside, large,
and did not say: This is me; but This is.
And by the end your look was neither
curious nor possessive, and of such pure poverty
it finally wanted to possess
not even yourself: holy.

I want to recall you so, as you placed yourself
in the mirror, deep into it,
away from everything.
Why have you come back so different?
Why do you contradict yourself?
Are you trying to tell me that in those beads
of amber round your neck was still some heaviness

of weight unknown in the other world
of becalmed images?
Why does your posture speak with such foreboding?
What makes you arrange the contours of your body
like the lines of a palm
so I must see them as your fate?
Come here into the candle-light. I'm not afraid
to face the dead. When they return
they have a right to be within our view
like other things. Come here.

Let us be silent for a while.
Look at this rose here on my writing-table:
isn't the light surrounding it as timid
as that which falls around you?
The rose shouldn't be here either.
It should have stayed out in the garden,
or died, should not have been involved with me.
Now it remains like this:
what does my awareness mean to it?

Don't be afraid if now I understand:
Oh, it wells up in me—
I can't help it, I have to understand
even if I die of it—
understand you are here. I understand.
As a blind man encircles with his touch
the surfaces of things and understands—I feel your fate
and cannot name it.

Let us grieve together that you were taken
out of your mirror. Can you still shed tears?
No, you cannot. You transformed
your tears' power and force
into your mature gaze.
You were about to change
your every juice into a strong being
that rises, circles, balanced and unseeing.
And just then chance, your final accident,

pulled you back from your furthest transformation,
back into a world where juices *reign*.
Not all at once: pulled just a piece at first.
But when, day after day, around that piece
reality kept growing, making it heavy,
you needed yourself completely.
And so you went and tore yourself away,
painfully, in fragments, from the law,
needing yourself. You took yourself away
and pulled out of your heart's night-warm earth
the still-green seeds from which your death was meant to grow—
yours, your own death, the end of your own life.
And these you ate, the seeds of your death;
Like all the others;
ate its seeds and had their after-taste
of unintended sweetness, had sweet lips,
you, already sweet yourself within your senses.

O let us mourn. Do you remember how your blood
returned from its incomparable circling
with hesitation and reluctance when you
called it back? How it took on again, confused,
the body's brief cycle; how amazed, mistrustful,
it entered the placenta,
suddenly tired from the long journey back?
You drove it on, you pushed it forward,
you wrenched it to the fire as you would drag
a herd of animals to sacrifice;
and you expected it to rejoice.
And finally, you got your way:
it was glad, came up, and gave itself to you.
Used as you were to timelessness,
you thought all this would last only a little while;
but now you were in time again, and time is long.
And times goes on, and time expands,
and time is like a relapse after long illness.

How short your life, when you compare it
with all those hours you sat silently

turning the many forces of your unbounded future
upon the new seed in you
which became fate again.
O painful toil, O toil beyond all strength!
Day after day you did the labor, dragged yourself there,
pulled the lovely weaving out of the loom
and used all your threads differently. And finally,
you still had courage to celebrate.
For when it was done, you wanted
to be praised like a sick child for swallowing
the bitter-sweet liquid which might cure you.
So you rewarded yourself: for you were still too far
from all else, even then;
No one could have guessed the right reward
for you. But you knew. You sat up
in child-bed, and before you was a mirror
that gave all back to you.
That was all *you*, all *outside*,
and inside it just illusion, the lovely illusion
of any woman trying on her jewels,
combing her hair in a new way.

And so you died as women used to die
in olden times, old-fashionedly you died
in the warm house, the death
of women after birth, who want to close themselves
again but can't, because
that darkness they have also given birth to
comes back again, and prods, and enters them.

Wouldn't it have been better to have found
wailing women, those who mourn for money,
whom one can pay to sob all night
when all is quiet? Rituals, come back!
We are poor in rituals. Everything
is talked into extinction.
That's why you come here, dead,
so we can make up for all the lamentation
left undone. Can you hear me mourning?
I'd like to cast my voice like a cloth

over the shards of your death
and tear it into shreds, till everything I say
walks freezing in the tatters of this voice:
if mourning were enough.
But now I accuse: not Him who took you from yourself
(I can't single him out, he's like them all)
but in him I accuse all of them: Man.

If somewhere deep in me is rising
a sense I'm unaware of yet
of having been a child
perhaps the purest childness of my childhood:
I don't want to know it.
I want to make an angel of it, without looking,
and hurl it into the front rank of howling angels
who keep reminding God.

For this suffering has gone on too long,
no one can bear it, it's too hard for us,
the twisted pain caused by a false love
which counts on getting-off through lapse of time,
through habit; claims to be just,
although unjustly grown.
Where is the man with right of ownership?
Who can own what can't possess itself,
what can, from time to time,
just joyfully catch and fling itself away
like a child playing with a ball?
Does the sea-captain still possess the figurehead
at his prow, when the mysterious lightness
of her god-like self lifts her high into the bright sea-wind?
No more can one of us call back the woman
who does not see us any more,
who walks away from us as by a miracle,
on a narrow strip of her own being, without mishap;
unless guilt were indeed his calling and his pleasure.

For *this* is guilt, if anything is guilt:
not to enlarge a loved one's freedom
with all the freedom we find within ourselves.

Where we love, there can be only this: let go of one another;
for holding-on need not be learned, it's natural to us.

Are you still there? Which corner shelters you?
You know so much of this, could do so much
as you walked along, open to everything,
like a day breaking.
Women suffer:
to love means to be alone, and artists
suspect sometimes in their work
that loving means transforming.
You started both: and both will now
become distorted by your fame,
which takes them from you.
Oh, you were remote from any fame.
You were inconspicuous, had drawn your beauty
inside you, gently, as one takes in a flag
on a grey workday morning.
You wanted nothing but a long piece of work,
which remains unfinished, in spite of all,
not finished.

If you're still here, if in this darkness
there is some place where your spirit
vibrates acutely with the shallow sound waves
set pulsing by a voice alone at night
in the air of a high-ceilinged room—
then hear me, help me.

See, we slide back, not knowing when,
from our advances, into something we don't mean,
getting caught there as in a dream
in which we die without awakening.
No one goes further. It can happen
to anyone who has lifted his blood high
into a long piece of work—he can't
sustain it there, it falls
by its own gravity, and fails.
For somewhere there is an old enmity

between life and the great work.
Help me recognize it, help me say it.
Do not come back: if you can bear it,
stay dead, with the dead.
The dead have things to do.
But help me, still, some way that won't distract you,
as what is furthest off can sometimes help me:
within myself.

1908

Adrienne Rich:

Paula Becker to Clara Westhoff

The autumn feels slowed-down,
summer still holds on here, even the light
seems to last longer than it should
or maybe I'm using it to the thin edge.
The moon rolls in the air. I didn't want this child.
You're the only one I've told.
I want a child maybe, someday, but not now.
Otto has a calm, complacent way
of following me with his eyes, as if to say
Soon you'll have your hands full!
And yes, I will; this child will be mine,
not his, the failures, if I fail
will be all mine. We're not good, Clara,
at learning to prevent these things,
and once we have a child, it *is* ours.
But lately, I feel beyond Otto or anyone.
I know now the kind of work I have to do.
It takes such energy! I have the feeling I'm
moving somewhere, patiently, impatiently,
in my loneliness. I'm looking everywhere in nature
for new forms, old forms in new places,
the planes of an antique mouth, let's say, among the leaves.
I know and do not know
what I am searching for.

328

Remember those months in the studio together,
you up to your strong forearms in wet clay,
I trying to make something of the strange impressions
assailing me—the Japanese
flowers and birds on silk, the drunks
sheltering in the Louvre, the river-light,
those faces. . . . Did we know exactly
why we were there? Paris unnerved you,
you found it too much, yet you went on
with your work . . . and later we met there again,
both married then, and I thought you and Rilke
both seemed unnerved. I felt a kind of joylessness
between you. Of course he and I
have had our difficulties. Maybe I was jealous
of him, to begin with, taking you from me,
maybe I married Otto to fill up
my loneliness for you.
Rainer, of course, *knows* more than Otto knows,
he believes in women. But he feeds on us,
like all of them. His whole life, his art
is protected by women. Which of us could say that?
Which of us, Clara, hasn't had to take that leap
out beyond our being women
to save our work? or is it to save ourselves?
Marriage is lonelier than solitude.
Do you know: I was dreaming I had died
giving birth to the child.
I couldn't paint or speak or even move.
My child—I think—survived me. But what was funny
in the dream was, Rainer had written my requiem—
a long, beautiful poem, and calling me his friend.
I was *your* friend
but in the dream his poem was like a letter
to someone who has no right
to be there but must be treated gently, like a guest
who comes on the wrong day. Clara, why don't I dream of you?
That photo of the two of us—I have it still,
you and I looking hard into each other
and my painting behind us. How we used to work

side by side! And how I've worked since then
trying to create according to our plan
that we'd bring, against all odds, our full power
to every subject. Hold back nothing
because we were women. Clara, our strength still lies
in the things we used to talk about:
how life and death take one another's hands,
the struggle for truth, our old pledge against guilt.
And now I feel dawn and the coming day.
I love waking in my studio, seeing my pictures
come alive in the light. Sometimes I feel
it is myself that kicks inside me,
myself I must give suck to, love . . .
I wish we could have done this for each other
all our lives, but we can't . . .
They say a pregnant woman
dreams of her own death. But life and death
take one another's hands. Clara, I feel so full
of work, the life I see ahead, and love
for you, who of all people
however badly I say this
will hear all I say and cannot say.

1975–1976

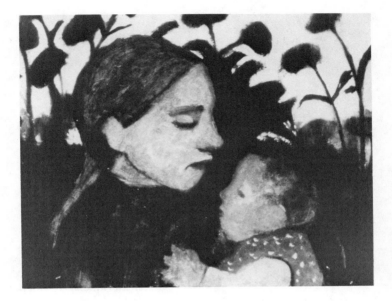

Girl with Child

cardboard, 44.5 × 50cm (17½ × 19½ in)
c. 1904
Collection Haags Gemeentemuseum, The Hague

Index